MediaArtHistories

LEONARDO

Roger F. Malina, Executive Editor
Sean Cubitt, Editor-in-Chief

MediaArtHistories

edited by Oliver Grau

The MIT Press
Cambridge, Massachusetts
London, England

MIT Press books may be purchased at special quantity discounts for business or sales promotional use. For information, please email special_sales@mitpress.mit.edu or write to Special Sales Department, The MIT Press, 55 Hayward Street, Cambridge, MA 02142.

This book was set in Garamond 3 and Bell Gothic on 3B2 by Asco Typesetters, Hong Kong, and was printed and bound in the United States of America.

Library of Congress Cataloging-in-Publication Data

MediaArtHistories / [edited by] Oliver Grau.
 p. cm. — (Leonardo)
Includes bibliographical references.
ISBN-13: 978-0-262-07279-3 (hc : alk. paper)
1. Art and technology. 2. Art and science. 3. Art—Historiography. I. Grau, Oliver.
II. Title: Mediaart histories. III. Title: Media art histories.

N72.T4M43 2006
701′.05—dc22 2006046635

10 9 8 7 6 5 4 3 2

Contents

Series Foreword

The arts, science, and technology are experiencing a period of profound change. Explosive challenges to the institutions and practices of engineering, art making, and scientific research raise urgent questions of ethics, craft, and care for the planet and its inhabitants. Unforeseen forms of beauty and understanding are possible, but so too are unexpected risks and threats. A newly global connectivity creates new arenas for interaction between science, art, and technology but also creates the preconditions for global crises. The Leonardo Book series, published by the MIT Press, aims to consider these opportunities, changes, and challenges in books that are both timely and of enduring value.

Leonardo books provide a public forum for research and debate; they contribute to the archive of art-science-technology interactions; they contribute to understandings of emergent historical processes; and they point toward future practices in creativity, research, scholarship, and enterprise.

To find more information about Leonardo/ISAST and to order our publications, go to Leonardo Online at http://lbs.mit.edu/ or email leonardobooks@ mitpress.mit.edu.

Sean Cubitt
Editor-in-Chief, Leonardo Book series

Leonardo Book Series Advisory Committee: Sean Cubitt, *Chair*; Michael Punt; Eugene Thacker; Anna Munster; Laura Marks; Sundar Sarrukai; Annick Bureaud

Doug Sery, Acquiring Editor
Joel Slayton, Editorial Consultant

Leonardo/International Society for the Arts, Sciences, and Technology (ISAST)

Leonardo, the International Society for the Arts, Sciences, and Technology, and the affiliated French organization Association Leonardo have two very simple goals:

1. to document and make known the work of artists, researchers, and scholars interested in the ways that the contemporary arts interact with science and technology; and
2. to create a forum and meeting places where artists, scientists, and engineers can meet, exchange ideas, and, where appropriate, collaborate.

When the journal *Leonardo* was started some forty years ago, these creative disciplines existed in segregated institutional and social networks, a situation dramatized at that time by the "Two Cultures" debates initiated by C. P. Snow. Today we live in a different time of cross-disciplinary ferment, collaboration, and intellectual confrontation enabled by new hybrid organizations, new funding sponsors, and the shared tools of computers and the Internet. Above all, new generations of artist-researchers and researcher-artists are now at work individually and in collaborative teams bridging the art, science, and technology disciplines. Perhaps in our lifetime we will see the emergence of "new Leonardos," creative individuals or teams that will not only develop a meaningful art for our times but also drive new agendas in science and stimulate technological innovation that addresses today's human needs.

For more information on the activities of the Leonardo organizations and networks, please visit our websites at http://www.leonardo.info/ and http://www.olats.org/.

Roger F. Malina
Chair, Leonardo/ISAST

ISAST Governing Board of Directors: Martin Anderson, Michael Joaquin Grey, Larry Larson, Roger Malina, Sonya Rapoport, Beverly Reiser, Christian Simm, Joel Slayton, Tami Spector, Darlene Tong, Stephen Wilson

Acknowledgments

This book is the fruit of the labors of many colleagues with whom I have had the pleasure to work and get to know on various levels during the past fifteen years. Thanks to all the authors from many disciplines for the highly professional worldwide collaboration which made this book possible. The desire to bring together a collection of thinkers from a variety of fields, all examining media art, is answered in this book as well as by a conference for which I served as chair in 2005. Refresh! The First International Conference on the Histories of Media Art, Science, and Technology was produced by the Database for Virtual Art, Leonardo, and the Banff New Media Institute (where the conference was held) and was a great success for the emerging field of scholars for whom this book is also produced. Though this book is not a direct result of the conference, Refresh! nonetheless definitively influenced our discussions.

I would like to thank the Advisory and Honorary Board of the Refresh! conference, many of whom are contributors to this book, for their engagement in the creation of our emerging field: Rudolf Arnheim, Andreas Broeckmann, Paul Brown, Karin Bruns, Annick Bureaud, Dieter Daniels, Diana Domingues, Felice Frankel, Jean Gagnon, Thomas Gunning, Linda D. Henderson, Manray Hsu, Erkki Huhtamo, Douglas Kahn, Ángel Kalenberg, Martin Kemp, Ryszard Kluszczynski, Machiko Kusahara, W. J. T. Mitchell, Gunalan Nadarajan, Christiane Paul, Louise Poissant, Frank Popper, Jasia Reichardt, Itsuo Sakane, Edward Shanken, Jeffrey Shaw, Barbara Maria Stafford, Tereza Wagner, Peter Weibel, Steven Wilson, and Walter Zanini.

Special thanks go to the Leonardo Network, namely Roger Malina and Melinda Klayman. Special thanks also to Sara Diamond, who shared very early the vision of Refresh!, and to the Deutsche Forschungsgemeinschaft, whose sponsorship built the financial ground for several years of research.

I am very grateful to my colleagues Anna Westphal for her worldwide research, Anna Paterok for her organizational help with the authors and manuscripts, to Wendy Jo Coones for her editing, her cordial and endless organizational help—this book wouldn't have been realized without her— and to all three for their good spirits. Thanks go to Gloria Custance and Susan Richter for their translation work. Special thanks go to Tensing.

This book would naturally not be possible without MIT Press, but the people behind the press providing support and encouragement are the important element. I would like to thank Doug Sery for his early support of this book, Valerie Geary for her constant help along the way, and especially Judy Feldmann, who worked with the text during the final editing of this book crossing twenty authors—from four continents and with six different native languages.

My deepest thanks to Rudolf Arnheim, whose influence on the field and lifetime of work have been greatly impressed upon my own research.

Introduction

Oliver Grau

> The technology of the modern media has produced new possibil-
> ities of interaction.... What is needed is a wider view encompass-
> ing the coming rewards in the context of the treasures left us by
> the past experiences, possessions and insights.
> —RUDOLF ARNHEIM, SUMMER 2000

Recognizing the increasing significance of media art for our culture, this book
will discuss for the first time the history of media art within the inter-
disciplinary and intercultural contexts of the histories of art. It explores and
summarizes the mutual influences and the interactions of art, science, and
technology and assesses the status of digital art within the art of our times.
To do so, this collection assembles some of the most well-known researchers
of this emerging field.

This book discusses questions of historiography, methodology, terminol-
ogy, and the roles of institutions and inventions in media art. It contains key
debates about the function of the machinic, of projection, visuality, automa-
tion, of neural networks and mental representation, as well as the prominent
role of sound during the last decades, contemporary science theory, and scien-
tific visualization. It will also emphasize themes of collaborative research and
pop culture in the histories of media art.

The goal is to open up art history to include media art from recent decades
and contemporary art forms. Besides photography, film, video, and the little-
known media art history of the 1960s to the '80s, today media artists are

active in a wide range of digital areas (including net art, interactive, genetic, and telematic art). Even in robotics, a-life, and nanotechnology, artists design and conduct experiments.[1] This dynamic process has triggered intense discussion about images in the disciplines of art history, media, cultural studies, and the history of science. The focus will be to view and analyze media art against the backdrop of art history and reflections from neighboring disciplines. This anthology in media art histories offers a basis for attempting an evolutionary history of audiovisual media. It is an evolution with breaks and detours; however, all its stages are distinguished by a close relationship between art, science, and technology.

This is what it's about: hundreds of names of artists, thousands of artworks, art trends, theory of media art in keywords, presented in an enormous circle-diagram (fig. 1.1). Thirty-two slices are offered as a subdivision into themes, such as representation, emotion and synesthesia, the material issue in art, atmosphere, games, therapy, mission, and art as spatial experience through which we find glimpses of a history of media art.[2] Over the last thirty years

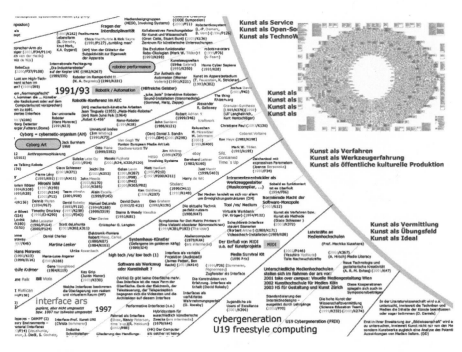

Figure 1.1 Gerhard Dirmoser, *Ars Concept Cluster*, 2004. By kind permission of the author.

media art has evolved into a vital factor of the contemporary artistic scene. Digital art has become the art of our times, yet it has not "arrived" in the cultural institutions of our societies. It is still rarely collected, it is not included or supported under the auspices of art history or other academic disciplines, and it is almost inaccessible for the non-north-Western public and their scholars. To change this is our goal! What is needed is a wider view encompassing media art in the context of the treasures left us by past experiences, possessions, and insights.

On the path leading toward installation-based virtual art, Charlotte Davies transports us with *Osmose* or *Éphémère*—already classics—into a visually powerful simulation of a lush mineral-vegetable sphere, which we can explore via an intimate interface (fig. 1.2).[3] Japanese-flavored interaction is observed with Hiroo Iwata's *Floating Eye* (2000; fig. 1.3), in which a camera on a blimp replaces one's normal vision with a panoramic spherical screen, so that one can observe oneself from above. Operating in both the scientific and artistic arena, Karl Sims's artificial life research can be found at the Centre Pompidou

Autumn Flux I real-time frame capture from Ephemere (1998)
© 2000, Char Davies/Immersence Inc. & Softimage Inc.

Figure 1.2 Char Davies, *Éphémère*, 1998. See plate 1. By kind permission of the artist.

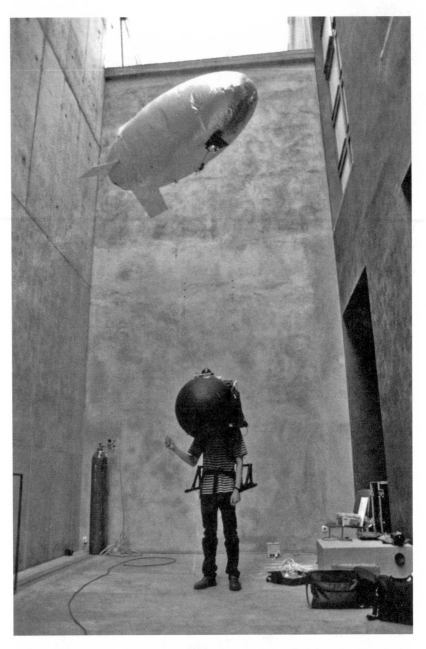

Figure 1.3 Hiroo Iwata, *Floating Eye*, 2000. By kind permission of the artist. Photo by Ars Electronica.

Figure 1.4 Karl Sims, *Genetic Images*, 1993. See plate 2. By kind permission of the scientist.

and in his technical journals (fig. 1.4). Constructed on a database, the interactive installation *Ultima Ratio* by Daniela Plewe offers a first glimpse of a future system for interactive theater (fig. 1.5). Intellectually challenging, her concept piece allows the spectator to solve an open conflict at a high level of abstraction using combination of different dramatic motifs. Plewe's goal is to generate a visual language for argument and debate.[4]

David Rokeby's *Very Nervous System* is a classic sound piece now twenty years old on publication of this book. Presented in galleries and public outdoor spaces and used in performances over the past two decades, this work creates a complex and resonant aural relationship between the interactor and the system (fig. 1.6).

In a finely meshed alliance between science and art, media art today explores the aesthetic potential of interactive, processual image worlds. Leading exponents of virtual image culture work in basic research and combine art and science in the service of today's most complex technology for generating images. These internationally prominent artists, who often work as scientists at research institutes, are engaged in the development of new interfaces, models for interaction, and innovative codes: they set the technical limits themselves according to their own aesthetic goals and criteria.

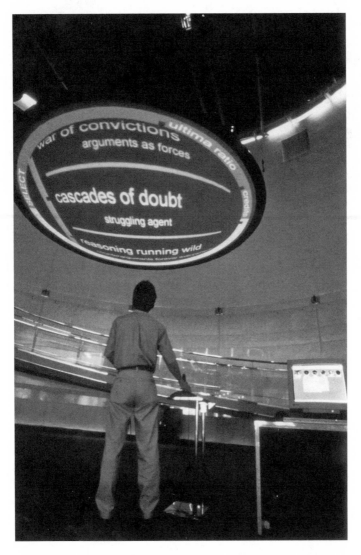

Figure 1.5 Daniela Plewe, *Ultima Ratio*, 1997. By kind permission of the artist.

Figure 1.6 David Rokeby, *Very Nervous System,* 1986. By kind permission of the artist.

The Next Five Seconds

These artworks both represent and reflect the revolutionary development that the image has undergone over the past few years. Never before has the world of images changed at such a breakneck pace as over the last few decades. Images were once exceptional and rare, reserved mainly for religious rituals; later, they were the province of art, then of museums and galleries. Today, in the age of cinema, television, and the Internet, we are caught up in a matrix of images. Images are now advancing into new domains. Television, for example, is changing into a zapping field of thousands of channels; gigantic projection screens are invading our cities; infographics permeate the print media; and cell phones transmit micromovies in real time. Currently, we are witnessing the transformation of the image into a computer-generated, virtual, and spatial entity that seemingly is capable of changing "autonomously" and representing a lifelike, visual-sensory sphere. Interactive media are changing our perception and concept of the image in the direction of a space for multisensory, interactive experience with a temporal dimension. Things that formerly

were impossible to depict can now be represented; temporal and spatial parameters can be changed at will so that virtual spheres can be used as models or simulations for making specific types of experience. Artists are making image spaces of interactive art that can be experienced polysensorially, spaces that promote processuality, narration, and performance, and thus also give new meaning to the concept of gaming. The dynamic process of change has fueled the interdisciplinary debate about the status of the image, a debate with protagonists such as Mitchell, Belting, Elkins, Stafford, and Manovich.[5]

But without exception, neither these artworks nor the last decades of digital art in general have received the appropriate attention by academic disciplines or have been added in adequate numbers to the collections of museums and galleries. We are thus in danger of erasing a significant portion of the cultural memory of our recent history. The evolution of media art has a long history and a new technological variety has now appeared.[6]

However, this art cannot be fully understood without an understanding of its history, which is why Rudolf Arnheim's recently published plea for integrating the new, interactive, and processual worlds of images into the experiences and insights that have come down to us from the art of the past begins the selected articles in this book. There are many stories yet to be told about media art, the discipline of art history, media artists, and their work. However, we are also waiting for a great deal more: studies that will aid media art to overcome its existence at the periphery of the discipline of art history. A first step, of course, will be to tell the story in numbers, places, names, and technologies, like many current international databases and archiving projects are doing.[7] Beyond that: by focusing on recent art against the backdrop of historic developments, it is possible to better analyze which aspects are new and which aspects inherited in media art. Therefore it is important that we become familiar with our media history, with its myths and utopias. Media art history and media archaeology are a valuable aid to understanding our present and our future goals in a period where the pace appears to get faster and faster—that is the epistemological thesis. It is not about a new canon, but about the many-voiced chorus of the involved approaches. For the interests of media art it is important that we continue to take media art history into the mainstream of art history and that we cultivate a proximity to film, cultural and media studies, and computer science, but also to philosophy and other sciences dealing with images.

A central problem of the current cultural situation stems from a serious lack of knowledge about the origins of audiovisual media. This stands in complete contradistinction to current demands for more media and image competence. Considering the current upheavals and innovations in the media sector, where the societal impact and consequences cannot yet be predicted, the problem is acute. Social media competence, which goes beyond mere technical skills, is difficult to acquire if the area of historic media experience is excluded. Media exert a general influence on forms of perceiving space, objects, and time, and they are tied inextricably to humankind's evolution of sense faculties. For how people see and what they see are not simple physiological questions; they are complex cultural processes that are influenced by many and various social and media technological innovations. These processes have developed specific characteristics within different cultures and it is possible to decipher these step by step in the legacy left by historical media and literature concerned with visualization, including the history of the fields of medicine and optics. Not least, in this way light can be shed on the genesis of new media, which are frequently encountered for the first time in works of art as utopian or visionary models.

Film, cinema, and even television we already regard today as "old" media, because the image industries develop and offer new generations of media at ever-shorter intervals, with the modern and postmodern periods already in the rearview mirror. Although there is scant analysis and engagement with these media because of their continuing dominant, self-evident position in connection with creating collective "reality" and illusionary spectacles, slowly but surely their dominance is waning. This will allow the pre- and posthistory of visual mass culture in the twentieth century to surface more clearly and promote awareness that it is necessary to engage with both the past and the present of media to understand their ability to produce illusions and their formation through distribution networks.

Mass communication using audiovisual media is generally regarded as a twentieth-century phenomenon. In fact, however, the contemporary forms of these media are the result of complex historical processes that had already formed finished sets of industrial technologies, distribution procedures, and forms of design by the mid-nineteenth century, which made it possible to supply a mass audience. And we can go back even further. Seeing machines and the image worlds of magic lanterns, panoramas, and dioramas are

regarded as having paved the way for photography, cinema, and the digital media of the present day. Yet without the revolution in image space, which the representational technique of perspective wrought in portrait and landscape painting, without the *camera obscura*, which became the guarantor of "objective observation" before photography was invented, the image media of the twentieth century would be unthinkable. At the same time, the prehistory of artificial visualization points the way forward to the digital world and its immediate future.[9] The contributions to the "Origins" section therefore deal explicitly with this complex of themes: rediscovering kinetic art and op art in a new context, Peter Weibel shows that terms like "virtual" were already current in the 1960s; Edward Shanken's questions pertain to methodology and canonicity and locate the historicization of cybernetic, telematic, and electronic art within a larger art historical context through a critical reflection on the mechanisms of canonization in art history. Erkki Huhtamo examines interactivity and tactility through a media-archeological perspective, and Dieter Daniels's essay analyzes the contribution of Duchamp's inventions to media art. Going further back into history, Oliver Grau discovers in the phantasmagoria a visual principle, so far not introduced into the theory of media art, which combines concepts from art and science in search of a total medium; and Gunalan Nadarajan in the writings of Al Jazari examines a history of Islamic automation Western art history has thus far been unaware of.

Based on this historical framework, the section entitled "Machine—Media—Exhibition" offers a critical reexamination of key terms in media art theory. Edmond Couchot examines hybridization and automatization for the future orientation of art and culture. The machine is looked at as a productive and transformative principle in Andreas Broeckmann's contribution considering the "aesthetics of the mechanic." While the transformation in media art is analyzed through the new contexts of textuality, technology, and cultural institutions by Ryszard Kluszczynski, Louise Poissant finds the transformation in the medium itself, as interest moved from the object's plasticity to that of the spectators' neural network. Investigating the shift from object to process and from lone artist to collaborative models of production and presentation, Christiane Paul shows that the accommodation of new media art within the institution and gallery runs counter to traditional ideas of the museum as shrine.

The dividing lines between art products and consumer products, between art images and science images have been disappearing more and more since

the 1960s. So also the distinction between maker and recipient has become blurred. Most recently, the digitization of our society has sped up this process enormously. In principle, more and more images are no longer bound to a specific place and can be further developed relatively easily. The cut-and-paste principle has become an essential characteristic of contemporary image and culture production. The spread of access to the computer and the Internet gives more people the ability to participate in this production. The part entitled "Pop and Science" examines, therefore, concrete forms that today determine the cultural context of new media and what consequences they could have for the understanding of art in the twenty-first century.

With her essay on Device Art, Machiko Kusahara takes us to a concept derived from the Japanese media art scene. On this basis she reexamines the art–science–technology relationship from both contemporary and historical aspects. Ron Burnett's contribution instead explores the ubiquitous use of the term "interactivity" as a marker between old and new media, asking questions about the context that led to the invention of photography and the cinema, with the goal of showing strong historical links among the various technologies in use today and the ways in which their discourses are interconnected. Lev Manovich traces the influence of science on abstraction and brings us to an understanding of the role played by scientific complexity theory in contemporary software abstraction. From the view of another neighboring discipline, the history of science, Timothy Lenoir examines the societal and ethical implications of contemporary technoscience with its multidisciplinary character and encourages collaborative research allowing technoscience to be made public and new media to be made critical.

An increase in the power of suggestion appears to be an important, if not the most important, motivating force driving the development of new media of illusion. Image science, or *Bildwissenschaft*, now allows us to attempt to write the history of the evolution of the visual media, from peep show to panorama, anamorphosis, myriorama, stereoscope, cyclorama, magic lantern, eidophusikon, diorama, phantasmagoria, silent movies, films with scents and colors, cinéorama, IMAX, television, telematics, and the virtual image spaces generated by computers. It is a history that also includes a host of typical aberrations, contradictions, and dead ends.

However, if one were to interpret the telling of this hitherto neglected story line of art and media history as a sign of the changes taking place in the discipline of art history, which parallels current developments in philosophy

and cultural studies and goes by the new label of "image science," this would be far too superficial. Rather, we must return to and develops an older and successful tradition in art history, which in Hamburg and elsewhere in the 1920s can only be classed as image science. It drew its inspiration from Aby Warburg's cultural history–oriented, inter- and transdisciplinary approach as well as from Panofsky's "new iconology." Although already in the nineteenth century, art history included artisanship, medieval studies, collections of photography and was, therefore, in effect image science (see Alois Riegl, *Spätrömische Kunstindustrie* [Vienna: Staatsdruckerei, 1901]), it was Aby Warburg, today regarded as the most important art historian of the early twentieth century, who helped to expand art history explicitly into image science. His research, which included all forms and media of images, the impressive library he built up, and his MNEMOSYNE image atlas all testify to the universal interpretive energy that can often reveal important discoveries in apparently marginal images. The Nazis extinguished this development, which only went forward again in the 1970s. Film, video, net art, and interactive art have, as yet tentatively, pushed art history in the direction of image science once again.

But today, image science sets out to investigate the aesthetic reception and response to images in all areas. Thus this new interdisciplinary subject is in good company with the recent research areas of the historical study of image techniques, the history of the science of artistic visualization, art history of scientific images,[8] and particularly the natural sciences–oriented occupation with images in science. This latter recently celebrated its inaugural congress at the Massachusetts Institute of Technology,[9] an event which also demonstrated that image science without art history—particularly without its tools for critical image analysis—is not capable of developing a deeper and historical understanding of images. It is in danger of propagating old myths and, lacking a "trained eye," of succumbing to the power of images. The rise of media art has added fuel to this debate, for questioning images has acquired not only new intensity but also new quality and media. The final part, "Image Science," starts with Felice Frankel's essay examining the role of intention in visual representations of scientific phenomena. She brings up the need to develop a visual language that can be used by scientists as well as artists.

Further heirs to this interdisciplinary tradition today are scholars who open up new perspectives pleading for an extended image science. Thus the founder of the new image science W. J. T. Mitchell provokes the reader with the headline "There Are No Visual Media"—asking "is 'visual media' simply short-

hand for 'visual predominance?'" and "what is at stake in straightening out the name 'visual' media?" From the history of film studies perspective, Sean Cubitt asks whether the field of projected light has more to offer than the emulation of the real, reproducing the separation of the object and subject and revealing a new term in the series subject—object—project. Image science is broadened beyond the visual in the contribution from Douglas Kahn on early computer arts, when music made on mainframes such as that by James Tenney at Bell Labs can be called the first digital art because it required computers for its realization. In the last essay included in this collection, Barbara Stafford brings us full circle, back to one of the major intellectual problems of our times, the accurate depiction of uncertainty as a nonimagistic notion of "mental representation" informed by recent findings in cognitive science.

This book represents the network of scholars who over the past years have been a part of the growing number of dedicated researchers searching for insights into the histories of media art in order to build a solid field of study for the future. Many of the authors had the opportunity to participate in the first international conference on the histories of media art, science, and technology at Banff, for which I served as chair. Planned long before the conference, the contributions of this book went through days of intense discussions at Banff and afterward. With a top-notch international advisory team and dedicated organization partners, this conference laid a foundation of scholarship to build on. The outcomes of the conference and future developments in the field can be found on the Web forum for the field, http://MediaArtHistory .org/. This book draws on great thoughts from preceding decades and is just the beginning of the emerging field of MediaArtHistories.

Notes

1. The pioneer project in the field is the Database of Virtual Art: http://virtualart.at/. See Oliver Grau, *For an Expanded Concept of Documentation: The Database of Virtual Art* (Paris: ICHIM, École du Louvre, avec le soutien de la Mission de la Recherche et de la Technologie du Ministère de la Culture et de la Communication, 2003), 2–15.

2. Gerhard Dirmoser, "25 Jahre Ars Electronica—Ein Überblick als Gedächtnis-theater," in *Time Shift: The World in Twenty-Five Years, Ars Electronica 2004*, ed. Gerfried Stocker and Christine Schöpf (Ostfildern: Hatje Cantz, 2004), 110–115.

3. See Margaret Wertheim, "Lux Interior," *21C*, no. 4 (1996), 26–31; Eduardo Kac, "Além de Tela," *Veredas* 3, 32 (1998), 12–15; Charlotte Davies, "Osmose: Notes on Being in Immersive Virtual Space," *Digital Creativity* 9, no. 2 (1998), 65–74.

4. Bernhard Dotzler, "Hamlet/Maschine," *Trajekte: Newsletter des Zentrums für Literaturforschung Berlin* 2, no. 3 (2001), 13–16; Yukiko Shikata, "Art-Criticism-Curating—As Connective Process," *Information Design Series: Information Space and Changing Expression*, vol. 6, ed. Kyoto University of Art and Design, 145.

5. See David Freedberg, *The Power of the Images: Studies in the History and Theory of Response* (Chicago: Univ. of Chicago Press, 1989); Hans Belting, *Bild-Anthropologie: Entwürfe für eine Bildwissenschaft* (Munich: Wilhelm Fink Verlag, 2001); Jonathan Crary, *Techniques of the Observer: On Vision and Modernity in the Nineteenth Century* (Cambridge, Mass.: MIT Press, 1990); William J. T. Mitchell, *Picture Theory: Essays on Verbal and Visual Representation* (Chicago: Univ. Chicago Press, 1995); James Elkins, *The Domain of Images* (Ithaca: Cornell Univ. Press, 1999); Lev Manovich, *The Language of New Media* (Cambridge, Mass.: MIT Press, 2001).

6. Oliver Grau, *Virtual Art: From Illusion to Immersion* (Cambridge, Mass.: MIT Press, 2003).

7. Database of Virtual Art (founded in 1999), Langlois Foundation (2000), V2 (2000), the recent Boltzmann Institute Linz (2005), which was influenced by the concept of the Database of Virtual Art.

8. Bruno Latour, "Arbeit mit Bildern oder: Die Umverteilung der wissenschaftlichen Intelligenz," in B. Latour, *der Berliner Schlüssel: Erkundungen eines Liebhabers der Wissenschaften* (Berlin, 1996), 159–190; Christa Sommerer and Laurent Mignonneau, eds., *Art@Science* (New York: Springer, 1998); Martin Kemp, *Visualisations: The Nature Book of Art and Science* (Berkeley: Univ. of California Press, 2000).

9. The Image and Meaning Initiative (http://web.mit.edu/i-m/) held its first conference at MIT in 2001, followed by the Getty Center in 2005.

The Coming and Going of Images

Rudolf Arnheim

Let me begin with a few definitions. By "images" I mean two different but intimately related things. We have images when we use our sense of vision. We see physical objects, such as art objects, sculpture or paintings. But we speak of images also in a more universal sense. Our thoughts, inventions, and fantasies are sensory images not produced by the presence of physical objects. Furthermore images may be immobile like rocks or full of action like living bodies.

Both of them, however, are subject to "coming and going." Physical objects suffer from the fragility of matter. They are exposed to the destructive forces of nature and human neglect and brutal vandalism, which keep them from being what they were before. What also changes is our conception of things. Our image of the *Mona Lisa* is not what it was when it was painted.

In the more active media of communication there is a difference in the degree to which the audience communicates. In the theater it is mostly limited to applause. But take for example the liturgy of the churches with its prescribed responses. Through the ages and through different cultures there is an endless variety of response, to the degree of total involvement of all participants.

The technology of the modern media has produced new possibilities of interaction. Here is an example from the field of education: in a class on architecture the instructor presents on the computer screen images of a building.

Originally published in LEONARDO, vol. 33, no. 3 (2000), pp. 167–168.

As he discusses various aspects and perspectives on the building or its size relative to its distance from observers, he varies the image accordingly. This enables him to illustrate his theoretical points concretely, not only by static examples like slides in the conventional lecture room, but as a dynamic counterpart, as actively alive as the instructor's performance; and the students react with their own requests. The object discussed need not be immobile like a building. It can be an action evolving in time.

To return to the fine arts, I will illustrate the theory with an obvious example taken from the work of this journal's figurehead, Leonardo da Vinci. His *Last Supper* may be called the most famous painting of the Western world. It exemplifies the various aspects of imagery here under discussion. What makes for the unusual attention and adoration this painting has received?

The Last Supper was designed around 1495, for its place and its "audience" in the refectory of the Dominican monks of Santa Maria delle Grazie in Milan. Ever since then, it has attracted attention. We owe to Goethe a masterly description of the painting, written in 1810. At that time the painting was already in the miserable state in which we know it today, thereby exemplifying the physical fragility of images. *The Last Supper* received its share of mistreatment via restoration, vandalism, and neglect. Yet the uniqueness of the work has survived. Its subject has been treated by many other artists, among them quite excellent ones, but none has equaled Leonardo's fame. To a large extent, this is due to the power of its composition, the elements of which survive even the worst reproductions.

The composition of *The Last Supper* is held together by its balancing symmetry and the horizontal base formed by the table and its parallel, the line of heads. This stability is dynamized by the way the perspective draws the viewer into the center and the varying gestures of the disciples, which swing toward or away from their master in their varying responses to his revelation. He, in his contrasting quietness, establishes the center of the room but is also kept in the world outside by the light of the landscape surrounding him.

The image of Jesus presents the viewer with the embodiment of humanness at its highest to serve both as a model of charity and as a leader raised to the level of the divine. But this model also embodies human suffering, the victimized martyr. We are therefore accorded an image of the epitome of human nature. This quality is needed by every good work of art, although to varying degrees of perfection. It applies as well to other fields of character and

behavior. As a single example, I mention the *Venus* of Melos, standing for femininity.

In the flow of coming and going, these significant images provide an indispensable counterweight. They offer a store of lasting meaning, without which we would be helplessly exposed to the flight of transitory happenings. This sharpens the key point of the present paper. The awareness and understanding of our experience depends on the interaction of stable, lasting images and the coming and going of happenings in time. The stationary images allow us to explore the world in its being, while the transitory ones let us follow what takes place in sequence.

This would seem to be relevant at the present time, as the millennium makes the calendar impose on us an arbitrary interruption in the continuity of time. In pondering the future we are tempted to limit our attention to the curiosity about the inventions and discoveries awaiting us. This, however, would be narrow-minded. What is needed is a wider view encompassing the coming rewards in the context of the treasures left us by past experiences, possessions, and insights.

I

Origins: Evolution versus Revolution

It Is Forbidden Not to Touch: Some Remarks on the (Forgotten Parts of the) History of Interactivity and Virtuality

Peter Weibel

Kinetic art and op art are being rediscovered. But the context in which these movements are regaining public awareness is new. First, they are being recognized as developments that ran parallel with the emergence of computer art, of computer graphics and animation. In the 1960s shows like "New Tendencies" (Zagreb and Milan) played a special role in this interplay among computer art, kineticism and op art. Second, this contextual shift makes it clear that works of op and kinetic art accomplished with manual and mechanical means have attributes of observer dependency, interactivity, and virtuality; indeed, terms like "virtual" were already current. Third, the presence of covert instructions to act—viewers of op and kinetic works are expected to press buttons, move components, and so on—reveals the rudiments of rule-based algorithmic art.

These procedural instructions forge a link to a further important direction of art in the 1960s: the happening and Fluxus movements, which substituted items of daily use for the work of art. These items of daily use were subsequently replaced by instructions for use which, addressed to the audience, now became instructions to act. Basic elements of algorithmic art therefore figured in happening and Fluxus, too.

Thus, the three major art movements of the 1960s—op and kinetic art, happening and Fluxus, computer graphics and animation—are being reconsidered from the algorithmic angle and placed in new relation to each other. With all three movements able to be considered as different forms of "algorithmic art," it becomes clear that the attributes of programmability, immersion, interactivity, and virtuality did not first appear in the media and

computer art produced from 1970 onward, but were already present in the op and kinetic art of the 1960s.

What Is an Algorithm?

Cameras, cars, planes, ships, household devices, hospitals, banks, factories, shopping malls, traffic planning and routing technology, architecture, literature, visual arts, music—no area of social or cultural life exists that is not permeated by algorithms. In science, the algorithmic revolution began in 1930 or thereabouts; in art, some thirty years later.

An algorithm is understood to be a decision procedure—a set of instructions to act—made up by a finite number of rules, a finite sequence of explicitly defined elementary instructions that exactly and completely describe the stepwise solution to a specific problem. The most familiar implementation of algorithms is in computer programs. A program is an algorithm written in a language enabling it to be executed in steps by a computer, and therefore every computer program (as a high-level machine language) is an algorithm, too. The task of executing the steps in generating procedures or decision-making processes that sometimes require hours or days of computing has been transferred to a machine: the computer. And as these computing machines became more advanced, so the programming became more precise. Computers are controlled by algorithms in the form of computer programs and electronic circuits. The first algorithm written specifically for a computer was recorded in 1842–43 by Ada Lovelace in her notes on Charles Babbage's *Analytical Engine* (1834). Since Babbage was unable to complete his proposed machine, however, Lovelace's algorithm (whose purpose was to compute Bernoulli numbers) was never executed on it.

The lack of mathematical precision of the early twentieth-century definition of an algorithm was a source of irritation to many mathematicians and logicians of the period. In 1906, Andrey A. Markov[1] created a general theory of stochastic, or random, processes on the basis of his so-called Markov chains, which were generalized by Andrey Kolmogorov in 1936.[2] These chains represent the mathematical model of a memory-free process that describes a physical system when the probability of state transition depends solely on the state of the system at a given time and not on the previous history of the process. The transition probability of the state at time $t + 1$ is dependent solely on the state at time t. In this way, the Markov chains allow sequences of mutually

dependent variables to be studied in accordance with laws of probability. They are sequences of random variables in which the future variable is dependent on the current variables, but independent of the state of its predecessors. In the late 1950s and early 1960s this theory of stochastic processes was successfully applied to the stochastic generation of poetry and music, that is to say: random music and random text. The concept of the algorithmic coincidence was accepted as the ultimate definition of chance, and led to the foundation of an algorithmic information theory by Gregory Chaitin[3] and Andrei Solomonov.

Around 1930 the intuitive concept of computability, or of the algorithm, underwent mathematical precision. The works of Kurt Gödel, Alonzo Church, Stephen Kleene, Emil L. Post, Jacques Herbrand, and Alan Turing[4] demonstrated that all formal versions of the concept of computability are equally valid and can be viewed as a precise version of the concept of the algorithm. Algorithms are older than computers, therefore, but have been most famously deployed in computer programming over the course of the past seventy years. Any problem able to be programmed can be solved algorithmically with any current programming language (high-level machine language).

The development of programming languages began with Axel Thue,[5] whose "Probleme über Veränderungen von Zeichenreihen nach gegebenen Regeln" in 1914 delivered the first precise version of an algorithmic decision process: with the aid of a finite alphabet (i.e., six letters) and a system of rules R (i.e., two rules of transformation) it was possible to determine in individual cases whether a specified sequence of signs could be generated from the given alphabet and system of rules. Semi-Thue systems of this kind were used to develop the theory of formal languages. In the 1950s Noam Chomsky referred to semi-Thue systems in order to describe grammatical structures of natural languages. On the basis of Chomsky's semi-Thue systems, John Backus and Peter Naur around 1960 introduced a formal notation enabling the syntax of a language to be described, and from this system of notation evolved (algorithmic language) ALGOL 60, the first successful programming language.

Algorithms in Art

Running in parallel development with these advances in computing machines, machine languages, and the associated algorithmic procedures and beginning around 1960, intuitive algorithms in the form of instructions for use and action also began to be used in forms of analog art ranging from painting to

sculpture. One might say that sequences of signs in the form of digits are instructions for machines to act. Known as programming languages, artificial languages, or digital codes, they are used in digital art. Sequences of signs in the form of letters can be instructions for human beings to act. These are termed natural languages, and are used in analog art. Accordingly, instructions to act exist for manual and mechanical tools like hands, buttons, keys, and so forth. And instructions to act likewise exist for digital and electronic tools. Accordingly, there are two forms of interactivity between work and viewer: manual and mechanical (for instance, in op and kinetic art) or digital and electronic (as in new media art).

For centuries algorithms have been used intuitively as control systems, instructions, rules of play, and as plans and scores in architecture and music. In music and the fine arts, algorithms have long been valuable instruments of creation. The artists' books of the Renaissance, such as Leon Battista Alberti's tract *De re aedificatoria* (1452), Piero della Francesca's *De prospectiva pingendi* (c. 1474), or Albrecht Dürer's illustrated book *Underweysung der Messung* (1525), already amounted to manuals for making paintings, sculptures, and buildings. Mathematical aids and even small mechanical contraptions are known to have been used by composers from Bach to Mozart, from Schönberg to Joseph Schillinger.[6] A central role is played in modern music by serial and static processes, by techniques and algorithms which are aleatoric and stochastic, permutative and combinatorial, recursive and fractal; and this function is exercised not just intuitively, but also in the sense of high-precision mathematics.[7]

There are two different uses of the algorithm in modern art: intuitive application, as in the Fluxus movement (a plausible example being Karl Gerstner's *Variables Bild* (*Rotbunte Reihen*) (Variable Image) of 1957/1965, which consists of variable wooden bars in a metal frame), and exact application, as in computer art. There have been attempts to reconcile both modes in various measures. The Fluxus artist George Brecht produced a work entitled *Universalmaschine*,[8] an explicit allusion to the computer as a *universal machine*,[9] and in 1969–1970 Karl Gerstner created a work entitled *AlgoRhythmus 1*.

Dick Higgins, another Fluxus artist, in 1970 published *Computer for the Arts* including a machine score for computer music by James Tenney (with text by Higgins). As early as 1962, a text by Umberto Eco appeared with the telling title *arte programmata*.[10] Written for the exhibition "Arte Programmata—arte

cinetica, opere moltiplicate, opera aperta" (Milan, 1962), Eco's text dealt with the interplay between accident and programming. This notion of programming was extended to architecture by the Italian architect Leonardo Mosso in 1969.[11]

In the analog art forms (op and kinetic art, Fluxus, happening) the intuitive use of the concept of the algorithm led to mechanical and manual practices of programming, procedural instructions, interactivity, and virtuality. In the "New Tendency" shows of the early 1960s in Zagreb, Milan, and elsewhere, viewer participation in the construction of a work of art played a considerable role. In works associated with Fluxus, happening, or performance, the object of painting or sculpture was entirely replaced by instructions to act. Along with stepwise instructions to bring about events, the instructions for use that implicitly accompany any item of daily use took the place of the actual item, in this way leading to the explicit integration of the audience.

Op and Kinetic Art

Kinetic art achieved major historical and popular influence in the 1960s, as evidenced by exhibitions like "Rörelse i Konsten" (Moderna Museet, Stockholm, May–September 1961), organized by K. G. Pontus Hultén and first shown under the title "Bewogen Beweging" in Amsterdam (Stedelijk Museum, March–April 1961), "Kinetic and Optic Art Today" (Albright Knox Art Gallery, Buffalo, 1965), and "Licht und Bewegung—kinetische Kunst" (Kunsthalle Düsseldorf, 1966). The titles of the shows point to the intertwining of the problem of representing movement with that of representing optical phenomena in which kineticism originated and developed. In both cases, mere representation was renounced in favor of real movement, real light. Optical illusions became recognizable as such. Real movement and real light became media of art. Perceptual phenomena and optical illusions were used not as instruments but as subjects, not as means of representation but as activated perceptual experiences in which the viewer was now a crucial factor.

As early as 1955, K. G. Pontus Hultén had curated the show "Le Mouvement" (featuring Agam, Bury, Calder, Duchamp, Jacobsen, Soto, Tinguely, Vasarely) at the Galerie Denise René in Paris, and contributed the text "Petit moments des arts cinétiques." With a title alluding to Moholy-Nagy's book *Vision in Motion* (Chicago, 1947), the exhibition "Vision in Motion—Motion

in Vision" at the Hessenhuis, Antwerp that same year showed work by artists including Roth, Macky, Piene, Tinguely, Spoerri, Bury, and Klein.

Although the chronology of kinetic art can be traced back to 1900, the de facto beginning was in 1920. The sources—avant-garde film (Walther Ruttmann, Viking Eggeling), Constructivism, Bauhaus, De Stijl, futurism—are as diverse as the stations (*arte cinetica*, 1914–16; Viennese kineticism, 1920–24, with protagonists including Franz Cizek). The primary source is Russian Constructivism, which produced geometrical objects free of any mimetic function (Tatlin, Rodchenko, El Lissitzky, Gabo, Pevsner). In Moscow in 1920, Naum Gabo demonstrated to his students that a single rod of wire, if set in motion with the aid of a clock spring, can become a volume or, more accurately, a virtual volume. This *Kinetic Construction No. 1* (fig. 3.1, fig. 3.2), which in 1922 was also exhibited in Berlin, emanated from "The Realistic Manifesto" Gabo wrote in 1920. Cosigned by his brother Antoine Pevsner, it was in fact a "Constructivist manifesto" (as early as 1915, Gabo named a sculpture *Constructed Head No. 1*), and is now considered to represent the beginning of Constructivism.

Illusory Movement—Illusory Volume

Kinetic Construction No. 1, whose very title expresses the historical connection between Constructivism and kinetic art (incidentally, in 1941 Zdeněk Pešánek's book *Kineticism* appeared in Prague; it represents the missing link in the evolution of avant-garde film and kinetic sculpture) refers not only to motor-driven movement, the agent for all future kinetic sculptures of artists from George Rickey to Jean Tinguely, but also to a lesser-known motor driving the development to kineticism. That motor is apparent movement, virtuality: for Gabo's line—a rod of wire—produced an apparent volume. Virtuality connects kinetics with op art. Kinetic art evidently lies between Constructivism and op art, is connected with them both, and the connecting element is evidently perceptual phenomena. This realization allows us to advance beyond the purely mechanical categories of kinetics and chart the evolution from analog mechanical to digital electronic kinetics. Mobile parts are more than mere machine components; they are virtual components, too.

This finding also points to a further important source of kineticism, namely to the science of perception, of special optical phenomena encompassing everything from stereoscopy to stereokinesis. The new schools of gestalt and per-

Figure 3.1 Naum Gabo, *Kinetic Construction No. 1*, 1920 (stationary). By kind permission of the Neue Galerie Graz.

It Is Forbidden Not to Touch

Figure 3.2 Naum Gabo, *Kinetic Construction No. 1*, 1920 (in movement). By kind permission of the Neue Galerie Graz.

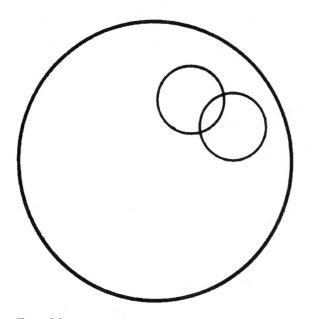

Figure 3.3 Vittorio Benussi, 1912. Apparent transparency with the stereokinetic phenomenon. If the circle pieces are glued or drawn onto a piece of card which is then slowly rotated, monochrome circles can then be seen—like the sheared edges of a roller—stretching backward. By kind permission of the Neue Galerie Graz.

ceptual psychology that arose around 1900 (Vienna, Prague, Graz, Berlin, Frankfurt) and are connected with names such as Ernst Mach, Christian von Ehrenfels, Alexius Meinong, Alois Höfler, Vittorio Benussi, Wolfgang Köhler, Max Wertheimer, Kurt Koffka, experimentally investigated the laws of visual perception, in particular gestalt and movement experiences, illusory movements, optical illusions, and so forth.

The Graz-based experimental psychologist Vittorio Benussi, an Italian national, in 1912 published "Stroboscopic Illusory Movements and Geometric-Optic Gestalt Illusions." The year 1921 saw the publication in Leipzig of Johannes Wittmann's "Über das Sehen von Scheinbewegungen und Scheinkörpern." Pentti Renvall's "Zur Theorie des stereokinetischen Phänomens" appeared in 1929.

These apparent movements and illusory bodies take us into the realm of the virtual. In 1912 Benussi had conducted a simple experiment that connected movement (kinetics) with depth perception (op art). Patterns of circles on

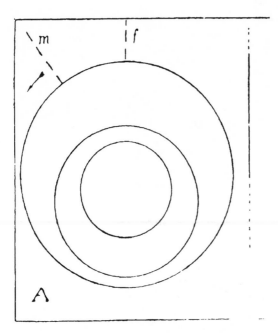

Figure 3.4 Cesare L. Musatti, 1924. Circles which produce stereokinetic effects when rotated. By kind permission of the Neue Galerie Graz.

rotating disks generated the optical illusion of moving cones, and as a result produced the illusion of a three-dimensional structure in movement (fig. 3.3). Movement in combination with depth perception (stereo manifestations) leads to a kinetic spatial effect (or the "stereokinetic effect," to borrow the term which Cesare L. Musatti, a pupil of Benussi in Padua, coined for stereokinetic spatial images and illusory bodies) (fig. 3.4). The optical disks of the film *Anémic cinema* (1925–26) and Marcel Duchamp's *Roto-Reliefs* (1923–35) are based on the same stereokinetic phenomenon (fig. 3.5).

Research into illusory bodies and illusory movements was carried forward in the 1950s and 1960s, partly with the assistance of apparatuses. Gaetano Kanizsa, a pupil of Musatti, followed up the investigations of Friedrich Schuhmann, who in 1900 had published the first "illusory contour," that is to say, the perception of a nonexistent, illusionary, virtual line. From 1955 onward, Kanizsa popularized as "subjective contours" those in reality nonexistent illusory contours, illusory boundaries, and illusory edges (*Scientific American* 234, April 1976, pp. 44–52) (fig. 3.6). Working in Innsbruck in the 1950s,

Figure 3.5 Marcel Duchamp, optical disk from the film *Anémic cinéma*, 1925–1926. By kind permission of the Neue Galerie Graz.

Theodor Erismann and his assistant Ivo Kohler deliberately generated optical malfunctions by means of inverting spectacles, thus adding to the foundations for understanding illusory worlds (fig. 3.7).

From Virtual Volumes to Virtual Environments

As can be seen, Naum Gabo's *Kinetic Construction No. 1* generated apparent—virtual, we would say today—movement. Art history shows us that the realm of virtual movement and virtual bodies stretches from the painting to the sculpture, from plane surface to three-dimensional space, and that already in the 1920s the term "virtual" had begun to be used instead of "illusory."

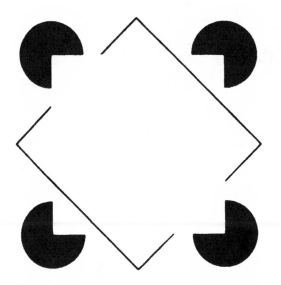

Figure 3.6 Resistance to superimposition is a measure of the intensity of perceiving subjective surfaces. Separating lines appear to be superimposing themselves over a subjective surface, but the subjective contours are destroyed by the line. Source: Gaetano Kanizsa. By kind permission of the Neue Galerie Graz.

Figure 3.7 The peaked cap with the mirror that turns everything on its head. Source: Ivo Kohler. By kind permission of the Neue Galerie Graz.

Figure 3.8 Moholy-Nagy, *Space Modulator*, 1940. By kind permission of the Neue Galerie Graz.

In his book *From Material to Architecture* (1929) Moholy-Nagy describes as the fifth stage in the development of sculpture the addition of the fourth dimension of time to the three dimensions of volume. Mass tends toward immaterialization as a result of movement. Through movement sculpture becomes the manifestation of virtual volumetric relationships. Moholy-Nagy therefore explicitly refers to the development of material and static volumes into ones that are kinetic and "virtual" (fig. 3.8).

Jesús Rafael Soto produced kinetic art not by fusing light and movement but by the classical device of producing with two-dimensional means the illusion of movement (fig. 3.9). In the process he quickly recognized the laws governing apparent movement, whereby precisely the relations among the elements, as opposed to the elements themselves, are crucial to the generation of illusory motion. He therefore spoke of "virtual relations" and extended these

Figure 3.9 J. R. Soto, *Deux relations virtuelles*, 1967. By kind permission of the Neue Galerie Graz.

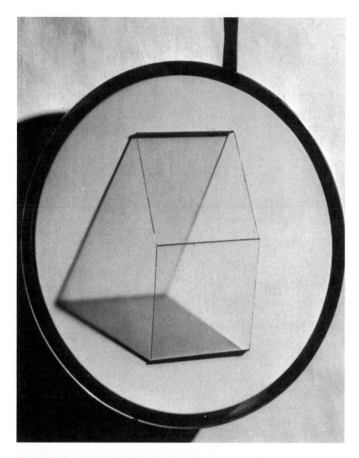

Figure 3.10 Gabriele de Vecchi, *Strutturazione virtuale A*, 1964. By kind permission of the VAF Foundation.

relations from the surface within a room into the "environment," at the same time drawing the viewer, too, into the work of art. In 1964 Gabriele de Vecchi spoke of "*Strutturazione virtuale*" (fig. 3.10), and in 1963 Giovanni Anceschi created a kinetic object with the title *Strutturazione, cilindrica virtuale* (fig. 3.11). In awareness of this tradition, Jean Tinguely in 1955 likewise made an electro-motorized sculpture entitled *Volume virtuel no. 1*, as well as an entire series of "virtual volumes" (1955–59), which were motor-driven sculptures with moving parts, wires, and wheels that, when moving at relatively high speed, produced the retinal impression of transparent three-dimensional bodies—virtual volumes, in other words.

Figure 3.11 Giovanni Anceschi, *Strutturazione, cilindrica virtuale*, 1963, VAF Stiftung. By kind permission of the VAF Foundation.

Using analog means, Soto delivered a notion of a virtual environment that changes along with the viewer. Polysensual environments with optical and kinetic effects were likewise constructed by Getulio Alviani (*Cubo-Environment*, 1964–69), Gianni Colombo (*Spazio elastico*, 1967) (fig. 3.12), Mario Balocco (*Effetti di assimilazione cromatica con figure virtuali*, 1968–72) (fig. 3.13), Yaacov Agam (*Kinetisches Environment*, 1970), Domingo Alvarez (*Raumgrammatik Environment*, 1971), and Stanislav Filko (*Universum Environment*, 1966–67; *Kosmos Environment*, 1968). Under the title "Cinétisme, Spectacle, Environment," a show featuring de Vecchi, Colombo, Mavellet, Mari, Le Parc, and other artists was mounted in Grenoble in 1968.

Spectator participation soon extended from the adjustable painting (Yaacov Agam, *Transformables*, 1956, whose various pictorial elements could be slid around) to sculptures (by artists from Colombo to Tinguely), and from the sculpture into the space, the "environment" (Colombo, *Spazio elastico*, 1967). GRAV (Groupe de Recherche d'Art Visuel), founded in 1961 and made up

Figure 3.12 Gianni Colombo, *Spazio elastico*, 1967. By kind permission of the VAF Foundation.

by the artists Horacio-Garcia Rossi, Julio Le Parc, François Morellet, Francisco Sobrino, Joel Stein, and Jean-Pierre Yvara, in 1963 presented its first collective work: a labyrinth still on display at the Museum Cohue de Vannes. Twenty-two meters long, 3.65 meters wide, and made up of twenty single parts, the labyrinth is a homogenous space in which it is only too easy to lose one's bearings. Visitors can walk freely about the structure—in line with the museum's exhibition motto, which reads "Défence de ne pas participer, Défence de ne pas toucher."

As well as the movement implied by its name, therefore, kineticism produced elements which played an important role in the further development

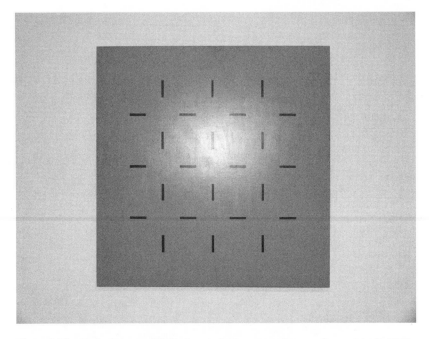

Figure 3.13 Mario Balocco, *Effetti di assimilazione cromatica con figure virtuali*, 1968–1972. By kind permission of the VAF Foundation.

of art: virtuality, the environment, the active spectator and/or user. Everything that would later characterize computer art and the interactive virtual environment was there already, albeit in purely analog or mechanical form.

Arte Programmata

The future of digital art can be found in approaches explored by kinetic practitioners. Bruno Munari in 1952 published *Macchinismo*, a manifesto aimed at reconciling art with the machine: "The machine must become a work of art! We will discover the art of the machines." This idea was carried forward in the 1962 exhibition "Arte Programmata: Arte cinetica, opera muliplicata, opera aperta," which was curated by Bruno Munari and Giorgio Soavi. Umberto Eco contributed a text from which the movement took its name. Arte programmata is a form of kinetic art in which on the one hand the movement is predictable because it more or less follows the rules of mathematical programs, but on the other hand, it at the same time permits random processes. That is

to say, the course of movement fluctuates between random and programmed, between precise predisposition and spontaneity, and therefore occurs within a system we would today term dynamically chaotic. Programmability—at least as a concept—had now taken its place alongside the notions of virtuality, the environment, the internal observer and/or interactivity (the user sets in motion the mobile work of art, the kinetic sculptures, co-constructs the "kinetic construction").

Working with colored light elements and movable machines in the period 1966–1968, Lev Nusberg and other members of the "Moscow kineticists" already produced so-called cyber-creatures. Viewers of this "cyber theater" were invited to participate in the programmed actions. Jeffrey Shaw, a leading pioneer of virtual environments and interactive art, similarly progressed from kinetic to cyber art. The virtual space, or environment, of his *Virtual Museum* (1991) likewise contains virtual sculptures caught up in virtual movements, apparent bodies in apparent movement in an apparent space—the transition from kinetic to cyber art is complete.

The optical changes induced by movement of the viewer in op art, the mobile elements of kinetic paintings and sculptures, the incorporation of viewers expected to manually interfere, to press buttons or keys: All this amounts to early—precomputer—forms of mechanical and manual interactivity. The works of art were exposed to random influences, or were rendered manually or mechanically controllable and programmable—algorithmic, in other words—by their viewers. Images were produced by programs before the computer came along, just as interactive and virtual relationships existed between works of kinetic and op art and their viewers. It is there—and not with the availability of the computer as technical interface—that the history of interactive and virtual art begins.

Notes

1. 1856–1922; Russian mathematician who helped to develop the theory of stochastic processes, especially those called Markov chains. Based on the study of the probability of mutually dependent events, his work has been developed and widely applied in the biological and social sciences. A. A. Markov, "Extension of the limit theorems of probability theory to a sum of variables connected in a chain," reprinted in Appendix B of R. Howard, *Dynamic Probabilistic Systems*, volume 1: *Markov Chains* (New York: John Wiley and Sons, 1971).

2. 1903–1987; A. Kolmogoroff, "Zur Theorie der Markoffschen Ketten," *Mathematische Annalen* 112: 155 (1936).

3. 1947–; Gregory Chaitin, *Algorithmic Information Theory* (Cambridge: Cambridge University Press, 1987).

4. 1912–1954; Alan Turing, "On Computable Numbers with an Application to the Entscheidungsproblem" (1936) in *Proceedings of the London Mathematical Society*, series 2, volume 42 (1936–37) pp. 230–265.

5. 1863–1922; Axel Thue, "Über unendliche Zeichenreihen," *Kra. Vidensk. Selsk. Skrifter*. 1 *Mat.Nat.Kl* 1906, Nr. 7, Kra 1906; "Über die gegenseitige Lage gleicher Teile gewisser Zeichenreihen," *Kra. Vidensk. Selsk. Skrifter*. 1 *Mat.Nat.Kl* 1912, Nr. 1, Kra 1912; "Probleme über Veränderungen von Zeichenreihen nach gegebenen Regeln," *Kra. Vidensk. Selsk. Skrifter*. 1 *Mat.Nat.Kl* 1914, Nr. 10, Kra 1914.

6. Joseph Schillinger, *The Schillinger System of Musical Composition*, volume I: books I–VII, volume II: books VIII–XII (New York: C. Fischer, 1946). First published as a correspondence course under the title *The Schillinger Course of Musical Composition* (ed. Lyle Dowling and Arnold Shaw, New York: C. Fischer 1941).

7. See Pierre Barbaud, *Musique Algorithmique (A Collection of Compositions Spanning Twelve Years of His Work)*. Compositions include "Mu-Joken" (for six instruments, 1968), "Saturnia Tellus" (tape, 1980), "Apfelsextett" (for string sextet, 1977), and "Hortulus coelicus" (instrumental ensemble, 1975). Beginning in 1958, Barbaud championed a rigorously determined algorithmic composition process, made possible with the assistance of computers. His goal was to create human-made music with machines, reflecting only the human thought process, without emotion. Performances were by Ensemble GERM (Pierre Marietan, conductor), Élèves de l'École d'Archet Tibor Varga (Pierre Marietan, conductor), and Ensemble Instrumental de Musique Contemporaine de Paris (Konstantin Simonovitch, conductor). "Saturnia Tellus" was realized at l'INRIA; constructed by Pierre Marietan.

In 1979 Pierre Barbaud and his collaborator Frank Brown employed their computing program *Ludus Margaritis Vitreis* to produce music in the style of Bruckner. The task of the program is to work out musical sequences with harmonic part writing, using a simulated orchestra of ten instruments. One of the primary compositional tasks is carried out by a stochastic matrix responsible for linking together the chords. To define this matrix in specific cases, a work of the particular composer must first be analyzed—in this case Anton Bruckner's String Quartet in C Minor. The music so recomposed is then converted into audible form by a conversion program called

AUDITV, with every tone being assembled from units of 1/20,000-second duration, producing a remarkably precise adjustment to the required tonal effects. After being recorded on magnetic tape, the piece can then be performed. The *Ludus Margariti Vitreis* program was evaluated at the Research Institute for Information and Automation Science (IRIA) in Rocquencourt; the magnetic recording with the assistance of AUDITV took place in the Research Institute for Acoustic-Musical Coordination (IRCAM).

8. In 1965.

9. Responding to Hilbert's question about "decidability" in mathematics, until then unanswered, Turing came up with the idea now called a Turing machine. It was his exact formalization of what had informally been described by expressions such as "effective method."

Turing argued that his formalism was sufficiently general to encompass anything that a human being could do when carrying out a definite method. The Turing machine concept involves specifying a very restricted set of logical operations, but Turing showed how other more complex mathematical procedures could be built out of these atomic components. He had the further idea of the universal Turing machine, capable of simulating the operation of any Turing machine.

A universal Turing machine is a Turing machine with the property of being able to read the description of any other Turing machine, and to carry out what that other Turing machine would have done. It is not at all obvious that such a machine, a machine capable of performing any definite method, could exist. While one might intuitively think that tasks of ever-increasing complexity would need machines of ever-increasing complexity, this is not the case: It is sufficient to have a specific, limited, degree of complexity, and then greater amounts of storage capacity for more laborious tasks.

10. Originally published 1962 in the catalogue, ed. by Bruno Munari, accompanying the exhibition "Arte programmata" at the exhibition space of the Olivetti company. Reprinted in Volker W. Feierabend and Marco Meneguzzo, eds., *Luce, movimento & programmazione-, Kinetische Kunst aus Italien 1958/1968* (Cinisello Balsamo: Silvana 2001, 242–248).

11. Leonardo Mosso, *Architectura programmata* ed. Studio di Informazione Estetica and Vanni Scheiwiller (Turin: 1969).

Historicizing Art and Technology: Forging a Method and Firing a Canon

Edward A. Shanken

> Science and technology, the handmaidens of materialism, not only
> tell us most of what we know about the world, they constantly
> alter our relationship to ourselves and to our surroundings.... If
> this materialism is not to become a lethal incubus, we must
> understand it for what it really is. Retreat into outmoded forms
> of idealism is no solution. Rather, new spiritual insights into the
> normality of materialism are needed, insights that give it proper
> balance in the human psyche. A small beginning is to record its
> effects upon one art form. This book is directed toward that task.
> —JACK BURNHAM, *BEYOND MODERN SCULPTURE*

In the early 1990s my professional life fell under the influence of some writings about art and technology: Jack Burnham's *Beyond Modern Sculpture: The Effects of Science and Technology on the Sculpture of This Century* and Roy Ascott's essays, including "Is There Love in the Telematic Embrace?"[1] I was a first-year graduate student in art history at Duke University and had planned to study a more conventional topic. But the rush of the twenty-first century as the very near future simultaneously bore down on and uplifted me with great intensity. Recent developments in consumer technologies, including relatively powerful personal computers, user-friendly software, and interactive media, including CD-ROMs and perhaps more significantly, the World Wide Web, seemed to open up a new future of creative expression and exchange in which

everyone could be a multimedia content-provider and thus break free from the tyranny of the culture industry.

Inspired by, but skeptical of, such techno-utopian rhetoric, with Burnham and Ascott as my guides, with further illumination from the pioneering work of Frank Popper, Douglas Davis,[2] and Gene Youngblood and under the mentorship of Kristine Stiles, I began to think more and more about the effects that science and technology were having on contemporary art, and about how artists were using the ideas, methods, and tools of science and engineering to envision and create aesthetic models of the future. I also wondered what role art history might play in making sense of these developments in visual culture. Very quickly I realized that I had to study the entwined histories of art, science, and technology in order to have a clue about what was happening at the moment, much less what its future might bring.

The following discussion addresses the problem of writing a history of art that focuses on the nexus of art, science, and technology (AST). Although a fully elaborated history of AST must distinguish between science and technology with respect to their relationship to art, for simplicity's sake I shall refer to the intersection of art with either or both as AST. What follows constitutes a personal report from the trenches and a call to arms. Given the nascent state of the field, combined with its dynamic growth and extraordinary breadth, in some cases my arguments have forsaken subtlety in order to provoke. My foci are canonicity, methodology, and historiography, and my aim is to set out a prolegomena for future scholarship by critics, curators, art historians, and other cultural workers who produce, present, or otherwise try to make sense of AST.

Defining the Problem: Canonicity, Methodology, and Historiography

The development and use of science and technology by artists always has been, and always will be, an integral part of the art-making process. Nonetheless, the canon of Western art history has not placed sufficient emphasis on the centrality of science and technology as co-conspirators, ideational sources, and/or artistic media. Bound up in this problem is the fact that no clearly defined method exists for analyzing the role of science and technology in the history of art. In the absence of an established methodology (or constellation of methods) and a comprehensive history that would help clarify the interrelatedness of AST and compel revision, its exclusion or marginality will persist. As a re-

sult, many of the artists, artworks, aesthetic theories, institutions, and events that might be established as the keystones and monuments of such a revised history of art will remain relatively unknown to general audiences.

Indeed, there is no comprehensive scientific/technological history of art, as there are feminist and Marxist histories of art, for example. This leads one to wonder what a history of art written through a lens that emphasized AST would look like. What would be its monuments? How would they be related through historical narrative? What similarities and differences, continuities and discontinuities, might be mapped onto the use of technology for artistic purposes throughout the history of art? Why are there periods of fervent activity and others of apparent dormancy? In other words, how would the story go if standard survey texts such as Janson's *History of Art* were rewritten with an emphasis on the roles of science and technology on the history of art? In this regard, the sharp new two-volume set, *Art Since 1900*, written by Hal Foster, Rosalind Krauss, Yve-Alain Bois, and Benjamin Buchloh, ignores the history of art and technology to such an extent that Billy Klüver and E.A.T. are not even mentioned. Such exclusion from a text that is destined to gain canonical status has significant, deleterious ramifications for the history of AST.

With respect to the literature in the field, Linda Dalrymple Henderson's "Writing Modern Art and Science" is, to my knowledge, the only historiographical analysis of writing about AST, perhaps because relatively little art historical attention has focused on the subject.[3] More of such studies would be a valuable asset to current and future researchers as they evaluate and understand our intellectual heritage.

Leading art historians, including Jonathan Crary, James Elkins, Henderson, Martin Kemp, and Barbara Maria Stafford, have contributed greatly to understanding the history of AST during the Renaissance, Baroque, and modern periods. With respect to contemporary art, however, much of the pioneering historical, critical, and theoretical literature in English has been written by artists, including Ascott, Burnham, Critical Art Ensemble, Douglas Davis, Mary Flanagan, Alex Galloway, Eduardo Kac, Margo Lovejoy, Simon Penny, Peter Weibel, and Steve Wilson, to name just a few. Notable exceptions include the work of Jonathan Benthall, Marga Bijvoet, Charlie Gere, and Frank Popper, the media-archaeological scholarship of Oliver Grau and Erkki Huhtamo, and the criticism and editorial work of Tim Druckery.[4]

Curatorial practice has made important contributions historically, including the production of exhibitions and exhibition catalogs by Burnham, Pontus

Hultén, Frank Popper, and Jasia Reichardt, and, more recently, by Sarah Cook, Steve Dietz, Beryl Graham, John Ippolito, Christiane Paul, and Benjamin Weil,[5] who have also made contributions to exhibition theory with respect to curating electronic media. Festivals including SIGGRAPH, ISEA, and Ars Electronica, and major exhibitions at the ZKM also have provided important forums for discourses pertaining to AST, though the proceedings and catalogs generated by these events typically have focused more on practice, criticism, and theory than on history. Similarly, until the mid-1990s, the journal *Leonardo* primarily published writings by artists and scientists, in large part because critics and historians simply did not generate much material on the subject.

Much of the influential current literature is being produced in other disciplines, such as comparative literature, film history, performance studies, and cultural studies. Rather than argue for the innovative theoretical positions that characterize AST's history as embodied in works of art and articulated in artists' theoretical writings, much recent criticism, particularly that outside of art history, is heavily peppered with citations of the usual suspects: Benjamin, Barthes, Baudrillard, Latour, Derrida, Deleuze, and Virilio. Summoning such demigods to lend authority to an argument reifies the existing structures of power and authority in academic writing—a result that conflicts with the aims of poststructuralism and deconstruction. Suzanne Stone, the psychopathic television journalist portrayed by Nicole Kidman in the film *To Die For* (1995) famously stated, "you're nobody if you're not on TV." The same logic applies in academia: You're nobody unless you're footnoted. The historical monuments and documents of AST will continue to be excluded from the canon of art history and intellectual history unless their theoretical contributions to critical discourses are credited. If art historians do not succeed in doing so, no one will.

One must ask: What is the voice of art history and criticism with respect to AST? What unique and valuable contributions have they made, and what contributions can they make now and in the future to historicize the subject—both in art history and in a broader cultural framework? Although I have more questions than answers, I hope that these provocations will spur debate and dialogue so that artists and art historians, collectively, can define the problems of our specialized field more clearly and begin to address them, if not in a systematic and concerted way, then at least in a way that provides grounds for identifying and problematizing methods and goals.

My discussion begins with an analysis of Burnham's *Beyond Modern Sculpture*, which I shall consider critically with respect to methodology and historiography. Questions pertaining to methodology and canonicity shall be further developed through self-reflections on my own attempts to historicize cybernetic, telematic, and electronic art within a larger art historical context.

Beyond Modern Sculpture: Historiography, Methodology, and Teleology

Burnham began his career as an artist, first using incandescent light in 1954 and, following the model of Gyorgy Kepes, neon light in 1955. After earning a B.F.A. and M.F.A. in sculpture at Yale in 1959 and 1961, he became a professor of art at Northwestern. There, he continued his research on what he called *photokinetics*, or light-motion phenomena, and began writing his magnum opus, *Beyond Modern Sculpture: The Effects of Science and Technology on the Sculpture of This Century* (*BMS*), published in 1968. The subtitle, the author explained, was not intended to limit the subject of his inquiry so much as to identify the close parallels between the development of modern sculpture and the rationalism and materialism that characterize the scientific culture of which it is a part (*BMS*, vii–viii).

Even in the best of circumstances, it is difficult to gauge a book's influence. In the case of *BMS*, this difficulty is compounded by several factors, including: (1) its highly polarized reception; (2) the author's subsequent mysticism in the 1970s, which undermined his academic credibility; (3) the author's disappearance from public life since the early 1980s, which stunted his ability to spawn intellectual progeny; and (4) the cyclical nature of popular sentiment toward the idea of joining art with science and technology. Regarding this latter factor, after going through at least six printings, the book fell out of print in the early 1980s, but in the late 1990s experienced a significant resurgence of critical attention amidst a rebirth of interest in AST.[6] Despite the difficulties of ascertaining the influence of *BMS*, it is a landmark in the history of writing about art, science, and technology. As such, I believe it holds many clues into the past, present, and future of the field's historiography.

The book's preface, in particular, sheds much light on Burnham's methodology and warrants close reading for its insights into the historiography of AST. The author described a spiritual kinship with Gottfried Semper's *Der Stil in den technischen und tektonischen Künsten oder praktische Ästhetik* (1863).

Semper, Burnham stated, not only established a method for interpreting art as the combined result of "'purpose, material, and technique,'" but promoted the idea that art reflected the "economic, technical, and social relationships" undergirding society (viii). Burnham contrasted this methodological ethos with one developed thirty years later by Alois Riegl, who decried Semper's theory as *Kunstmaterialismus*—a reduction of interpretation exclusively to the material conditions of art production. In its place, Riegl advocated *Kunstwollen*, or artistic volition, which remained the dominant hermeneutic until the mid-twentieth century.[7] Drawing on Siegfried Giedion's (1962) archaeology of art historiography, Burnham explained that, despite its idealism, Riegl's *Kunstwollen* theory, updated by Wilhelm Worringer, resulted in two generations of art historians since the 1920s being "studiously taught to shun the crass manifestations of the technical milieu" (*BMS*, ix). Many artists and art historians working in the 2000s might argue that this prejudice persists. As mentioned above, the recent survey by Foster, Krauss, Bois, and Buchloh exemplifies an abhorrence of technology that contributes to the continued exclusion of AST from canonical histories of art.

Despite Burnham's explicit concern with methodology and historiography, perhaps the unusual approach taken in *BMS* stems from the author's lack of specialized training as an art historian, for he was neither indoctrinated into nor beholden to any particular methodological mold. Indeed, with a combination of irony and arrogance, he stated, "my lack of success with the tools of art scholarship is in part responsible for this present book. Had the tools served their purpose, I might not have sought out others less respected" (*BMS*, ix). At this formative juncture in establishing the histories of media art, science, and technology, perhaps artists, critics, and historians would do well to purge their methodological prejudices, scour retrograde methods like Semper's and Burnham's, and create synthetic, interdisciplinary approaches to analysis, interpretation, and exposition. I shall return to this proposal with respect to my own work, but first the methodology behind *BMS* shall be examined in greater depth, with particular attention to the question of teleology.

Burnham argued that science and technology have played an important role in art's increasing embodiment of the qualities of living beings. His examples traversed a vast swath of history, from the myth of Pygmalion's ancient living sculpture to the realization of automata in the eighteenth century, and from early twentieth-century vitalist sculpture to the emergence at mid-

century of art incorporating cybernetics, computers, and robots. His argument wove in and out of the teleological claim that the historical unfolding of art had been driven by the underlying goal of becoming ever more lifelike. Indeed, *BMS* was commonly criticized for being simultaneously too general and too deterministic. For example, in 1969, Donald Judd complained, "It's a pastiche of art survey information and misinformation. His idea of history, such as it is, is deterministic. Everyone has his hindsighted place and history rolls on."[8] Krauss, in *Passages in Modern Sculpture*, wrote, "Burnham argues that the most fundamental ambition of sculpture, since its beginnings, is the replication of life.... But is sculpture ... necessarily 'about' the imitation, simulation, and nonbiological re-creation of life? And if it is not about that, what are we to think of Burnham's thesis?"[9]

Despite the validity of these and other critiques of *BMS*, the prescience of Burnham's thesis has been striking. Developments in technoscience such as artificial life, bottom-up models of embodied intelligence in robotics, nanotechnology, and molecular biology have become important models and tools for AST research. Krauss acknowledged the material conditions of art production but did not grapple directly with science and technology, an omission, from Burnham's perspective, of the features that defined the prevailing epistemological conditions of the twentieth century. Although one cannot know with certainty the historic place of any given cultural moment within the context of large-scale cultural shifts, the conditions Burnham identified in 1968 have intensified over the past four decades. He likely would not have concurred with Krauss's paraphrasing of his thesis as "sculpture ... necessarily [being] 'about' the imitation, simulation, and nonbiological re-creation of life." For Burnham, the development toward an increasing embodiment of lifelike qualities was not exclusive to art, but was characteristic of rationalist, materialist culture as a whole, of which art was a part. At the same time, one reasonably might be skeptical, as Burnham himself later was, of a method that identified a certain set of artistic practices as avant-garde by virtue of mapping a model of scientific progress onto them.[10]

In "A Teleological Theory of Modern Sculpture"—the final section of the final chapter of the book—Burnham explicitly established his position regarding teleology with respect to art, science, and technology. He lay the groundwork for his argument by replacing the romantic refrain, "art for art's sake," with a more enigmatic explanation of art's raison d'être in scientific culture: "art is what we do when we expend great time, care, and patience on

an activity without knowing why" (*BMS*, 374). This apparently purposeful purposelessness set the stage for Burnham's subsequent reflections and prognostications on the crucial importance of art as a means of survival in an overly rationalized society. Indeed, like many intellectuals in the 1960s, he feared that the cultural obsession with, and faith in, science and technology would lead to the demise of human civilization. For Burnham, the apocalypse would not be caused by thermonuclear war but by the ascendancy of intelligent automata and cyborgs, a fear that Sun Microsystems cofounder Bill Joy trumpeted to great fanfare in *Wired* magazine in April 2000.[11] Joy's sudden awakening to this danger after years of contributing to it, art historian Kristine Stiles has noted, is "symptomatic of the problem" of a technologist "burying his head in the proverbial sand ... with utter disregard for the insights and research of his colleagues in the arts and humanities."[12] One can only imagine the impact that *BMS* might have had on Joy and other technologists had it been assigned reading along with electrical engineering and computer science texts in the 1970s.

Echoing McLuhan's description of art as a "distant early warning system," Burnham wrote, "Art ... may be a means for *preparing* man for physical and mental changes *which he will in time make upon himself*" (*BMS*, 373). Having previously reflected on the "role of sculpture in shaping our destination as a post-human species" (*BMS*, 371), he speculated that the "quasi-biological nature of future art ... implies a gradual phasing out, or programmed obsolescence of all natural organic life, substituting far more efficient types of life forms for our 'inferior' and imperfect ones" (*BMS*, 376). Alternately, he mused, an "increasing general systems consciousness" may convince us that our "desire to transcend ourselves" through technology is "merely a large-scale death wish," and that ultimately, "the outermost limits of reasoning" are not reachable by posthuman technology but "fall eternally within the boundaries of life." Would it not be ironic, he asked, if "organic life and 'intelligence' [are] ... the same thing" (*BMS*, 376). This rhetorical question anticipated discussions concerning embodiment, disembodiment, and the posthuman three decades hence.[13]

Burnham did not attribute a universal, transhistorical essence to art, science, or technology. In fact, following Semper, his teleological account was rooted in the historically variable contingencies of purpose, material, and technique. Culture was malleable for him, but once certain epistemic formations took shape, they could exert great and enduring influence until their in-

ternal logic was played out or otherwise replaced by alternative formations. For centuries, Burnham claimed, the ethos of rationalization dominated Western civilization, all aspects of which, including science and art, necessarily were sucked into its undertow. *BMS* provided an account of rationalization with respect to art. Burnham's teleological master narrative may be interpreted as reflecting the enduring characteristics of that ethos. It was internally consistent in the sense that it simultaneously made a case for and exemplified the persistence of rationalized culture, including the necessity that explanatory narratives coherently progress to a univocal, ultimate conclusion. In other words, the tendency to formulate grand, totalizing narratives paralleled the rationalism and materialism of the scientific culture that framed Burnham's argument and the teleological theories that pervaded science and technology —to say nothing of art history—at the time *BMS* was written.

Burnham was at once enthralled by and apprehensive of science and technology. His greatest fear, however, was that the rationalistic and materialistic milieu—of which science and technology were symptomatic and constitutive—would run rampant. Three decades later, the Sokal hoax and the ensuing "science wars" suggested that, while many humanists had adopted a much more relativistic and nonlinear approach to explain the march (not progress) of science, many scientists clung vehemently, if not antagonistically, to a more traditional and teleological notion that science progresses toward discovering absolute truth. Burnham forecast that if human civilization persisted along that rationalistic path, it ultimately would be supplanted by technology. If, however, culture was reordered according to the principles of general systems theory (a theory credited to biologist Ludwig von Bertalanfy and highly influential on Burnham's thinking and in the humanities and social sciences), he suggested that the species might come to realize that organic life held greater bounties of intelligence and insight than any form of technology.

Burnham's entire *oeuvre* as a critic, art historian, and curator—including his books *BMS*, *Art in the Marcusean Analysis*, and *The Structure of Art*, his catalog essays and regular contributions to *Arts* magazine and *Artforum*, many of which were compiled in the volume *The Great Western Salt Works*, and the theoretically and technically ambitious "Software" exhibition[14]—demand a more elaborated historiographical analysis than can be offered here. The most comprehensive account of the history of AST in the twentieth century, *BMS* not only provides the foundation for his other critical and theoretical work

but, for the purposes at hand, represents his most unabashed championing of AST. He would not remain an advocate for long.

The seeds of Burnham's disenchantment with AST began to emerge in "The Aesthetics of Intelligent Systems,"[15] and are evident in "Software," despite the exhibition's explicit use of computers. His most explicit and antagonistic pronouncement, however, appeared much later, in "Art and Technology: The Panacea That Failed,"[16] where he stated that art and technology are incommensurable on the most basic structural level. After writing *BMS* Burnham began forging a method that incorporated structuralism, alchemy, and kabbalah. This method, applied to his research on Duchamp and conceptual art, led him to conclude that the internal logic of Western art compelled it to reveal its own internal semiotic structure. Using Duchamp's *Large Glass* as a metaphor, he explained that art was stripping itself bare, "dissolving into comprehension."[17] Technology contributed nothing to that process and amounted to "whipped cream" on the cake, he later noted.[18] Having lost faith in the ability of technology to contribute in a meaningful way to the signifying system that, according to his theory, mediated the mythic structure of Western art, in "Software" he purposely joined the nearly absent forms of conceptual art with the mechanical forms of technological non-art to "exacerbate the conflict or sense of aesthetic tension" between them.[19]

For all his brilliance and erudition, Burnham's methods obscured his ability to understand the broader implications of technology as an integral part of art-making. Technology was, for him, merely a means to a predetermined end that had nothing to do with technology, per se. By shedding the surface layers he believed he could uncover a grand scheme, what he referred to as the meta-programs, self-metaprograms, and mythic structures that explained why art unfolded and evolved as it did and would continue to do so. In *BMS*, beneath the surface he posited and found life. In "Software" and *The Structure of Art*, he attempted to uncover the structural foundations of art as a social institution. In an odd way, this self-reflexive methodological approach may be compared with and contrasted to an advanced stage of post-Greenbergian formalism taken to a metalevel of analysis. Greenberg posited three ineluctable modalities of painting—the characteristics of flatness, frame, and facture—and valorized work that explicitly addressed these formal qualities. Burnham identified increasing vitality as the underlying principle that propelled the historical unfolding of art and valorized work that instantiated and revealed that systemic process.

While vitalism and structuralism may remain important philosophical models, their limits in explaining the underlying motivations of art's history hardly need to be rehearsed. Indeed, one of the important lessons of poststructuralism has been a suspicion, if not outright rejection, of the very idea of universalizing master narratives, a deconstruction of what Burnham himself might have described as the mythic structure of Western epistemology. His pioneering application of structuralism to art historical methodology remained one order of analysis removed from such an insight—that crucial level that distinguishes structuralism from poststructuralism. Despite this and other shortcomings, *The Structure of Art* remains a fascinating if abstruse text that begs critical reappraisal as part of a larger reconsideration of Burnham's important contributions to art history.

Art, Science, and Technology: Toward Forging a Method and Firing a Canon

From the invention of one-point perspective and the creation of oil paint to the development of interactive virtual reality environments and telematic art, technical innovation and the use of emerging scientific ideas and technologies as thematics and media have substantial continuity throughout the history of Western art. This is at once not saying very much while also making a significant claim. For one could state just as easily and correctly that various forms of sociology, economics, psychology, and philosophy, along with other analytic and creative tools have been employed in artistic practice and art historical interpretation for hundreds of years. What makes my claim significant is that the discipline of art history has embraced biography, formalism, feminism, Marxism, psychoanalysis, poststructuralism, postcolonialism, and other critical apparata as bona fide methodologies. This leads me to ask: How can this field develop a more comprehensive understanding of art and technology without appropriate methods designed to bring it into relief? What would such methods consist of? What insights might emerge into the relationship between art, science, and technology, especially during periods when they seem relatively unrelated?

The critical and historical work of the aforementioned art historians, critics, and artists offer valuable models that could be formalized into a set of methods. The history, philosophy, and sociology of science and technology, exemplified by the work of Thomas Kuhn, Andrew Feenberg, Paul Feyerabend, Douglas

Kellner, Bruno Latour, and Michael Heim, offer valuable tools for interpreting developments in AST. Literary criticism has a long tradition of critically analyzing media, ranging from pioneers like Marshall McLuhan to more contemporary authors including Jay David Bolter, N. Katherine Hayles, and Janet Murray. Emerging from various fields, cultural studies has developed synthetic methods that draw on a variety of critical approaches to analyze complex phenomena, particularly with respect to mass culture, including television, film, and mass media, as pioneered by Raymond Williams and more recently applied by media theorists Sherry Turkle and Lev Manovich to interpret screen-based multimedia. Given the increasing emphasis on inter- and transdisciplinary collaboration, social science methods from fields including anthropology and psychology, as in the work of Brigitte Steinheider, may offer important insights into the hybrid processes of such research.

Art history is, by its nature, an interdisciplinary undertaking. Ultimately, no single method is sufficient to exhaust the infinite possible interpretations of a work of art. AST, moreover, is a remarkably broad field with a long history. Hence, no single method could hope to provide a comprehensive tool for analyzing a subject of such breadth and duration. Nonetheless, the field of art history would benefit by studying the methods employed by other disciplines to analyze the relationship between science, technology, and culture in general and by elaborating a methodological framework(s) designed to address the particularities of the aspect of AST in question. Such a method(s) would offer valuable insights into the historical relationship of art, science, and technology and provide a basis for understanding how that nexus, in turn, relates to other cultural forces (e.g., politics, economics, and so forth) that have shaped the unfolding of art.

In the absence of a basic method that incorporates the history, theoretical content, and practical applications of science and technology, the canon of art history exhibits an impoverished understanding of the role of both technology in the history of art-making and the contributions of artists who have been important innovators in that regard. This is a slippery slope. On the one hand, the reconstruction of a master narrative is challenging theoretically, if not ethically. Indeed, many of the distinguishing characteristics of contemporary AST would seem to challenge the epistemological foundations that legitimate grand narratives. In this respect, the canonization of AST is arguably tantamount to ensuring its failure by its own criteria. At the same time, ca-

nonical revision that reflects the importance of technology throughout the history of art implies a critical reconsideration and recontextualization of artists, artworks, art-making practices, and historical narratives that previously have been excluded, marginalized, or not understood to their fullest potential. In a different context, Burnham himself once remarked, "all progressive things are accomplished with the aid of the System."[20]

In confronting this dilemma, I hope that the following considerations will at least help demarcate some of the critical issues that surround this problematic enterprise, with respect to the particularities of contemporary art involving emerging technologies and to the more general concern of including the study of science and technology as central to the history of art. I'll begin by sharing some of my thoughts on these questions with respect to art and art history after 1900, which I shall expand with more detailed examples drawn from my own work in the field.

Although theoretical challenges to master narratives and grand schemes constitute a valuable corrective to naturalized discursive strategies and methodological models, the problem of defining a data set remains. Discourse depends on and necessitates that participants in it agree that they have a more or less coherent subject to respond to or talk about. They may disagree vehemently about certain objects, methods, and goals, but there must be some common ground. Canons provide that common ground, a shared database of generally accepted objects, actors, and moments that are held together by virtue of their participation in the construction of an evolving discourse. In order to be part of the discussion, those objects, actors, and moments must be admitted to the canon by its gatekeepers. The primary gatekeepers are art critics, art historians, curators, dealers, and collectors and the institutions they represent: journals, the academy, museums, commercial galleries, auction houses, and collectors. Practically speaking, a canon can be only so large. While it must have sufficient examples to demonstrate its authority, its significance is predicated on a certain exclusivity. So, for each work newly admitted to it, another must be removed. The sorts of judgments that administer this gatekeeping function cannot be separated from ideological agendas, professional ambitions, and financial investments. Support for and acceptance of a work as a canonical monument requires strenuous and subtle negotiation in order to make a case that compels other gatekeepers to concur. For the more gates an object, actor, or moment succeeds in passing through, the more securely

entrenched in the canon it becomes. And, of course, the canon is neither monolithic nor set in stone.

Indeed, the canon of Western art history has been modified dramatically, particularly by reconstructions mounted in the name of Marxism, feminism, multiculturalism, and poststructuralism. In Janson's *History of Art*, second edition (1977), which I read in college in the 1980s, women artists were all but absent. The canon is, to be sure, patriarchal and authoritarian, but it is not fascistic. Rather, it has proven to be quite flexible and resilient. Its existence and status do not appear seriously threatened, in part because challenges to it have focused on remedying exclusions or altering its narrative of stylistic progression rather than dismantling the fundamental structures of power endemic to it. Such a project would demand fundamental epistemological shifts that lie beyond the domain of art history, though the field might be able to offer useful models of noncanonical schemes for creating a shared discursive database, perhaps incorporating interactive technologies to produce a nonlinear narrative structure. As appealing as such a transformation might be, one can imagine the extraordinary challenges they would pose in the classroom. More to the point, they do not provide a solution for remedying the lack of recognition and marginalization of AST. To accomplish that goal, the monuments of AST must be identified and admitted to the canon (or other discursive database).

One approach to canonical recognition is through surveys that include specific chapters on art and technology, as in Kristine Stiles and Peter Selz's *Theories and Documents of Contemporary Art*.[21] Alternatively, AST monuments might be woven into thematic or chronological narratives that integrate the role of science and technology more fully into the fabric of art history. Along these lines, the study of technology as a hermeneutic method must be incorporated as part of the art historian's standard methodological tool-kit. Artists and intellectuals working in this area must become involved in the process of negotiation and gatekeeping that will enable AST to gain canonical status or to enter into the discursive domain of whatever will replace it. Such involvement includes attaining positions of authority in professional organizations, funding and exhibition institutions, the academy, publishing, and so forth. In many respects, the AST clan, such that it is, has already begun to infiltrate these ranks, but it has a long way to go. I am not suggesting a takeover of the art world, merely a leveling of the playing field.

Methodological Examples in My Own Work

Telematic Embrace

In 1995 I presented my first paper on Ascott at the "Einstein Meets Magritte" conference in Brussels.[22] I continued to research the artist's work, and in 1997, I received a contract to publish a collection of his essays. In my lengthy introduction to *Telematic Embrace: Visionary Theories of Art, Technology, and Consciousness (TE),*[23] I attempted to contextualize Ascott's work as a practitioner, theorist, and teacher within the history of art, the history of technology, and intellectual history. My text was grounded fundamentally in the history of art in order to locate Ascott's oeuvre within a continuity of aesthetic strategies employed in experimental art in the twentieth century. For example, I framed Ascott's cybernetic work from the 1960s in the context of painterly tendencies ranging from Cézanne to Jackson Pollock, vitalist and constructivist tendencies in British art from Moore to Pasmore and Nicholson, the use of alleatory techniques and a process-oriented approach to art-making by Arp and Cage, the interactive aspects of kinetic art and happenings, and the conceptualism of Duchamp, Kosuth, and Art & Language. I considered Ascott's work with telematic art in the context of these constituents of cybernetic art, plus mail art, situationism, performance, artists' use of telecommunications, interactive video, and other experimental streams.

I attempted to dispel the commonly held belief that art merely emulates concepts that first emerge in scientific or technological contexts. I theorized that the historicization of ideas often fails to acknowledge artistic developments as an originary source because the languages of art are neither as literal nor widely spoken as the symbolic and textual languages of science and philosophy. My research suggested that ideas emerge simultaneously in various fields and that the cross-fertilization of those ideas presupposes that an underlying context already exists in order for seeds from one field to germinate in another. In the case of Ascott's work, I argued that cybernetics could be applied to the problems of art only because there already was a significant history of artistic experimentation with process, systems, and interactive forms. Cybernetics, then, provided a formalized, scientific method to describe approaches with which artists (and others) had already been experimenting. As an example, I showed how Ascott's *Change Painting* (1959) could be interpreted on the basis of cybernetic principles, yet its creation predated his

awareness of cybernetics. To be sure, the elaboration of the science of cybernetics also provided a theoretical foundation on which related aesthetic research could build, and I demonstrated how Ascott's art practice, theory, and pedagogy could be systematically applied to those models.

With respect to Ascott's theories of cybernetic art, I drew a parallel between the process by which ideas become historicized and the role of artists' writings in theorizing a field. In this regard, I claimed that his writings exemplified how innovative artists often established the theoretical foundations of their practice long before it was incorporated into critical, curatorial, and historical discourses. Over and above that claim, I emphasized that Ascott's writings, like those of artists associated with conceptual art, such as Kosuth and Art & Language, not only theorized his practice but were an integral part of it. Indeed, Ascott's integration of practice, theory, and pedagogy was a central theme of the introduction, as was his integration of artistic, philosophical, scientific, and non-Western systems of knowledge.

Given the importance of science and technology in Ascott's work, my analysis demanded explanations of cybernetics and telematics, in terms of both their basic principles and theoretical implications for the artist's work and for art and culture in general. Key sources for the evolution of cybernetic thought included the work of Norbert Wiener, Gregory Bateson, Heinz von Foerster, and James Lovelock. Simon Nora and Alain Minc's *Computerization of Society*, the 1978 report to French president Valéry Giscard d'Estaing in which the term "telematics" was coined, was a key source for theorizing the implications of computer networks. Moreover, diverse influences, including the metaphysical ideas of Charles Fourier, Henry Bergson, Teilhard de Chardin, and Peter Russell, the structuralist and poststructuralist notions of Barthes, Foucault, and Derrida, and Confucian, Taoist, Native American, and shamanistic traditions were explicated in relation to Ascott's theory and practice of cybernetic and telematic art.

McLuhan's famous adage, "the medium is the message," served as a foil for my analysis of the relationship between form and content in telematic art. I argued that "The processes by which technological media develop are inseparable from the content they embody, just as the developing content [conveyed by] ... technological media is inseparable from the formal structures that embody it." I concluded that "form, content, and process must be considered within the particular contexts of their creation and interpretation," and that telematic art "emerges as a dialogical process of interaction in which

exchanges of information create bonds through shared systems of meaning and value" (*TE*, 85–86).

Related considerations of the relationship between self and others in mediated, screen-based environments drew on Manovich's archaeology of screen culture, Heim's dialectical theories of technology, original reflections based on a literary notion of love in Lawrence Durrell's novel *Justine*, and my interpretation of Duchamp's *Large Glass* in contradistinction to Ascott's. Such questions led to a discussion of responsibility with respect to media, drawing on Baudrillard's "Requiem for the Media,"[24] and further commentary on the topic by artist-theorist Eduardo Kac, media historian–theorist Douglas Kellner, and film–media historian Gene Youngblood.[25]

My analysis and interpretation of Ascott's work of the early 1960s as protoconceptual kindled the insight that telematic art also shared affinities with conceptual art. This intuition, reinforced by an interview with artist Carl Loeffler and in response to an essay by Simon Penny, led to the conclusion that, like conceptual art, the meaning of telematic art, as theorized by Ascott, was embedded largely in its idea. In another context, I applied this strategy— identifying parallels across categories of practice that traditionally had been historicized as discrete and impermeable—to a more general analysis of the relationship between technology and conceptual art.[26]

I offer these examples to demonstrate the breadth and depth of sources and methods that I drew on in my research for *TE*. Although I certainly am more predisposed to and comfortable with some approaches than others, I did not come to the task with a predefined method but rather attempted to allow the subject of my inquiry to dictate an appropriate approach. In the case of Ascott's work, which itself draws on such diverse sources, a highly synthetic method seemed necessary. With respect to the creation of a methodology for writing the history of AST, I conceive of the emergence of methodology and historical narrative as a mutual and reciprocal process, in which each functions for the other as both the cart and the horse that pulls it.

Art and Electronic Media

In 2002 I started writing a book tentatively entitled *Art and Electronic Media*. It consists of a large-format, richly illustrated, hard-bound volume that includes a 20,000-word survey essay illustrated with 50 reference images; a works section of 180 color plates with captions of 100–150 words; a documents section consisting of 110,000 words of edited critical writings

pertaining to the topic; and, in addition, artist biographies and a bibliography. In other words, the volume will present itself as canonical. However, unlike other topics in the same book series, such as minimalism, arte povera, and conceptual art, there is no clearly defined canon of electronic art.

The opportunity and responsibility to create a canonical survey of this topic has been both euphoric and fearful. My overriding goal has been to enable the rich genealogy of art and technology in the twentieth century to be understood and *seen*, not just as a quirky and marginal activity, but as central to the history of art and visual culture since the early twentieth century. To this end, I included work of artists, engineers, and institutions from over thirty countries; attended to issues of race, gender, and sexuality; and structured the book thematically to emphasize continuities across periods, genres, and media.

While assembling this manuscript, I confronted a number of difficult questions about how to historicize the use of electronic media in and as art. The list below identifies some of these issues and the following discussion will address them more or less sequentially.

- How might various subgenres and modes of art inquiry within art and electronic media be classified and categorized?
- What role do particular media or technical innovations play in defining these histories, as opposed to aesthetic or art historical continuities?
- Given limited space and a finite number of illustrations, how does one balance the representation of work by artists with long careers with that of younger artists?
- How can the diversity of artists with respect to nationality, race, gender, sexuality, and other characteristics best be represented? How can a topic of such diversity be addressed in a coherent narrative of 20,000 words?

The other books in the series shared an organizational structure whereby the survey, works, and documents sections were divided into consistent subsections. *Arte Povera* was divided into subsections, structured primarily by artist or locale; *Minimalism* was structured according to chronological subsections; *Conceptual Art* was structured thematically. Organizing the book by artist was not applicable to *Art and Electronic Media.* I rejected using a chronological structure because I wanted to stress how similar media and/or concepts have been used at different times for varied artistic goals. I opposed a medium-

based organizational scheme for two main reasons: (1) it would foreground technological apparatus as the driving force behind the work (a message I did not want to convey); and (2) it would fail to show how related conceptual and thematic issues have been addressed by artists using varied media. The ability to show these sorts of continuities was a top priority, so I elected to organize the book thematically, despite the difficulty of defining themes that are internally coherent and meaningful.

As I began to consider themes with which to organize the book, I also was compelled to define a database, which, as mentioned above, constitutes an essential core of any canon. In the absence of an overarching thesis and predetermined methodology, I intuited that by simultaneously formulating thematic sections and compiling a list of works, each activity would inform the other. Further, I anticipated that the process of defining and populating those sections would enable me to identify critical issues. Ultimately, I hoped that the thematic issues raised by the individual works and the sections they constituted would drive the narrative.

I made a list of some five hundred works, discovering in the process a richness in the field that previously I had not appreciated so fully. This database revealed absences in the thematic scheme, and vice versa. The sections I initially sketched out morphed several times, coming to be defined as follows:

Coded Form and Electronic Production

Following a long artistic tradition of employing technology to generate form or produce multiple images, the emergence of computer graphics and electronic photocopying in the 1950s and 1960s, and high-resolution digital photography, printing, and rapid prototyping (RP, which enables the production of three-dimensional copies) in the 1980s and 1990s expanded the possibilities for artistic production and reproduction. Artists include Ken Knowleton, Sonia Sheridan, and Michael Rees.

Motion, Light, Time

Defying the traditional conception of art as a static object, beginning in the early twentieth century artists began to introduce actual motion into their work, making explicit the continuity of consciousness in the perception of art through time and space. The use of artificial light, such as neon or laser, as an artistic medium also explicitly draws attention to the extension of art in time and space, thereby shifting the artwork from being an illuminated object

to being an actual light source. Artists include Gyula Kosice, Nicholas Schöffer, and Raphael Lozano Hemmer.

Networks, Surveillance, Culture Jamming

Even prior to the advent of computer networking and satellite communications, artists produced work in which the exchange, transfer, and collaborative creation of information often involve remote participants. Public access cable, satellite transmissions, and especially the union of computers and telecommunications (often referred to as *telematics*) vastly expanded these capabilities. Artists include Roy Ascott, Julia Scher, and rtmark.

Simulations and Simulacra

Simulations are copies that share many attributes with the concrete originals they represent. By contrast, the term "simulacra" can refer to a form of similarity particular to media culture, wherein distinctions between original and copy become increasingly murky. The originals may no longer exist, may never have existed, or their significance has been dwarfed in comparison to the simulacra, which attain a level or primacy and authenticity that traditionally had been the exclusive province of the original. Artists include Myron Krueger, Char Davies, and Jeffrey Shaw.

Interactive Contexts and Electronic Environments

Art has always been implicitly interactive in the sense that it demands some manner of perceptual and cognitive interaction on the part of the viewer. Artists working with electronic media increasingly came to think of themselves as providing open-ended contexts that offered audiences infinite possibilities for the production of unpredictable meanings through creative exchanges. Artists include Le Corbusier, Keith Piper, and Toshio Iwai.

Bodies, Surrogates, Emergent Systems

Artists have joined their bodies (and/or those of their audiences) with electronic media or created robots and other forms of surrogates in order to examine the cyborgian nature of human existence and to ponder what a posthuman existence might consist of. Their work bridges the apparent divide between carbon-based organisms and silicon forms of intelligence and life, between the real and the artificial, suggesting that these distinctions are becoming in-

creasingly blurred if not simply a social convention. Artists include Stelarc, Christa Sommerer and Laurent Mignonneau, and David Rokeby.

Communities, Collaborations, Exhibitions, Institutions

Although the history of art traditionally has celebrated a cult of individual artist-geniuses, the field increasingly has recognized the importance of exhibitions, institutions, and communities in shaping the production, reception, and historicization of art. Owing to its technical requirements and financial overhead, art involving electronic media often demands close collaboration between artists, scientists, and engineers, and between individuals, communities, and institutions. This section includes the ZKM, the Software exhibition, and Rhizome.org.

Thematic categories do not admit of hard and fast distinctions. Indeed, there are many works in the book that could have fit comfortably in two or more sections. For example, Sommerer and Mignonneau's *A-Volve* (1993–94) was appropriate for the sections "Simulations and Simulacra" or "Interactive Contexts and Electronic Environments," but the emphasis of this work on the creation of and corporeal interaction with artificial life forms was the factor that determined its place in the section entitled "Bodies, Surrogates, Emergent Systems." On the other hand, Jane Prophet's *TechnoSphere* (1994–95) also emphasizes the interactive creation of artificial life forms, but to my knowledge was the first to do so using a Web-based interface. As a result, this work was placed in "Networks, Surveillance, Culture Jamming." In both these cases the placement of the work in a particular section helped to represent the diversity of practices within it and the extensive crossover between sections. In this way, I hoped that the sections would at once hold together in their expansiveness while demonstrating their permeability, that they would be internally coherent yet interpenetrating. In some cases, decisions were based on intuition, while in others they were determined very purposely in order to achieve a more balanced representation in each section. Overall, my goal was for each section to make sense as a unit, while mutually reinforcing the other sections in order to form a coherent and comprehensive whole.

When I began the project, 180 color plates and 50 reference images seemed to be a lavish abundance. I quickly realized how even twice that number would not provide a sufficient platform for representing the international

scope and richness of electronic art. This situation demanded making tough choices to select works that represented the diversity of the field by decade, gender, nationality, and so on, in a way that seemed fair. For example, how many works sufficiently represent the work of a pioneer, like Paik, with a career spanning five decades, compared to an artist working with electronics for less than ten years? As suggested above in the discussion of canonical revision, for each additional illustration allotted to a pioneer, one less artist could be included in the volume. I made a decision to make the book as inclusive as possible by providing only one color plate for any given individual artist, except in the case of collaborative work. I placed no limit on black-and-white reference images, which I used to represent the breadth of an artist's career and to include additional artists not represented in the works section. In the end, over two hundred artists from over thirty countries were represented. Women artists in the field—few and far between in the 1960s—came to represent a significantly larger proportion of the book, constituting approximately one-third of the artists since 1990. Issues of race, nation, gender, and sexuality were not addressed explicitly as distinct topics; rather, this diversity was woven into the fabric of the volume.

The problem of constructing a narrative that brings together the extraordinary diversity of artistic strategies and media over many decades was a major struggle. As a scholar, I was trained to identify a problem, establish a thesis with respect to that problem, and compile a series of arguments that draw on extant literature, primary sources, and theoretical propositions in support of the thesis. The general topic of art and electronic media admits of no apparent thesis. Burnham's thesis of increasing vitality neither holds true nor offers useful insight into the subject. I began by writing separate short essays for each of the sections. My initial goal was to address the diversity of work within each section, while at the same time suggesting the cumulative effects of artistic development within a broadly defined area of inquiry. As a result, the narrative within each section often follows a chronology, but in a nonteleological way that emphasizes parallels and affinities. For example, in the section "Motion, Light, Time," I drew on Robert Mallary's theorization of "transductive art"[27] to identify a broad range of electronic art, including Jean Dupuy's *Heart Beat Dust* (1968), Gary Hill's *Soundings* (1979), Shawn Brixey's *Photon Voice* (1986), Carsten Nicolai's *Milk* (2000), and Sachiko Kodama and Minako Takeno's *Protrude/Flow* (2001). Spanning more than three decades, all of these works transform matter and energy from one form or state to another.

Concluding Reflections: Art History, Interdisciplinary Collaboration, and the Interpretation of Hybrid Forms

Although eighteenth- and nineteenth-century aesthetic theories asserted the autonomy of art, the development by artists of one-point perspective, anatomy, photography, and virtual reality attest to the deeply intermingled histories of art, science, and technology.[28] Moreover, throughout history, artists have created and utilized technology to envision the future, not just of art, but of culture and society in general. Unfortunately, the history of art has neglected to incorporate this visionary conjunction of AST into its canon in any systematic way. Just as the insights afforded by diverse methodologies, ranging from feminist theory to Marxism to poststructuralism, have resulted in substantial revisions of the art historical canon, so the history of art must be revised in a way that explicitly addresses interactions between art, science, and engineering. This revision will be required not only because it corrects an obvious omission but because contemporary artists are increasingly employing science and technology as artistic media and students are increasingly being trained to use them as standard materials and techniques and to collaborate with scientists and engineers in the pursuit of interdisciplinary research.

Leading contemporary artists are now directing interdisciplinary graduate programs at major research institutions where they are training a new generation of hybrid practitioners.[29] As the number of such hybrid practitioners increases, their impact on the centrality of technology and science to the practice of art and design (and vice versa) also will force a reconsideration of the canons of art history and the histories of science and technology. Such work seeks to create new forms and structures of meaning that expand the languages of art, design, engineering, and science, and that open up new vistas of creativity and invention.

In order to understand the evolving relationship between contemporary art, science, and technology, one must grapple with the complex processes and products that sustain and result from collaborative research. The evaluative methods of art history do not offer adequate measures of success or failure. Interpretive scholarship in this arena will require an interdisciplinary approach that joins together multiple methods of analysis. New methods for ascertaining the value of the new hybrid outcomes of interdisciplinary collaboration must be developed just as new methods for teaching, cultivating, and recognizing the value of hybrid scholars must emerge. Perhaps even new forms of

critical and/or historical exegesis and means of publication and distribution must be developed to articulate and convey the meaning and significance of evolving forms of interdisciplinary creation.

On a philosophical level, if the fruits of hybrid research practices are not strictly science, or engineering, or art, then one must wonder about the epistemological and ontological status of these hybrid forms: what exactly are they? What new knowledge do they produce or enable? What is their function in the world? On a practical level, the future sustainability of hybrid research depends on answering these questions, because the academic careers of scholars whose work fuses disciplines will be cut short if their contributions are not recognized and rewarded within the university. The absence of appropriate methods for evaluating and granting tenure to interdisciplinary professors will create a disincentive for future scholars to pursue interdisciplinary work, disrupt the ability of existing interdisciplinary faculty to mentor future hybrid researchers, and prevent the ascension of interdisciplinary faculty to positions of power and authority in academe, where they can influence infrastructural change and facilitate the creation of new forms of invention, knowledge, and meaning at the intersections of art, science, and technology.

Notes

The first version of this essay was presented at "Historicising Digital Art" sessions at the annual meeting of the Association of Art Historians, University of London, Berkbeck College, London, UK, April 11–12, 2003, chaired by Charlie Gere. Subsequent drafts were presented at Future Technology: Media Arts and Culture Colloquium, coordinated by Ken Rinaldo at the Wexner Art Center, The Ohio State University, Columbus, Ohio, April 28, 2003, and at the MediaArtHistory organizational meeting at Villa Vigoni, Menaggio, Italy, May 28, 2004. This essay is dedicated to Roy Ascott, Jack Burnham, Douglas Davis, Frank Popper, and Gene Youngblood.

1. Jack Burnham, *Beyond Modern Sculpture: The Effects of Science and Technology on the Sculpture of This Century* (New York: Braziller, 1968); Roy Ascott, "Is There Love in the Telematic Embrace?," *Art Journal* 49:3 (fall, 1990), 241–247.

2. Especially Doug Davis, *Art and the Future: A History/Prophecy of the Collaboration between Science, Technology, and Art* (New York: Praeger, 1973), Frank Popper, *Origins and Development of Kinetic Art* (Greenwich, Conn.: New York Graphic Society, 1968) and

Art: Action and Participation (London: Studio Vista, 1975), and Gene Youngblood, *Expanded Cinema* (New York: Dutton, 1970).

3. See Linda Dalrymple Henderson, "Writing Modern Art and Science—I. An Overview; II. Cubism, Futurism, and Ether Physics in the Early Twentieth Century," *Science in Context* 17 (2004): 423–466.

4. Survey texts, including Christiane Paul's *Digital Art* (London and New York: Thames and Hudson, 2003) and Rachel Greene's *Internet Art* (London and New York: Thames and Hudson, 2004), together with edited anthologies, such as Ken Jordan and Randall Packer's *Multimedia: From Wagner to Virtual Reality* (New York: Norton, 2001), Noah Wardrip-Fruin and Nick Montfort's *New Media Reader* (Cambridge, Mass.: MIT Press, 2003), and Judy Malloy's *Women, Art, and Technology* (Cambridge, Mass.: MIT Press, 2003), as well as Rudolf Frieling and Dieter Daniels's *Media Art Net 1: Survey of Media Art* (Vienna and New York: Springer, 2004) and *Media Art Net 2: Key Topics* (Vienna and New York: Springer, 2005), originally published online at http://mediaartnet.org/, also have helped to historicize the field, though it must be noted that of these authors and editors, only Daniels is trained as an art historian.

5. Other important AST curators and archivists include Isabelle Arvers, Annick Bureaud, Andreas Broeckmann, Nina Czegledy, George Fifield, Rudolf Frieling, Darko Fritz, Jean Gagnon, Jens Hauser, Sabine Himmelsbach, Manray Hsu, Tomoe Moriyama, and Michelle Thursz.

6. Marga Bijvoet, *Art as Inquiry: Toward New Collaborations between Art, Science, and Technology* (New York: Peter Lang, 1997); Mitchell Whitelaw, "1968/1998: Rethinking a Systems Aesthetic," *ANAT News* 33 (May 1998), http://www.anat.org.au/pages/archived/1999/deepimmersion/diss/mwhitelaw.html/; Edward A. Shanken, "The House That Jack Built: Jack Burnham's Concept of Software as a Metaphor for Art," *Leonardo Electronic Almanac* 6:10 (November 1998), http://mitpress2.mit.edu/e-journals/LEA/AUTHORS/jack.html/; and Simon Penny, "Systems Aesthetics and Cyborg Art: The Legacy of Jack Burnham," *Sculpture* 18:1 (January/February 1999), http://www.sculpture.org/documents/scmag99/jan99/burnham/sm-burnh.shtml/.

7. Burnham notes that subsequent critics compared this idealistic theory with the mystical and metaphysical concepts of "phlogiston" and "élan vital," which he described as "spurious doctrines that employed impressive terms to cover phenomena that had no satisfactory physical explanation" (*BMS*, viii–ix).

8. Donald Judd, "Complaints, Part 1," *Studio International* 177, no. 910 (1969), 184. Cited in Janet McKenzie, "Donald Judd," *Studio International* (2004), http://www.studio-international.co.uk/sculpture/donald_judd.htm/. Cited 30 June 2005.

9. Rosalind Krauss, *Passages in Modern Sculpture* (Cambridge, Mass.: MIT Press, 1977), 209–211.

10. Willoughby Sharp, "Willoughby Sharp Interviews Jack Burnham," *Arts* 45, no. 2 (Nov. 1970), 21.

11. Bill Joy, "Why the Future Doesn't Need Us," *Wired* 8, no. 4 (April 2000).

12. Kristine Stiles, "Rants," *Wired* 8, no. 7 (July 2000).

13. See, e.g., N. Katherine Hayles, *How We Became Posthuman: Virtual Bodies in Cybernetics, Literature, and Informatics* (Chicago: University of Chicago Press, 1999).

14. See *Art in the Marcusean Analysis* (State College, Penn.: Penn State Papers in Art Education, 1969); *The Structure of Art* (New York: George Braziller, 1971); *The Great Western Salt Works: Essays on the Meaning of Post-Formalist Art* (New York: George Braziller, 1974); *Software, Information Technology: Its New Meaning for Art*, ed. Judith Burnham (exhibition catalogue) (New York: The Jewish Museum, 1970).

15. Jack Burnham, "The Aesthetics of Intelligent Systems," in *On the Future of Art*, ed. Edward Fry (New York: The Viking Press, 1970), 95–122.

16. Jack Burnham, "Art and Technology: The Panacea That Failed," in *The Myths of Information: Technology and Postindustrial Culture*, ed. Kathleen Woodard (Madison: Coda Press, 1980); reprinted in *Video Culture*, ed. John Hanhardt (New York: Visual Studies Workshop Press, 1986), 232–248.

17. Willoughby Sharp, "Willoughby Sharp Interviews Jack Burnham."

18. Jack Burnham, personal correspondence with the author, 16 March 2001.

19. Jack Burnham, personal correspondence with the author, 23 April 1998.

20. Quoted in Grace Glueck, "Art Notes: The Cast Is a Flock of Hat Blocks," *New York Times*, 21 December 1969.

21. Kristine Stiles and Peter Selz, *Theories and Documents of Contemporary Art: A Sourcebook for Artists* (Berkeley: University of California Press, 1996).

22. Edward A. Shanken, "Technology and Intuition: A Love Story? Roy Ascott's Telematic Embrace," in *Science and Art: the Red Book of Einstein Meets Magritte* (Dordrecht: Kluwer Academic Publishers, 1999), 141–156.

23. Edward A. Shanken, "From Cybernetics to Telematics: The Art, Pedagogy, and Theory of Roy Ascott," in Roy Ascott, *Telematic Embrace: Visionary Theories of Art, Technology, and Consciousness*, ed. Edward A. Shanken (Berkeley: University of California Press, 2003), 1–94.

24. Jean Baudrillard, "Requiem for the Media," in *For a Critique of the Political Economy of the Sign* (New York: Telos Press, 1983, c. 1972).

25. Eduardo Kac, "Aspects of the Aesthetics of Telecommunications," *Proceedings, ACM SIGGRAPH '92* (New York: Association for Computing Machinery, 1992), 47–57; Douglas Kellner, *Jean Baudrillard: From Marxism to Postmodernism and Beyond* (Cambridge: Polity Press, 1989); and "Resurrecting McLuhan? Jean Baudrillard and the Academy of Postmodernism," in *Communication for and against Democracy*, ed. Marc Raboy and Peter A. Bruck (Montreal/New York: Black Rose Books, 1989), 131–146; Gene Youngblood, "Virtual Space: The Electronic Environments of Mobile Image," *International Synergy* 1, no. 1 (1986), 9–20.

26. See my "Art in the Information Age: Cybernetics, Software, Telematics, and the Conceptual Contributions of Art and Technology to Art History and Aesthetic Theory," doctoral dissertation, Duke University, 2001; and "Art in the Information Age: Technology and Conceptual Art," in *SIGGRAPH 2001 Electronic Art and Animation Catalog* (New York: ACM SIGGRAPH, 2001), 8–15.

27. Robert Mallary, "Computer Sculpture: Six Levels of Cybernetics," *Artforum* (May 1969), 29–35.

28. The ideas presented below are derived from my essay, "Artists in Industry and the Academy: Collaborative Research, Interdisciplinary Scholarship, and the Interpretation of Hybrid Forms," *Leonardo* 38:5 (October, 2005): 415–418.

29. Many graduates of the Planetary Collegium Ph.D. program founded and directed by Roy Ascott in 1996 currently head interdisciplinary programs. These include

Eduardo Kac at the School of the Art Institute of Chicago; Jill Scott at the Hochschule für Gestaltung und Kunst, Zürich; Bill Seaman at the Rhode Island School of Design; Christa Sommerer and Laurent Mignonneau at the Kunstuniversität Linz; and Victoria Vesna at UCLA. Pioneering AST Ph.D. programs in the U.S. include the Digital Arts and Experimental Media (DX Arts) at the University of Washington, co-directed by Richard Karpen and Shawn Brixey; the Media, Art, and Technology program at UC Santa Barbara, directed by George Legrady; and the Digital Media program, directed by Janet Murray at Georgia Tech's School of Literature, Communication, and Culture. Other notable U.S. graduate programs include the Arts Computation Engineering program, directed by Simon Penny at UC Irvine; the Arts, Media, and Engineering program, directed by Thanassis Rikakis at Arizona State University; and the Art and Technology program, directed by Ken Rinaldo at The Ohio State University.

5

Twin–Touch–Test–Redux: Media Archaeological Approach to Art, Interactivity, and Tactility

Erkki Huhtamo

A visual sense is born in the fingertips.
—F. T. MARINETTI

The idea of interactive art is intimately linked with touching. As it is usually understood, an interactive artwork is something that needs to be actuated by a "user."[1] If the user "does nothing," it remains unrealized *potential*—rules, structures, codes, themes, and assumed behavioral models designed by the artist and embedded in a software-hardware configuration. An interactive work challenges one to undergo a transformation from an onlooker to an "interactor," an active agent. A peculiar kind of dialogue develops. In addition to mental interaction that is a precondition to the reception of art in general, physical bodily action—one that involves more than just movement of the eyes—takes place. One touches the work, often repeatedly—either physically, by stepping on a pressure-pad, fingering a "touch-screen," clicking on a mouse or pressing a custom-made interface, or remotely, mediated by a video-camera, sound, light, or heat sensors, and so on. As innocuous as these acts may seem, they have potentially far-reaching consequences for the notion of art as we have come to know it. Not only does the emphasis on touch run counter to the customary idea of the "untouchability" of the art object; it challenges us to compare art with a whole range of other human activities—from work to play—where physical contact is expected.

It is not just the "proxemic" relationship between humans and human-made contraptions—from power looms to mechanical toys and videogame

consoles—that matters. If the traditional proxemics, as developed by Edward T. Hall and others, focused on relatively short range relationships within physical spaces, it is increasingly clear that we have entered the era of "tele-proxemics."[2] Technological systems from mobile phone networks to the Internet connect humans with each other across great distances, redefining the idea of place in the process. As Marshall McLuhan already stated in the early 1960s, the formative development of the "global village" (whether it has happened as McLuhan predicted or not) emphasized the role of tactility as part of a more general reconfiguration of the senses.[3] Artists and "metadesigners"—Kit Galloway and Sherrie Rabinowitz, Roy Ascott, Paul Sermon, Hiroshi Ishii, Rafael Lozano-Hemmer, and many others—have explored the ramifications of what it means to "teletouch" at a distance. Although the models they have created have rarely been implemented on a permanent basis, the transmission, simulation, and/or substitution of the sense of touch have become vital concerns in many fields from personal telecommunications (including "cybersex") to networked multiperson training simulators, games, telemedicine and remote-controlled warfare. That such developments run parallel with artists' and designers' explorations of similar issues is enough to warrant an inquiry.

This article develops a media-archaeological approach to "touching art" as a contribution to a wider cultural mapping of interactive media.[4] The emphasis is on technologically mediated situations, where the interaction happens via an interface, a hardware-software complex designed for this purpose. The issue of proxemic social interactions between human participants, like those taking place in happenings, body art, and experimental dance pieces, all major elements of the "dematerialized" art scene since the 1960s, is of secondary importance here.[5] The psychophysical constitution of the human–machine interaction is not a major concern in this essay either. Social psychologists like Sherry Turkle have already done a substantial amount of work to uncover its complex "mechanisms."[6] The emphasis here is cultural and historical, dealing with questions such as the following, without pretending to provide conclusive answers: What are the cultural, ideological, and institutional ramifications of touching artworks—whether these artworks are labeled as "touchable" or not? What are the discursive formations informing such practices? How has touching art been related with the acts of touching taking place in other contexts—at work, leisure, and in ritual? Finally, why does asking questions like these matter?

Haptic Visuality and the (Physical) Touch

Before beginning to tackle such complicated issues, we must state certain premises. First of all, this essay will focus on cases that involve corporeal engagement with an artwork—the use of one's hands, arms, feet, or even the entire body. So far most discussions of tactility in art have concentrated on what Laura U. Marks has characterized as "tactile, or haptic visuality."[7] This refers to a peculiar visual relationship between an observer and an image (whether static or in motion). As Marks explains, the issue concerns both the modes of visual perception and the "haptic" qualities assigned to the images themselves. The discussion about haptic vision (also known as "visual touch") originated around 1900 in the works of German art historians like Adolf Hildebrand and Alois Riegl. As Jacques Aumont has pointed out, Hildebrand identified two tendencies in figurative art, "the optical pole of distant vision" and "the haptic (tactile) pole of close vision."[8] The first tendency emphasized representation, often situating characters and events "deep" within perspective spaces, while the latter emphasized the "near" presence of the objects themselves, highlighting their textures and surfaces, in other words, the "skin" of things.

For Hildebrand, these tendencies were linked with two ways of seeing: "the nearby image" (*Nahbild*), which corresponded to the everyday vision of a form in lived space, and "the distant image" (*Fernbild*), which corresponded "to the vision of this form in terms of the specific rules of art." The former could be interpreted as more informal and intimate, while the latter was more formal and distant, bound by the conventions of representation. However, as has been pointed out, in actual practices of looking the "optical" and the "haptic" can never be entirely separated. Rather, the observer negotiates between these modes. These ideas have been developed further by Deleuze and Guattari, and others, elaborating on the ideological implications of this division.[9]

The idea of "haptic visuality" implies the transposition of qualities of touch to the realm of vision and visuality. It confronts the issue of the physicality of touch indirectly, through a corporeal operation involving the eyes and the brain. The hands are not part of it, except as an imaginary "projection." Although useful, the notion of "haptic visuality" cannot be applied as such to the analysis of phenomena like interactive art, where the body— sometimes coupled with a "body image," like the "levitating hands" in virtual reality applications—is directly involved. The haptic gaze is supported—and

perhaps at times contradicted?—by other corporeal operations. Quite clearly, any segregation of the senses from each other is out of the question. As McLuhan stated, "tactility is the interplay of the senses, rather than the isolated contact of skin and object."[10] This applies well to interactive art, which often engages not only sight and touch, but sound as well.

Like David Howes, I emphasize the cultural nature of sensory perception. "The cultural meaning of the senses ... is not simply derived from any presumed inherent psychophysical characteristics, but elaborated through their use," Howes writes.[11] In short, sensory perception is culturally coded. Codes are not learned and used in mechanical ways. In sensory activities a process of negotiation takes place, where internalized "schemes" are tried out and activated in various ways in response to sensory "input," sometimes subverting the most obvious meanings.[12] Anthropologists and cultural scholars like Constance Classen and Howes have provided ample evidence about variations in the sensory expressions and responses within different cultures. The most obvious example is salutation; there is a great variety of salutations, not only in those involving touch, but also those that do not. Far from being haphazard or anarchic, these conventions correspond with social sanctions and divisions, and deeply felt needs within the society. Touching is never just an improptu act, a personal expression of "universal" feelings and intuitions. The meanings of touch depend on the cultural context within which they are activated and negotiated. In a technological culture, forms of touch have been instrumentalized into coded relationships between humans and machines. Arguably they have been genderized as well, a fact reflected in strategies of interface design.

Artists have designed ingenious ways of mediating between humans and machines, and between humans and humans via the *mediation* of machines. But are their solutions always "original," without precedent? Or could artists rather be seen as transmitters and transformers of sensory traditions rooted in preceding cultural forms? As art historians have shown, artists are not always fully aware of their influences and the implications of their choices. In some cases, however, they can be highly aware of their goals, drawing on cultural models and modifying them to suit their needs. Both alternatives are encountered in the artists' involvement with touch. From the media-archaeological perspective artists can be considered cultural agents working within cultural traditions (even when they deliberately claim to clash with them) and reenacting existing forms and schemes in their works, either consciously or uncon-

sciously. An artwork can give us clues about how cultural traditions work and recycle their elements in an effort to renew themselves. Of particular interest are the cultural elements and clichés that appear, disappear, and reappear in cultural traditions and provide "molds" for cultural expressions and experiences. Inspired by the work of Aby Warburg and Ernst Robert Curtius, I have called such elements *"topoi"* (*topos* in the singular).[13] What kind of *topoi*, if any, can be discovered operating in interactive artworks? What purposes do they serve?

Art and the (Anti-)Tactile Tradition

How convenient it would be to state that tactile art began with interactive media art! However, this is not the case. Although it has usually been seen as a phenomenon of secondary importance, the idea of "touchable art" was already evoked in the context of the historical avant-gardes of the early twentieth century; the discourses on touching artworks go much further back in time. To understand the role of tactility in contemporary media arts, one must first trace these earlier manifestations. One also has to explore their reverse: the absent and prohibited touch. We could speak about "tactiloclasms"—cases where physical touching is not only absent, but expressly prohibited and suppressed. Instead of being a minor issue involving one of the "lower" senses at the fringe of dominant cultural practices, the question "to touch or not to touch" turns out to have wide implications. Far from being marginal, it is linked with important cultural issues—contestations and tensions, rules and transgressions—happening in social spaces. These issues are still—and perhaps more than ever—felt in today's museums and galleries due to the ongoing "crisis" of the traditional art object, the emphasis on interactivity and tactility and the emergence of what Nicolas Bourriaud has called "Relational Aesthetics."[14] Many exhibitions now present both works that encourage touching and those that strictly prohibit "fingering."[15] Exhibition visitors often find this situation confusing, yet it is not totally unique or unprecedented.

The emergence of the discourse on haptic visuality in the end of the nineteenth century echoed both the dominant aesthetics and the academic practices of displaying artworks. "Touching with one's eyes only" was a manifestation of an ideological "mechanism," where the formation of the aesthetic experience was associated with "stepping back"—maintaining physical

distance from the artwork. Touching a sculpture or a painting was not only deemed vulgar, but forbidden. Behind this situation there were multiple determinants that did not always merge seamlessly with each other. The Romantic cult of the genius had emphasized the "otherworldly" quality of the artwork; as a product of "divine" inspiration, it had a special "aura" that made it almost sacrilegious—and therefore also tempting, at least for those longing for a "touch of genius"—to touch it with one's hands. Art museums and galleries were conceived as "temples of beauty and the sublime." Religious connotations associated with behavioral modes were thinly veiled (but not fully suppressed) by secular ones—indeed, touching a statue of a saint to gain power or "contact" has been part of many religious traditions involving images. However, alongside the veneration of their otherworldly qualities, artworks were also admired for their superior craftsmanship, which emphasized their material quality. They were increasingly seen as commercial products—collectibles, investments, and status objects for the bourgeoisie. Thus the prohibition of touching was linked with the "untouchability" of private property, as the "cult value" was gradually replaced by exchange value.

Another development was the democratization of the museum, spurred by the ideology of visual education of the masses.[16] While access to museums had earlier been retricted to privileged visitors who were assumed to know the proper codes of behavior, the situation changed in the "age of the masses." Artworks were increasingly enclosed in transparent display cases or behind protective sheets of glass and kept under the inspecting eyes of museum guards. Even the *potential* for touch, now seen as a threat of transgression, was eliminated. As Classen has shown, the nineteenth-century museum, where nontactility reigned supreme, was not a given, but a cultural and ideological construct.[17] In the early museums, stemming from private collections and cabinets of curiosities, touching the artifacts was often not only allowed, but encouraged. Many visitors took this as self-evident and were offended if the right to touch the objects was denied. Not just three-dimensional objects, but even paintings were touched, as a complement to the act of looking. The tactiloclasm that came to dominate the museum institution, and in many cases is still valid today, was a combination of factors—ideas about public domain and private property, notions of access and education, social hierarchies translated into relationships to objects, surveillance, and protection (the museum could be seen as an ideological machinery whose purpose was to ease mounting social tensions).

It is not entirely inappropriate to compare the museum to another great nineteenth-century institution, the department store. While the museum did its best to eliminate all forms of tactile access to the artifacts on display, the department store looked for a working relationship between tempting haptic visuality (represented above all by the window display) and tactile access to the goods for sale. In the nineteenth century most merchandise was still kept safely behind counters, only reached by the mediation of shop assistants. The right to touch the merchandise had to be carefully controlled, because the department store could inadvertently encourage kleptomania, a "dangerous" mixing of social classes and sexes, as well as chaotic and even manic behavior during sales events. This did not prevent Emile Zola from characterizing the department store as "a cathedral of modern commerce," while the architect and polytechnician Julien Guadet called it a "museum of merchandise."[18]

The museum, the church, and the department store all regulated behavior, although the suppression of the tactile dimension took different forms. Such more or less strictly enforced institutional "tactiloclasms" provide the backdrop against which the emergence of the "society of interactivity" should be assessed. Popular culture, including penny arcades and other forms of "Automatic Entertainments," as well as avant-garde art, provide early hints of a sprouting phenomenon that burst into the cultural mainstream during the twentieth century.

The Futurist Art of Tactilism

Although F. T. Marinetti's "Manifesto of Tactilism" (1921) has been considered one of the minor manifestos of futurism, it is the most programmatic and explicit early plea for an art of touch.[19] It emerged logically from the futurists' attack on academic institutions and bourgeois culture. The art museum with its static displays was the embodiment of "passéism" and an obvious target for the futurist veneration of speed, machines, masses, and art turned into a social force. While proclaiming the destruction of decadent and obsolete cultural forms, the futurists wanted to renew the totality of contemporary culture by resorting to multisensory and synesthetic strategies.

In his manifesto Marinetti outlines the principles of Tactilism as a new art form, including the education of the tactile sensibility, the creation of "scales" of different tactile values, and the construction of models for tactile artforms. Marinetti's list includes various types of "tactile tables," consisting of different

materials to be touched, as well as tactile divans, beds, clothes, rooms, roads, and even theaters. It is a pity that Marinetti does not explain all of his ideas in detail. The rooms, however, anticipate some aspects of installation art with their walls covered by large tactile boards made of different materials. The floor provides tactile values by means of running water, stones, brushes, velvet, weak electricity, and so on. All this is said to offer "maximum spiritual and sensual pleasure to the naked feet of male and female dancers." In the tactile theaters the audience members would place their hands on long tactile "belts" that move at variable rhythms.[20] The belts could also be applied to small rotating wheels, accompanied by music and lighting effects.

For Marinetti, his "still embryonic tactile art" must be kept distinct not only from painting and sculpture, but also from "morbid erotomania." Its purpose is to achieve tactile harmonies and to contribute to the "perfection of spiritual communication between human beings, through the epidermis." Marinetti does not consider his tactile art as separated from the other senses. Rather, he feels that the distinction between the senses is arbitrary; Tactilism can contribute to the discovery and cataloging of "many other senses." Still, Marinetti remarks that "a variety of colors" should be avoided in the tactile tables so that they do not lend themselves to "plastic impressions." Because painters and sculptors tend to subordinate tactile values to visual ones, Marinetti suggests that Tactilism may be "especially reserved to young poets, pianists, stenographers. . . ." This statement is interesting. It seems to prioritize the writer's, the pianist's, and the stenographer's hands because these are means for evoking nonvisual realms of imagination and suggestion beyond the visible. Their touch is both sensual and intrumental. If this interpretation is correct, it could be associated with Marcel Duchamp's famous critique of "retinal" art. For Duchamp, instead of clinging to the surface effects as the impressionists did, art had to become "cerebral," penetrate beyond the retina, beyond the purely visual. Of course, Marinetti only hints at the intellectual possibilities of tactile art. Still, his reasoning embodies an interesting paradox: Tactilism, the ultimate art of the surface, is really about what is beyond it. It is in the mind of the toucher. It is not a coincidence that he also compares Tactilism with X-ray vision and points out its practical value for surgeons and the handicapped. With Tactilism, "a visual sense is born in the fingertips," one that "sees" deeper than the skin.

Knowing the futurists' affectionate relationship with technology, it is striking to note that the "Manifesto for Tactilism" says nothing about machines as

a new touchable realm (with the possible exception of the mechanisms for the moving belts in the tactile theaters). One wishes Marinetti had mentioned the hands of the typist (captured in motion in a "photodynamism" by fellow futurist Anton Giulio Bragaglia already in 1912) or those of the driver clutching a steering wheel, almost a fetish for the futurists. Such "interface awareness" obviously had not yet developed, although the works of some futurists, like Gino Severini, did contain mechanical parts to be manipulated by the viewer.[21] It had also been implied in Giacomo Balla and Fortunato Depero's manifesto "The Futurist Reconstruction of the Universe" (1914), which described varieties of fantastic machines and "futuristic toys." Depero's *Plastic Complex: Motorumorist Pianoforte* (1915), a mechanical noise-making machine, was controlled by a human performer via a keyboardlike interface. Marinetti's reference to weak electric shocks given to the dancers in his tactile room is, however, a lead worth following. It refers to what may have been the most popular technologically augmented tactile experience. Well-known to the public through popular-scientific lectures at fairground attractions, doctors' offices, and even homes, electric shocks were a nineteenth-century novelty that was considered both exciting and healing. "Electricity is Life" was a well-known slogan in the broadsides for shows and on devices administering electric shocks. The quack machines meant for domestic electrotherapy had their counterpart in the coin-operated "strength testers" at penny arcades; the task was to grasp two metal handles for as long as possible while a steadily increasing electric current flowed through one's body.

Already in their first manifesto (1909) the futurists had promised to "sing of great crowds excited by work, by pleasure, and by riot."[22] It was in the mass society that various technology-related tactile experiences emerged during the nineteenth century, ranging from work in mechanized factories and offices to the new kinds of pleasures offered by the varieties of coin-operated devices at amusement parks, penny arcades, and on city streets. While the department store windows kept their desirable offerings behind panes of glass, the strength testers, mutoscopes, and other "Automatic Entertainments" invited the user to a direct physical contact. As one can still experience at places like the Musée Mecanique in San Francisco, the "user interfaces" of such devices often had hand- or foot-shaped molds. Some even had surrogate metal hands, challenging the visitor to an arm-wrestling match with Uncle Sam or some other mythic figure. Operating these devices often required more physical strength than dexterity, which seems to have directed their

"gender-designation" toward the male, while a more passive onlooker's role was reserved for women. However, other devices, including shooting games and even mutoscope-like peepshows, appealed to females as well; the gender divide was never as sharp as has been assumed. These devices also inspired lively discursive manifestations, often evoking tactile relationships. This issue has been dealt with in the author's earlier writings.[23]

There is no lack of evidence about the influence of popular culture on the avant-garde movements of the early twentieth century.[24] Sergei Eisenstein's revelation, according to which his radical intellectual montage, including the principle of "shock attraction" used in his classic *Battleship Potemkin* (1925), was influenced by the experience of riding on a roller coaster, is a striking example, but not the only one.[25] It might be claimed that Picasso's and Braque's practice of using found material, including tram tickets, newspaper cuttings, cloth, and other pieces of residue from the urban mass culture in their collages was *potentially* tactile, in line with Marinetti's tactile tables, even though they hardly encouraged actual touching. The tactile dimension was enhanced by the soirées, cabarets, city wanderings, and other events organized by the Dadaists, surrealists, and other radical movements to break down the barriers between artists and non-artists. The sensational boxing match between the Spanish Dadaist Arthur Cravan and the reigning world champion John Johnson (1916), which led to Cravan's predictable knockout in the first round, shifted the focus from the art object to the corporeal tactility of spectator sports, although the audience's participation was limited to haptic visual sensations from the other side of the ring. However, the infamous and deliberately provoked scuffles that sometimes took place between the performers and the spectators at Dadaist and surrealist events demonstrated that cracks were beginning to appear in the invisible shield separating art from its audience.

Duchamp, Kiesler, and the Invitation to Touch

Marcel Duchamp's readymades should also be discussed this context. As is well known, Duchamp chose visually unremarkable mundane objects that were put to tactile uses in everyday life without much thought—a bicycle wheel and a stool, a bottle rack, a snow shovel, and the protective cover of an Underwood typewriter, familiar from thousands of offices. In their mass-

produced ordinariness such objects easily turn "invisible" in their normal contexts. Duchamp's idea of displaying them in the gallery in the place usually reserved for "untouchable" art objects is an ambiguous gesture that created a powerful irony. Far from denying the tactile nature of these objects, it could be claimed that their new site (with its preexisting connotation of "distance") increased the temptation to touch them as a subversion of their newly acquired "status." Duchamp provided some of his readymades with enigmatic texts that may have urged the visitors to come closer to study them, thus further increasing the tension between "to touch or not to touch." It should perhaps be noted that as cultural artifacts, texts—whether on the pages of a book or as public inscriptions or notices—seem less controlled by tactile restrictions than images. Books are tactile objects par excellence, meant to be perused with one's fingers. Public inscriptions, often carved in stone, may not have been meant to be touched (prohibitions controlling their untouchability exist), but they often have nevertheless endured the touches of generations of believers or tourists.

The first of Duchamp's readymades (their "distant forerunner," according to Octavio Paz), *Bicycle Wheel* (1913), was different from the others in that it incorporated an active possibility of (interactive) movement.[26] There is some evidence suggesting that Duchamp himself enjoyed putting it in motion by hand. Whether this was ever done by exhibition visitors is uncertain, but the form of work could certainly persuade the user to interaction. Unlike its typical situation when it is attached to a bicycle, the wheel protrudes toward the viewer, while the stool serves as a pedestal.[27] This might warrant calling it —without belittling its other possible readings and identities—a "proto-interactive" work. It went further in this direction than Man Ray's *Objet à detruire* (Object to Be Destroyed), a modified metronome with a cutout eye attached to its pendulum. Although Man Ray also uses mechanical motion, the (destructive) suggestion is largely transmitted by the title, obviously challenging the viewer to break the hypnotic spell of the to and fro movement of the eye.[28] Constantin Brancusi's *Sculpture for the Blind* (c. 1920), an egg-shaped, polished marble object, suggests touching both by its formal qualities and its title, reminding one of the strong potential tactility of Brancusi's work.[29] Meret Oppenheim's *Le déjeuner en fourrure* (Breakfast in Fur/Fur Teacup, 1936) is an example of a surrealist object with a suggestive but ambiguous tactile quality. It is not meant to be touched physically—it exists

more in the realm of haptic visuality, albeit on its tactile edge, almost "within the reach of the hand." Of course, while the fur may be inviting to the hand, it may also feel repulsive if associated with the act of drinking.

Traditional exhibition design served as a "machinery" for maintaining the untouchability of art within museums. Therefore it is logical that tactile ideas were probed on this field by avant-garde innovators like Duchamp, Man Ray, and Frederick Kiesler. Duchamp's and Man Ray's play with lighting at the opening of the 1938 Exposition Internationale du Surréalisme is a *cause célèbre*. The main hall was nearly dark, and the visitors were given flashlights to see the works. Even the flashlights were quite dim, forcing the visitors to get very close to the artworks, leading to an unusual interaction with the environment.[30] Kiesler incorporated touch on multiple levels into his famous design for Peggy Guggenheim's Art of This Century gallery in New York (1942).[31] He created swiveling "baseball bat" wall mounts that detached the artworks from the walls and made them "rush" toward the spectator, as well as "biomorphic displays," systems of strings stretched between the floor and ceiling, holding small sculptures in between, potentially elevated or lowered by the visitor. Perhaps Kiesler's most radical—and controversial—gesture was the construction of peep boxes for viewing artworks in the Surrealist Gallery. Thus André Breton's *Portrait of the Actor A. B.* could be seen by pulling a lever that opened a diaphragm, allowing the work to be seen inside the box. Reproductions of the contents of Duchamp's *Boîte en valise* could be inspected by peeping into a hole and turning a large "ship's wheel" (obviously a homage to Duchamp's *Rotoreliefs*). Critics immediately associated these designs with popular cultural motives, calling them "a kind of artistic Coney Island," or "a penny-arcade show without the pennies." According to Lewis Kachur, they also recalled Julien Levy's original plan for a surrealist nickelodeon arcade for the 1939 New York's World's Fair.[32] Although they hardly created a tradition, Kiesler's designs are an important link between popular "proto-interactive" devices and the interactive media of the future.

However, the most explicit experiment in tactility by Kiesler is the little-known *Twin–Touch–Test*, a work created in collaboration with Duchamp for the surrealist *VVV: Almanac* in 1943.[33] It is disguised as a prize competition, complete with a cutout coupon to be returned with the entry. Returning cutouts by mail was, of course, a common form of "programmed feedback" in the popular press. The reader is asked to join the palms of one's hands from both

sides of a chicken wire fence, and caress it until ready to describe the experience "in no more than one hundred words." If there is no access to a wire screen, the back cover on the journal, containing a piece of actual chicken wire inserted in a cutout slot in the shape of a female torso, could be used. Detailed instructions for conducting the experiment both alone and with another person are given. Although it has been described simply as an "autoerotic exercise," the fact that a two-person mode is also available suggests a training for sensual interpersonal communication, which Marinetti mentioned as one of the goals behind his tactile experiments.

As can be expected, the work contains numerous other connotations. As far as I know it has not been pointed out, for example, that the photograph on the Twin–Touch–Test page, showing a young female (Peggy Guggenheim's daughter Pegeen) engaged in the act of caressing the wire fence with her hands, eyes closed, undergoes a transformation when seen through the chicken wire slot of the back cover. Only a part of the photograph is visible as if through a peephole.[34] The most prominent features are the raised hands behind the wire fence, while the girl's shoulder may be mistaken for her head pushed back (her real head is framed outside). The connotation might be religious exctasy, but sadomasochistic fantasies, reminiscent of those seen through the peepholes in Jean Cocteau's film *Le sang d'un pôete* (1930), may be evoked as well. Ironically, the words "Five Prizes" can also be seen, increasing the ambiguity of the view.

The gender of the implied user has been left deliberately ambiguous. Although the photograph shows a girl doing the exercise in the autoerotic mode, the female figure of the cutout would seem to suggest the male as the implied "toucher" (as well as the "peeper" when the back cover is closed). The profuse and fetishistic use of naked female bodies in surrealist exhibitions and actions—from "prepared" mannequins to actual nude models—would seem to reinforce this.[35] Duchamp himself used a female breast, made of soft foam-rubber, in his famous cover design for the deluxe version of the exhibition catalog *Le Surréalisme en 1947*, accompanied with the exhortation: *Prière de toucher* (please touch). The erotic tactile play of the cover was made even more explicit in the photograph of a nude model posing in the exhibition hall next to Kiesler's *Totem of the Religions*, wearing nothing but a bandage over her eyes and Duchamp's foam-rubber breast covering her sex.[36] Although this action may be interpreted as merely a typical surrealist prank, it also engages the

a

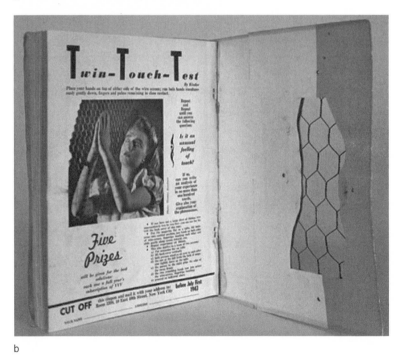

b

Figures 5.1a, 5.1b Frederick Kiesler and Marcel Duchamp, *Twin-Touch-Test*, 1943. See plate 3.

discourse on tactility by placing a living human body among the artworks and even providing her with a kind of eroticized "push button." The "blinding" of the model further emphasizes the tactile register. Enrico Donati, the American painter who helped Duchamp in the production of the foam breasts, remarked that "I had never thought I would get tired of handling so many breasts," to which Duchamp is said to have replied: "Maybe that's the whole idea."[37] Perhaps—perhaps not; *Prière de toucher* was an oblique commentary on the amount of naked breasts in surrealist art at the time.

Feminist Play with the Tactile Passive Body

Art that emphasized the tactile relationships between bodies, often mingling those of the performers and the participants, became a major element of the happenings, performances, "body art," and other art events of the 1960s and the '70s. As already stated, this topic falls outside the frame of this essay, so the discussion will be limited to a few projects that linked bodies with technological interfaces. Of primary importance is Valie Export's *Tapp und Tastkino* (Touch and Taste Cinema, 1968). Helped by her partner Peter Weibel, who—ironically—worked as her barker, Valie Export appeared in the city street wearing a box with curtains that covered her naked breasts. The passers-by were exhorted to reach out their hands and fondle them. In this "expanded (or perhaps reduced?) cinema" piece, the naked female bodies offered by (mostly male) producers and exhibitors to the anonymous collective consumption of cinema audiences have been replaced by a personalized and proxemic experience involving not representation, but "the real thing." Unlike the pornographic images on a screen, this experience is controlled by the female subject herself. While fondling her breasts, the toucher is also forced to encounter her gaze. This is the opposite of the voyeuristic situation reigning in the cinema, where the characters never really look back (although they may pretend to do so). The haptic visuality of pornographic cinema was replaced with corporeal bodily contact.[38]

Valie Export made this link even more explicit in her *Action Pants: Genital Panic* (1969), a performance in which she entered a cinema showing a pornographic film in pants with the crotch cut away and a sub-machine gun on her sholder, offering herself to be sexually used by the audience, as a replacement to the projected sex on the screen. Marina Abramovic, another pioneering feminist artist, used a similar strategy in her action *Rhythm 0* (1974). For the

duration of six hours, she submitted herself passively to the physical manipulation by the (mostly male) audience, even providing an array of torture and pleasure instruments for the purpose.[39] Abramovic aimed to expose the taboos, desires, and inhibitions related with physical tactility in the "society of the spectacle," where the relationship to bodies has purportedly been distanced and commodified.[40] Both Export's and Abramovic's actions had been anticipated by Yoko Ono's *Cut Piece* (1965) that introduced the figure of the seemingly passive female subject left at the (tactile) mercy of the spectators.[41] Another early tactile feminist work was Orlan's *Baiser de l'artiste* (The Kiss of the Artist, 1976–77). Orlan posed as a coin-operated dispenser machine, behind a "shield" showing a naked female body. After depositing a coin that fell into a basket between Orlan's legs, the user was allowed to kiss her.

Tactile motives also began to appear in works that directly linked the spectator with media technology. Although it may encourage haptic visuality, the television set in its daily use is a nontactile object (in spite of Marshall McLuhan's arguments for its tactility).[42] The television set was redefined as an object for touching and manual manipulation in the early installations and actions by Nam June Paik and Wolf Vostell. By modifying the electronic television image with a magnet, or by turning knobs or shouting into microphones, Paik's "Participation TV" works turned the TV set from a terminal for passive consumption of remotely transmitted content into a means of self-expression. Paik's goal of "doing television with one's fingers" was not only a transposition of his earlier preoccupations as a pianist from the aural to the visual, but arguably echoed the *topos* expressed in Marinetti's saying: "a visual sense is born in the fingertips."[43] Portapak, Sony's early portable videocamera and recorder, provided Paik and an entire generation of video artists a means of exploring the body as it became interfaced with technology. The Portapak came to be used in live performance and tape works focused on the artist's body, as well as in closed-circuit installations, where the visitor's body image was captured and transmitted back as if in a technological mirror. Video scanned the skin and magnified body parts, creating an intimate, haptic discourses. It also helped to set up stage situations where actual and represented bodies were juxtaposed or superimposed. Video was linked with the possibilities of the computer in the early works by interactive art pioneers like Myron Krueger and Erkki Kurenniemi, leading to new ways of exploring the relationships between bodies, technology, and body images.[44]

Tactility and Interactive Art

An Internet search for "tactile art" produces mostly results that refer to a specific phenomenon, namely aesthetic experiences for the blind. There are exhibitions and museums of tactile art, usually offering replicas of well-known sculptures or embossed, relieflike versions of famous paintings (including, in one case, Duchamp's *Nude Descending a Staircase*). In these cases the sense of touch is meant as an ersatz to the missing visual channel. While it can be argued that a faithful replica of Rodin's *The Thinker* could indeed give some kind of an idea of the artwork (sculpture itself can be seen as potentially tactile, although this possibility is negated by institutional restrictions), the tactile translations of paintings and other two-dimensional images are more problematic. A relieflike copy of *Nude Descending a Staircase* may transmit some idea of its representational content to experienced hands, but other levels are lost. Some rare original artworks have been meant for both the visually impaired and people with normal sight. The Japanese artist Takayuki Mitsushima, whose works were recently shown at the Touch, Art! exhibition at the Kawagoe Art Museum in Japan, was weak-sighted at birth and lost his sight completely by the age of ten.[45] His collages use delicate paper cuttings to create relieflike surfaces that appeal both to blind visitors and those with normal sight. Remarkably, the artist uses colors, resorting to the visual memories from his childhood. Mitsushima also took part in *Tactile Renga* (1998–), a collaborative networked painting project he created with media artists Toshihiro Anzai and Rieko Nakamura. As part of the project, a new kind of printer and plotter technology for the creation of embossed images was developed.[46]

The realm of tactility in art is not, however, limited to the experiences for the visually impaired. Interactive art, in particular, is tactile art almost by definition. As already stated in the beginning of this essay, interactive art requires the user's action to function. The work then responds in some way, and a "conversation" between the user and the work develops. This is, of course, the most rudimentary definition of interactive media. Adding the issue of tactility raises numerous questions that cannot be fully answered here. First, the nature of the touch itself: Is it possible to create taxonomies of different kinds of touches? What are the connotations of caressing versus hitting, pressing versus pulling? How does proxemic touching differ from teleproxemic touching? How does actual physical touching differ from "virtual touching"

(without direct contact with the interface)? Second, the function of the touch: Does touching the work trigger "local responses" (from the physical artwork and/or the surrounding space) or "remote responses" (i.e., touching the work affects realities that are spatially distant, while the responses are mediated by the work)? Do the responses come from a system (a software-hardware complex) or from other human beings via the mediation of the system? Third, the relationship between touch and the other senses: Is the goal of the work the "purification" and segmentation of the sensorium by separating touch from the other sensory channels, or, rather, their synthetic integration? Can the work serve the interchangeability of the senses, or the simulation of other senses? Fourth, the role of tactility itself: Is all art that involves touching "tactile art"? Must there be a physical response ("force-feedback") to the user's touch for the application to qualify as tactile? Does tactile sensation have to be a goal in itself, or can touching play a more metaphorical or instrumental role, and still warrant the piece's classification as tactile art?

Here it is possible to give only tentative answers by examining some artworks where the issue of touching plays an important role. Quite clearly, a very rich range of "touch modes" has been proposed by new media artists, from gently fingering living plants (functioning as an interface to growing a digital garden) in Christa Sommerer and Laurent Mignonneau's *Interactive Plant Growing* (1993) to aggressively throwing balls at a wall-relief made of modified computer keyboards in Perry Hoberman's *Cathartic User Interface* (1995). While some artists prefer to use standard interface devices (mouse, keyboard, joystick), others see designing their own as an essential aspect of the work. Ken Feingold's *The Surprising Spiral* (1991) has two interface objects: a touch screen designed as the cover of a simulated book and a pile of books with a model of a mouth on top of it (putting one's finger across the "lips" makes the mouth speak). A tactile interface does not always involve the use of hands. The user communicates with Tony Dove's interactive narrative installation *Artificial Changelings* (1998) by stepping on interactive floor pads. Marnix de Nijs' *Run Motherfucker Run*, recently awarded at Prix Ars Electronica (2005), invites the viewer to run on a large industrial treadmill. In the virtual reality installation *Osmose* (1995) Char Davies used a combination of a breathing interface and body motion tracking as a way of controlling the user's movements within a virtual world.

To what extent should the user "feel" the responses from the work? In most cases artists seem content with providing visual-aural feedback, only implying

tactile responses. There are, however, works where tactile feedback has become an integral part of the concept itself. Bernie Lubell's surprising wooden (resolutely nondigital) interactive installations often contain pneumatic tubes and soft diaphragms (inspired by the work of Étienne-Jules Marey) that provide the interactor genuine tactile sensations. In *Cheek to Cheek* (1999) the interactor sits on a specially built wobbly stool; the gyrations of one's bottom are transmitted through pneumatic tubes to one's cheeks, leading to an uncanny "autoerotic" experience. Christa Sommerer and Laurent Mignonneau's recent works have also explicitly begun to explore the tactile dimension. *NanoScape* (2002) uses powerful magnetic forces to "tactilize" (visualize would not be the right word) the invisible nanolevel phenomena. The interface is a ringlike device worn by the user; by moving one's hand over a special table one feels the forces in motion without actually touching the table surface. In *Mobile Feelings* (2001–) Sommerer and Mignonneau explore wireless tactile communication between human participants. Using Bluetooth-technology and advanced microsensors for mobile communication, they have created wireless objects that allow users feel each other's heartbeats, and will soon provide other sensory experiences as well. While the first versions were hidden inside actual pumpkins (an organic interface evoking the plants in *Interactive Plant Growing*), the later egg-shaped objects strangely remind one of Brancusi's *Sculpture for the Blind* (and the human heart, of course). The idea behind *Mobile Feelings* can also be read as a *topos* going back to the seventeenth-century proposals for intimate distant communication by means of magnetism.

Mobile Feelings raises the issue of tactile communication over a distance. This in itself is not a new idea. Kit Galloway's and Sherrie Rabinowitz's telematic art workshops (1980s), Paul Sermon's *Telematic Dreaming* (1992) and Stahl Stenslie and Kirk Woolford's *CyberSM* (1993) were all in their own ways concerned with exploring the intimate touch between people separated by distance. The teletouch could be achieved either by a mental transposition of visual impressions (two "body images" touching each other) or by using a custom-made "teledildonic" interface, technologically transmitting the partner's body movements.[47] Numerous art and design projects have explored the real-time transmission of the sense of touch to another location by means of force-feedback interfaces. A well-known example is *inTouch* (1997–98), created by the Tangible Media group at the MIT Media Lab,[48] which used synchronized wooden "massage rollers" as its telematic interface. Japanese media laboratories in particular, such as the one led by professor Hiroo Iwata

Figure 5.2 Bernie Lubell, *Cheek to Cheek*, 1999. By kind permission of the artist.

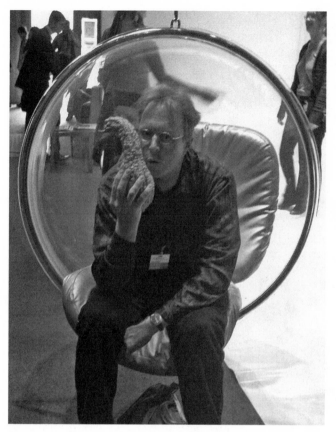

a

Figures 5.3a, 5.3b Professor Machiko Kusahara and the writer experimenting with Christa Sommerer and Laurent Mignonneau's *Mobile Feelings I* (2001) at Ars Electronica 2001. See plate 4. Photos by Christa Sommerer.

at the Tsukuba University, have created many prototypes for new kinds of force-feedback applications, often shown at Siggraph. Recently the possibilities of teletactility have also been explored by artists and designers interested in smart clothes and wearable media, which is a logical path to follow, clothes being the most intimate and persistent "interface" everyone uses.

There are also works where touching plays a more metaphoric and/or instrumental role. Marinetti's idea of "a visual sense born in the fingertips" was realized by Agnes Hegedues in her installation *Handsight* (1992), where

b

Figure 5.3 (continued)

"the hand that sees" is a Polhemus sensor disguised as an eyeball. It is held in hand by the user to explore a virtual world supposedly inside a glass jar—a poetic but also rather literal translation of McLuhan's idea of technology as an extension of the human body. In Rafael Lozano-Hemmer's teletactile work *Displaced Emperors* (1997), the user's "hand image" was projected on the facade of the Linz Castle, peeling away layers of history. The idea of a dataglove (reduced to a wearable ring) was given a new role and interpretation, rich in cultural connotations. Although no actual touch was involved, the sense of mediated touch was strong. Feingold's *The Surprising Spiral*, already

Figure 5.4 Paul Sermon, *Telematic Dreaming*, 1992. By kind permission of the artist.

mentioned above, not only explores tactility, but also tactility's media-archaeological implications and earlier discursive manifestations. The name on the back of the book interface reads "Pierre de Toucher," an explicit reference to Duchamp's *Prière de toucher*. The work builds a dense network of references around tactile media, from fairground attractions (also present in Feingold's later works using speaking and animated puppet heads, descendants of popular "talking heads" and ventriloquist dummies) to surrealism, Duchamp, and Alain Robbe-Grillet's *L'immortelle* (1963), a film where sensual touching plays a central thematic role.[49]

These examples by no means exhaust the range of uses of tactility in contemporary media art. While exploring state-of-the-art technologies and new ways of linking humans and machines, many artists draw from a rich pool of shared cultural storehouse of sensory experiences, discourses, and imaginaries. Sometimes this happens unknowingly, but often quite consciously, as Feingold's example shows. The critical and theoretical exploration of this pool has only recently begun in earnest. The recently introduced book series Sensory Formations, published by Berg, is one demonstration of this interest. As it happens, the volume about tactile culture, *The Book of Touch* (2005), edited by Constance Classen, has devoted very few of its 450 pages to the topic of

Figure 5.5 Ken Feingold: *The Surprising Spiral* (installation detail), 1991. Interactive installation: computer, laserdisc, audio, projection, silicone, wood, books. Collection: ZKM Center for Art and Media, Karlsruhe. By kind permission of the artist.

interacting with machines and media.[50] The words "interactive" and "interactivity" don't even appear in the index. After hundreds and thousands of years, during which the "(in)human touch" was the most important form of tactility in its countless manifestations, the practice of touching technological artifacts for self-expression, communication, entertainment, or erotic sensation is still a recent phenomenon. Videogames, purportedly one of the dominant forms of tactile media already now and even more clearly in the near future, only have a history of some thirty-five years. How these developments will affect the realm of tactility as we know it remains to be seen. How will the "new" merge or converge with the "old"? Interactive artworks can provide some—strictly imaginary—sneak previews.

Notes

1. The juries for the "Interactive Art" category at the prestigious Prix Ars Electronica competition have in recent years made efforts to annihilate this definition—they have

given awards to many works that recuire no active input from the spectator at all. For a closer analysis, see my essay "Trouble at the Interface, or the Identity Crisis of Interactive Art," available online at http://www.mediaarthistory.org/ (in the section "programmatic key texts").

2. This concept was used by the experimental designers Anthony Dunne and Fiona Raby in their presentation "Fields and Thresholds" at the Doors of Perception 2 conference in Amsterdam, 1995. See http://www.mediamatic.nl/Doors/Doors2/DunRab/ DunRab-Doors2-E.html/. On proxemics, see Edward T. Hall, *The Hidden Dimension* (Garden City, N.Y.: Doubleday, 1966).

3. On McLuhan's ideas about tactility, see Takeshi Kadobayashi, "Tactility, This Superfluous Thing—Reading McLuhan through the Trope of Sense," *University of Tokyo Center for Philosophy Bulletin*, 4 (2005), 26–35.

4. For earlier stages of this project, see my articles "'It Is Interactive, But Is It *Art?*,'" in *Computer Graphics Visual Proceedings: Annual Conference Series, 1993*, ed. Thomas E. Linehan (New York: ACM SIGGRAPH, 1993), 133–135; "Seeking Deeper Contact: Interactive Art as Metacommentary," *Convergence* 1, no. 2 (autumn 1995), 81–104; "Time Machines in the Gallery: An Archeological Approach in Media Art," in *Immersed in Technology: Art and Virtual Environments*, ed. Mary Anne Moser with Douglas McLeod (Cambridge, Mass.: MIT Press, 1996), 232–268; "From Cybernation to Interaction: A Contribution to an Archaeology of Interactivity," in *The Digital Dialectic: New Essays on New Media*, ed. Peter Lunenfeld (Cambridge, Mass.: MIT Press, 1999), 96–110, 250–256; "Slots of Fun, Slots of Trouble: Toward an Archaeology of Electronic Gaming," in *Handbook of Computer Games Studies*, ed. Joost Raessens and Jeffrey Goldstein (Cambridge, Mass.: MIT Press, 2005).

5. For overviews of these developments, see Udo Kultermann, *Art and Life*, trans. John William Gabriel (New York and Washington, D.C.: Praeger, 1971); *Out of Actions: Between Performance and the Object, 1949–1979*, ed. Russell Ferguson (New York: Thames and Hudson, 1998).

6. See Sherry Turkle, *Second Self: Computers and the Human Spirit*, 20th anniversary edition (Cambridge, Mass: MIT Press, 2005 [1984]).

7. Laura U. Marks, *Touch: Sensuous Theory and Multisensory Media* (Minneapolis and London: University of Minnesota Press, 2002).

8. Jacques Aumont, *The Image*, trans. Claire Pajackowska (London: BFI Publishing, 1997 [1990]), 77–78.

9. Deleuze and Guattari, *A Thousand Plateaus: Capitalism and Schizophrenia*, trans. Brian Massumi (Minneapolis: University of Minnesota Press, 1987).

10. Marshall McLuhan, *Understanding Media: The Extensions of Man* (London: Sphere Books, 1967 [1964]), 335.

11. David Howes, *Sensual Relations: Engaging the Senses in Culture and Social Theory* (Ann Arbor: University of Michigan Press, 2003), xx.

12. About the use of "schema," see E. H. Gombrich, *Art and Illusion* (London: Phaidon Press, 1977 [1960]).

13. For *topoi* in media culture, see my "From Kaleidoscomaniac to Cybernerd: Towards an Archeology of the Media," in *Electronic Culture*, ed. Timothy Druckrey (New York: Aperture 1996), 296–303, 425–427. For an interesting collection of essays on Warburg's contribution to cultural history, see *Art History as Cultural History: Warburg's Projects*, ed. Richard Woodfield (Amsterdam: G+B Arts International, 2001).

14. Nicolas Bourriaud, *Relational Aesthetics* (France: Les presses du réel, 2002 [1998]).

15. I experienced this on a recent visit to the exhibition Ecstasy: In and About Altered States (MOCA, Los Angeles, 2005). To give just one example, here is a story of my encounter with Olafur Eliasson's *Your Strange Certainty Still Kept* (1996). The following note had been posted at the entrance to the installation: "Viewers with light sensitivities please be advised: the artwork uses strobe lights." Entering the darkened space, I noticed a transparent "curtain" created by water dripping from the ceiling. It was illuminated by strobe lights, which made the waterdrops "dance" in different formations. The installation was placed close to the entrance, and there was no barrier that would have prevented the visitors from standing right next to it; it was even possible walk around the water curtain to the other side. Because of this it felt natural to stretch out one's hand and feel the running water. In fact, this caused interesting changes to the patterns of light as well as to the surface of the water as it fell to the pool below, and may well have been intended by the artist (at least, there was no notice forbidding it at the entrance). However, when I started playing with the dripping water, a guard immediately intervened and told me that it was forbidden to touch the

water. To my question why it was so, he explained that he had "received instructions." Exiting from the other side, I began to suspect that the unannounced tactiloclasm had nothing to do with Eliasson and everything to do with the fact that the museum administration was concerned about the floor getting wet from sprinkles. Indeed, I noticed the familiar yellow "Cuidado piso mojado/Caution wet floor" signboards, at both entrances to the installation (although one of them was folded and leaning against the wall).

16. See Tony Bennett, *The Birth of the Museum: History, Theory, Politics* (London and New York: Routledge, 1995).

17. Constance Classen, "Touch in the Museum," in *The Book of Touch*, ed. Constance Classen (Oxford and New York: Berg, 2005), 275–286.

18. Stephen Bailey, *Commerce and Culture: From Pre-Industrial Art to Post-Industrial Value* (Tunbridge Wells: Penshurst Press, 1989), 46. For a history of the early department store, see Michael B. Miller, *The Bon Marché: Bourgeois Culture and the Department Store, 1869–1920* (Princeton: Princeton University Press, 1981).

19. F. T. Marinetti: "Tactilism" (1924), in Marinetti, *Selected Writings* (New York: Farrar, Straus, and Giroux, 1972), 109–112.

20. Interestingly, similar ideas were proposed by Luis Bunuel and Salvador Dalí as a tactile addition to their film *Un chien andalou* (1929). The spectators were supposed to receive tactile sensations to enhance the deliberately shocking scenes they witnessed on the screen. Such ideas have since become commonplace in the theme park industry.

21. See Classen, *The Color of Angels: Cosmology, Gender, and the Aesthetic Imagination* (London and New York: Routledge, 1998), 128. Classen refers to Severini's *Dancer with Movable Parts*.

22. "The Founding and Manifesto of Futurism" (*Le Figaro*, February 20, 1909), in Marinetti, *Selected Writings*, 42.

23. See my "Slots of Fun, Slots of Trouble: Toward an Archaeology of Electronic Gaming."

24. See Kirk Varnedoe and Adam Gopnik, *High & Low: Modern Art and Popular Culture* (New York: The Museum of Modern Art, 1990).

25. Tom Gunning, "The Cinema of Attractions: Early Film, Its Spectator, and the Avant-Garde," in *Early Cinema: Space Frame Narrative*, ed. Thomas Elsaesser and Adam Barker (London: British Film Institute, 1990), 56–62.

26. Octavio Paz, *Marcel Duchamp: Appearance Stripped Bare* (New York: Seaver Books, 1981), 185.

27. Varnedoe and Gopnik point to the wheel jacks used in bicycle repair shops as a possible iconographic source for Duchamp's piece. Whether the connection is actual or not, the wheel jack is a highly tactile application. Varnedoe and Gopnik have also published a photograph from 1915 showing a bicycle display (from a shop or a fair?) with a commercial installation resembling Duchamp's. Varnedoe and Gopnik, *High & Low*, 275.

28. The complex evolution and personal background of this work has been investigated by Janine Mileaf, "Between You and Me: Man Ray's *Object to Be Destroyed*," *Art Journal* 63, no. 1 (spring 2004), 4–23. Although the work may date back to 1923, versions with different titles were shown over the years, and Man Ray later produced several replicas. It got the title *Objet à detruire* only in the early 1930s, when Man Ray provided it with a cutout of Lee Miller's, his lover's, eye. Privately the work came to signify the hypnotic spell Miller had on him, and the new title can be read as a sign of despair or an effort to break Miller's spell, after she had left him. Other readings are also possible. Whether Man Ray himself smashed any of the versions is unclear; he definitely planned doing so as a performative act. One version was smashed by a group of protesting students in 1957, taking the suggestion of the title seriously (Mileaf, "Between You and Me," 5).

29. The work can be seen in the Brancusi gallery of the Philadelphia Museum of Art. For the yet unwritten history of tactility in art, it is worth remembering the close relationship between Brancusi and Duchamp.

30. Lewis Kachur, *Displaying the Marvelous: Marcel Duchamp, Salvador Dalí, and Surrealist Exhibition Installations* (Cambridge, Mass.: MIT Press, 2001), 73–74.

31. See *Peggy Guggenheim and Frederick Kiesler: The Story of Art of This Century*, ed. Susan Davidson and Philip Rylands (New York: Guggenheim Museum Publications, 2004).

32. Kachur, *Displaying the Marvelous*, 201.

33. *VVV*, no. 2–3, 1943. In the journal the experiment is credited to Kiesler. See the reproduction in *Frederick Kiesler: Artiste-architecte* (Paris: Centre Georges Pompidou, 1996), 137.

34. Obviously this use of the peephole is another anticipation of Duchamp's last major work, *Etant données*, which he worked on for two decades in secret. This work is far too complex to be dealt with here. Another peephole work was Duchamp's *Rayon vert*, which Kiesler installed according to Duchamp's instructions in the Le Surrealisme en 1947 exhibition. It was peeped at through a hole in the wall, seen through a sheet of green gelatin sandwiched between two panes of glass.

35. See Kachur, *Displaying the Marvelous*.

36. Pictured in *Frederick Kiesler: Artiste-architecte*, 124.

37. Francis M. Naumann, *Marcel Duchamp: The Art of Making Art in the Age of Mechanical Reproduction* (Ghent and Amsterdam: Ludion [distr. Abrams, New York], 1999), 165.

38. Laura U. Marks does not agree about the haptic visual quality of pornographic cinema. For her, hapticity has more to do with revealing and hinting. See Marks, *Touch*, 15. In this sense *Tapp und Tastkino* could be haptically erotic, if Valie Export did not shatter the eroticism by the presence of her direct stare.

39. See *Out of Actions*, 100–101. In her work with Ulay, Abramovic also created situations that encouraged audience tactility. In *Imponderabilia* (1977) Ulay and Abramovic stood naked in the narrow entrance to the museum, facing each other. Visitors could only enter sideways, touching their bodies; they were also forced to decide whether to look at Abramovic or Ulay, thus making a gender-oriented choice (see *Out of Actions*, 101).

40. In 2005 Abramovic performed a version of Export's *Action Pants: Genital Panic* as part of her *Seven Easy Pieces*, at the Guggenheim Museum, New York.

41. Ono sat motionless on a stage inviting the audience to cut off any of her clothes with scissors. The link between Ono and Export has been made by Regina Cornwell, "Interactive Art: Touching the 'Body in the Mind,'" *Discourse* 14, no. 2 (spring 1992), 206–207. Another work by Ono, *Painting to Hammer a Nail* (1965), originally introduced in slightly different form as a series of instructions in her book *Grapefruit* (1964), also featured audience tactility: the visitors were invited to hammer nails into

a wooden panel hanging from the wall. This seems like a concrete interpretation of Duchamp's famous saying: "The spectator makes the picture" (Paz, *Marcel Duchamp*, 86). Other tactile works from fluxus include Ay-O's *Tactile Box* (1964) and *Finger Box* (1964), meant to be released as fluxus editions. The cubical boxes have holes for the finger to penetrate. The boxes contained foam rubber.

42. For a discussion of McLuhan's idea of television as a tactile medium in relation to the work of David Cronenberg, see Mark Fisher, *Flatline Constructs: Gothic Materialism and Cybernetic Theory-Fiction*, chapter 2.8, "Tactile Power." Available online at http://www.cinestatic.com/trans-mat/Fisher/FC2s8.htm/.

43. "Fingering the TV screen" had already been practiced in the early 1950s in the popular children's television program *Winky Dink and You* (CBS, 1953–57, plus a short rerun in the 1960s), where the child was encouraged to draw on the TV screen following the finger of the host, Jack Barry. A transparent "Magic Window" would be attached to the screen, and the child would draw on it with Magic Pens. The window and the pens could be bought as a set, as the host often reminded viewers throughout the program.

44. A rich source of Krueger's ideas is his book *Artificial Reality II* (Reading, Mass: Addison-Wesley, 1990). About the recently rediscovered Kurenniemi, see Mika Taanila's remarkable DVD about his career, *The Dawn of DIMI* (Helsinki: Kiasma/Kinotar, 2003).

45. Touch, Art!, Kawagoe Art Museum, January 7 to March 26, 2006. I visited the exhibition on the opening day. It featured works by six contemporary Japanese artists. While some of the works were genuinely tactile (meant to be touched), touching certain works was forbidden. The exhibition thus shared the problematic relationship to touching that is often encountered in contemporary art exhibitions.

46. For more information about this ambitious project, see http://www.renga.com/tactile/.

47. Although as an artwork, *CyberSM* anticipated the explosive interest in "sex machines," high-tech masturbatory devices that have arguably become one of the most titillating forms of tactile cyberculture, albeit usually without the possibility of teletactile communication. Examples can be easily found on the Internet.

48. Credited to Scott Brave, Andrew Dahley, and Hiroshi Ishii.

49. For an analysis of *The Surprising Spiral*, see Cornwell, "Interactive Art: Touching the 'Body in the Mind,'" 213–214.

50. *The Book of Touch*, part IX, "Touch and Technology," 399–447. This section is very mixed, and only Susan Kozel's Essay "Spacemaking: Experiences of a Virtual Body" (439–446) analyzes new media art, the experience of using Paul Sermon's *Telematic Dreaming*.

Duchamp: Interface: Turing: A Hypothetical Encounter between the Bachelor Machine and the Universal Machine

Dieter Daniels

Translated by Jeanne Haunschild and Dieter Daniels

Can Marcel Duchamp's ideas and the discourse he opened on an art that goes beyond the "retinal" be extended to include the so-called new media and further on media art? In a collection of essays, I have worked out multiple affinities between the work of Marcel Duchamp and the effects of the media on art and society.[1] This may, not least of all, show the personal passions of the author, for these two fields have been the focus of my academic work up to now. For this reason it should be obvious that in the present text, I felt the need to look for something beyond my individual obsessions by searching for a possible, deep-rooted common ground between the two fields—and for a new perspective on the basic questions of the relevance of the arts and the technical media in today's world.

Does art merely react to what media technology has developed, whether accepting it as a working medium or countering it with art-inherent strategies? Or does art offer still other models and insights that oppose the actual pressure of technical progress and have other assets that perhaps even surpass it, thus contributing to an understanding or even to a formulation of our media-sated world? These questions are posed in the field of media art even more urgently. Does an art that deploys technical means simply supply an illustration or, at best, a subversively ironic misappropriation of a technological potential, whose power over, and repercussions on, our life today are barely comprehensible and, even more so, unassailable in an art context? Such an

impotence of art in the age of the media has been propagated, for instance, by Friedrich Kittler: "Certainly, art has historically been a highly efficient method of signaling the presence of omnipotence. But as, already in Hegel's time, it ceased to be the highest form of mind, so it is today that art under computer conditions is replaced by a sorcery that no longer swears to omnipotence but to reality.... And artists, unless they themselves have become engineers or programmers, have been cut off from this power over reality."[2]

The actual distribution of power between art and the media may be indisputable. But does this not amount to a confusion between cause and effect, to making the power of the factual the yardstick for the imagination? And do not media technology and art equally find their roots in models, sketches, and blueprints—in the imagination of things that do not yet exist—before they become concrete as apparatuses and art works? In my considerations I would like to proceed from two cases in point, that of Alan Turing, the mathematician and most important co-inventor of the computer, and Marcel Duchamp, perhaps the most influential artist of the twentieth century. You may well ask why it is that two individuals and their respective biographies should be at all useful in the investigation of such a comprehensive theme, particularly since neither during his lifetime had any contact with the other, or possibly even knew of the other's existence. But the following is not meant to prove anything, but only sound out the range of a hypothetical encounter between two concepts. The method is experimental, in the sense of trying to follow a hypothesis as far as possible, without hesitating to touch upon the absurd.

In the first part of my essay, by a partly ironic expansion of art historical terminology, I would like to attempt to apply concepts from new technologies to Duchamp's work. In the second part, parallels will be drawn between Duchamp and Alan Turing; the third will present works by Duchamp in analogy to current media techniques; the fourth will conclude by investigating the common structural grounds between today's media practice and the designs drafted by Duchamp and Turing.

The element that links these four parts is the convergence of man and machine. The point of man–computer communication is generally called an interface.[3] It sets up a relationship between the two information structures and to a certain extent it defines the parameters of interaction between two immaterial settings through the material world. Available for input are switch, keyboard, mouse, joystick, dataglove; for output, screens, loud-

speakers, projectors, or virtual reality glasses. Corresponding on the side of the human body are fingers, eyes, and ears; examples of other body parts will be cited later.

Because of the way we today commonly speak of interactivity as a technical achievement, we all too easily forget that similar principles existed long before digital technology was ever introduced, though this was an interactivity between man and man and not between man and machine. A good example is a chessboard: a board with 64 squares and 32 pieces functions as a direct man–man interface. The game rules, as well as the chess pieces and the coded display of the "user interface" or chessboard, determine the course of the interaction. The "interface" or chessboard is meant to serve as an exchange between the thoughts of two people, thoughts that are, however, not altogether mutually readable, but whose possible intentions can be deduced from the moves each player makes. In other words, despite a clearly coded system, there is a degree of interpretation needed that can be compared to the interpretation of an artwork, at least insofar as we follow Duchamp's approach.

Art History

There is an entire series of Duchamp's drawings and two oil paintings on the subject of chess, in which he works out this process of "interpretation." In *La Partie d'échecs* from August 1910 he painted, in a style still firmly in line with Cézanne, his two older brothers Jacques Villon and Raymond Duchamp-Villon in the garden at Puteaux playing chess. But in 1911 the twenty-three-year-old Marcel made his entry into the Paris avant-garde, thanks to his brothers' mediation and, using the same motif in *Étude pour les joueurs d'échecs* (1911), manifested his personal encounter with the formal vocabulary of cubism. Counter to the basic realistic elements, the picture plane is strikingly divided into two halves, as if the two conceptual systems of the chess-playing brothers were separated by a slash. Shortly afterward, *Étude pour portrait des joueurs d'échecs* (1911, fig. 6.1) took a decisive step toward a reduction to a few formal elements. The dissolution of perspectival space corresponds to the doubling of the two faces, in which the chess piece itself becomes the physical location where the two profiles meet. And, in fact, the chess game is set directly between the two countenances, becoming a literal "inter-face." What is striking is the emphasis given the hands of the players, one of them in action, the other making a thoughtful gesture. On the whole it

Figure 6.1 Marcel Duchamp, *Étude pour portrait des Joueurs d'Échecs*, 1911. Philadelphia Museum of Art, Collection Arensberg.

is made clear that, through eye and hand, the two heads, that is, the thinking that takes place within them, are linked across the chessboard. These sketches eventually led to the oil painting *Portrait de joueurs d'échecs* (1911), a piece that perhaps shows Duchamp's obligation to cubism the most clearly and yet takes his work a step further. He, in fact, carries over the cubist perceptual space into the chess game's conceptual space. Again our attention is called to the active hand holding the chess piece in the lower left that has been strangely and very pointedly set into the picture.

For Duchamp chess was always a metaphor for art, and these two passions were always meant as complementary, just as much as they were also in competition. Their rivalry went so far as to inspire the myth that he had given up art in favor of chess. As a French master Duchamp played successfully at international tournaments and wrote a book on recherché endgame variations.[4] "Through my close contact with artists and chess players I came to

the conclusion that while all artists are not chess players, all chess players are artists."[5]

Under the leitmotif of the interface, an analogy between painting and chess could be spun further. The easel painting and the chessboard are both a user interface, and the thought constructs that are represented by manual proceedings (applying the paint, moving the pieces) invite interpretation. But of course the comparison is a lame one. The transmission in art only goes in one direction, from painter to the viewer—and that, in part, over a distance of centuries. In chess and in the electronic media, the exchange is interactive and takes place in real time, as we say in current terms. It is via media art that such interactions first begin to cross-pollinate.

Duchamp expands the theme of chess with the mysterious painting *Le roi et la reine entourés des nus vites* (1912). The king and the queen are still a part of the chessboard, but the "fast nudes" that surround them come from another world. They move between the static figures, perhaps like the two naked hands of both the chess players, which carry out the symbolic movements of the pieces and never come in physical contact with each other. At the same time the king and queen, via the "fast nudes," are also in a potentially erotic relationship. This painting spans a bridge from the chess studies to the erotic machinery of the *Large Glass*. That becomes clear in the compositionally related first sketch on the subject of the *Large Glass, La mariée mise à nu par les célibataires*, also from 1912. Instead of an *intellectual unveiling* of the player's intentions manifested in the chessboard, a *physical exposure* of a woman's body takes place between the two bachelors.

The arc that Duchamp spanned from chess to sex in the successive transformation of this series of pictures is the leitmotif for the following considerations. It is the passage between two extreme forms of interhuman relations: here, the complete reduction to the intellect and a strictly formalized exchange of information via a system of codes and rules; there, complete physicality with all its sensual components. Chess and sex serve Duchamp as the cornerstones for investigating the function of the pictorial artwork that, quite in the sense of classical aesthetics, links physical expression with intellectual content. For Duchamp the artwork is, so to speak, a sensual interface between the intellect of the artist and of the viewer; the message must pass through the physical stage. The original work would thus be the physical trace of an individual's mental act. The most radical culmination of this concept is Duchamp's *Paysage fautiv* (1946), a drawing that consists of nothing more than an

ejaculation of sperm, whereby he anticipated Warhol's piss paintings in a more subtle form.

The tie-in between chess and sexuality, also found with other artists (Max Ernst, Dalí), was later summed up by Duchamp in a famous photo showing him playing chess with a young naked woman in 1963 at his first large retrospective in the Pasadena Museum. On the other hand, the game between Marcel Duchamp, his wife Teeny, and John Cage entitled *Reunion* in Toronto 1968 shows that a chessboard can also serve as a technical interface (fig. 6.2). Every move made on the chessboard's electrical contacts triggered a change in the electronic sound structure. This pioneering, interactive media artwork is not

Figure 6.2 Marcel Duchamp, his wife Teeny, and John Cage at "Reunion," Toronto, 1968. Photo by Shigeko Kubota. The chess board is wired as an interface to generate a composition by Cage.

unconditional evidence of Duchamp's intentions, since he only appeared here as an accomplice in Cage's musical concept, but the work was undoubtedly inspired by Duchamp and composed for him.[6]

Media Theory

From the notes in Duchamp's *Green Box* we learn that the complex apparatus of the *Large Glass* served only to transmit the sexual desire of the bachelors in the lower half to the bride in the upper half. The nine bachelor forms called *Moules mâlic* are comparable to chess pieces and the clearest relic left from the game of chess to be found in the Glass. The bachelors' lust remains unfulfilled, since it is only technically transmitted to the bride, without ever resulting in a physical encounter. Thus Duchamp insists in his very first drafts that there is no real contact between the bachelors and the bride, only an "electric link" and a "short circuit on demand."[7] The lower half of the glass is the driving force of the whole erotic mechanism that Duchamp coined a "bachelor machine."

The term "bachelor machine," since its first appearance in the cryptic notes of the *Green Box*, has had an amazing career that made it known far beyond the framework of the *Large Glass*. It served in 1954 as the title of a book by Michel Carrouges that, according to André Breton, rattled surrealism, was taken up in 1972 by Gilles Deleuze and Félix Guattari in *L'anti-Oedipe*, and made into the theme of a large exhibition curated by Harald Szeemann in 1975.[8] Carrouges reaches far back into the nineteenth century and, in the series of bachelor machines that he presents, the *Large Glass* is one of the last examples and, above all, the only pictorial one among otherwise purely literary descriptions of such machines.

Yet to say this is to ignore the fact that glass and box, that is, picture and text, were given the same title by Duchamp: *La mariée mise à nu par ses célibataires, même*; they are two halves of *one* work. The *Large Glass* shows the blueprint of a machine, a construction rendered as a "precision painting, and beauty of indifference" that only becomes comprehensible and begins to ferment in our minds via its workings described in the *Green Box*.[9] The *Large Glass* and the *Green Box* stand in the same relation to each other as a chessboard to its game rules, or as a computer to its program.[10] No part makes sense without the other; only in concert do they become a functioning unity (fig. 6.3). Carrying this analogy further would make the *Large Glass* the

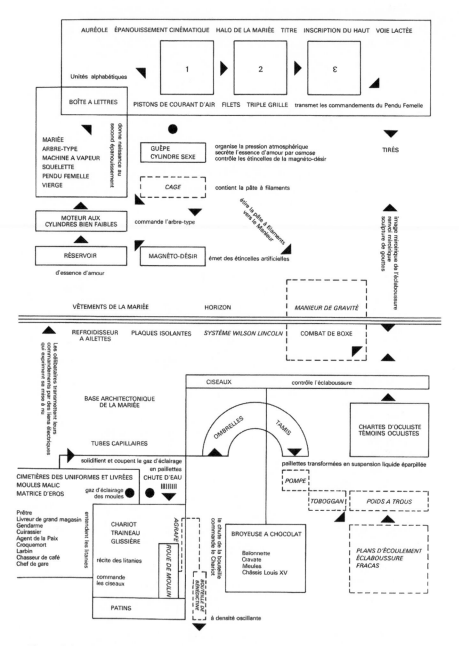

Figure 6.3 Diagram of the *Large Glass* according to the notes from the *Green Box*, by Richard Hamilton, published in *L'Oeuvre de Marcel Duchamp*, Centre Pompidou, Paris 1977, p. 108.

hardware and the *Green Box* the software of the bachelor machine. Yet instead of a computer we should perhaps speak more correctly of a blueprint for a computer. Just as in the *Large Glass*, in a computer design and description, construction schema and program language are developed in parallel and mutually determine each other.

In the books of Poe, Villiers, Verne, Jarry, Roussel, and Kafka we find imaginary machines, which Carrouges also considers to be bachelor machines. Some can talk and some can write, yet they cannot take that one more decisive step: their language remains descriptive, it is not operational. For a computer, however, the program language is part of its function; it no longer describes, it acts. When I type in "delete," I do in fact delete data. This switch from description to command can never be reached through literature alone. In the fields of art and literature, language cannot be made operational; this is first possible only when they join forces with the technology of an apparatus.[11]

This ontological turning point in language's function is possible only through the division between machine and program, between hardware and software. The *Large Glass* and the *Green Box* portray such a relation of machine and program and go a crucial step further than all other literary bachelor machines.[12] Even if its function remains an imaginary one, that is, remains art, it points to the possibility of a machine consisting of hardware and software, together forming what Alan Turing defines as a "universal machine" that provides the theoretical basis for all computers: "The importance of the universal machine is clear. We do not need to have an infinity of different machines doing different jobs. A single one will suffice. The engineering problem of producing various machines for various jobs is replaced by the office work of 'programming' the universal machine to do these jobs."[13] Yet there is one important difference between Duchamp and Turing: the *Large Glass* portrays the complex inner-psychic course of unfulfilled sexual desire via technical metaphors; the universal machine, as the beginning of artificial intelligence, does the opposite in that it portrays an otherwise human activity, thinking, as now predominantly performable by a machine.

Since all machines, including the universal machine of the computer, have up to now been built by humans, the *Large Glass* could specify the reasons *why* we at all bother to design and manufacture such machines. Such is a first thesis on the relation between the bachelor and the universal machines, which may still sound somewhat off the wall. In order to underpin it there are various strategies available. We could draw on the authorities of postmodernism,

Mouse Pad Center $9.95 ea.

A place for pens/pencils
an a "mouse garage".
Includes foam rubber pads
for firm mouse control.

Bach. Picture Pads $12.95 ea.

Bachelor PAD (Girl)
BachelorettePAD (Boy)

Also available are...
Sport Pads, Animal Pads,
Star Trek Pads, and more.
Call for exact pricing.

Figure 6.4 Bachelor Mouse Pad, ca. 1994, advertisement.

such as Jean Baudrillard, who writes: "Artificial intelligence is a bachelor machine," without, however, even mentioning either Duchamp or Turing.[14] A glance at the "collective unconscious" would be just as good, where the tie between the bachelor and the universal machine seems already firmly anchored. It is manifest in many trivial everyday metaphors for the man–machine interface, such as the "bachelor mousepads," which transform everyday work onscreen to a symbolic, erotic potential for fondle-bytes (fig. 6.4).[15]

The world of geeks, nerds, and hackers provides the most drastic examples for psychic effect of computer technology and thus for the status of the universal machine as a bachelor machine. The almost entirely male community of hackers thrives in what they call "bachelor mode" because nights at the computer allow no room for contact with the opposite sex.[16] One of them says: "I think of the world as divided between flesh things and machine things. . . . I stay away from the flesh things. . . . I often don't feel like a flesh thing myself. I hang around machines, but I hate myself a lot of the time. In a way it's like masturbating."[17] There is not much to add to such statements.

The attempt to get to the bottom of the tie-in between the bachelor and the universal machine takes us to the latter's originator, Alan Turing, the

B -- -- -- -- -- -- -- -- **A**
♀ ♂ / **Maschine**

Fragensteller

Figure 6.5 Diagram of the Turing test.

English mathematician, who already in 1935–1936 described the essential features of a computer *cum* universal machine in his paper "On Computable Numbers." He did a trial run with a "paper machine," that is, he simulated it per written calculation, even before the first programmable device was built. The acid test came with World War II, whose outcome is intertwined with the fact that Turing's meanwhile functional machine broke the code of the German Enigma cipher. A universal machine can, according to Turing, imitate all other machines, and the case of the mechanical Enigma cipher machine provided the practical evidence to prove this. But what does this mean in reference to other, specifically human functions?

In a 1950 paper that was as philosophical as it was mathematical, Turing posed the question: "Can a Machine Think?"[18] To answer this he suggested what is today known as the Turing test. This paper is cited in almost all academic literature (and even in practical tests) in what is only a very abridged version: a test person must discover via a written dialogue whether he or she is "talking" with a machine or a person. However, Turing's original concept is much more complex. He called his test an "imitation game" that consisted of a threefold arrangement. A man and a woman in separate rooms must answer an interrogator via a teleprinter. The interrogator is given the task of finding out which one is the man and which the woman. Then in the second phase, the machine replaces *the man* and the error quota in the interrogator's replies are compared to the previous results (fig. 6.5).[19]

The purpose of the test, according to Turing, lies in "drawing a fairly sharp line between the physical and the intellectual capacities of a man."[20]

The interrogator is supposed to try to determine the gender of his opposite number without seeing or touching his two coplayers, solely by means of verbal communication. The proof that the machine can think does not lie in the resolution of practical questions but in an imitation of a gender-specific communication without physical contact. Turing was convinced that a machine could assume all human qualities not only in purely intellectual fields but, as he said in a radio interview in 1951, for example, those "influenced by sex appeal."[21] The crucial criterion of successfully replacing a man by a machine in Turing's test is, therefore, the ability to confuse the interrogator by means of the sexual identity of his or her counterpart. Though sexuality is not an explicit theme, Turing's entire text reads like a perfect psychograph of Turing himself, who was not only highly intelligent but also a homosexual and who, at a time when being the latter was still a criminal offense in England, made no effort to conceal it.

Electronic networks today actually correspond to a globally expanded reconstruction of the Turing test. The Internet takes up the function of Turing's communication via teleprinter and makes the decoupling of corporeality and verbal dialogue through a technical medium an everyday mass phenomenon. And should it in the least surprise us that gender swapping is a popular game in Internet chats: "60% of those who pose on the cyberboard as libidinous women are in reality men," a popular magazine reported already in 1994, at the very beginning of the Internet boom.[22]

It is indeed absolutely amazing that as early as 1950, long before online sex was ever heard of, the goal of the man in Turing's imitation game was to deceive the test person as to his sexual identity, while the woman is meant to help him or her identify the genders of the two partners correctly. Quoting Turing: "I am the woman, don't listen to him!"[23] This allocation of roles seems at first to reflect the conventional schema of the helpful female and the combative male. Likewise, the second phase of the test, when the man is replaced by the machine, seems to correspond to the usual pattern of masculine self-identification with technology. But the test goes deeper, for its real goal is to decouple all physical and biological sexual characteristics from the psychic-intellectual forms of speech that, if the test is to succeed, must likewise be determinable as specifically masculine or feminine.

Thus Turing's test implicitly contains a thesis that forty years later Judith Butler supported in a feminist context: gender identity is not a physical category but a discursive construct that first comes to light in performative acts

through language.[24] Strangely enough, Butler does not go into the phenomenon of gender-swapping over the electronic nets and the virtual communities of MUDs (multi-user domains) and MOOs (MUD-object-oriented), although it arose simultaneously with her theses and could serve as their ideal evidence. Inversely, Sherry Turkle thoroughly studies these virtual gender constructions on the Internet from a sociological viewpoint and refers specifically to the Turing test, but completely ignores the sexual dimension of Turing's original paper.[25] Only by going back to the origins of the universal and bachelor machines can we find the common basis for these postmodern gender- and cybertheories. And against the background of these theories, the two machines imagined by Duchamp and Turing become, at the same time, recognizable as specifically masculine scenarios that revolve around an insurmountable distance from the female and, as a result, install a media-technical communication as a replacement for a physical encounter.

It is more to the point I am making here when Donna Haraway, the pioneer of cyberfeminism, in 1985 describes cyborgs as creatures in a postgender world.[26] The relationship of Butler's theses to Turing's test is made clear by Juliane Rebentisch: "By the imitation in play here, the imitative structure of the so-called feminine and the so-called masculine is shown up as such, as is also its contingent."[27] I would like to go even further by presuming that Turing left it to the reader's logic to conclude what he expressly never allowed himself to write. If a machine can "imitate" thinking so successfully that no difference from a human can be detected in the dialogue, then we must characterize this feature as thinking, since no criterion can be cited that would define the difference from an imitation of thinking—which means that when a machine successfully "imitates" a gender identity, this must then be accorded. With this, any prerequisite of a natural, unalterably binary gender division among humans is obsolete. For Turing and Butler the consequences are similar: the idea of sex as predetermined by nature is replaced by gender identity as individual performative construction, reacting to a set of society's conventions.

However, Turing was to experience personally the conventional inflexibility and mercilessness of society versus any difference between the physical sex and the mental gender. In 1952, that is, soon after he published his paper on the Turing test, he was forcibly given hormone injections to "cure" his homosexuality.[28] Marcel Duchamp tried a more playful way: he bridged the insurmountable separation of the sexes shown in the *Large Glass* with an "imitation

game" slipping into the role of his alter ego Rrose Sélavy. She appears as the authoress of some of his works' plays on words, and, in the famous transvestite photos by Man Ray, Duchamp is reincarnated in her image.

The overall constellation of the Turing test and the *Large Glass* are comparable, since in both there is a technically transmitted discourse between the sexes that is kept in play by the fact that no actual physical encounter can occur. Turing's paper contains such cryptic formulations as: "Finally, we wish to exclude from the machines men born in the usual manner." Or: "One might for instance insist that the team of engineers [who build the machine] should be all of one sex."[29] All this is supposed to exclude a "biological," that is, heterosexual, solution to the generation of intelligence, but at the same time it confirms the status of *the universal machine* as a *bachelor machine* in that sexuality can no longer lead to procreation. Again statements by hackers are today the most explicit ones on this track: "Men can't have babies, and so they go to have them on the machine. Women don't need a computer, they have them the other way."[30]

Michel Carrouges defined the bachelor machine as "a fantastic imaginary picture that transforms love into a lethal mechanism." And it is surprising how close he comes to Turing's universal machine when he calls it an "improbable machine," but simultaneously declares: "This machine's main structure is based on mathematical logic."[31] A psychoanalytical correspondence to the Turing test is provided by Deleuze and Guattari's definition. They borrow "the term of 'celibate machine' to designate a machine that produces a new link between wish machines and organ-less bodies for the purpose of a new humanity or of a glorious organism."[32] In 1972 they described psychophysical processes with media-technical metaphors, even before the debate on cyborgs ever took place.

It is possible that all who have followed this train of thought up to now will no longer be surprised that most computer inventors have been interested in chess and have tried to solve chess problems with their machines: Babbage, Turing, Zuse, Shannon, and Wiener.[33] Turing, even before his test, saw the game of chess as the best opportunity "to have a machine show its intelligence."[34] For this he developed a preliminary version of the test in which one test subject plays against two invisible opponents in separate rooms, one of which is a "paper machine," that is, a program prescribing firm rules written by hand that calculate the chess positions. "A man provided with paper, pencil and rubber, and subject to strict discipline, is in effect a universal ma-

chine," as Turing expresses it. The test subject "may find it quite difficult to tell" which of his invisible opponents is a "rather poor chess player" and which is the "paper machine," Turing continues, for: "Playing against such a machine gives a definite feeling that one is pitting one's wits against something alive."[35] This experience is based on experiments Turing carried out himself.

Duchamp's *Green Box*, the origin of the term bachelor machine, has remained in the stage of a "paper machine" that, although it demands no such "strict discipline" from the user, captivates him via its countless links through the notes, within which he moves in no firm sequence as through a hypertext. Machines, science, and sexuality overlap here in the same way they do in the subtexts of Turing's investigations.

In Duchamp's sequence of pictures from the years 1911 to 1912, which led to the *Large Glass*, and in the two different versions of Turing's test, first chess and then sex serve as a model of interpersonal connection or man–machine interchangeability. Turing was to be proved right in his prognosis in the case of chess. The interface of the chessboard can serve in a game between humans exactly the same as in communication with a machine, while the rules of chess, in principle, form a calculable multiplicity of game combinations. This is why chess was the first domain of interpersonal activity in which the computer became a serious rival to man. On May 10, 1997, the IBM computer Deep Blue beat the world champion Garry Kasparov with a score of 3.5 to 2.5. It won $700,000 and IBM stock soared.[36]

Today's practical trials of the borderline between media, men and machines do indeed touch on the same cornerstones that already played a key role in the creation of the *Large Glass* and the development of the Turing test: chess and sex.[37] Could it be that the actual significance of Duchamp's and Turing's machine models will thus evolve within the current testing of the limits of media-technical experience and at the same time herald their potential synthesis?

Technological Imagination

"How is it possible that a common basic structure is part of all bachelor machines?" Michel Carrouges asks in retrospect of his case studies from the nineteenth and twentieth centuries. Like Jean Suquet or Thomas Zaunschirm he has no answer.[38] All of them have noted a broad correspondence between

themes from Duchamp's *Large Glass* and other works of literature and art. In the continuation of this puzzle I will juxtapose post–*Large Glass* works by Duchamp with popular depictions of media technology. I don't want to conceal the fact that it was the coincidence of these pictures that inspired this essay.

I'll begin again with the game of chess. Duchamp's *Pocket Chess Game* from 1944 is for him first of all a practical device with no claim to art. Fifty years later, comparable travel sets are available as pocket chess computers or as software for the laptop. The wooden chessboard is replaced by a peripatetic game for bachelor globetrotters. In both cases, a game between two people is turned into a solitary engagement with an imaginary opponent. And while Duchamp played long-distance chess preferably by mail, Internet chess has become today's great success story.

For his biographer Robert Lebel, Duchamp added a rubber glove and thus expanded his travel chess set to an assemblage, making it into an artwork (fig. 6.6). But why the glove? We'd do well to remember the hand that is placed so

Figure 6.6 Marcel Duchamp, *Pocket Chess with Rubber Glove*, 1944. Collection Lebel, Paris.

strikingly in Duchamp's chess drawing and painting, both from 1911 (see fig. 6.1). The hand as a physical element intrudes into the mental space of chess. In the same way the dataglove intrudes into the dataspace, which it thus makes physically tangible instead of only manipulable via keys and signs. In today's digital technology, the size of the human finger is a physical limitation in humanity's continual attempt to miniaturize the interface of the keyboard. This limit to the manual access of immaterial information is what Duchamp seems to investigate in his assemblage with a rubber glove and a pocket chess game—in his own way.

By means of interfaces with physical references like the dataglove, movement within dataspace approaches natural movement. In this way cyberspace becomes a place of physical experience and is given a potentially erotic dimension, exactly as Turing had foreseen in the still thoroughly nonsensual computer era of punched cards and endless columns of numbers (fig. 6.7). This opposition between tactility and reading (that is, that a text only works in the imagination whereas the haptic finds a direct path to consciousness) may be one aspect of the book cover that Duchamp designed for Le Surréalisme en 1947 under the motto "Please touch" (fig. 6.8).

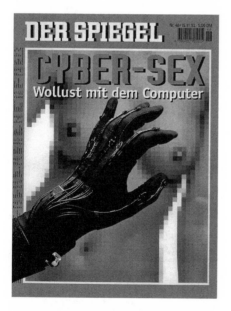

Figure 6.7 *Cybersex*, cover of the magazine *Spiegel*, 1993. Copyright: Der Spiegel.

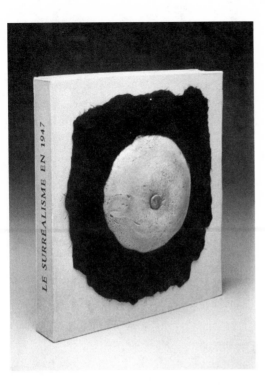

Figure 6.8 Marcel Duchamp, *Prière de toucher*, cover for *Le Surréalisme en 1947*, Museum Ludwig, Cologne.

In comparison to Turing's purely verbal test structure, the bachelors in Duchamp's *Large Glass* have the media-technical luxury of an electric visual link to their bride; according to the notes in the *Green Box*, what is transmitted are the "cinematic effects of the electric stripping bare."[39] This imaginary apparatus of the *Large Glass* could well correspond in some of its essential elements to the media-technical devices that since the 1990s have been designed around the theme of cybersex. The dataglove has been expanded to include the whole body and tactile impulses are added to the optical signals. Like the artificial women of nineteenth-century science fiction novels, cybersex has remained a mostly imaginary practice; it never took off in real life the way it was expected at the time of the virtual reality euphoria. Like some pieces of media art, cybersex is a hypothetical incarnation of inherent motives of the universal machine. This is made even clearer by the fact that some of the most discussed examples of cybersex devices are developed in an art context.[40] They

pretend to be real machines, simulating a physical encounter by means of media-technical apparatuses, but most of their erotic attraction is born in sexual fantasy instead of physical experience.

With Duchamp, too, fifty years after the *Large Glass*, the previously imaginary bride goes concrete in *Étant donnés*. Instead of a technosexual metaphor only comprehensible via the *Green Box*'s operating instructions, we, through two eyeholes in a door, gaze at a perfect illusion whose effect, without any textual explanation, is direct. A comparison to virtual reality discloses the fact that the illusion of the object of desire can always only be seen by one viewer who is obliged to turn away from the real world and look through two peepholes at a perfect simulation, whether the ocular device is two holes in a door or virtual reality glasses. But where are the bachelors who were linked media-technically to their virtual bride in the *Large Glass*? In *Étant donnés* as in cybersex we as viewers take up their position.[41] While in the *Large Glass* a text-based metaphor is still in operation, we are now in the position of those to whom a virtual bride appears in absolute perfection while remaining absolutely out of reach.

The immense interest today in the possibility of teledildonics is evidenced by the success of the website "FuckU-fuckme," which claimed worldwide interest with several thousand hits daily.[42] The product offered here is, however, a fake, launched in 1999 by the Moscow Internet artist Alexei Shulgin.[43] The direct casts of the primary sex organs necessary for such interfaces are also found in Duchamp's works that lead up to *Étant donnés*, such as the *Female Figleaf* from 1950. Duchamp's entire love of detail is also dedicated to the perfect depiction of skin in the preliminary models and the end version of *Étant donnés*. The first model for *Étant donnés* from 1948–49 has an inscription on the reverse side that expressly states that the female dummy may not be touched even in the case of repairs or a new frame for the work, since otherwise the sensitive shading of the skin would be destroyed.[44] We see that even when dealing with concrete material, the contradiction is maintained between perfect illusion and untouchability.

Here we must once again quote Turing: "No engineer or chemist claims to be able to produce a material which is indistinguishable from human skin. It is possible that at some time this might be done, but even supposing this invention available we should feel there was little point in trying to make a 'thinking machine' more human by dressing it up in such artificial flesh."[45] Behind these reflections stands the question as to whether something like a

tactile illusion can even exist. The relation between verbal imagination and tactility is also what Duchamp deals with in the rubber breasts as book cover under the motto "Please touch." He had already confided to Julien Levy in 1927 ever-wider-reaching speculations: "He said jokingly he was thinking of contriving a mechanical woman whose vagina would be made up of interconnected springs and ball bearings and be contractile, possibly self-lubricating and activated by a remote control, perhaps located in the head." Duchamp illustrated his explanation of a striking anticipation of present-day cybersex designs by bending two wires: "When these wire lines are formed in such a way that the exact effect is triggered and you then extract them from their function as message transmission, they become abstractions."[46] The technical function of the "Network of Stoppages," which connects the bachelors to the bride, could hardly be more exactly described, since they too are an abstraction of a randomly formed cord that serves as the means of transporting masculine desire. At the same time, five years after ending work on the *Large Glass*, Duchamp announced the incarnation of the imaginary bride that was to end forty years later in *Étant donnés*.

But the bride in *Étant donnés* will remain for the viewer just as untouchable as for the bachelors in the *Large Glass*, for whom according to Duchamp they long only "negatively" while suffering the torture of Tantalus.[47] The unattainability of what seems close enough to touch is in *Étant donnés* not made any less urgent by "artificial flesh" in Turing's sense. The question of whether a technical surrogate for a physical encounter is possible is denied by both Duchamp and Turing. This has not prevented present-day media technology from developing a material called "cyberflesh" that, in its tactile feel, comes very close to the mucous membrane that lines the inner body.

En Route to the Universal Bachelor Machine

Long before the existence of blueprints for cybersex, Turing's test as well as Duchamp's *Large Glass* point out the consequences of synthesizing telematics and artificial intelligence. This leads to the actual goal, not yet redeemed, but seemingly subliminally present: the machine as perfect sexual partner. This goal would be reached in merging Turing's and Duchamp's models to become the *universal bachelor machine*.[48] This would be, however, no longer a construct stemming from an artistic or mathematical imagination, but would follow

from the practice of dealing with media techniques, which have already been prefigured in the cited examples.

What would this practice look like? Do I perhaps always lose against my new Internet chess opponent because he is a computer with even more power than Deep Blue? And when I want to have intercourse with my distant partner per data suit, how will I know that I am actually linked to him or her and he or she is not just running my known favorite software while finding amusement elsewhere? Such fictions are a vital part of current media developments, which are working toward the goal of a universal bachelor machine. This means that media technology turns Turing's and Duchamp's models into reality—*without ever having heard of them*!

What does this mean in regard to the "power over reality" that Friedrich Kittler claimed for technology and not for art (quoted at the beginning of this essay)?[49] As to the factual situation, the difference between art and technology seems to be clear. Duchamp's bachelor machine can be found stored in a safe place, the Philadelphia Museum of Art. On the other hand, we sit opposite umpteen copies of Turing's universal machine daily. Put even more simply: Duchamp's machine remains a model, that is, art, while Turing's machine is in operation; a theory has become a technology. In this respect, the "power over reality" could hardly be more different: comprehensively in Turing's case, negligibly in Duchamp's case. But is this the last word on the impotence of art versus technology?

Duchamp's and Turing's machine models each stem from a deeply individual imagination. In both cases the technical model can be understood as a substitute for the solution to a difficult or even hopeless sexual and emotional situation. Expressed in the words of Friedrich Nietzsche: "The degree and the type of a person's sexuality reach into the highest pinnacle of his mind."[50] This is at least claimed by their biographers who pinpoint the decisive impulse for the step to a new conceptual approach as stemming from an incisive personal and sexual loss.[51] In both cases the interchangeability between man and machine provides a substitute for a physical and emotional deficit.

The universal machine and the bachelor machine both made their first appearances in the form of "paper machines." Up to this point there was no question of a difference in power between them. Both are "atremble with reflections on the future," as André Breton, and with him Walter Benjamin, formulates as the only value of an artwork.[52] But here ends the factual

analogy. Despite the meticulous technical details, no functioning machine could be built using the directions given in the *Large Glass* and the *Green Box*. Their technical features and imagined functions do not result in an operative system, but their associative ambivalence and multiplicity correspond to a psychic feedback that lies between a "wish machine" and a genuine technical machine. It is from this that the psychic motifs and connections come about that lead to the construction of real apparatuses. Duchamp's *Large Glass* shows how closely the wish to build machines is linked to becoming a machine oneself.

Turing's machine, on the other hand, was built. It has become an indispensable part of everyday life. Most machines are built to take over the tasks of humans. But the universal machine has no special purpose; its functions are as varied as human thought, with which it now competes. In so doing it surmounts the individual as well as the imaginary. By becoming technical practice, the universal machine as a veritable apparatus in all fields of life lays the foundation for the generalization of the psychical aspiration, that is, the wish for a man–machine replacement. Paradoxically, its individual motif of origin, which resulted from Turing's most profound personal loss, *remains "inscribed" in the universal machine* beyond his person. What else shows the use of the computer in the noted examples from gender-swapping to cybersex?

But how can something be "inscribed" in a universal machine, since it is characterized by the fact that it can imitate all other machines, even including humans, and consequently does not dispose of any unchanging capacities of its own? This claim to universality would then be its only specification. But again, what does universality mean here? Turing as mathematician stepped over a boundary line that was previously taboo: the mental purity of *mathematical function* is transmitted via the computer to the world of things, that is, it becomes a *real, technical function.*[53] Thus, from the hypothetical universality of his theoretically rendered machine, an actual universal use develops for the apparatus based on it. In today's factually universal deployment of computers, as proven by the examples of machine-chess and machine-sex, (which have no connection to Turing), the same motifs become manifest that had occupied him when he developed his theory of the universal machine. Parallel to the technical universality of the function of the apparatus actually built, the psychic universality of the motives behind its invention becomes evident. And it is exactly for this reason that the universal machine can be aligned with the series of bachelor machines that, mysteriously, all have a common basic struc-

ture, although they crop up in extremely diverse forms and, above all, among different authors. The psychic universality of the bachelor machines corresponds to the functional universality of Turing's machine.

The machine's claim to universality is, at the same time, the touchstone for its "power over reality." For the definition of this power depends on how far the substitution and the accessibility of all areas of reality go that are reached by the machine. Only when all areas of life can become operational does the universal machine also represent "omnipotence."[54] And it is exactly here that the *decisive difference between Turing and Duchamp* becomes apparent. Turing seems to consider an absolute man–machine exchangeability possible and almost inevitable. For him there is no "special human feature" that "can never be imitated by a machine."[55] Duchamp's *Large Glass*, in contrast, remains in an onanistic cycle of frustration with a "short circuit on demand."[56] Like all bachelor machines it stands for the unattainability of a perfect substitute— and thus for the *suffering from the phenomenon* it describes.

This suffering from the phenomenon, which the *Large Glass* as well as *Étant donnés* describes, seldom becomes very explicit with Duchamp. But as is sometimes the case with such complex trains of thought, the initial idea can clearly outline the core of what then becomes the basis of a larger-scale construction. Thus Duchamp's *Box of 1914*, the predecessor to the *Green Box*, already contains such a central note whose meaning first becomes visible and understandable through the later, more complicated structure. He writes very cryptically of "L'électricité en large" as the "only possible use of electricity 'in the arts.'" This widespread electrification "in the arts" (the quotation marks doubtless signal irony) follows immediately after: "Given the fact ...; if I assume I would suffer very much" and a very unambiguous, even onomatopoetic allusion to onanism. I do not want to go into this first hint of the later title *Étant donnés*, but into what for Duchamp is a very unusual, even unique confession of suffering from the phenomenon described. It is the sole occasion in all Duchamp's notes on the *Large Glass* where the word "I" is used. And on one of the copies of the box he has added by hand on this note: "Given ...; if I assume that I would suffer very much (express it like a mathematical theorem)."[57] This is exactly what *Alan Turing was successful in doing, expressing his suffering in a mathematical theorem.* Because of its "widespread electrification," this machine has established itself in today's society. More and more this universal technology is taking over the role that was once reserved for the arts, creating a suprapersonal expression of suffering, love, and desire.

Despite this, the omnipotence of the machine runs into clear limitations, which in turn can be marked by exactly those two test fields that Turing and Duchamp had invoked: chess and sex. In the case of chess the equality of the machine was proved no later than Deep Blue's victory over Kasparov. In the area of general, interhuman communication, however, there is no serious competition of the machine in sight. In 1950 Turing had predicted that his test would be passed by a machine by the end of the century.[58] In 1991 the Loebner Prize announced that it will award $100,000 to the first program that passes Turing's criterion for a five-minute dialogue.[59] Up to now the results of the annual tests are far removed from the short examples of dialogues cited by Turing in 1950, in which, among other things, poetry is spoken of.[60] The theme of sex has several times played a central role in the programs that turned out to be the best, but has proved a far cry from an erotic irritation.[61] By means of an unequivocal interface and the game's set rules, chess has become operational. On the other hand, "sex appeal" (which Turing believed machines also susceptible to), as a game of rules and a game of overstepping those rules, has eluded all operational capacities.

The flexible rules of interhuman communication, according to Turing, can be learned by the machine only through longer exchanges with people. As a prerequisite he names the capacity of the machine to feel pleasure and frustration. Only in this way can the machine be educated, since reward and punishment is the only way to learn and the only means by which the machine can become comprehensively intelligent in a human sense.[62] A capacity for pleasure would thus be one of the prerequisites for thinking in its fully developed form. This is exactly what in today's research for simulating emotions in artificial intelligence seems to be so difficult to program.[63] That is why machines up to now have neither convinced us of their "sex appeal" nor produced art.[64]

Phone sex and the countless new forms of sexual encounter and identity-change on the Internet—forms of an sexuality, stimulated by media without any physical encounter—are only acted out between humans up to now and are much further developed than any man–machine exchange. The human imagination and the will to realize it in this field is still far beyond the capacity of the machine. Exactly this human wish to play the part of a machine, even perhaps to become one, in order to dispose of the incapacity for physical fulfillment in a sexual encounter, in order to encompass it in a form that is separable from one's own agony of impotence—that is the theme that Duchamp so meticulously depicts in the *Large Glass*. But today the bachelor ma-

chine has left the field of art and literature far behind and instead become a motif of the omnipresent practice of media technology. The universal machine of the computer serves as a means to realize these wishes, but its capacity does not suffice to fulfill them completely, nor to replace the human counterpart.

This as-absurd-as-it-is-significant contest between the operational capacity of the universal machine and the imaginative capacity of the bachelor machine comes down to the question of who can better imitate whom: whether the machine a man or whether the man a machine.[65] The universal machine is one in a series of bachelor machines, but it at the same time *claims to be their ultimate end*, since its principle has become a technical, factual reality, independent of any individual and beyond any imagination. It is sometimes called the "Turing machine" and in this way one could say that Turing "lost his name to a machine."[66] But countless nameless people follow his highly individually motivated wish of replacing a human by a machine, because his machine has put this seemingly within our reach. Only from a synthesis of the psychic universality of the bachelor machine in tandem with the mathematic and technical universality of Turing's machine does a steady expansion in the technological "power over reality" result.

From a technical viewpoint, this contest will continue into the future, its result open to all comers. But up to now, the above examples show that the bachelor machine, having started out as an artistic vision, has turned into a way of embracing and developing technologies. As such, it is still miles ahead of the universal machine, which started out from technology so as to maybe one day equal man.

Notes

1. See Daniels 2003. The present essay is based on a chapter from this book and was reworked in many parts for this first English publication.

2. Kittler 1993, 47, 51.

3. Use of the word "man" throughout this essay is intentional, as it indicates the gender issues involved.

4. See Strouhal 1994, *Duchamps Spiel*, an informative study which, at least as concerns chess, also deals with Turing.

5. Duchamp in a talk at the chess congress in Cazenovia (Strouhal 1994, 11).

6. See the photo and audio documentation in the book by Shigeko Kubota, *Marcel Duchamp and John Cage* (n.p, n.d.).

7. Duchamp 1975, 59. On the countless references to the technology of the telegraph and radio concerning the link between bachelors and bride see the very detailed studies made by Linda Dalrymple Henderson, above all, the section "Wireless Telegraphy, Telepathy, and Radio Control in the Large Glass" (Henderson 1998, 103–115).

8. See Carrouges 1954; Deleuze and Guattari 1974; Clair and Szeemann 1975.

9. Duchamp 1975, 46.

10. This division into physical schema and formal rules in chess corresponds to two ways of experiencing the world, according to Duchamp: "I think that every chess player experiences a mixture of two aesthetic pleasures: first the abstraction of the delineation that is similar to the idea of poetry when writing, second, the sensuous pleasure in physically executing the delineation on the chess board." (Speech at the chess congress in Cazenovia 1952, in Strouhal 1994, 19.) Similar things could be said of the aesthetic experience of working with a computer.

11. Cf. Friedrich Kittler, "Es gibt keine Software," in Kittler 1993a, 229ff.

12. Jean Suquet writes on the *Large Glass* along these lines: "The machine runs only on words." Jean Suquet, "Possible," in de Duve 1991, 86.

13. Turing 1992, 7.

14. Baudrillard 1989, 128.

15. This corresponds to an action by the Hamburg female artists group "—innen," who in 1996 handed out men's mouse pads at the CeBit computer fair printed with the slogan: "Has your computer ever feigned an orgasm?"

16. Levy 1994, 83.

17. Statement by hacker Burt in Turkle 1984, 198.

18. Alan M. Turing, "Computing Machinery and Intelligence," in *Mind* 59 (1950). Reprinted in Turing 1992, 133–160.

19. It is surprising that the sexual components of the test have gone unnoticed by authors who otherwise very exactly register the gender-specificity of the media. See, e.g., Kittler 1986, 30; Wiener 1990, 93; and even in explicitly feminist studies on gender and computers, e.g., Kirby 1997, 136, 177. On the other hand, the Turing biographer Andrew Hodges, for example, finds the test a "bad analogy" that shows the "definitely camp humour in Turing's paper, reflecting his gay identity," which moreover encourages a "wild misinterpretation of what he had in mind." See Andrew Hodges, "The Alan Turing Internet Scrapbook," with links to other texts on the theme, at http://www.turing.org.uk/turing/scrapbook/index.html/. A more profound analysis of the gender-specific implications of the test is given by Rebentisch 1997.

20. Turing 1992, 134.

21. Hodges 1983, 540.

22. *Stern*, May 5, 1994, p. 56.

23. Turing 1992, 134.

24. Butler 1990.

25. Sherry Turkle, *Life on the Screen* (1995). Note the flirt of a student with the program Julia that he took for a girl (chapter 3, "Julia").

26. Haraway 2000, 292.

27. Rebentisch 1997, 29.

28. Cf. Hodges in Herken 1994, 12.

29. Turing 1992, 135–136. A certain irony can be seen in play here in Turing's formulations.

30. Statement by hacker Anthony in Turkle 1984, 235.

31. Carrouges in Clair and Szeemann 1975, 21.

32. Deleuze and Guattari 1974, 25.

33. Pias 2002, 198. According to Claus Pias, chess can be seen as a mental image (*Denkbild*) of the computer. It is almost a matter of course that hackers also develop chess programs, whose aim is to have the machine beat the human player. See Levy 1994, 89ff.

34. Turing's ACE report from 1945, according to Hodges 1983, 333.

35. Turing 1992, 127, 113, 109. It may today seem absurd or ironic to have a person "play" a machine in order to deceive another person into thinking he or she is playing against a person instead of against a machine. But this reflects only the phase of the pre-apparatus thought experiment.

36. Garry Kasparov later insisted that Deep Blue must have secretly received human assistance. However, in the meantime, even standard chess programs are able to beat grand masters; thus in May 1999, a "Fritz," version 5.32, available on CD-ROM beat Judith Polgar (Elo 2677) by 5.5 to 2.5. And in October 2002, the two-week match between the upgraded version "Deep Fritz" and chess world champion Wladimir Kramnik ended in a draw.

37. "The milieu of chess players is far more sympathetic than that of artists. These people are completely cloudy, completely blind, wearing blinkers. Madmen of a certain quality, the way the artist is supposed to be, but isn't, in general." (Duchamp, quoted in Cabanne 1987, 19.) This statement by Duchamp could today easily be applied to the phenotype of the computer hacker, whereby the celibate tendency in both milieus is clear.

38. Carrouges in Clair and Szeemann 1975, 44. See also Jean Suquet on Duchamp's *Large Glass* and Herman Melville's tale "The Paradise of Bachelors and the Tartarus of Maids" from 1852, in which nine bachelors meet nine lonely, freezing virgins who are operating a large machine that produces a kind of spermatic liquid out of old clothes. This enigma of a coincidence, which goes as far as "a correspondence of names and numbers," Suquet calls the actual reason for his book (Suquet 1974, 229ff). Thomas Zaunschirm (1982) comes to similar far-reaching conclusions in *Robert Musil und Marcel Duchamp*.

39. Duchamp 1975, 62.

40. At the Art Academy for Media, Kirk Woolford and Stahl Stenslie developed a cybersex suit that drew a lot of attention in the media, but whose function was more symbolic (see, e.g., "Prinz Reporterin testete Cyber-Sex, Orgasmus und Computer, Wie war's?," in *Prinz*, May 1994). Compare also the statements of artists in *Lab 1, Jahrbuch der Kunsthochschule für Medien*, Cologne (1994), 40ff, 74ff.

41. See Daniels 1992, 288–289.

42. Cf. Howard Rheingold, "Teledildonics," chapter 4 in Rheingold 1991.

43. See http://www.fu-fme.com/. According to Alexei Shulgin there were many orders for the nonexistent product, and on his website, in the meantime, the traffic was so high that it would have been possible to run ad banners bringing in several thousand dollars a month.

44. For the inscription, see Schwarz 1997, 794, cat. no. 531.

45. Turing 1992, 134.

46. Levy 1977, 20. From 1925 Duchamp several times collaborated with Frederick Kiesler, whose designs for audiovisual depiction techniques in part approach concepts of today's virtual reality. See Daniels 1996.

47. Duchamp, *Notes*, 1980, note 103. According to Greek mythology, Tantalus is punished by the gods and made to suffer hunger and thirst while water and the most luscious fruits are held before his eyes but withdrawn at his every attempt to reach them.

48. Jean Baudrillard developed theses on the sexual dimension of media technology that come very close to the ones represented here: "The relationship to a discussion partner via telecommunication is the same as that to input knowledge in data processing: tactile and groping.... That is why electronic data processing and communication, in a kind of incestuous convolution, always fall back on each other" (Baudrillard 1989, 121, 122).

49. See Kittler 1993b, 47, 51.

50. Friedrich Nietzsche, *Jenseits von Gut und Böse*, part 4, epigram 37.

51. Andrew Hodges draws a direct connection between the death of Chris Morcom, the young Turing's first love, and the notion of the universal machine, claiming that

the idea was born out of Alan Turing's personal loss. The transformation of love into a death mechanism as a principle of the bachelor machine fits in when he goes on to write: "Christopher Morcom had died a second death, and *Computable Numbers* marked his passing" (Hodges 1983, 110, 108, 45ff). Arturo Schwarz sees Duchamp's unfulfilled, incestuous love for his sister Susanne as an explanation for almost everything in his work (Schwarz 1969). Such interpretations are always one-dimensional and, as concerns Arturo Schwarz, clearly exaggerated. Yet nothing speaks against their having a true core.

52. Benjamin 1989, 500.

53. Andrew Hodges writes about Turing's first, still mechanical machine experiments from 1939: "The machine seemed to be a contradiction," because "a pure mathematician worked in a symbolic world and not with things. . . . For Alan Turing personally, the machine was a symptom of something that could not be answered by mathematics alone." The machine was a way "of making some connection between the abstract and the physical. It was not science, not 'applied mathematics,' but a sort of applied logic, something that had no name" (Hodges 1983, 157). Duchamp's work aims exactly in the same direction of something not yet named—beyond painting, literature, or technology.

54. See Kittler 1993b, 47, 51.

55. Turing in Hodges 1983, 539–540.

56. Duchamp 1975, 59.

57. The wording in the note: "L'électricité en large—Seule utilisation possible de l'électricité 'dans les arts' Étant donné . . . ; si je suppose que je sois souffrant beaucoup (énoncer comme un théorème mathématique)" (Duchamp 1975, 36–37; Suquet's addition to this in Suquet 1974, 191).

58. Turing 1992, 142.

59. Compare the transcripts of the tests at http://www.loebner.net/Prizef/loebner-prize .html/.

60. Turing 1992, 146.

61. See, e.g., the Turing test transcript on the winner of the Loebner Prize 1995 by Joseph Weintraub. The tests were, however, carried out only in the reduced version of man vs. machine, not in the man–woman–machine constellation of the imitation game suggested by Turing.

62. Turing 1992, 118ff, 121ff, 154ff.

63. For Baudrillard the machine's inability to feel pleasure is exactly the last defense in man's assurance of not being a machine: "What will always distinguish the functioning of even the most intelligent machines from man is the ecstasy, the pleasure, of functioning.... All kinds of artificial props can contribute to securing man pleasure, but he cannot invent anything to feel pleasure in his place" (Baudrillard 1989, 130). But, according to Turing, such a position leads to a vicious solipsistic circle (Turing 1992, 146). In analogy to Ludwig Wittgenstein's study on conveying pain, he put it this way: Only I can know if I feel pleasure (cf. Ludwig Wittgenstein, *Philosophical Investigations*, no. 244ff). Turing went to Wittgenstein's seminars in Cambridge, and on a conceptual relation between them there would be at least as much to say as on that between Duchamp and Turing (Hodges 1983, 152ff).

64. Turing investigates the question of whether art production is a criterion for thinking within the framework of arguments on consciousness. See Turing 1987, 164ff.

65. At the Turing test competition for the Loebner Prize in 2000, the testers had, at least once, mistaken all human opponents for a computer, but no computer was mistaken for a human.

66. Bernard Dotzler and Friedrich Kittler, in Turing 1987, 5.

References

Baudrillard, Jean. 1989. "Videowelt und fraktales Subjekt." In *Philosophie der neuen Technologien*, 113–133, ed. Ars Electronica. Berlin: Merve.

Benjamin, Walter. 1989. "Das Kunstwerk im Zeitalter seiner technischen Reproduzierbarkeit." In his *Gesammelte Schriften*, vol. II (1). Frankfurt/Main: Suhrkamp.

Bonk, Ecke. 1989. *Marcel Duchamp. Die Grosse Schachtel*. Munich: Schirmer/Mosel-Verlag.

Butler, Judith. 1990. *Gender Trouble*. New York: Routledge.

Cabanne, Pierre. 1987. *Dialogues with Marcel Duchamp*. New York: Da Capo.

Carrouges, Michel. 1954. *Les machines célibataires*. Paris: Arcanes. (2nd ed. 1976.)

Clair, Jean, and Harald Szeemann, eds. 1975. *Junggesellenmaschinen/Les machines céliba-taires*. Venice: Alfieri Edizioni d'Arte.

Daniels, Dieter. 1992. *Duchamp und die anderen*. Cologne: Dumont.

Daniels, Dieter. 1996. "Points d'interférence entre Frederick Kiesler et Marcel Duch-amp." In *Frederick Kiesler, Artiste-Architecte*, 119–130, ed. Chantal Béret. Paris: Centre Georges Pompidou.

Daniels, Dieter. 2003. *Vom Ready-made zum Cyberspace. Kunst/Medien Interferenzen*. Ostfildern-Ruit: Hatje Cantz Verlag.

de Duve, Thierry, ed. 1991. *The Definitively Unfinished Marcel Duchamp*. Cambridge, Mass.: MIT Press, 1991.

Deleuze, Gilles, and Félix Guattari. 1974. *Anti-Oedipus*. Frankfurt/Main: Suhrkamp. (Originally published as *L'anti-Oedipe*, Paris: Minuit, 1972.)

Duchamp, Marcel. 1975. *Duchamp du Signe: Écrits*. Ed. Michel Sanouillet. Paris: Flammarion.

Duchamp, Marcel. 1980. *Notes*. Ed. Paul Matisse. Paris: Centre Georges Pompidou.

Haraway, Donna. 2000. "A Manifesto for Cyborgs: Science, Technology, and Socialist-Feminism in the Late Twentieth Century." In *The Cybercultures Reader*, 291–324, ed. David Bell and Barbara M. Kennedy. London/New York: Routledge. (Originally pub-lished in *Socialist Review* 80 [1985].)

Henderson, Linda Dalrymple. 1998. *Duchamp in Context: Science and Technology in the Large Glass and Other Related Works*. Princeton: Princeton University Press.

Herken, Rolf, ed. 1994. *The Universal Turing Machine: A Half-Century Survey*. Vienna/New York: Springer.

Hodges, Andrew. 1983. *Alan Turing: The Enigma of Intelligence*. London: Burnett Books.

Kirby, Vicky. 1997. *Telling Flesh.* New York/London: Routledge.

Kittler, Friedrich. 1986. *Grammophon, Film, Typewriter.* Berlin: Brinkmann and Bose.

Kittler, Friedrich. 1993a. *Draculas Vermächtnis: Technische Schriften.* Leipzig: Reclam.

Kittler, Friedrich. 1993b. "Künstler—Technohelden und Chipschamanen der Zukunft?" In *Medienkunstpreis 1993*, ed. Heinrich Klotz and Michael Roßnagel. Ostfildern-Ruit: Hatje Cantz Verlag.

Kubota, Shigeko. *Marcel Duchamp and John Cage.* No publisher, no date.

Levy, Julien. 1977. *Memoir of an Art Gallery.* New York: Putnam.

Levy, Steven. 1994. *Hackers: Heroes of the Computer Revolution.* New York: Penguin.

Pias, Claus. 2002. *Computer Spiel Welten.* Munich: Sequenzia.

"Prinz Reporterin testete Cyber-Sex, Orgasmus und Computer, Wie war's?" 1994. *Prinz* (May).

Rebentisch, Juliane. 1997. "Sex, Crime, und Computers. Alan Turing und die Logik der Imitation." *Ästhetik & Kommunikation* 96 (March): 27–30.

Rheingold, Howard. 1991. *Virtual Reality.* New York: Summit.

Schwarz, Arturo, ed. 1969. *The Complete Works of Marcel Duchamp.* New York: Abrams.

Schwarz, Arturo, ed. 1997. *The Complete Works of Marcel Duchamp*, vol. 2, 3rd ed. New York: Delano Greenidge.

Strouhal, Ernst. 1994. *Duchamps Spiel*. Vienna: Sonderzahl.

Suquet, Jean. 1974. *Miroir de la Mariée*. Paris: Flammarion.

Turing, Alan. 1987. *Intelligence Service.* Berlin: Brinkmann und Bosse.

Turing, Alan. 1992. *Mechanical Intelligence*. Ed. D. C. Ince. Amsterdam/London: North Holland. (Vol. 1 of *Collected Works of A. M. Turing*.)

Turkle, Sherry. 1984. *The Second Self: Computers and the Human Spirit*. New York: Simon and Schuster.

Turkle, Sherry. 1995. *Live on the Screen*. New York: Simon and Schuster.

Wiener, Oswald. 1990. *Probleme der künstlichen Intelligenz*. Berlin: Merve.

Zaunschirm, Thomas. 1982. *Robert Musil und Marcel Duchamp*. Klagenfurt: Ritter.

Remember the Phantasmagoria! Illusion Politics of the Eighteenth Century and Its Multimedial Afterlife

Oliver Grau

In 1919, a Viennese student of philosophy Natalia A. consulted the psycho-analyst and early Freud-disciple Victor Tausk, complaining that her thoughts were being controlled and manipulated for years by a strange electrical device by doctors in Berlin. An *Influencing Machine*, according to the patient's obsessive idea, operated clandestinely, which forced upon her dreams, repellent smells, and emotions, telepathically and telekinetically.

Influencing Machine, created in 2002 by the Scottish-American artist Zoe Beloff, is a representation of Natalia's ominous medium (fig. 7.1). Stereoscopic floor diagrams viewed through red and green glasses and interactive video draw the visitor into a 3-D environment consisting of performative collages and DVD film (fig. 7.2). Using a pointer, we can interactively influence video sequences from medical teaching aids, home movies, and commercials, which appear as interactive loops on a letter-sized glass display.[1]

This is how we enter Natalia's inner world of images. With her *Influencing Machine*, the artist succeeds in presenting us with hallucinatory visions of "the" new medium.

Beloff visualizes the cinematographic as an intimate-interactive dialogue. Sounds of short-wave transmissions, popular songs of the 1930s, as well as recordings of atmospheric and geomagnetic interference expand a strangely oppressive scenario, with which the artist invokes a phantasmagoric presence or immersion into the mental topography of a schizophrenic. That older image media may acquire fresh importance in fields of artistic experimentation is a generally accepted insight in media art history. Beloff compiles her work of

Figure 7.1 Zoe Beloff, *Influencing Machine*, 2002. By kind permission of the artist.

electronic passages from material that, after extraction from lost contexts, emerges as a media-archaeological arrangement inscribed with new meaning. This renders *Influencing Machine* a sensitive reflection on media per se as well as a meditation on an ultimate medium. Beloff, too, demonstrates that machines are not mere tools and emphasizes just how deeply rooted technological media are in the subconscious, in media history, in the space of utopian projections and how they transport magical beliefs. The artist's gaze backward in time transports us to a thinking-space in the sense of Ernst Cassirer—and makes us aware of the evolutionary development of the media through aesthetic means.[2]

Although it has become a fancy word in modern art debates in other contexts[3] on the ideas underpinning the *Influencing Machine*,[4] we appear to encounter the "uncanny" described by Freud in conjunction with the "survival of primitive ideas," the resurfacing of infantile conceptions of life that the

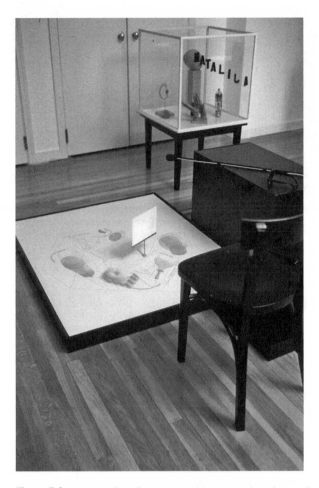

Figure 7.2 Zoe Beloff, *Influencing Machine*, 2002. See plate 5. By kind permission of the artist.

rational adult imagines have been overcome. These include belief in the existence of supernatural destructive forces, the return of the dead or contact with them, all of which belong to the doctrine of animism. According to Freud, the uncanny results from the contradiction between what we think we know and what we fear we perceive at a particular moment.[5]

There are also reflections of the phantasmagoria: Brazilian artist Rosângela Rennó's 2004 media-archeology work *Experiencing Cinema* comprises the intermittent projection of photographs onto a volatile screen, made from nontoxic

Figure 7.3 Rosangela Rennó, *Experiencing Cinema*, installation, 2005. See plate 6. By kind permission of the artist.

smoke from vegetable oil (fig. 7.3).[6] Or consider Toni Oursler's *Influence Machine*, a "psycho-landscape" for Soho Square, New York,[7] which reflects on historic shows that invoked the "spirit" of the site, such as the phantasmagoria. In this context, we could also take a look at Gary Hill, Douglas Gordon, or Laurie Anderson.

Media exerts a general influence on forms of perceiving space, objects, and time, and they are tied inextricably to the evolution of humankind's sense faculties. Currently, we are witnessing the transformation of the image into a computer-generated, virtual, and spatial entity that seemingly is capable of changing "autonomously" and representing a lifelike, visual-sensory realm. For how people see and what they see are not simple physiological questions; they are complex cultural processes. Not least, in this way light can be shed on the genesis of new media, which are frequently encountered for the first time in works of art as utopian or visionary models. Therefore a central problem of current cultural policy stems from a serious lack of knowledge about the origins of audiovisual media. And this is in complete contradiction with the current demands for more media and image competence.

Marginal and fragile, Beloff's cinematographic code seems like a highly expressive visualization of a media-historical phantasm, as brought forth by *laterna magica*, panorama, radio, early television, and the discussion of cyberspace and virtuality. In this way, the artist expands an individual psychosis into a societal and image-political horizon.

Whereas Beloff utilizes set pieces from media history, the almost forgotten play *Lichtenberg*, written by Walter Benjamin in the 1930s, designs a set of new utopian media.[8] At a productive distance from the conditions that prevail on Earth, the inhabitants of the Moon study our blue planet with the help of utopian media, and so even the famous experimental physicist Lichtenberg becomes the focus of media users' interest. Thus, the Moon knows everything about the Earth, but the Earth knows nothing about the Moon. Those media are: the Spectrophone, which detects and keeps under surveillance everything that happens on Earth—it is both ear and eye of God; the Parlamonium, which transforms human speech (which is irritating to the ears of Moonlings) into the delightful music of the spheres; and the Oneiroscope, which materializes the psychoanalytically motivated desire to visualize dreams.

Although all three devices trigger associations with Beloff's *Influencing Machine*, it is the Oneiroscope that brings us closest to Beloff's work. Benjamin's visions are of media that can hear all, see all, and even read the mind's dreams; but they remain passive, whereas the *Influencing Machine*, in Natalia's magical beliefs, affects the psyche and the sexual organs.

Utopians versus Apocalyptians

Media revolutions have often led to bipolar discourses between utopians and apocalyptians, platonic, or even apocalyptic commentaries. These positions often exhibit an antitechnology thrust and have developed partly from critical theory and poststructuralism. At the other end of the spectrum are the utopian-futurist prophecies. Both poles are either positive or negative teleological models, which follow largely the pattern of discourse surrounding earlier media revolutions. On the utopian side, variations of ideas like *Now we will be able to touch with our bodies into the far distance*, and *now the illusion will become total*, have collided with fears like *our perception will suffer*, *our culture will be destroyed*, and even *we will lose our bodies*. Eisenstein,[9] Minsky,[10] Youngblood,[11] and Moravec[12] belong probably to the "utopian" group, while Eberhard,[13] Postman,[14] Baudrillard,[15] and even Flusser[16] come more from the

"apocalyptic" side. This discourse, provoked by media revolutions, returns again and again: recall the discussion around virtual reality ten years ago, the cinema debate in the early twentieth century, the panorama in the eighteenth century, and so forth. But analogies or fundamental innovations in contemporary phenomena can be discerned only through historical comparison, and that is what this approach is based on.

We know that Marshall McLuhan's influential materialistic discourse interpreted media as externalizations of bodily organs and sensory perception. In my view, however, new and older image media not only conform to the Extensions of Man, they also expand the sphere of our projections and appear to bring us (so the utopian idea goes) not only into contact with far-off objects telematically, but also virtually, and this is my point here, with the psyche, with death, and with artificial life—with the most extreme moments of our existence. At the same time and in the opposite direction, these phenomena appear to be reaching out to us and to an increasing number of our senses. Pseudo-certainty of these illusions is created by the cultural technique of immersion.

The Magic Lantern and Phantasmagoria

The recurrent hope that is ascribed to the media of "bringing back what is absent" finds its most impressive expression in the attempt to communicate with the dead. We know that Athanasius Kircher and Gaspar Schott pressed the *laterna magica* into the service of the Jesuits' *propagatio fidei* in order to put the fear of God into their audiences by illuminating the devil (fig. 7.4).[17] Unfortunately, today there are very few opportunities for experiencing the visual media of the nineteenth century. This is in total contrast to the situation regarding the painting and sculpture, theater, and music of this period. Without actual experience of performances, access to the origins of modern audiovisual media is blocked for interested observers. Imagine what it would mean for our appreciation of modern art if the paintings by Matisse or Monet were available only as postcards or book illustrations!

The rise to fame of this optical wonder began with the projection of the image of a corpse by its first mediator, the traveler Rasmussen Walgenstein (1609–1670), at the court of King Frederik III in Copenhagen.[18] As of the mid-seventeenth century, the *laterna magica*, or magic lantern, provided the means to tell stories in projected images;[19] however, from the outset when

Figure 7.4 *Projection of the Devil,* in Guliemo Jacobo sGravesande, *Physices Elementa Mathematica,* ill. 109 (Genf: 1748), p. 878.

the device was in less scrupulous hands, it was employed to deceive, terrify, and manipulate naive spectators. The courtiers in attendance in Copenhagen were frightened out of their wits to such a degree that the king, who could not abide timidity, commanded the performance to be repeated three times, that is, until the spectators had become accustomed to the new visuality, which annulled the effect.[20] Although eye-witnesses did not record any actual details concerning the content of these first magic lantern shows, they are unanimous in their verdict that Walgenstein was a "showman," who was out to produce shock effects and deceptions, and to play on his audience's superstitions using a new optical instrument. It was apparent that for him, the main attraction of the magic lantern was its ability to make supernatural apparitions and ghosts appear as if by magic. These objections raised against the magicians operating

the lanterns express a general deep-seated suspicion, which continues to be leveled today at the suggestive power of images, particularly by writers.[21]

During the following decades, use of the *laterna magica* spread and its tiny light made a great impression in the dark nights of those days, which we have difficulties imagining today. Contemporary accounts testify to the magical and spiritualistic nature of the magic lantern performances: After some minutes, the likeness of a person, who was familiar to the assembled company, in the form of the generally accepted notion of a spirit seemed to rise slowly from out of the floor, quite recognizable and clear to see. From February 1790, such shows were institutionalized in a special theater in Vienna's Josefstadt. This establishment was entirely draped in black and decorated with skulls and a white "magic circle." The evening's entertainment began with a simulated storm complete with thunderclaps, wind, hail, and rain. The dramatic climax was the conjuration of spirits. At each performance, three so-called spirits appeared. Each apparition took some steps toward the audience, and then disappeared in the manner in which it had appeared. Ghosts and terrifying apparitions made a spectacular comeback in the 1790s. In the mid-1780s showmen like Paul Philidor had begun to put on shows in Germany for curious and fascinated audiences, which were modeled on the performances by Johann Georg Schröpfer, a freemason and magic lantern illusionist, whose occult powers were legendary.[22] The pièce de resistance of Schröpfer's later shows was the projection of ghostly apparitions onto smoke using a concealed magic lantern.[23] The images produced by this technique were flickering and ephemeral, and the effect was apparently very frightening. Schröpfer used a whole suite of tricks including projection with mirrors, hollow voices spoken through concealed tubes, assistants dressed as ghosts, and thunder sound effects. To this arsenal of illusions Paul Philidor added the recently invented Argand lamp, which produced a much stronger light and thus enabled larger audiences to see the images—this was the birth of the phantasmagoria (fig. 7.5).

Another pioneer of this early illusion industry was the master of illusion Johann Carl Enslen, who was well known all over Europe for his "Hunts in the Sky," his flying sculptures, and many other meticulously organized illusions. His phantasmagoria shows in Berlin expanded the repertoire of subjects that Philidor had presented in his ghostly presentations.[24]

It was in Berlin too that the phantasmagoria cast its spell over the most famous protagonist of the genre, the Belgian painter, physicist, brilliant orga-

Figure 7.5 *Phantasmagoria,* in Etienne Gaspard Robertson, *Mémoires récréatives scientifiques et anecdotiques,* frontispiece (Paris: 1831).

nizer, balloonist, and priest Etienne Gaspard Robertson (fig. 7.6). In 1798, he exported the immersive medium to postrevolutionary Paris, and, starting in 1802, he presented it all over Europe, from Lisbon to Moscow.[25] The nineteenth century saw the success of the medium all over the West.[26]

Laterna magica projections continued to evolve further from the eighteenth-century traditions and became more differentiated. Projection apparatuses like the fantascope achieved mobility and moved silently on polished brass wheels behind a semitransparent screen (both screen and apparatus were invisible to the audience) so that the projections appeared to move closer and further away. Moreover, a dissolver in front of the lens made it possible to shift dramatically from one scene to another so that a sophisticated impression of movement and different moods was created. The phantasmagoria opened up the virtual depth of the image space as a sphere of dynamic changes for the first time. This was all made possible by the use of a screen.[27]

As with "illusionism" or "immersion," however, phantasmagoria is by no means a simple term. Toward the mid-nineteenth century, phantasmagoria had also become a key political concept. Even Marx used the term in 1867 in *Das Kapital* where he refers to the origination of surplus value as "phantasmagorical."[28]

Robertson had spectacular success in Paris with his shows, especially after he moved them to the atmospheric venue of an abandoned Capuchin monastery,

PROF. ROBERTSON

Figure 7.6 Etienne Gaspard Robertson. From Francoise Levie, ed., *Lanterne magique et fantasmagorie*, Musée national des techniques (Paris: CNAM, 1990), p. 6.

which the audience could enter only via a cemetery. He refined Philidor's technical innovations and improved on Enslen's atmospheric repertoire, offering his audiences Voltairesque visions, the temptation of St. Anthony, and the three witches from *Macbeth*.[29]

In the evening twilight the spectators made their way through the courtyard, proceeded down a long dim corridor hung with dark paintings to the Salon de Physique, a *Wunderkammer*—a cabinet of wonder—with optical and aural attractions such as peep shows, distorting mirrors, and tableaux of miniature landscapes. Robertson produced electrical sparks, which he called *fluidum novum*, that "for a time could make dead bodies move." Thus, "the other side," the new medium of electricity with its utopian connotations was linked with sensory illusions so that the audience was in the right scientific

and magical frame of mind as they entered the projection room. Here, Robertson announced, the "dead and absent ones" would appear.[30]

The viewers were surrounded by utter blackness, there was no foreground, no background, no surface, no distance, only overwhelming, impenetrable darkness—"sublime darkness," as Burke has put it. This innovation distinguished the phantasmagoria from all other image machines of the period. The awareness of being in a room was progressively negated by the absolute darkness, haunting music, and particularly the image projections. Together these elements served to constrain, control, and focus perception.

Once seated, the audience heard the voice of a commentator, who spoke of "religious silence"; this was then immediately broken by sounds of rain, thunder, and a glass harmonica. This instrument, which all famous composers of the time, from Mozart to Beethoven, wrote pieces for, was invented by Benjamin Franklin, a representative of the new scientific age and master of electricity. It provided an eerie soundtrack for this visual spectacle and heightened the audience's immersion in the staged images even more. Then, out of the darkness, glowing apparitions approached the audience.

Today, the illusions of these image caverns may appear amusing; but contemporaries' media competence was at an entirely different level. Robertson describes guests striking out at the misty images, and the journal *Ami des Lois* advised pregnant women to stay away from the phantasmagoria to avoid having a miscarriage.[31] It could be argued that this was, in fact, merely good publicity. This is certainly true in part, yet a medium that differed radically from its advertising would certainly not have achieved such lasting success. In 1800, the well-known Parisian writer Grimod de la Rynière wrote: "Herewith it is established that the illusion is complete. The total darkness of the room, the selection of pictures, the astounding magic of their truly monstrous growth, the magic that accompanies them—everything is arranged to impress the imagination and conquer all your senses."[32]

Certainly Robertson could not allow himself to be put on the same level as charlatans like Cagliostro, nor be associated with representatives of Catholic image magic, such as della Porta, Kircher, Schott, and Zahn.[33] He referred to himself as a producer of "scientific effects," although, naturally, he did not give away his tricks. Robertson's iconography also included the recently executed contemporaries, such as Marat, Danton, and Robespierre. In a variation of the doctrine of transubstantiation, he made them come alive again with

his magic medium in the swirling sulphurous smoke. Louis XVI, however, he hesitated to resurrect in postrevolutionary Paris. And when a paid extra in the audience stood up and shouted "My wife! It's my departed wife!" then panic would break out. Typically, the shows ended with skeletons, and with Robertson warning, "Look well at the fate that awaits you all one day: Remember the phantasmagoria!"

In the figure of Robertson and the phantasmagoria the ambivalence of the era is concentrated as in a burning glass. The yoke of the Church's authority had just been shrugged off and the phantasmagoria established itself in its former architectural territory. However, the brightness of the Age of Enlightenment was already beginning to darken with eerie testimonies of superstition, pseudoscientific experiments, and the horror of the mass executions during the Terror, which appeared in front of the audience during the phantasmagoria séances. The fresh suggestive potential of a hitherto unknown medium transformed the perception of magical tricks into what appeared to be scientific.[34]

The medium of the phantasmagoria is part of the history of immersion, a recently recognized phenomenon that can be traced through almost the entire history of art in the West, as documented in my latest book.[35] Immersion is produced when works of art and image apparatus converge, or when the message and the medium form an almost inseparable unit, so that the medium becomes invisible.

In the phantasmagoria, phenomena come together that we are again experiencing in today's art and visual representation. It is a model for the "manipulation of the senses," the functioning of illusionism, the convergence of realism and fantasy, the very material basis of an art that appears immaterial, as well as the associated issues pertaining to epistemology and the work of art itself. In contrast to the panorama (fig. 7.7), which made wide vistas of landscapes available, the phantasmagoria connected with the old magic of shamanism to overcome the separation from one's ancestors through the medium.

The image worlds of the terrifying magic lantern thus tapped into notions that already existed in the populace and amplified them through powerfully suggestive new media. Although Beloff does not present her images as a supernatural presence we perceive a simulacrum of implausible beliefs. Therefore, the phantasmagoric fascination remains. But phantasmagorical spaces play an important role in connection with utopian media also in other fields of media art, like telepresence and genetic art.

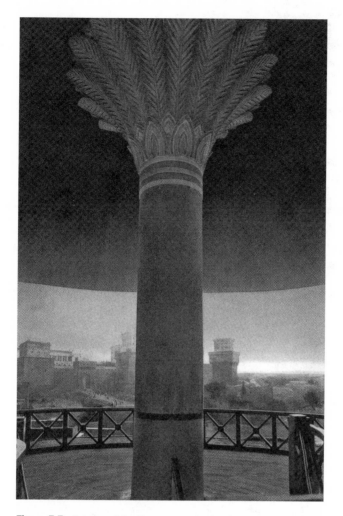

Figure 7.7 Interior of the Panorama rotunda Altötting. Panorama by Gebhard Fugl, 1903. Photo by Erika Drave, Munich, SPA Foundation Panorama Altötting. By kind permission.

Figure 7.8 Paul Sermon and Andrea Zapp, *A Body of Water*, telematic installation, 1999. By kind permission of the artists.

Telepresence

A new, data-mediated epistemology has opened up with the new parameter telepresence and its global exchange of images—a paradox.[36] Digital images appear on HMDs, CAVEs, walls, or in the case of Paul Sermon's *Telematic Dreaming* on a simple bed sheet, or in *A Body of Water* on a wall of water. The installation *A Body of Water* (1999) visualizes in a ghostly way the social power of Paul Sermon's and Andrea Zapp's art (fig. 7.8). In a chroma-key room, visitors to the Wilhelm-Lehmbruck-Museum established contact with visitors in a disused mine, the Waschkaue Herten at a second location of the installation. Projected onto gauzy pyramids of water spray from showers in the mine, images of the museum visitors themselves gain phantasmagorical intimacy. In this ruin of the industrial age, Paul Sermon and Andrea Zapp created an experience that was both uncanny *and* vivid. Quantum physics teaches us that reality is a product of observation; here, however, near and far come together in real time to create a paradox: *I am there where I am not and experience sensory proof against my better judgment.*

Formulating an imaginary space evoking the generations of miners who washed the ubiquitous coal dust from their sweating bodies, Sermon expands

telematics to include social critique that is disturbing in its phantasmagorical intimacy. While *Influencing Machine* makes contact with the psyche, the use of telepresence throughout media history again and again attempts to make contact with transcendence, as shown in previous literature. Paul Sermon's installations must also be understood in this context.

Digital Evolution: A-Life

Recently, within the evolution of art genres, digital art media have begun to change the traditional tableaux of art in the direction of a processual model of art.[37] The new parameters, such as interaction, telematics, and genetic image processes, have not only encouraged and intensified the crossing of boundaries, as the theory of media archaeology has often argued. The trend is toward a fusion of the observers' perception with an image medium that is moving increasingly toward the inclusion of all human senses; this is becoming prevalent in media art. Whereas the phantasmagoria connects with death via immersion and spiritualism, *A-Volve*, the icon of genetic art by Christa Sommerer and Laurent Mignonneau, visualizes luminous artificial life in a semidarkened space.[38]

Artworks are being created that integrate as simulations the genres of architecture, sculpture, painting, and scenography, or even historical image media such as theater, cinema, and photography. All these elements are absorbed into a space that exists only by virtue of its effects.

Digital images open up an interactive image space that is fed information from sensors and data banks. This enables it to change its visuality in a processual and "intelligent" way. These are images whose physicality approaches the function of a display or screen; images that serve as surfaces for projecting networked information, which can telematically bring distant actions up close and, conversely, allow us to perform actions in distant places. Digital images thus blur the distinctions between hitherto separate genres. Through the use of genetic algorithms, an image space can appear to be biologically populated and undergo evolutionary processes and changes, thereby amalgamating artificial nature and art.

The idea of letting objects float almost magically in front of an audience as in phantasmagoria and the magic lantern is currently encountered—apart from, obviously, in IMAX cinemas—particularly in computer art. Artist-scientists such as Thomas Ray, Christa Sommerer, and Karl Sims simulate

processes of life: evolution and selection have become methods used by media art. With the aid of genetic algorithms, the scenic image worlds of the computer not only have gained new tools for design but also can be endowed with the semblance of being alive. Software agents, which appear to be three-dimensional, transmit their phenomenology to the next "generation" of agents according to patterns of evolutionary reproduction, which is then combined in new variations according to the principles of crossover and mutation. The sole constraint is the selection framework determined by the artist.

A phantasmagoric installation that combines playful combinations with the visualization of complex forms of artificial life, *SonoMorphis* was created in 1999 by Berndt Lintermann. In its dark space, ever-new biomorphic bodies are created on the basis of genetic algorithms (fig. 7.9). Lintermann makes the artificial creatures rotate continually and enhances the spatial effect with stereo sound, which is also generated by random processes. Lintermann's intention was to create a highly flexible interactive structure for his installation, which he would like understood as an instrument consisting of visual and acoustic components. The number of possible forms is 10^{80}—according to Lintermann, analogous to the number of all the atoms in the universe. Be that as it

Figure 7.9 Berndt Lintermann, *SonoMorphis*, CAVE installation, 1999. See plate 7. By kind permission of the artist.

may, the number of possible variants in *SonoMorphis* is incredibly high and impossible to explore even in part. And, in the darkness of a CAVE, the lifelike forms appear as a modern phantasmagoria.

The discussion about genetics and artificial life, or a-life,[39] that at first was mainly confined to the disciplines of bioinformatics and computer science, was supplemented by models, visions, and images from art that became catalysts in this controversial debate. From a theoretical point of view, evolution represents a groundbreaking process for images: the controlled use of random principles enables the creation of unpredictable, irreproducible, unique, and transitory images. One of the problems with representatives of the hard-core a-life approach, like Langton and Ray, is that they regard computer ecospheres as "alive" in the conventional meaning of the word.[40] A-lifers claim that the projected creatures are not only *similar* to life, they are life itself, which is, from a theoretical point of view, naive. The pictorialisms of a-life may be labeled images, but they are computations, like all digital images. As far as the functions and program of life processes are concerned, the image is an abstraction based on the biomorphic structure of concretization. The scientific legitimacy of an image is especially the result of an algorithmic analogy to lifelike principles of evolution. Nonetheless, the process succeeds in visualizing facets of scientific theories about life, and the results are images, no more, but also no less.

To use the vocabulary of art, a-life research seeks among other things to break down the divisions between genres and to dissolve the distinction between art and life—in the future, as Ray and Sommerer suggest, in ubiquitous computer networks.[41]

Thus phantasmagorically animated artificial life and artificial consciousness remain human projection onto human-made technology in transition, a symbolic space, which above all says something about the reflection of the image of the human within the development of technology—this is reflected by Lintermann too.

This brief excursion into the history of media, which seeks the old in the new, brings us to the question, "What is really new about new media?" and should enable a more penetrating view of current hype regarding media development.

The phantasmagoria stands for a principle, which so far has not been introduced into the discourse about media art: a principle that combines concepts from art and science to generate illusionism and polysensual immersion using

all contemporary means available. In fact, the phantasmagoria represents a turning point in image history, between the suggestive images of Roman Catholicism (Kircher) and self-declared rationalism. In my view, the issue is as follows: Just as it has been possible to demonstrate and establish the history of immersion in conjunction with the panorama, the phantasmagoria can be understood as a media principle that suggests that contact can be made with the psyche, the dead, or artificial life forms. It is therefore necessary to expand McLuhan's theory. Addressing emotions and paranormal human experiences with magical means stems from the insecurity produced by the technological utopia. Benjamin's persiflage moves already in this direction. Considered in this light, a number of contemporary artists can be found working today in the tradition of the phantasmagoria, a hybrid between art, science, and magic.

Coda: Implications for Image Science

If we take a broad look at the history of image media to date, we see that a main force behind the development of new media for creating illusions is the aim to gain greater power of suggestion. This mechanism appears to be the motive behind perennial efforts to renew and maintain power over the observer through developing new potential for suggestion and erecting ever-new regimes of perception. The magic lantern, panoramas, dioramas, phantasmagoria, cinema, computer displays, and technical image media all appear in this perspective as aggregates of continually changing machines, forms of organization, and materials that remain, in spite of all standardizations, seldom stable; we are constantly fascinated by the possibility of heightening the illusion.

Finally, digital images give new meaning to the category of "image" in the history of the media. Differences between inside and outside, near and far, physical and virtual, biological and automatic, image and body are disappearing. We can recognize a sheer endless stream, which on closer scrutiny reveals supposedly established entities, like cinema, to be assemblages of components that are arranged in ever-changing new constellations in the kaleidoscope of evolutionary development of the art media.

Immersion, as we recognize today, is undoubtedly a key element for understanding the development of the media, although the concept remains somewhat opaque and contradictory. Obviously, the relation between critical distance and immersion is not a simple matter of "either–or"; the many and

diverse connections are interwoven, dialectic, in part contradictory, and most certainly dependent upon the individual dispositions of the observers and their historically acquired media competence. Immersion can be a mentally active process; in the majority of cases, however, both in earlier and more recent art history, immersion is mental absorption initiated for the purpose of triggering a process, a change, a transition. Its characteristics are a diminished critical distance to what is represented and an emotional involvement in the same.[42]

An increase in the power of suggestion appears to be an important, if not the most important, motive force driving the development of new media of illusion. Image science, or *Bildwissenschaft*, now allows us to attempt to write the history of the evolution of the visual media, from peep show to panorama, myriorama, stereoscope, cyclorama, magic lantern, eidophusikon, diorama, phantasmagoria, silent films, color films, films with scents, IMAX, cinéorama, anamorphosis, television, telematics, and the virtual image spaces generated by computers. It is a history that also includes a host of typical aberrations, contradictions, and dead ends. But image science without art history— particularly without its tools for comparison and critical image analysis—is not capable of developing deeper historical insights. It is in danger of propagating old myths and, lacking a "trained eye," of succumbing to the power of the images. The rise of media art has added fuel to this debate, for questioning images has acquired not only new intensity but also a new quality.

Image science does not imply that the experimental, reflection, and utopian spaces provided by art are to be abandoned. On the contrary: within these expanded frontiers the underlying, fundamental inspiration that art has provided for technology and media, which is associated with names such as Leonardo, Wallgenstein, Pozzo, Barker, Robertson, Daguerre, Morse, Valery, Eisenstein, and many exponents of the art of our digital present, is revealed with even greater clarity. Image studies is an open field that engages equally with what lies between the images, as in the case of Beloff, and with the new perspectives resulting from interplay with neuroscience, psychology, philosophy, research on emotion, and other scientific disciplines.

Notes

1. See Pascal Beausse, "Zoe Beloff, Christoph Draeger: images rémantes—After-Images," *Artpress* 235 (1998): 43–47; Chris Gehman, "A Mechanical Medium. A Conversation with Zoe Beloff and Gen Ken Montgomery," *Cinéma scope* 6 (2001):

32–35; Timothy Druckrey, "Zoe Beloff," in *Nam June Paik Award 2002*, International Media Art Award NRW (Ostfildern-Ruit: Hatje Cantz, 2002), 20–21; and Steven Shaviro, "Future Past: Zoe Beloff's Beyond," *Artbyte: Magazine of Digital Arts* 3 (1998): 17–18.

2. More so than perhaps any other thinker, Ernst Cassirer reflected on the power of distance for intellectual productivity and creating awareness. In *Individuum und Kosmos*, he proposes that distance constitutes the subject and is alone responsible for producing the "aesthetic image space" as well as the "space of logical and mathematical thought." See E. Cassirer, *Individuum und Kosmos* (Darmstadt: Wissenschaftliche Buchgesellschaft, 1963 [1927]), 179. Two years later, Aby Warburg stressed the intellectual, awareness-enhancing power of distance and even included this "original act of human civilization" in the introduction to his *Mnemosyne-Atlas* (*Der Bilderatlas Mnemosyne: Gesammelte Schriften Abteilung 2, Band 2* [Berlin: Akademie Verlag, 2000], 3–6).

3. Anthony Vidler, *Unheimlich: Über das Unbehagen in der modernen Architektur* (Hamburg: Edition Nautilus, 1992).

4. Victor Tausk, "On the Origin of the 'Influencing Machine' in Schizophrenia," *Psychoanalytic Quarterly* 2 (1933): 521–522.

5. Sigmund Freud, "Das Unheimliche," in *Gesammelte Werke*, vol. 12, ed. Anna Freud (Frankfurt am Main: Fischer, 1947), 227–268.

6. The first program comprises thirty-two images extracted from family albums gathered in different countries, presenting couples, groups, or families in formal situations, "bourgeois portraits" of domestic scenes. Other programmes are available: "love movies," "crime scenes," and "pictures of war."

7. *The Influence Machine* was developed with the assistance of the Public Art Fund in New York. It was presented in Madison Square Park from 19–31 October 2000. The "ghosts" of key figures in media history such as television pioneer John Logie Baird and the Fox Sisters, who claimed to have made telegraphic contact with the spirit world in the mid-nineteenth century, roamed the square at night. Just yards from where Logie Baird made his first public experiments in the 1920s (a room above Bar Italia on Frith Street), *The Influence Machine* was a fractured multimedia landscape of spectres, sounds and light. The ghosts escaped the machine . . .

8. Walter Benjamin, "Lichtenberg," 1932, in his *Gesammelte Schriften*, IV/2, ed. Rolf Tiedemann (Frankfurt am Main: Suhrkamp, 1991), 696–720.

9. See Sergei Eisenstein, *Das dynamische Quadrat: Schriften zum Film* (Leipzig: Reclam, 1988). (Originally: *Stereokino*, 1947.)

10. See Marvin Minsky, *Society of Mind* (New York: Simon and Schuster, 1988).

11. See Gene Youngblood, *Expanded Cinema* (New York: E. P. Dutton, 1970).

12. See Hans Moravec, *Robot: Mere Machine to Transcendent Mind* (Oxford: Oxford University Press, 2000).

13. See J. A. Eberhard, *Handbuch der Ästhetik*, part 1 (Halle: Hemmerde und Swetschke, 1805).

14. See Neil Postman, *Amusing Ourselves to Death: Public Discourse in the Age of Show Business* (New York: Penguin Books, 1986).

15. Jean Baudrillard, *Symbolic Exchange and Death* (London: Sage Publications, 1993).

16. Vilém Flusser, *Ins Universum der technischen Bilder* (Goettingen: European Photography, 1985).

17. See Ulrike Hick, *Geschichte der optischen Medien* (Munich: Fink, 1999), 115ff. and 129–130; W. A. Wagenaar, "The Origins of the Lantern," *New Magic Lantern Journal* 1, no. 3 (1980): 10–12; Francoise Levie, ed., *Lanterne magique et fantasmagorie*, Musée national des techniques (Paris: CNAM, 1990); Laurent Mannoni, *The Great Art of Light and Shadow: Archaeology of the Cinema* (Exeter: University of Exeter Press, 2000 [1995]).

18. Its name—*laterna magica*—(coined by Charles Francois Millet Dechales, who saw one of Walgenstein's shows in 1665 in Lyon) reflects faithfully the lantern's miraculous ability to blow up small pictures of spectacular subjects to life-size proportions. Charles Francois Millet Dechales, *Cursus seu mundus mathematicus* (Lyon: 1674), vol. 2, 665.

19. The three most important players in the early history of the magic lantern were the scientist Christiaan Huygens (1629–1695), who probably invented it and was also its earliest critic, the traveler Thomas Rasmussen Walgenstein (1627–1681), who gave shows all over Europe and probably had a decisive influence on how the device was received by intellectuals and scientists, and Johann Franz Griendel (1631–1687),

who began to produce magic lanterns for sale in 1671 in Nürnberg and founded a tradition of manufacture that would last for over two hundred years. Griendel was a former Capuchin friar who converted to protestantism and moved to Nürnberg in 1670. He had extensive knowledge of military architecture, optics, and mathematics. Among the optical instruments that he offered for sale in 1671, and on a list of 25 instruments that he sent to Gottfried Wilhelm Leibniz in Hannover, there was also a magic lantern. Its design, a horizontal cylinder mounted on a funnel-shaped metal base, differed considerably from Dutch and other Western European models with their vertical cylinders or rectangular wooden boxes.

20. Oligerus Jacobeus, *Museum regierum, seu catalogus rerum* (Copenhagen: 1710), vol. II, 2.

21. See Martin Jay, *Downcast Eyes: The Denigration of Vision in Twentieth-Century French Thought* (Berkeley: University of California Press, 1993).

22. Baltasar Bekker, *Chr. August Crusius' Bedenken über die Schöpferischen Geisterbeschwörungen mit antiapocalyptischen Augen betrachtet* (Berlin: 1775).

23. This technique was described for the first time 1769–1770 by Gilles-Edmé Guyot in "Nouvelles récréations physiques et mathematiques."

24. He showed Petrarch at Laura's graveside, told the story of Abelard and Eloise, and presented portraits of Frederick the Great and General Ziethen; see Stephan Oettermann, "Johann Karl Enslen's Flying Sculptures," *Daidalos* 37, 15 (1990): 44–53.

25. J. E. Varey, "Robertson's Phantasmagoria in Madrid 1821," *Theatre Notebook* 9–11 (1954–55 and 1956–57).

26. Shows were also put on in North America, some of them using the phantasmagoria lanterns of the Dumontiez brothers. Instead of the spirits of Voltaire and Frederick the Great, audiences there made acquaintance with George Washington, Benjamin Franklin, and Thomas Jefferson. Theaters in London, New York, Berlin, Philadelphia, Mexico City, Paris, Madrid, Hamburg, and a host of other cities staged phantasmagoria shows and established the magic lantern in the early nineteenth century as a useful device in staging public performances for large audiences. The rapid technical progress in the first half of the nineteenth century was followed by a change in the culture of the magic lantern in the second half. In the early 1820s, the British company Carpenter and Westley produced a sturdy metal model, which used an Argand-type lamp.

This made it possible to use the magic lantern in the classroom, in lectures and seminars. It may not be purely coincidental that magic, spiritualism, and horror were so closely associated with the new medium, for up to the mid-nineteenth century spiritualism developed into a veritable mass movement in the United States. In 1859, it was estimated that there were some eleven million spiritualists. Alan Gauld, *The Founders of Psychical Research* (New York: Schocken, 1968), 29. On the relationship of spiritualism and electricity, see Wolfgang Hagen, "Die entwendete Elektrizität: Zur medialen Genealogie des 'modernen Spiritismus,'" http://www.whaagen.de/publications/. Among the spiritualists were many prominent personalities of the era, including, for example, Harriet Beecher Stowe and President Abraham Lincoln. Russel M. Goldfarb and Clara R. Goldfarb, *Spiritualism and Nineteenth-Century Letters* (Rutherford, N.J.: Fairleigh Dickinson University Press, 1978), 43–44.

27. According to the Oxford English Dictionary the word "screen" appeared for the first time around 1810, in connection with the phantasmagoria.

28. Adorno and Benjamin work with his term. The phenomenon of world fairs was analyzed by Benjamin as "phantasmagorical." See Margaret Cohen, "Walter Benjamin's Phantasmagoria," *New German Critique* 43 (1989): 87–108.

29. In addition, he manufactured and sold the so-called fantoscope lantern. The ingenious design of this apparatus allowed both the projection of transparent slides and opaque, 3-D puppets.

30. E. G. Robertson, *Mémoires récrétifs, scientifiques et anecdotiques d'un physician-aeronaute* (Langres: Clima Editeur, 1985). See also "La Phantasmagorie," *La Fleur Villageoise* 22 (28 February and 23 May 1793).

31. *L'ami des lois*, 955 (28 March 1798), 1.

32. Grimod de la Reyniére, in the *Courrier des Spectacles*, 1092, 7 March 1800, 3.

33. Barbara Maria Stafford and Frances Terpak, *Devices of Wonder: From the World in a Box to Images on a Screen* (Los Angeles: Getty Research Institute, 2001).

34. The dissolving technique invented for the magic lantern rendered the expansion or compression of time a special aesthetic visual experience, which was enhanced by the magic and illusionistic effect of the medium. The next logical step—we are getting closer to films—was to combine the large-format panorama with moving effects.

This stage refers to other predecessors of cinematography and is focused on the aesthetic category of the illusion of movement. Although the experience of time elapsing between different images in the mechanical theaters of classical antiquity and the Renaissance became the primary source of fascination with these media, and the magic lantern had anticipated this central innovation of the diorama, it was the moving panoramas as exhibited at the World Exhibitions of the nineteenth century that represented the breakthrough of movement as the core element of the illusion *dispositif*. Simulated journeys on steamships and trains, with images of slowly changing landscapes rolling past, were particularly popular as moving panoramas. Such visual experiences were also introduced into the theater, where long, painted backdrops mounted on rollers, so-called changing panoramas, were pulled past the onlooking audience. See Marie-Louise Plessen, ed., *Sehsucht: Das Panorama als Massenunterhaltung im 19. Jahrhundert*, exhibition catalog, Bundeskunsthalle Bonn (Basel: Stroemfeld/Roter Stern, 1993), 230ff. In the first half of the nineteenth century, the desire to see changing images, whether merely details or as a whole, stationary or moving, led to a great number of popular *mise-en-scènes* of images in which the representation of temporal processes was a constitutive characteristic. Toward the end of the century, panoramas were developed where the audience sat on a rotating platform, and one revolution—to see the entire painting—took twenty minutes.

35. Oliver Grau, *Virtual Art: From Illusion to Immersion* (Cambridge, Mass.: MIT Press, 2003).

36. Generally: Ken Goldberg, ed., *The Robot in the Garden: Telerobotics and Telepistemology on the Internet* (Cambridge, Mass.: MIT Press, 2000), esp. my essay: "The History of Telepresence: Automata, Illusion, and the Rejection of the Body," 226–246.

37. Recently: Martin Rieser and Andrea Zapp, eds., *New Screen Media: Cinema/Art/Narrative* (London: British Film Institute, 2002); Gerfried Stocker and Christiane Schöpf, eds., *ARS ELECTRONICA: CODE = The Language of Our Time* (Ostfildern: Hatje Cantz, 2003).

38. Laurent Mignonneau and Christa Sommerer, "Creating Artificial Life for Interactive Art and Entertainment," in *Artificial Life VII, Workshop Proceedings* (Portland: University of Portland 2000), 149–153.

39. See Christopher G. Langton, ed., *Artificial Life* (Cambridge, Mass.: MIT Press, 1995); M. A. Bedau, "Philosophical Content and Method of Artificial Life," in *The Digital Phoenix: How Computers Are Changing Philosophy*, ed. T. W. Bynam and J. H. Moor (Oxford: Blackwell, 1998), 135–152.

40. See Thomas Ray, "An Approach on the Synthesis of Life," in *The Philosophy of Artificial Life*, ed. Margaret Boden (Oxford: Oxford University Press, 1996), 111–145.

41. Laurent Mignonneau and Christa Sommerer, "Modeling Emergence of Complexity: The Application of Complex System and Origin of Life Theory to Interactive Art on the Internet," in *Artificial Life VII: Proceedings of the Seventh International Conference*, ed. M. A. Bedau (Cambridge, Mass.: MIT Press, 2000).

42. This aspect was the focus of two conferences on emotions organized by the Academy of the Berlin-Brandenburg Academy of Sciences in Menaggio, which included interdisciplinary approaches to the effects of emotional stimuli on observers of images generated by various media. A very recent publication in this area from an interdisciplinary perspective is Oliver Grau and Andreas Keil, *Mediale Emotionen* (Frankfurt am Main: Fischer, 2005).

Islamic Automation: A Reading of al-Jazari's *The Book of Knowledge of Ingenious Mechanical Devices* (1206)

Gunalan Nadarajan

Introduction

The *Kitab fi ma rifat al-hiyal al-handasiyya* (*The Book of Knowledge of Ingenious Mechanical Devices*) by Ibn al-Razzaz al-Jazari was completed between 1202 and 1204 and published in 1206. It was arguably the most comprehensive and methodical compilation of the most current knowledge about automated devices and mechanics. The work systematically charted out the technological development of a variety of devices and mechanisms that both exemplified and extended existing knowledge on automata and automation. Donald Hill, who translated and has done the most to promulgate the importance of this text, claimed, "[I]t is impossible to overemphasize the importance of al-Jazari's work in the history of engineering. Until modern times there is no other document from any cultural area that provides a comparable wealth of instructions for the design, manufacture and assembly of machines. . . . Al-Jazari did not only assimilate the techniques of his non-Arab and Arab predecessors, he was also creative. He added several mechanical and hydraulic devices. The impact of these inventions can be seen in the later designing of steam engines and internal combustion engines, paving the way for automatic control and other modern machinery. The impact of al-Jazari's inventions is still felt in modern contemporary mechanical engineering" (Hill 1998, 231–232).

This essay presents al-Jazari's *The Book of Knowledge of Ingenious Mechanical Devices* (1206) as a significant contribution to the history of robotics and automation insofar as it as enables a critical reevaluation of classical notions and

the conventional history of automation and therefore of robotics. Al-Jazari is in some ways the most articulate of what is a long tradition of "Islamic automation" in Arabic science and technology wherein automation is *a manner of submission* rather than the means of control that it has come to represent in our times. Thus, al-Jazari's work is presented as exemplary of Islamic automation, where the notions of control that have informed the conventional history of automation and robotics are substituted by subordination and submission to the rhythms of the machines. It is proposed here that "Islamic automation" also provides some interesting examples of what I call "untoward automation," which involves the deliberate and elaborate programming for untoward behavior in automated devices. In addition to articulating the cultural specificities of technological development, this essay positions al-Jazari's work as a catalyst for critical readings of and new directions in robotic arts.

Islamic Science and Technology

Before embarking on a presentation of al-Jazari's work, it is useful to contextualize the Islamic science and technology that informed and substantiated his work. It is noteworthy that the Abbasid caliphate that ruled over most of the Arab world from 758 to 1258 C.E. emphasized and encouraged the systematic development of science and technology. With its new capital in Baghdad, the Abbasid caliphate, especially during the rule of al-Mamun (819–833) invested huge amounts of resources in cultural activities and scientific scholarship. Al-Mamun was a firm believer in the value of drawing, as can be seen in the intellectual traditions of Greek, Sanskrit, and Chinese knowledge that thus infused Islamic science and technology. It is noteworthy that a substantial portion of Greek texts was translated into Arabic under the Abbasid caliphate, especially from the mid-eighth century until the mid-eleventh century. The principal driving force behind these translation initiatives was the establishment of the library, Khizanat al-Hikma (The Treasury of Knowledge), and a research institute, Bayt-al-Hikma (House of Wisdom), in the early ninth century. This quest toward developing a comprehensive knowledge resource was so ambitiously pursued that by the middle of the tenth century, the caliphate had gathered close to 400,000 volumes, and by 1050, all significant works of the Hellenistic period were available in Arabic (see Hill 1993, 10–14).

It is noteworthy, though, that our current notions of science and technology are significantly different from those that mediated the quest for knowledge in Islamic societies. The word, *'ilm*, that is most commonly used to denote "knowledge" in Arabic, Hill reminds us, included a wide range of fields as astronomy, mechanics, theology, philosophy, logic, and metaphysics. This practice of not differentiating between seemingly separate fields is best understood in the context of the Islamic view of the interconnectedness of all things that exist and wherein the quest for knowledge is a contemplation on and discovery of this essential unity of things. It is this essential unity and coherence of all things in the world, referred to in Islamic philosophy as *tawhid*, which makes it almost impossible to articulate and maintain the distinctions between the sciences and other areas of inquiry and experience.

According to Avicenna, a significant philosopher-scientist and an important Islamic proponent of this view:

[T]here is a natural hierarchy of knowledge from the physics of matter to the metaphysics of cosmological speculation, yet all knowledge terminates in the Divine. All phenomena are creations of Allah, His theophanies, and nature is a vast unity to be studied by believers as the *visible sign* of the Godhead. Nature is like an oasis in the bleak solitude of the desert; the tiny blades of grass as well as the most magnificent flowers bespeak of the gardener's loving hand. All nature is such a garden, the cosmic garden of God. Its study is *a sacred act*. (Cited in Bakar 1999, 114; emphases mine)

In Islam, Avicenna's notion of "visible sign" is embodied in the term, *a' yat* (sign), where the scientific study of the natural world and its manifestations issues not from an impassioned curiosity but from a passionate quest to discover these signs and thus arrive at a better understanding and appreciation of God's magnificence. The Qur'an has several instances where this invocation to Muslims to decipher the *a' yat* is made. For example, in Surah 10: "He it is who has made the sun a [source of] radiant light and the moon a light [reflected], and has determined for it phases so that you might know how to compute years and to measure [time] . . . in the alternative of night and day, and in all that God has created in the heavens and on earth, there are messages indeed for people who are conscious of Him" (cited in Bakar 1999, 70).

Bakar argues that in thus deciphering the peculiar ways in which each thing manifests itself and exists in this world, one arrives at an understanding

of its specific *islam* (manner of submission), that is, of how that thing submits to the will of God (Bakar 1999, 71). This notion of *islam* as a manner of submission is a useful reference point to begin a discussion of the Islamic notion of technology. While it is logical to assume that the Islamic notion of technology is related to and continuous with its notion of *'ilm*, there are practically no scholarly studies that are dedicated to the exploration of the Islamic conceptualization of technology. Although there are several works that exhaustively *describe* the various technologies developed by Islamic societies and scholars, these works rarely deliberate on their specific philosophical and cultural underpinnings. This paucity might be indicative of the refusal within Islamic thought to present technology as a *material application* of scientific knowledge, a practice that is common in many conventional histories of technology. It is suggested here that in the Islamic worldview, technology is yet another *a' yat* but of a different sort. It is suggested that technological objects are signs that have been *made to manifest as such by human design*. And it is important here to clarify that this design itself is a sign of the submission of the person who "makes" the technological object as much as it is a sign of the object's functional operations reflecting its own manner of submission. In Islamic aesthetics and technology alike, the notion of the human creator is philosophically subordinated to that of God the creator. The task of human creativity in Islamic thought is thus conceived as that of *referring to* and *making manifest God's creative work* rather than "showing off" one's own ability to create. In this sense, then, technological objects are also *a' yat* that manifest the *islam* or "manners of submission" of those forces and processes that are implicated in them.[1]

"Fine Technology" as Genealogical Nexus

In this reading of al-Jazari's work I draw on Michel Foucault's genealogical method. It is well beyond the scope of this essay, however, to engage in a full explication of the specific details and values of the genealogical method in reading histories of technology. Thus, what will be presented here is a very brief introduction to the principal elements of the genealogical method as formulated by Foucault via his reading of Friedrich Nietzsche.

According to Nietzsche, who first formulated the critical possibilities of genealogy as historical method: "whatever exists, having somehow come into being, is again and again reinterpreted to new ends, taken over, transformed,

and redirected by some power superior to it; all events in the organic world are a subduing, a becoming master, and all subduing and becoming master involves a fresh interpretation, an adaptation through which any previous 'meaning' and 'purpose' are necessarily obscured or even obliterated" (Nietzsche 1967, 77). Thus, the meaning of a thing in history is not fixed and unchanging as is sometimes conveniently assumed in conventional historical methods.

The conventional historiographical practice usually seeks out the *Ursprung* (origin), wherein there is, Foucault claims, "an attempt to capture the exact essence of things, their purest possibilities and their carefully protected identities because this search assumes the existence of immobile forms that precede the external world of accident and succession" (Foucault 1980, 142). The genealogical method in contrast is governed by the *Herkunfts-Hypothesen* (descent-hypothesis) that turns away from such metaphysical preconceptions and "listens to history"; leading the historian to the discovery that there is no eternal essence behind things; that things "have no essence or that their essence was fabricated in a piecemeal fashion from alien forms" (Foucault 1980, 142). With his ears cocked up to detect the faintest of sounds made within the historical space, the genealogist finds "not the inviolable identity of their origin," but rather "the dissension of other things." "Genealogy," he thus claims, "is gray, meticulous, and patiently documentary. It operates on a field of entangled and confused parchments, on documents that have been scratched over and recopied many times" (Foucault 1980, 139). Foucault also argues that genealogy is able and attempts to record events in their singularity without reference to some teleological design or purpose. He recognizes the usefulness of the genealogical method in subverting the totalizing histories that grew from the Hegelian teleological versions of history where notions of "purpose" or "utility" tended to predetermine the specific ways in which a thing's history was "always already" interpreted.

The primary value of the genealogical method in interpreting histories of technologies, it is proposed here, is in its suspension of utility or instrumental rationale of a technological object in its readings.[2] The genealogical method forgoes the notion of "original" utility in predetermining interpretation and instead seeks out the specific discourses and practices that constitute a particular technological object or experience. In this essay, it is proposed that there is a *genealogical nexus* between what have been variously described and discussed as machines, automation, and robotics. In formulating the link between them

as genealogical, the conventional practice of identifying either one of them as preceding or proceeding from the other (i.e., the habit of origin-seeking) is problematized. It is suggested here that one develops a better appreciation of their complex historical interactions and contemporary constitution by working from this *temporary suspension of their differences* within this nexus. It is also proposed here that the notion of "fine technology" provides a useful reference point to instantiate and analyze this nexus between machines, automation, and robotics. "Fine technology," science and technology historian Donald Hill states, "is the kind of engineering that is concerned with delicate mechanisms and sophisticated controls" and that "before modern times, comprised of clocks, trick vessels, automata, fountains and a few miscellaneous devices." Hill notes that the "apparent triviality of these constructions should not . . . be allowed to obscure the fact that a number of the ideas, components and techniques embodied in them were to be of great significance in the development of machines technology" (Hill 1993, 122).

Some of the earliest examples of fine technology are recorded in the works of an Egyptian engineer, Ktesibius from Alexandria circa 300 B.C.E. Vitruvius, the architect and theorist, claims that Ktesibius invented the organ and monumental water clock. According to Devaux, "Diodorus Siculus and Callixenes give this description of animated statues of gods and goddesses that featured at the festivities organized in 280 B.C. by Ptolemy Philadelphus in honor of Alexander and Bacchus: a four-wheeled chariot eight cubits broad, drawn by sixty men, and on which was a seated a statuette of Nysa measuring eight cubits, dressed in a yellow, gold-brocade tunic and a Spartan cloak. By means of a mechanism she would stand up unaided, pour out milk from a golden bottle, and sit down again" (P. Devaux, cited in Ifrah 2001, 169). The works of Philo from Byzantium (230 B.C.E.) whose text *Pneumatics* exists in a number of Arabic versions has also described a variety of automata and trick vessels that exemplify early fine technology. Another early text, which again only exists in Arabic versions, is *On the Construction of Water Clocks* by Archimedes. This work, though suspected to have been only partially written by him with later additions by Islamic scholars, was instrumental in introducing some of the principles of water-mediated control and power generation that was systematically developed by Islamic engineers. Hero from Alexandria (first century C.E.) is probably one of the most well-known and most widely read of the authors of fine technology. His primary texts are *Pneumatica* and *Automata*, where he expounds on the fundamentals of pneumatics and plans

for a variety of machines and automata that embody and are driven by such pneumatic forces.

While there are several important and interesting exponents of fine technology exemplifying Islamic automation, for the purposes of this essay, we will restrict our discussion to the work of the Banu Musa. *Kitab al-Hiyal* (The Book of Ingenious Devices) by Banu Musa bin Shakir (9th c.) is one of the foundational texts for the development and systematic exploration of automated devices in the Islamic world. It is clear from the various references in their text that they knew of Hero's work, which had already been translated by Qusta Ibn Luqa during their time (c. 864) and possibly with their support. In fact, of the slightly more than one hundred devices that they describe in their book, Hill identifies twenty-five devices with similar features to and in some cases almost completely resembling Hero's and Philo's automata. However, it is crucial here that despite these similarities in the physical and operational features between these automata, the culturally specific ways in which these machines were conceived and used by the Banu Musa are significantly different enough for one to be cautious not to perceive their work as simply derivative. It is also noteworthy that the Banu Musa were inventors in their own right and that there are several machines described in this book that are uniquely theirs and perhaps even invented by them. For example, their fountains are unique in their designs and mechanical features. Hill claims that the Banu Musa "display an astonishing skill in the manipulation of small variations in aerostatic and hydrostatic pressures." This attention to and ability to harness minute variations required the use of several innovative mechanisms including the crankshaft (which Hill suggests is the first recorded use of this historically significant technology); a variety of and differently arranged siphons; float valves that helped mediate and trigger the changes in water levels; throttling valves that helped maintain regular flow with minimal water pressure; and most importantly, the development of a sort of "on–off" control mechanism that responded to distinct and varying limits.

The Book of Knowledge of Ingenious Mechanical Devices

Al-Jazari was in the service of Nasir al-Din, the Artuqid King of Diyar Bakr, and he spent twenty-five years with the family, having served the father and brother of Nasir Al-Din. Al-Jazari notes in his introduction to the book that he "never began to construct a device of mine without his anticipating it [i.e.

its purpose] by the subtlety of his [the king's] perceptions" (al-Jazari 1206/ 1976, 15; words in brackets mine). While this patronage provided him with the financial means to continue his own research into the development of such devices, he felt obligated not just to make these machines for the benefit of the functional and aesthetic pleasures of the king but also to record it in for future generations and more importantly to contextualize his own work in relation to that of his predecessors whose works he was well aware of. He explicitly and/or indirectly refers to the works of Hero, Philo, Archimedes, Banu Musa, al-Muradi, and Ridwan—drawing upon the technical achievements and mechanical peculiarities of their works even while quickly noting how he has tried to further refine and depart from their mechanisms.

The book is presented in six categories (*naw'*)—ten chapters on water clocks, including one of his most dramatic and ambitious, Elephant Clock; ten chapters on what are called "vessels and figures that are suitable for drinking sessions" presenting a variety of trick automata vessels dispensing wine and water; ten chapters on water dispensers and phlebotomy (blood-letting) devices; ten chapters on fountains and musical automata, some of the devices explicitly seeking to improve on the rhythms and patterns expressed by the fountains of the Banu Musa; five chapters on water-raising machines—one version of which still survives in Damascus, in the As-Salhieh district on the slopes of Mount Qassiyoun; and five chapters on a miscellaneous list of machines, including geometrical designs for a latticed door, an instrument for measuring spheres, and a couple of locks. These devices are presented as *hiyal* (ingenious devices) that are driven by two forms of motive power, water and air pressure. The motive power of these pressures are inherently unstable and capricious and thus had to be managed in complex and meticulous ways so as to create the desired effects.

Jazari's descriptions are methodical and ordered in a form that he rarely veers from. He typically begins with a general description of the machine and follows this with a number of sections that provide details on the specific ways in which the machines work, along with accompanying drawings that illustrate the structural aspects of the machine. It is useful to note that these illustrations are relatively static with little or no dynamic elements incorporated into them to suggest their potential movement—the dynamics of the machines are only described through his exhaustive and point-to-point descriptions of how the mechanism works. In the following section, the descriptions of several automata are presented as in the original texts so as to

enable a clear understanding of style, detail, and specific mechanical outcomes of these machines.

Arbiter (Hakama) for a Drinking Session (Chapter 3 of Category II)

This is an elaborate three part automated *hakama* consisting of three distinct automata—a slave girl on a dais, a castle with four slave girls and a dancer and finally an upper castle with a horse and rider. The highly ritualized session begins with a servant bringing the automata in three different sections and assembling them in the middle of a drinking party seated in a circle around it. It is then left in the middle of the assembly until a period of *about* twenty minutes has elapsed. Then it emits an audible musical sound and the horse and rider rotate slowly past the members of the assembly as if to stop opposite one of them. The dancer makes a half turn to his left and [then] a quarter turn to his right. His head moves, as do his hands, each holding a baton. At times, both his legs are on the ball. At times [only] one. The flautist plays with a sound audible to the assembly and the slave girls play their instruments with a continuous regular rhythm, with varied sounds and drumbeats. [This continues] for a while and then the rider comes to a halt, with his lance pointing to one of the party. The slave girls are silent and the dancer is still. Then the slave girl tilts the bottle until its mouth is near the rim of the goblet, and pours from the bottle clarified, blended wine till the goblet is nearly full, whereupon the bottle returns to its previous position. The steward takes it [i.e., the goblet] and hands it to the person toward whom the lance is pointing. [After the goblet is drained] the steward puts it back in front of the slave girl. This is repeated about twenty times, at intervals of about twenty minutes. Then the leaves of the door in the upper castle open and a man emerges from the door, his right hand indicating "no more wine" and the left hand indicating "two more goblets." (al-Jazari 1206/1974, 100)

Boat of Automata (Chapter 4 of Category II)

The boat is placed on the surface of a large pool of water, and is seldom stationary but moves in the surface of the water. All the time it moves the sailors move, because they are on axles, and the oars move it [i.e. the boat] through the water until about half an hour has elapsed. Then, for a little while, the flute player blows the flute and the [other] slave girls play their instruments that are heard by the assembly. Then they fall silent. The boat moves slowly on the surface of the water until about half-an-hour has passed [again]. Then the flute player blows the flute audibly and the slave girls play the instruments, as happened the first time. They do not desist until they have performed about fifteen times. (al-Jazari 1206/1974, 107)

Perpetual Flute (Chapter 10 of Category IV)

Water flows from the supply channel and falls into funnel N and flows through end H of the pipe because it is tilted toward tank K and float E. It runs through hole P into tank A, driving the air from it, which streams into pipe J. The flute plays until the water rises to the level in the siphon S—the hole P is narrower than end H [of the pipe]. The water rises in the tank of float E, the float rises and lifts the extension H with its rod, pipe L tilts and discharges from end T into tank Z and float W. Water runs through hole Q into tank B, driving the air from it, which streams through pipe D into the flute's jar, which plays like a flute until tank B is filled. The water rises to the bend in siphon F, and in the tank of float W, which rises, lifting the extension of end T with its rod. The water in tank A has evacuated through siphon S. Then the water runs away from end T, which comes away from tank B. And so on as long as the water flows. (al-Jazari 1206/1974, 176)

Islamic Programming

Hill claims that one main distinguishing feature of the Arabs was a constant striving after control in order to construct machines that "would work automatically for long periods *without human intervention*" (emphasis mine). He states, "many types of control, most of which are thought of as quite modern, were employed to achieve these results: feed-back control and closed-loop systems, various types of automatic switching to close and open valves or change of direction of flow, and precursors of fail-safe devices" (Hill 1998, vol. 4, 30). In relation to al-Jazari's machines, Hill is similarly puzzled that in some cases "the techniques devised for given purposes were often more sophisticated than were strictly necessary. It is simpler, for example, to maintain a static head by fixing an overflow pipe, rather than using a valve-operated feedback control" (Hill 1998, vol. 2, 233).

Ifrah claims that al-Jazari in his works "gives a description of true *sequential automata*, driven notably by a camshaft, which transforms the circular motion of a sort of crankshaft into an alternating motion of a distributor: such automata thus mark a break with the Greco-Roman concept of the simple device endowed with automatic movements" (Ifrah 2001, 171). This, he argues, is a significant milestone in the *sequential programming* of machines, in that he views it as having achieved a greater level of control over the movements. While this retrospective reading of al-Jazari's works as yet another tendency in the greater teleology of the striving toward machines that achieve greater

levels of control fits well into a cybernetic conceptualization of the history of automata, it fails to acknowledge the religious and cultural specificities that informed Islamic automation as that exemplified by al-Jazari. It is suggested here that the reasons for these elaborate mechanisms devised by Islamic engineers were informed by the religious worldviews within which the works were conceptualized and made.

As discussed earlier, since the notion of Islam requires the human creator to always subordinate his creative interventions to those of God as creator, these devices need to be understood not as means to show how effectively and efficiently one could control the natural forces of air and water but as conduits of allowing these forces *to play out* their capricious movements that were pleasurable because they conceived as *expressions of God's will*. It is not surprising therefore to note in several of the early texts on automata, specifically that of the Banu Musa, the expression "if God wills" accompanying the technical descriptions of several devices. The fact that this has become such a conventional expression in the everyday lives of Muslims might make one doubt that these references are anything but conventionalized ways of speaking and writing in these societies, and thus might make it seem not worthy of serious attention. However, this notion of including divine will in mechanical treatises is peculiar to Islamic scholars of the medieval period and thus needs to be understood within the context of how religion mediates scientific and technological aspirations.

One of the most conspicuous uses of this expression in mechanical treatises is that of the Banu Musa. In describing one of their trick vessels (Model 20) which dispenses a variety of colored liquids through a complex series of siphons, they state: "It is [also] possible for us to install floats and valves in this jar as we did in the pitcher that accepts [nothing], if God wills" (Banu Musa 1979, 80). While many of their trick vessels rely on the subtle "sleights of hand" of an accomplice servant who manages the flow or lack thereof through a hole that controls the aerostatic pressures in these vessels, some of them are based on the motive power of hydrostatic and aerostatic pressures, which are not easily subject to such artful manipulations. It is significant that they begin using the expression "If God wills" in Model 20 in reference to a trick vessel of the latter kind.

It is impossible within the scope of the present essay to systematically study other comparable texts of this period and make an assessment of the significance these Islamic engineers placed on divine will in mechanical devices and

processes. However, based on the organic context within Islamic science and technology developed as an extension of religious inquiry in the medieval period coupled with such explicit articulations, as noted above, of the relationship between divine will and mechanical processes, it is useful to remain attentive to these interconnections. It is pertinent here that the creative programming of these devices issues not from an engineering intent to achieve greater levels of control but as a means to show the sophisticated ways in which divine will operates in or on the world. Thus the elaboration and sophistication of these machinic processes seem to be aimed at ensuring the most conspicuous and viscerally pleasing expression of the wonders of divine will.[3]

Untoward Automation

Some aspects of Islamic automation support a useful model for rethinking programming for robotics and automation in terms of untoward automation—one *where predictable movement is substituted by unpredictable or untoward behavior.* It should be emphasized here that programming for untoward behavior is not the same as programming for emergent behavior, as the former is unpredictable by structurally enabling difference without setting the parameters of such differential effects. According to Ifrah, one of the principal breakthroughs in programming that led to the development of the computer was "to devise a machine whose functioning would be controlled by a modifiable control unit governed by a sequence of instructions recorded on a malleable input medium that was independent of the material structure of the internal mechanisms" (Ifrah 2001, 178). Interestingly and conversely, one of the features that enables Islamic automation to sustain its untoward behavior is the fact that there is no such separation. The material structure of these automata, the motive power that drives them and the material elements that support the sequential programming are intricately interconnected. In the concluding part of this essay, some unique features of this "untoward automation" are presented through a discussion of three kinds of automata developed by al-Jazari.

For the fountains (*fawwara*) that al-Jazari developed and describes in his book, he claims to have drawn some of his ideas from his predecessors, the Banu Musa. Al-Jazari had very specific ideas of how to improve on the designs of the Banu Musa. He claims that of the fountains that change shape (*tabaddala*), "I did not follow the system of the Banu Musa, may God have mercy

upon them, who in earlier times distinguished themselves in the matters covered by these subjects. They made the alternation with vanes turned by wind or by water do so that the fountains were changed at every rotation, but this is too short an interval for the change to appear (to full effect)" (al-Jazari 1974, 157). Al-Jazari was obviously more concerned with creating an aesthetic experience one could dwell on rather than presenting such fountains as mere distractions. This concern toward prolonging, intensifying, and diversifying the experiences of those who encounter these devices is also found in an another discussion (category IV, chapter 7) where he notes this of a particular musical automaton designed by a predecessor which he had personally examined: "even if the [water] wheel caused a number of rods to fall in succession it would not be slow enough to display the changes adequately." However, his designs, despite their attention to longer intervals between spurts, coordinated alternations, and diverse shapes, only seemed to be more programmed. The composite result of these programs do not seem to be focused on creating more predictable fountains that had a regularized rhythm but to bring a greater level of variety and depth to the experience without compromising on the untowardness of the fountains' repertoire.

In the various phlebotomy (blood-letting) devices he constructed, al-Jazari incorporates elements into its automated operations that show sensitivity to the psychological state of the patient who is being bled (*al-mafsud*). He states clearly at the outset of the section where he discusses these devices that "it is based upon [the work of] a predecessor, that was simply a sphere for collecting the blood. I have excelled him with various designs" (al-Jazari 1974, 136). He describes how one of these devices incorporating two automated scribes is programmed to switch constantly between providing accurate information to the patient on the exact amount of blood that is filling the basin and also distracting the patient from these indicators. He writes, "I decided to use two scribes because the scribe in the circle rotates and then his pen becomes invisible to the patient, and the scribe's back turns toward the patient's face, while the board [that reveals the measurements] is not concealed from him at all" (al-Jazari 1974, 146; words in brackets mine). Al-Jazari also incorporates within this particular bloodletting device an elaborate mechanism for constantly distracting the patients even while reassuring them that the procedure is progressing smoothly. He has incorporated within the castle, which forms the principal motif for this device, a series of twelve automated doors that open each time a specific quantity (in this case, 10 *dirhams*, equivalent to 30 grams)

has been gathered in the basin, to reveal an automaton (a young male slave) that carries a board indicating "ten" so as to reinforce the measurement indicated initially by the automated scribe. One can easily imagine how the constant distraction provided by the rotating scribes and the successive openings of the doors that result therefrom would have helped a patient get through this painful procedure.

With regard to the Boat of Automata described above, Hill interestingly comments, "no method is described for imparting movement to the sailors, which indeed could only have been done while water was being discharged, not throughout the entire session" and also that "the interval between successive discharges would lengthen as the static head in the reservoir fell" (Hill 1974, 256). These comments indicate first, an inability on the part of Hill to fully appreciate the aesthetic appeal of the untoward automation that many of al-Jazari's automata seem to exemplify, where one's amusement derives not in the continuous and regular rhythms of automated performance but in the unpredictable and therefore surprising flurry of movements. For example, Hill has elsewhere noted that an important feature of Islamic machines is "the frequent occurrence of delayed-action mechanisms, which delayed the opening or closing, until a set period had elapsed" (Hill 1976, 233). However, Hill does not seem to consider the possibility that these delays were not always seeking to effect control over the timing of the automated movements, especially since the delays did not mediate the motive power so as to effect a controlled movement. Very often what resulted from these delays was a movement that had an order that was within certain predefined but not completely controlled parameters. So these delay mechanisms might have been more focused on an elegant management and "languishing within" the subtle caprices that resulted from them rather than on their control.

Conclusion

This essay is a modest contribution to the displacement of al-Jazari from the linear and conventional histories of automata that view him as an early proponent of "not yet so effective" methods of controlling machinic movements through programming. It has been argued here that the task of what has been referred to here as Islamic automation reflected in al-Jazari's works was not to achieve effective control over an automata but to present through these

automated processes a vicarious expression of divine will and the peculiar *manners of submission* inherent to those forces that provide the motive power for these devices. It has also been suggested that al-Jazari's work provides a useful platform to rethink automation in terms of untoward automation—a notion that might prove especially significant in developing new ways of working with robotic arts that are not informed by and therefore celebrate the departure from the instrumental logic of conventional robotic programming.

Notes

1. It is important here to clarify that although I elaborate a notion of how Islamic technology was conceived within a particular historical context, it is impossible within this essay to extrapolate and extend the study into how such religiously framed notions of technology operate in contemporary Islamic societies.

2. A more thorough analysis of the historiographical value of the genealogical method for the history of technology, though necessary, is well beyond the scope of this essay.

3. It has been suggested that conceptualizing these machines as being structured to express submission rather than achieve control does not represent a radical difference in interpretation insofar as submission is nothing more than the dialectical flipside of control. While it is true that one could conceptualize "control–submission" as a dialectical relationship expressed within machinic processes, this does not problematize the fact that control-oriented discourses of cybernetics and the industrial revolution that have informed conventional histories of automation are radically different from those that informed medieval Islamic engineering of automata.

References

al-Jazari, Ibn al-Razzaz. 1206. *Kitab fi ma 'rifat al-hiyal al-handasiyya. (The Book of Knowledge of Ingenious Mechanical Devices.)* Translated and annotated by Donald R. Hill. Dordrecht; Borton: Reidel, 1974.

Bakar, Osman. 1996. *The History and Philosophy of Islamic Science.* Cambridge: Islamic Texts Society.

Banu Musa, bin Shakir. 1979. *The Book of Ingenious Devices (Kitab al-Hiyal).* Trans. Donald R. Hill. Boston: D. Reidel.

Chapius, Alfred, and Edmond Droz. 1958. *Automata: A Historical and Technological Study*. Trans. Alec Reid. Neuchâtel: Éditions du Griffon.

Foucault, Michel. 1980. *Power/Knowledge: Selected Interviews and Other Writings, 1972–1977*. Ed. Colin Gordon. New York: Pantheon Books.

Hill, Donald R. 1993. *Islamic Science and Engineering*. Edinburgh: Edinburgh University Press.

Hill, Donald R. 1998. *Studies in Medieval Islamic Technology*. Ed. David A. King. Ashgate: Variorum Collected Studies Series.

Ifrah, Georges. 2001. *The Universal History of Computing: From the Abacus to the Quantum Computer*. Trans. E. F. Harding. New York: John Wiley.

Nietzsche, Friedrich. 1967. *On the Genealogy of Morals*. Trans. Walter Kaufman and Robert Holingdale. New York: Vintage Books.

Seyyed, Hossein Nasr. 1968. *Science and Civilization in Islam*. New York: New American Library.

II

Machine—Media—Exhibition

The Automatization of Figurative Techniques: Toward the Autonomous Image

Edmond Couchot

Figurative techniques depend on a whole array of procedures, which frequently aim at limiting the amount of time, materials, and movements involved in the creative process. This entails making certain operations automatic in order to alleviate part of the physical or intellectual work of the image-maker. The tendency toward *automatization* appears very early in the history of images. The handprints on the walls of Magdalenian caves already bear witness to this tendency, regardless of their symbolic significance. Again, one finds the same quest for automatization in the invention of complex machines for weaving and tapestry-making.

Optic, Geometric, Chemical, and Electronic Procedures

The search for automatization is neither constant nor systematic throughout the ages, but depends rather on historical conditions. Sometimes, figurative techniques did not evolve much for very long periods of time, as was the case during part of the Middle Ages. It also happened that they changed quite fast, as in the Renaissance period. Indeed, in the early fifteenth century the automatic processing of images gained speed. Painters elaborated a figurative technique that enabled them to construct a three-dimensional scene more easily: linear perspective. The procedures were optic and made use of little "viewing machines" (perspectographs). They were also geometric: there were "legitimate constructions" of "basic squares," and also the "vanishing point," "distance point," and so on. Remarkably, the perspectivist model of construction

prevailed in painting, with a few stylistic variations, until cubism proposed another model in the early twentieth century.

At the same time, during the nineteenth century, the automatization of figurative techniques underwent considerable change. Photography, whose principle of optical projection was isomorphic to that of perspective, made it possible not only to obtain an image resembling reality through chemical and optical means, but also to fix this image, and, with the invention of the negative, to copy it indefinitely. Perspective was only a first step in the automatization of images and was still largely based on the hand and the eye of the painter, but the full expansion of automatization started with the appearance of photography. From then on, image-making was set on a frantic race to automatization, which was greatly enhanced by scientific and industrial progress.

Cinematography made it possible to record images, no longer by rapidly slicing the flow of time, but by capturing time sequences of a certain duration that one could copy indefinitely like photos. Automatization made a great leap forward with television. Not only could television produce images that gave the illusion of movement like cinema, but it could also broadcast them automatically at considerable distances via Hertzian and cable transmission at the very second they were shot. Traditional images are always obtained by leaving a trace (a material trace in the case of painting, an optical-chemical trace in the case of photography and cinema, and an optical-electronic trace in the case of television).

Yet it is remarkable that even though automatization increases and its functions become ever more complex, photographic, cinema, and TV images follow a generally identical conception and perception of time and space in which the subject and the object are defined in relation to each other, in diametrical opposition on each side of the projection plane. The subject always occupies an epistemic position as he or she remains the master of viewpoint. These techniques produce the vast majority of images, and their diffusion has created a series of perceptive habits (a perceptive habitus) that is all-pervasive and universally shared by image-makers and image-viewers alike, regardless of their cultural differences.

Digital Procedures

With digital images, a radically different automatization mode appears. Let's not forget that digital images have two fundamental characteristics that

distinguish them from the images mentioned earlier: they are the result of an automatic calculation made by a computer. There is no longer any relation or direct contact with reality. Thus the image-making processes are no longer physical (material or energy-related), but "virtual."[1] Also, digital images are interactive, that is to say they can establish a form of dialogue with those who create or watch them—to the extent that interactive digital images exist only if their viewer (and their creator first) interacts with them.

The position of object, image, and subject is no longer linear. Through the interfaces, the subject hybridizes himself with the object and the image. A new feature of subjectivity is appearing. According to Roy Ascott, for example, subjectivity is no longer localized in a sole point in the space but distributed through the networks; according to Siegfried Zelinski, subjectivity is the possibility of action at the frontier of the networks; according to Pierre Levy, subjectivity has become fractal; Derrick de Kerckhove speaks of "borrowed subjectivity," the possibility of "alienarization." Therefore a new perceptive habitus is emerging.

Calculation and interactivity endow images with technical faculties that no images have ever possessed before. The computer automatically creates the shapes, the colors, the movements of the image—or more accurately of the *virtual semiotic objects* that the image simulates and from which it is inseparable: the digital image that shows on a screen is not only a luminous surface that the eyes see, it is also the product of a calculation, a program and a machine. Again, computers control the modes of circulation and reception of images, that is to say their socialization (from multimedia to the Internet). Computers deal more and more with operations that were previously performed only by humans, and each step in technical progress pushes the automatization of figurative processes a little further.

The development of modeling techniques shows this clearly. The first graphic tools made a number of operations previously limited to traditional automatic tools, while simultaneously offering new possibilities. These first graphic devices only processed two-dimensional images, but were soon joined by other tools that were designed to process more and more realistic three-dimensional images and set them in motion. Nevertheless, the two- or three-dimensional visual objects that composed images remained rudimentary and totally dependent on the programmer. But, thanks to research carried on simultaneously, in particular in artificial life and intelligence, these very disciplined objects were progressively endowed with the faculty to perceive

certain specific characteristics of other virtual objects (e.g., shapes, colors, positions, speeds, trajectories), and to engage in more and more complex relations with them or with the viewer.

Thus, images—that is to say, the virtual semiotic objects composing them—became capable of *behaving* like more or less sensitive, "intelligent," and lively artificial beings—more or less *autonomous* beings. Let's understand "autonomous" to mean *capable of creating its own laws*.

Autonomy and Artificial Intelligence

This idea of autonomy is not a novelty; it was already around as early as the mid-1950s—at the very time computers were invented—when von Neumann propounded a theory of self-reproducing automata. Some time later, John H. Conway, a mathematician, invented his famous "Game of Life" which was able to create simulations of virtual live beings that could grow, multiply and die. Christopher Langton then imagined "self-reproducing automata" (fig. 9.1); shortly after came "cellular automata networks," "morphogenetic algorithms" (i.e. Mandelbrot's fractals, Richard Dawkins's biomorphs), and "L-systems." And finally, "genetic algorithms" and the evolutionary strategies inspired by Darwin's theory, based on notions of variation and selection, arrived.

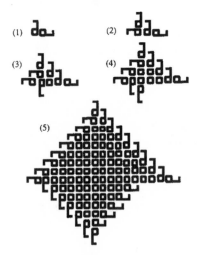

Figure 9.1 Christopher Langton, *Langton's Loops*, self-reproducing cellular automata, 1984.

Edmond Couchot

On the other hand, a new direction in computer research, connectionism was developed along principles different from those used previously by researchers in artificial intelligence, as the latter reduced the mind's operations to a mere series of calculations. We owe to connectionism, among other things, the invention of "neural networks": computer-calculated virtual networks simulating living cells that behave—because of the way they are interconnected—in a way none of them would behave if they were taken in isolation. This is referred to as "emergent" behavior. Neural networks are able to develop "cognitive strategies" and to find nonprogrammed solutions when they are placed in certain situations. They are capable of memorizing information, no longer in the form of data, recorded in the computer's central memory, but in the form of connections linking a relatively large number of elements together.

Artificial life and intelligence then join and reinforce the system's autonomy. At the basis of neural nets and of genetic algorithms, the same principle prevails: that of highly complex interactivity between constituent elements of artificial life and intelligence (genes and neurons) that, thanks to their configuration, interact in order to produce emergent phenomena. Interactivity then enters a more elaborate stage. My colleagues and I suggested the term "second interactivity" to refer to this stage. The evolution of interactivity techniques follows, in this sense, that of cybernetics. Whereas the "first cybernetics" dealt with notions of information, control, and communication (in animals and machines), the second cybernetics deals with notions of self-organization, emergent structures, networks, adaptation, and evolution.

In a similar way, whereas the "first interactivity" focused on the interactions between human beings and computers following the action–reaction or reflex model, the second interactivity examines action insofar as it is led by corporality, perceptions, sensorimotor processes, embodiment, and autonomy (or "autopoiesis," to refer to a concept we owe to Francisco J. Varela[2]). Autonomy itself doesn't form a homogeneous block but can be subdivided in two subgroups, according to certain specialists. The term *"low* autonomy" (or also "low self-organization") concerns systems whose "performances are realized thanks to changes in the connections that were not explicitly programmed,"[3] and *"high* self-organization," systems that accomplish tasks that *"emerge from the way the machine itself evolves"* (ibid.). To the physical and mechanical models of the first interactivity are now added models issued from cognitive science or

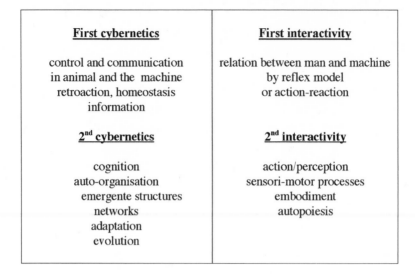

First cybernetics	**First interactivity**
control and communication in animal and the machine retroaction, homeostasis information	relation between man and machine by reflex model or action-reaction
2ⁿᵈ cybernetics	**2ⁿᵈ interactivity**
cognition auto-organisation emergente structures networks adaptation evolution	action/perception sensori-motor processes embodiment autopoiesis

Figure 9.2

biology. Thus computers and the images they produce gradually acquire the characteristics of intelligent and live beings (fig. 9.2).

Autonomy in Interactive Artistic Installations

While programmers are busily involved in research in the fields of artificial life and intelligence, explorers in the field of art have in turn tried to make these techniques their own, in order to create novel images endowed with new aesthetic characteristics. There are few examples, but they are very significant. I will only refer to the work of my colleagues Michel Bret and Marie-Hélène Tramus, from the center of university research I belong to, in collaboration with the neurophysiology department of the Collège de France. The device they set up invites the spectator to interact in real time either with a virtual tightrope walker or with a virtual dancer. The synthetic creature's body is programmed to obey biomechanical laws (its movements stay within the limits of feasibility) and is endowed with reflexes that help it maintain its balance on the ground. These features are imposed on it from the outside by the programmer (fig. 9.3).

But the creature also has a brain made up of a network of virtual neurons. This network enables it to learn certain gestures specific to dance or tightrope

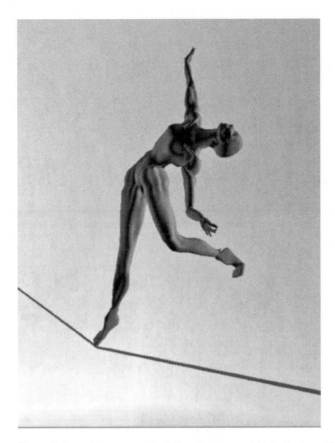

Figure 9.3 Michel Bret, Marie-Hélène Tramus, and Alain Berthoz, *The Virtual Tightrope Walker*, 2004. Copyright Michel Bret. By kind permission of the artists.

walking, by trial and error, during a preliminary training session with a real tightrope walker or a real dancer. During a second phase, a tightrope walker faces the virtual tightrope walker projected on a large screen; she then interacts with the virtual creature through the aid of a sensor placed on her own belt. The moving sensor's speed variations are then analyzed in real time by the computer: the virtual tightrope walker reacts[4] by improvising balancing gestures. These steps haven't been prerecorded in a central memory: they are not those the creature has learned nor do they repeat those of the real tightrope walker.

Rather, they are the result of a compromise between the balancing strategies that the creature has learned and the unexpected movements of the real

Figure 9.4 Michel Bret, Marie-Hélène Tramus, and Alain Berthoz, *The Virtual Tightrope Walker*, 2004. The virtual tightrope walker interacting with a real tightrope walker. See plate 8. Copyright Michel Bret. By kind permission of the artists.

performer. The neural networks configure themselves as the real tightrope walker stimulates them by her gestures, and endow the virtual creature with a certain degree of autonomy—true, of low autonomy in this case, but still, a sufficient degree of autonomy to produce the invention of new gestures. The process is the same when the device brings a real and a virtual dancer face to face. It is also possible to confront the synthetic creature with a spectator who is neither a tightrope walker nor a dancer; the exchange of movements then becomes different (fig. 9.4).

A Reembodied Dialogue

From an artistic point of view, the use of models issued from cognitive science in order to create autonomous visual artifacts capable of reacting to the gestures of real beings has enabled some artists to reinstate the decisive importance of the body, in all its mysterious complexity, at the core of aesthetic

relations. These experimental artists, who draw inspiration from connectionist theories, no longer consider thought as a product of the brain alone (Descartes used to think the pineal gland was the very place to which the soul was attached), but as a product of an indivisible body–brain. Perception and action are closely related and both take part in the elaboration of thought.

This position is opposed to a certain conceptualist vision of art in which the functions of body are considered secondary compared to intentions and pure Ideas. An unprecedented artistic situation springs from the choreographic interaction between real and virtual beings. Indeed, this situation is not too far removed from those provoked by certain interactive "immersion" devices, certain "online" and "offline" multimedia works, or certain hypertexts that can spark the audience's surprise and wonder, their imagination, their desire to explore and play. But autonomy brings an unusual element to interactive relations.

By inviting the spectator to use his or her own body in order to exert an influence on a virtual being endowed with intelligent and perceptive qualities (albeit very primitive, compared to the human body–brain), the dialogue between works and viewers is reembodied: it literally reincarnates. Art then becomes an art of the body questioning itself through itself, an art of the body's thought. It becomes an art that still produces and calls for forms (for there is no formless art), but the forms it produces are of a new kind: no longer the forms of the objects we perceive, but those of our perceptions themselves, grasped as forms, moving, transient, yet aesthetically coherent, on the chaotic background of the world around us.

Conclusion

The application fields of autonomous systems are not limited to images or to physical interactivity. "Intelligent agents" that issue directly from research in artificial life and make up a large part of these systems have filtered into every software. They operate with utmost discretion and their activity is extremely varied: they collect and analyze information (often illegally), control the operations of distributed networks, assist in electronic commercial transactions and accountancy, and perform electronic surveillance (or espionage). Even though these are only the first steps of autonomous computerized systems, they are spreading faster and faster and are increasingly efficient. Their development opens a new phase in human involvement with digital technology.

The capacity of human-made artifacts to simulate intelligence, life, and evolutionary processes will certainly change most human activity dramatically during this century. One can desire this upheaval, and one can certainly find it terrifying. In its attempt to tear these systems away from their mere technological efficiency, should art—or should it not—keep its control over beings it wants to endow with autonomy, in the name of creative freedom? This paradox isn't new, for every artist has always had the desire to see their creations break free from them and enjoy a life of their own in the eyes of others. But it is now set in terms that demand a radically different approach to the question of art.

Notes

1. These calculations rely on modeling algorithms to create realistic or nonrealistic images that are qualified as synthetic. But computers can also treat nondigital images (i.e. paintings, photos) once a scanner has digitized them.

2. On this subject, see Francisco J. Varela, *Autonomie et connaissance: Essai sur le vivant* (Paris: Seuil, 1989).

3. Henri Atlan, *Encyclodaedia Universalis 2004* (DVD), "auto-organization" entry.

4. An exoskeleton placed on a real dancer is used for this purpose. The movement is then analyzed either later or in real time. In the first case the procedures are manual (indicating the positions that were selected) or automatic (extracting remarkable positions). In the second case, the information provided is directly used in a learning process that modifies the matrix of the networks in real time.

Bibliography

Berthoz, Alain. *Le sens du mouvement*. Paris: O. Jacob, 1997.

Couchot, Edmond. *Images: De l'optique au numérique*. Paris: Hermès, 1988.

Couchot, Edmond. "L'art numérique." In *Encyclopaedia Universalis*. Paris: 2002.

Couchot, Edmond. *La technologie dans l'art: De la photographie à la réalité virtuelle*. Paris: J. Chambon, 1998.

Couchot, Edmond. "Virtuel" and "arts technologiques." In *Grand dictionnaire de la philosophie*. Paris: Larousse, 2003.

Couchot, Edmond, and Norbert Hillaire. *L'art numérique: Comment la technologie vient au monde de l'art*. Paris: Flammarion, 2004.

Couchot, Edmond, Marie-Hélène Tramus, and Michel Bret. "A segunda interatividade. Em direção a novas práticas artísticas." In *Arte e vida no século XXI*, ed. Diana Domingues. São Paolo: Editora UNESP, 2003.

Damasio, Antonio R. *Le sentiment de soi-même: Corps, émotion, conscience*. Paris: O. Jacob, 1999.

Heudin, Jean-Claude. *La vie artificielle*. Paris: Hermès, 1994.

Merleau-Ponty, Maurice. *Phénoménologie de la perception*. Paris: Gallimard, 1945.

Rock, Irvin. *La perception*. Bruxelles: DeBœck Université, 2001. Originally published, New York: Scientific American Books, 1984.

Varela, Francisco J. *Principle of Biological Autonomy*. New York: Elsevier North Holland, 1979.

Varela, Francisco J., Evan Thomson, and Eleanor Rosch. *L'inscription corporelle de l'esprit: Sciences cognitives et expérience humaine*. Paris: Seuil, 1993.

Image, Process, Performance, Machine: Aspects of an Aesthetics of the Machinic

Andreas Broeckmann

For many centuries, machines have influenced the way we construct, read, and understand the world. The pantograph is a simple mechanism for magnifying images, while the *camera obscura* allows us to project a proto-photographic image of our surroundings in real time, waiting to be captured in paint or on photosensitive surfaces. Trains traveling from city to city have given us the view from the window, a continuously transforming landscape observed by an unstoppable, fleeting gaze that can only pan, never zoom.

Such mediated approaches to the world have been further dramatized by digital machines, which force their signals to pass through the barely material interface of electrical currents and algorithmical calculations. Digital apparatuses abstract the visible as well as the conceptual, all sensory and mental information, to a high level of ephemerality where only the reconstruction in recognizable, concrete abstractions like text, image, and sound bring them into our perceptual range. Like in a text-to-speech translation program, we are continuously made aware of the construction, sensing the break beyond analog physicality.

There is a growing number of such digitally fed interfaces surrounding us, constructing and driving our shared reality, from office software structuring our working days, through wireless transmission systems enabling complex telecommunications and leisurely derivations, to the hyperpresence of televised images and televised "truths." For want of a better word, we can call this condition *digital culture*, a social environment, field of action and interaction, in which meanings, pleasures, and desires are increasingly dependent on

their construction or transmission and thus on their translation by digital devices. The necessary technical abstraction that the contents have to go through is becoming a cultural condition, which has effects far beyond the actual mechanism of extrapolated signal switching.

The German philosopher and cultural historian Martin Burckhardt suggests, in his study *Der Geist der Maschine*, that "the spirit of the machine" traverses human culture in a deep furrow, tying the invention of alphabets to the discovery of the unconscious and the development of calculating machines. Burckhardt argues for a broad understanding of what constitutes machines, approaching them not so much as technical apparatuses, but as cultural dispositions that articulate and disarticulate human agency, constructing relationships and cutting ties with multiple natures and multiple cultures.

What does it mean to think through the machine in artistic practice? This question lies at the heart of an investigation into an "aesthetics of the machinic," which the following text tries to evoke. Aesthetic experiences are shot through, perforated and articulated by the machinations of machines, apparatuses that are the exoskeletons of our perceptions and expressions. The apparent functional abstractions of digital machines, and their application and development by artists, make it easier to address the machinic also in relation to predigital art.

There is a notion of the digital that posits a deep break of *digital aesthetics* away from the aesthetics based on analog techniques. I will not pursue this discussion here; but I hope that the following will help to suggest that such an understanding of a digital aesthetics hinges on the technical aspects of artistic production. In contrast, an approach that highlights the experiential qualities of art, and the aspects of reception, is more likely to identify an aesthetic continuum between analog and digital aesthetics. This approach implies that, in this respect, media art should not be discussed in separation from contemporary art practice in general.

The recent reevaluation of conceptual art as a precursor to digital media art is an indication that the concepts of media art have evolved in a broader cultural environment in which game theory, cybernetics, space travel, television, genetics, and other areas of human endeavor were having an impact on cultural practices. However, there is much more media art *"avant la lettre"* in other historical periods that can be reread through the paradigms of an aesthetic theory that does not take digital technology as its main cue, but rather takes the machine as a productive and transformative principle.

Some key categories of such a reflection on art theory from the perspective of digital culture will be discussed below. The notion of the "image" is receiving a wide-ranging reevaluation in light of the conditions of its production, distribution, and display in digital culture. Then follow three sections which deal with different concepts of an artistic production that is not oriented toward finished, singular works, but at nonlinear and open, time-based structures (execution, performance, process). These aesthetic categories play a crucial role in computer-based art and can, at the same time, be applied fruitfully to nondigital art. In the last section, the notion of the "machine" is discussed as a conceptual tool for analyzing a particular type of aesthetic work, which hinges not on conveying an authorial artistic intention, but on the experience of machine-based, apparently autonomous processes, which, as is suggested, can be associated with the notion of the sublime. The overall goal of this discussion is a demonstration of the conceptual bridges between different fields of art theory, and a suggestion to mine recent scholarship on computer-based art for a reassessment of other art historical periods.

Image

Media art reminds us that the disciplinary terrain covered by art history extends far beyond the purely visual. While images continue to play a dominant role in our understanding of art, recent time-based, interactive, and generative artworks encourage us to revisit historical art practices and the aesthetic categories that guide their evaluation. While painting, sculpture, architecture, and other art forms produce mostly stable objects that can be viewed and reviewed over extended periods of time, more immediately time-based works have for a long time posed the problem of documentation and retrospective evaluation. Original music and theater performances, dance and ritual, festivities of all kinds, can only be "revived" for historical evaluation to a very limited degree. This is a condition of cultural production and has a strong impact on the way in which cultural traditions evolve.

One of the oldest and still most prevalent forms of artistic abstraction is the image. Its historical study, in a modern understanding of critical evaluation of form and content, has developed over the last four centuries, from the descriptions of the late Renaissance, through the emergence of academic art history at the beginning of the twentieth century, to the recent considerations of a *Bildwissenschaft* (German for "image science," best understood in the tradition

of visual studies). It is worth reconsidering the path that art history has taken from iconography—the study of the coded meanings of images—and iconology—the study of the semantic and generally speaking "social" conditions of producing and reading images. In these two approaches, the image is taken as a given; it is read in depth and contextualized. On the basis of modern hermeneutics, the approach of iconics (*Ikonik* in German) has sought to look more closely at the perceptual production of the image and to study its meaning as a result of the process of reception. Thus, temporal structures within images have come into view not as mere narrative dispositions, but as "programs" that need to be executed and thus actualized by the viewer.

More recently, and on the basis of older philosophical, semiotic, and technical debates, *Bildwissenschaft* or visual studies is asking more generally what "images" are—a question that arises, not accidentally, at a time when digital technologies erode the traditional understanding of the image as a limited surface covered by a visual construction. Digital images are unstable processes, which, even as "static" displays, are the results of continuous and ongoing computations. Printed computer graphics are the analog, arrested results of such processes and are thus not digital images in a narrower sense of the word.

An artist whose work exemplifies this digital dimension of the field of images, is Toronto-based David Rokeby. His long-term project *The Giver of Names* is an interactive installation in which a table surface is observed by a camera system (fig. 10.1). As soon as an object is placed on the table and recorded by the camera, a computer system connected to the camera analyzes the observed visual structure and matches it with a label from an existing database of shapes and words. The results of the analysis trigger a short, quasipoetical text that is composed of words from the database, displayed on a computer screen, and read out by a text-to-speech system. Is this a simulation of how we make sense of the things we see in the world? Or is it a potentially autonomous perceptual machine system that might work as a training device for machines, trying to develop a human sense of poetic language, based on visual input? Would we say that what the machine observes in *The Giver of Names* is an "image"?

Rokeby's work helps us to understand that the notion of the "image" is not a sufficient category for understanding the current, digitally spurred expansion of the perceptual field. The aesthetics of electronic or digital artwork hinges, to a large extent, on nonvisual aspects, such as narrativity, processuality, performativity, generativity, interactivity, or machinic qualities. In order to em-

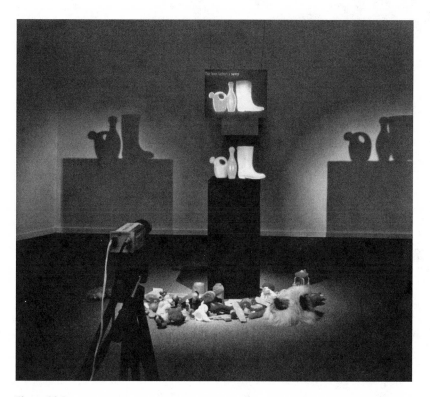

Figure 10.1 David Rokeby, *The Giver of Names*, 1991–. See plate 9. By kind permission of the artist.

brace these practices, we need to develop an aesthetic theory that is able to approach recent works of contemporary art that deploy digital technologies and that expand the categories of art-theoretical reflection. This theoretical work can then also influence the interpretation of predigital art, which may come into view as more dynamic and process-oriented than hitherto thought.

Execution

Computer software has, over the last few years, been recognized as a cultural artifact in its own right. Software was, for a long time, taken to be a neutral instrument. More recently, a growing critical and differentiated understanding of its constructedness, and of the way in which ideological presuppositions can be coded into software, has been paired with research by social historians of

science and technology. The evolution of the free and open source software movement, as well as the extensive use of—by no means fault-proof—digital systems in all walks of social and political life, has helped to build a critical understanding of "software as culture."

Wedded to this development is the emergence of "software art" as a term that describes artistic practices and projects that deal explicitly with the aesthetic and social dimensions of computer software. In this context, the British cultural theorist Matthew Fuller has proposed the useful distinction between "critical software," which reflects on the specificities and limitations of existing software programs, "social software," which deals with and expands the communal and social dimensions of software and software production, and "speculative software," which explores the very essence and the boundaries of what can be conceived as software.

In the 1960s and '70s the term software was still used for the "content" stored on or displayed by technical devices—thus the 1971 "Software" exhibition in New York and the early-'70s electronic art magazine *Radical Software*. Since the proliferation of computers in the 1990s, however, "software" has come to refer to the programs that run specific tasks on computer systems. "Executables" are coded sets of rules that can be worked through by a machine in iterative processes, executing tasks which interlock with other processes, turning the computer into a complex machine that is part black box, part tool, part display.

The continuous processing of code requires a precisely described, encoded "software" program that is executed by the "hardware" technical processing units. This structure lies at the heart of digital systems, and it has been reflected by artists not only since the advent of the personal computer, but since the emergence of cybernetics and game theory in the 1950s. A recent example are the programs developed by the Dutch *socialfiction.org* group, whose *.walk* project offers descriptions for "coded walks" through a city, instructing the human participants what to do, when to turn right, when left, and how to transform the rules controlling their behavior. This application of the principle of computer code to human behavior in the city offers a reflection both on the principles of technical software operations, and—in a postsituationist manner—on the way in which we act and interact in urban environments.

Similarly open, scripted scenarios were devised by happening and fluxus artists of the 1960s. An interesting example is Robert Rauschenberg's *Black Market*, an installation with an assemblage of different objects, including a

suitcase filled with things that the audience is invited to replace with other objects that they bring into the gallery. A small notebook documents the exchanges made. The gradual transformation of the installation is coded into the system and needs to be executed for the artwork as process to exist. Just as there is no market if nobody is trading, and no "computer" if no process is running, there is also no artwork if the program of the piece is not continually executed.

This is not a solely ontological or constructivist argument in the sense that the world, or an object, exists only if it is actualized by human perception. Here, the aesthetics of the work is dependent on a realization of the program. It is not the objects in the fixed assemblage that make up the core of Rauschenberg's work, but the conceptualization of the process of exchange. It should be a matter of discussion whether this principle must also be applied to paintings like Rembrandt's *Night Watch* or *Abraham's Sacrifice*, whose temporal structures have been analyzed by art historian Max Imdahl, or Jan Vermeer's *View of Delft*, with its shifting viewpoint that implies a virtual movement in space and that needs to be recreated as a virtual movement by the viewer during the reception. Such images have a spatiotemporal structure that requires a processual approach, *"Betrachtung"* as an act of realization, of execution, which is itself the very momentum of the aesthetic experience.

Performance

"Performance" is the domain of "live art." As a blanket term for music, dance, theater, and experimental variations thereof, it can be understood as the nonparticipatory live presentation of body movements, images, and sounds. In many cases, the notion of performance implies the presence of human actors or players on a stage, or a stagelike area. The same term is used to indicate the quality of a technical apparatus in operation: we can speak of the "performance" of a specific computer system, or of a car. This dual meaning is interesting in that it points to some general aspects of performance, for example, that it is an authorial execution system, an execution system that has a main actor. Performance can be understood as the presentation, the making present (and perceivable) of the results of an execution.

Performativity was an important issue in the art of the 1950s and '60s when the static paradigms of modernist art were being broken up by situationism, Fluxus, and intermedia, but also by the gestural and partly

mechanized painting performances of artists like George Matthieu and Jackson Pollock. Performativity has again come into view of the arts through the emergence of computers, not so much as a naturalistic counterreaction, but because of the impulse that digital systems have given to new ways of scripting live performances in dance and music. Automated or semi-automated machine-based notations have created a new relationship between composer or choreographer and performer, interjecting machinic operators into the creative process. In this respect, the experimentations of David Tudor in music were probably even more influential than the interactive transformation of William Forsythe's principles of dance choreography.

An interesting point of discussion is a comparison between, on the one hand, the scripted and documented walks by land artists like Robert Long, at times strongly authorial endurance pieces which were not meant to be repeated and copied, and on the other hand, the instructions for happenings by artists like Allan Kaprow or Dick Higgins, whose performances—or rather executions—were meant to be realized by any number of people in order to become what they were intended to be, namely, happenings.

In comparison, interactive or reactive installations, which were so prevalent in the media arts of the 1990s, are participatory execution systems. Unlike in a performance, where the execution is conducted by a main actor, in interactive systems the interacting person is typically not executing a more or less open program, but is included in the technical system as a secondary factor, or as a trigger, who can then observe passively the programmed results of his or her action. While the performance of interactive systems is frequently realized by the physical involvement, or contiguity, of the participant, their teleology may be channeled even further by a narrative structuring of the program.

In live performances based on digital media, a crucial factor is generally the relationship between onstage performers and offstage controllers of sound and video input and of the response parameters of the technical environmental. The degree of freedom offered to the performers is frequently competing, or in dialogue, with a programmed machine that imposes, or responds to, specific actions. Many artists exploring this field are consciously playing with this relationship, and attempting to use the dialogue in exciting work that embodies the tension of the struggle between human and machine in an open, unstable system. The "performance" of such a system is not immediately dependent on the involvement of an external actor, or on responses from

an audience, though it may be dependent on externally set parameters and conditions.

Process

While the term "process" in its most general sense implies any set of consecutive procedures sequenced in time, the notion of process-based art refers to the time-based evolution and transformation of describable yet not fully programmed sequences of events that build on one another in a nonteleological manner. Such processes are realized in social, semantic, and technical settings and are closely associated with the notions of communication, as a manner of semiotic interchange, and connectivity, as a form of temporary structure bonding noninterdependent actors.

Processuality in art is closely tied to the existence of communication tools. Of course, any communicative development in the preparation of an artwork —for instance the collaborative realization of a theater production or a movie —can be described as a process. However, it only makes sense to speak of process-orientation in cases where the evolving process itself is a main factor of the aesthetic experience of the work. Thus, in the formulation of an aesthetics of the machinic, it is necessary to emphasize the interlocking of machinic processuality with the social dimensions of engagement in process-based art.

The artists group Knowbotic Research (KRcF) has explored such machinic processes throughout the second half of the 1990s, especially in the project series entitled *IO_dencies*, and in the project *Anonymous Muttering* (fig. 10.2), which connected on-site visitors, music DJs, Internet users, and a computer system into a complex, interactive, open, and nondirectional assemblage. The output, and thus the aesthetic experience, varied from one interface setting to the other, and was mutually influenced by actions performed at any one of the connected positions, whether online, on-site, or automated. Whereas *Anonymous Muttering* created a delirious experience of being perceptually (and thus conceptually) overwhelmed, *IO_dencies* took a more analytical approach, trying to create interfaces and online communication tools that allowed participants to interact and continuously transform a shared knowledge environment. Processuality here meant an explicit communication not only mediated by machine systems, but a communication with these systems and the productive and transformational forces they brought to the assemblage. These works are

Figure 10.2 Knowbotic Research (KRcF), *Anonymous Muttering*, 1996. Photo: Jan Sprij, Rotterdam. By kind permission of the artists.

thus exemplary of an artistic engagement with technologies in which the machinic dimensions of a system including technology and human actors are deliberately explored, rather than taken for granted or ignored.

This kind of process-oriented art is, I would argue, without historical precedent. We find an interest in the aesthetics of processes, for instance, in the *corps exquise* experiments of the surrealists, or in the mail art networks of the Cold War era. However, the digital communications technologies of the last decade have created a historical situation in which communication and connectivity have taken on a new social and artistic significance, which is now explored not only through such technical media, but also in purely analog, local, and translocal artistic practices and projects. Unlike the artistic strategies of performativity, the dynamics of process-oriented art is coupled with the logic of its operational environment, be it the postal service, the Internet, or a particular segment of society. Whereas performance seeks to eliminate the impression of such a contextual dependency, the aesthetics of process-based art crucially implies this context—it cannot be other than relational.

Machinic

As was indicated earlier, the notion of the "machine" applied here refers not to machines as technological apparatuses, but as any kind of productive assemblages of forces, be they technical, biological, social, semiotic, or other. The notion of the "machine" is an operative term that makes it possible to describe open formations which do not require systemic structures, but that hold the potential for manifold realizations. The "machinic," then, is a quality of such formations; it describes an open, productive process arising from specific yet nonteleological relations between the constituent parts of the machine. The aesthetics of the machinic suggested here encompasses a form of aesthetical experiences that are effected by such machinic structures in which neither artistic intention, nor formal or controllable generative structures, but an amalgamation of material conditions, human interaction, processual restrictions, and technical instabilities play the decisive role.

It is therefore appropriate to introduce the notion of the sublime as a crucial quality of an aesthetics of the machinic. The aesthetical experience of the sublime, as characterized by Romantic writers of the late eighteenth and early nineteenth centuries, is characterized by a confrontation with unbounded and overwhelming nature, a transgressive experience that is based not on an appreciation for the grandiose beauty of nature, but on a disturbed sense of amazement about its limitless and uncontrollable force. Of course, the notion of the natural sublime is historically associated with, on the one hand, the experience of alpine and maritime wilderness and natural catastrophies like earthquakes, and on the other hand, with the progressive subjugation of nature under human will in the course of industrialization. The sublime is thus a paradoxical sign of both intimidation and frustration about the loss of "natural nature." Importantly, Kant insists that the basis of the sublime experience lies in the viewer's feelings, not in the object itself—making the notion of the sublime a decidedly aesthetical category.

The sublime is thus a sensation realized in the event of being confronted with some external force; it is an experience emerging from the imaginary drama of an unbridgeable gap between our experience and the forces that move it. The paradigmatic Romantic artwork is German painter Caspar David Friedrich's *Monk by the Sea* (*Der Mönch am Meer*), of which Friedrich's contemporary Heinrich von Kleist wrote that, looking at the painting was as though,

Figure 10.3 Maurizio Bolognini, *Sealed Computers*, 1992–. By kind permission of the artist.

"in the face of an overwhelming spectacle of nature, one tried to close one's eyes, yet the eye-lids had been cut away . . ." (Kleist, review in *Berliner Blätter*, 1810).

Closely connected to the Romantic unease about nature is the modern unease about machines. While modernist humanism has done everything to reinstate human perception of a contained world as the core motor of aesthetic experience, the emergence of technological art has brought the sublime back into the experience of contemporary art. Can we discuss modernist painters like Piet Mondriaan and Barnett Newman as artists of the machinic? They clearly play at the boundary between rational pictorial structures and a surplus that seeks to transgress rationalist certainty.

Andreas Broeckmann

A most radical gesture in this respect is the project by Maurizio Bolognini, *Sealed Computers* (fig. 10.3), for which the artist places over a dozen computers in a gallery space, networks them and has them jointly compute simple, generative graphic structures which, however, deliberately do not get displayed: the monitor buses of all the computers are sealed with wax, and the installation offers no indication of the communication between the computers, or its results. What we can perceive are the interconnected computers, humming, apparently processing code. They are neither keeping a collective secret from us—we would need to subjectify the computers for this—nor are they even "conceiving" of the results of their computations as visual structures. We know that they are as alone as we are.

The aesthetics of the machinic is an experience in the face of art that hinges on machine-based processes that are beyond human control. The only chance we have is to destroy the illusion and switch off the machine. For the time being, and as nature teaches us, this is not really an option.

Conclusion

The aesthetic categories analyzed—image, execution, performance, process, machine—form no conclusive list, but rather provide a sample of terms which can open up a renewed dialogue about a contemporary aesthetic theory that uses the experiences of digital culture to rethink art. While the argument laid out here would require a much more extensive and detailed art historical investigation, its main aim is to counter claims that "digital art" or "media art" might require an entirely separate aesthetic theory. A more idiosyncratic aspect of the discussion above is the attempt to argue for an "aesthetics of the machinic" which might help to describe an aesthetic experience that we can have not only in the face of an autonomously operating technical system, but also in the face of an artwork that enforces a logic of experience which surpasses our subjective control.

From Film to Interactive Art: Transformations in Media Arts

Ryszard W. Kluszczynski

The following essay is an introduction to a history of twentieth-century media arts, which outlines their transformations from film to interactive multimedia arts. My aim is not merely to analyze the process of substitution or complementation of the "old" media arts by newer ones, but also to focus on the persistence of the former, their reappearances in new technological contexts. I would like to make clear that the history of media arts involves an obvious interplay between textuality, technology, and cultural institutions.

Cinema Faced with the Challenge of Electronic Technologies

The forms of filmmaking, the contexts in which contemporary film art functions, have undergone deep transformations. For cinema, the consequences of technological progress in the field of electronics and the increasingly frequent employment of new technologies in various areas of culture have been far-reaching and profound.

The tools used by filmmakers are changing. In some cases (e.g., that of Zbig Rybczynski or Peter Greenaway) changes have led to an advancement and consolidation of artistic attitudes and strategies which, although clearly present, were previously realized only at the expense of enormous effort (Rybczynski) or were muted and sidetracked by the traditional properties of the film medium (Greenaway). As regards many other film artists, one can observe certain sweeping transformations of their poetics and the issues they have addressed. It is also easy to notice numerous innovations in the areas of image

presentation, editing, and narrative structure. Not only does state-of-the-art technology equip cinema with tools allowing for a better (easier, faster) realization of traditional film tasks, but it also initiates (or deepens) changes in film strategies, creating new conventions, transforming genres, contravening traditional relations between reality and its audiovisual representations. That, in turn, leads to a formation of new recipient attitudes, transcending both the identification-projection model and the distancing conventions of Brechtian cinema. Modern electronic technologies are profoundly affecting the ontological structures of traditional cinema and film.

What is more, cinema is beginning to function in new communication channels. If televising films was responsible for transforming the extant models of recipient response to a cinematic work and for introducing the first changes in film poetics, then the invention of the VCR contributed immensely to developing these changes, especially in the field of response mechanisms. Nonetheless, the genuine revolution is occurring at present, with the dissemination of interactive DVDs; its effects will have been felt even more strongly with the appearance of films, which will make full use of the navigational, interactive qualities of the computer medium. It is interactivity, above all, which will play a major role in the future development of motion picture arts.

Today, film, for a long time the sole art endowed with the attribute of the moving image, must seek its identity in an unusual situation. Namely, it has become only one of the many media for which the motion picture, combined with sound, forms the basis of communication. It must therefore make choices that will define its place in the complex, varied group of media and multimedia audiovisual arts.

At this point, one could risk the hypothesis that in the near future the heretofore heterogeneous (despite its internal diversity) evolutionary process of the cinema will diverge into at least two separate currents: one attempting to cultivate traditional principles and forms (new technologies being used merely to enhance or refresh the existing conventions; after Christine Paul 2003 we may call digital technology used in such a way a digital tool) and another, comprising interactive cinema, obliterating current conventions and offering the recipient a strikingly different type of experience (in this case we may talk about digital medium). Another possible differentiation, overlapping with the abovementioned one, will involve a development of interpersonal relations within the group of recipients in the case of films presented in public

spaces and will strengthen intrapersonal communication, where the reception turns into an intimate, individual interaction with the filmic hypertext. Both tendencies are already represented by examples both numerous (especially with regard to the first trend) and valuable. The recent interactive film performances by Chris Hales show the possibility of merging both types into one—a collective interactive film experience.

The sine qua non for understanding this process is the analysis of the very phenomenon of interactivity. Such an analysis ought to be more than a reflection on the strictly phenomenal dimensions of interactivity, its variants, its artistic applications and their prehistory, the structure of individual interactive works and the first emergent poetics; it should also delineate the methodological context and justify the choice. It is hardly necessary nowadays to emphasize the importance of the choice of language used to describe the object of study.

Cinema and Film—The New Media

All media and multimedia that have followed after cinema are a result of the development in electronic technologies, which are currently becoming the main factor behind the transformations in audiovisual culture and art, and which are consequently—because audiovisuality plays a major role in the world of today—the primary source of transformations in culture as a whole. The so-called digital revolution is transforming nearly all areas of human activity. Therefore, it is also responsible for transforming the domain of art and for creating new fields of artistic practice, in addition to transforming its traditional variants, some of which boast a history dating back thousands of years.

As a result of the developments in information-communication technologies and the emergence of electronic media and multimedia, the situation of cinema/film[1]—the first form of moving image media art—is changing to an extent that far outweighs the intensity of all its previous transformations, which consisted mainly in the additions of sound or color, or perhaps modifications in image parameters or audio standards. Those past transformations did not violate the basic determinants of the cinematic apparatus, but rather enriched it by adding several new qualities and modifying certain existing ones. In contrast, the current changes in cinema/film are profound and fundamental; most importantly, they occur in several distinct dimensions.

First, cinema itself is changing, assuming a new shape: we are witnessing the birth and development of electronic cinema and film. The first and most immense impact of this transformative process seems to be sustained by the textual-artistic aspect. Image structures, editing codes, and narrative discourse systems are acquiring a form largely defined by electronic technologies and techniques. Simultaneously, while the analog diegetic systems—the result of the reproductive representing machinery, which is the cornerstone of the traditional cinematic apparatus[2]—are being replaced by digital simulations, a product of synthesis technologies, we witness changes in the ontology of the film text, the diegetic structure and the epistemological function of the cinema. Instead of the image of the world, electronic cinema offers the image-as-world. In consequence, considering the gravity of this transformation, it may seriously influence the character of the dispositive, including the course and the qualitative organization of perception (even if the basic apparatus in electronic cinema does not undergo in this case particularly significant changes). Nevertheless, for the film's dispositive and perception to attain a new character, to accomplish the "unreality effect" or perhaps the "new reality effect" produced by simulation, its appeal must be stronger than that of the traditional function of cinema, that is, creating an impression of reality. This, however, is not the case as far as most of the electronic cinema is concerned, from which one might infer that many qualities ascribed directly to the cinematic apparatus in fact derive from textual processes or relations invoked individually (in particular films or film types) between the apparatus in a general sense and the textual instance.[3]

More and more frequently, cinema employs electronic means, perfecting the possibilities of editing and—most importantly thus far—expanding the domain of audiovisual effects. This latter application of new technologies developed the aesthetics of film (chiefly the visual aspect), which accounts for the attention given them by countless filmmakers. These elements combined serve to move film toward the dispositive of television. Counter to this migration, however, numerous artists who eagerly employ electronic means in their work (Peter Greenaway seems to be the first who presented this opinion) believe that despite the emergence of the new forms of presenting film works, the best way to exhibit them is a cinema screening. According to Greenaway, electronic means were supposed merely to refresh and expand film art's possibilities of expression, to create new forms of shaping the image. The cinematic dispositive, however, should remain intact as far as possible.

Combining images of photographic nature with those generated by electronic means within the confines of a single film work brings results that extend well beyond the domain of film poetics. After all, the two forms of imaging are fundamentally different. A photographic image is a kind of analogue of the reality that precedes it, whereas an electronically generated image is free of such restrictions: the reality presented may just as well emerge simultaneously with the image. In actual fact, a complete reversal of the relation described earlier may occur, with reality acting as an analogue to the image. When the two image types, the photographic and the digital, appear alongside each other, the upshot is an upsetting of the relation between reality and its representation as well as between fiction and the systems constructing it. The relations between reality and fiction are also affected thereby. Not only do digital synthesis and photographic film differ in their ontology, but they are also subject to different metaphysics.

Second, as mentioned above, the context in which cinema functions is undergoing deep change. Film (and indirectly its assigned apparatus) enters the domain of television broadcasting, the videotape, the laser disc, or—in response to our requirements—it reaches the display, integrated with a multimedia computer, via a fiber-optic telephone line. The consequences of entangling film in dispositives alien to it extend beyond the simple effects resulting from a transfer into new dimensions and require a separate analysis of each case type. The properties of the dispositives integrated in this way are mutually influential, leading to modifications and often—ultimately—merging to form intermedial, hybrid dispositive structures (e.g., a video projection). The frequency with which these processes occur, as well as the range of their influence, is responsible for the contemporary multimedia being dominated by the intermediality syndrome. The deep structure of the multimedia—the basic contemporary form (and institution) of communication—is essentially an intermedial system, which, in further consequence, gives the multimedia phenomena the character of a dynamic palimpsest.

The abovementioned functioning of film and, consequently, also of cinema, in new contexts leads to even further changes, which transcend the borders of substantial and ontological transformations. They certainly do not remain confined to the limits of film poetics, but instead reach toward film structure as a medium, transforming the methods of reception in addition to offering new forms of experience and comprehension. The previous paragraph emphasized the processes of the media dispositive integration, and the subsequent

emergence of hybrid structures; as a consequence of this gravitating toward hybridity, the cinematic dispositive—if one attempts to grasp its peculiarity and realize it in extracinematic perception—reveals numerous fissures and deformations. In this transformed situation in which the cinematic apparatus is now functioning, the films themselves are also experienced differently; similarly, the new situation influences the textual orders.

The new audiovisual media, developing parallel to cinema/film and entering into various relations with it, affect its structures and forms, as has been said above, but also undergo transformations themselves. As a result of this interference, film transcends its borders, appearing in video realizations, various forms of virtual reality and computer games. I have mentioned already the transformations of the cinematic dispositive, resulting from its intrusion into other dispositives; however, we ought to remember that film textuality has also proliferated beyond the domain of cinema. Artistic realizations belonging to the domain of video art, or the diverse multimedia art, as well as popular computer games, draw on the resources of cinema. The film-specific codes of image construction, editing, narration, dramaturgy, character development, and plot structuring constitute the basic articulation system of contemporary media and multimedia audiovisuality.

Third, the development of interactive computer technologies calls into existence various forms of interactive cinema/film that are spiritually rooted in the theory and distancing practices of Brechtian cinema, but divergent from it both on the level of actually created structures and in the character of the demands imposed on the recipient. The basic apparatus of interactive cinema and its dispositive differ immensely even from the unconventional varieties of the traditional cinematic apparatus.

What must be strongly emphasized at this point is the fact that "interactive cinema" is essentially a term comprising an array of discrete varieties, which often differ radically. The mainspring of this differentiation is the invariance of the dispositive, conditioned by the abundance of interfaces[4] and the profusion of applicable techniques. This diversity means that interactive cinema retains close intermedial relations with installation art, CD-ROM/DVD art, and computer games.

Progress (however disappointedly slow) in the field of interactive technologies of virtual reality (VR) creates certain prospects of further, profound transformations in the structure of film experience, allowing the recipient/user (now frequently termed "interactor" or "visitor") to immerse himself or herself

interactively[5] in the telematic (i.e., creating an illusion of bodily presence in remote locations) virtual world of the work. The basic attributes of VR apart from real-time interactivity, that is, immersivity and telematicity, expand certain vital properties of the cinematic apparatus; thus, virtual reality—enhanced by the textual qualities of film—potentially becomes the most crucial continuation of cinema in the field of multimedia.

Fourth, and finally, the Internet—by introducing networks into VR technologies—creates new directions of development for the potential net-based form of interactive, virtual cinema. The principal aim seems to be to establish the possibility of a telematic, multiuser participation in the virtual world thus conjured, which would turn all recipients into active, reciprocally interactive film characters. Today, such a vision seems to belong more in the cyberpunk novel[6] than in the domain of serious research. It must be observed, nonetheless, that although multimedia technologies are still in their infancy, the rapid pace of their development can let us assume that what we regard as merely potential nowadays—a futurological project—may actually be realized sooner than expected. Making predictions in this field, as long as it is based on a correct analysis of the development possibilities available to the multimedia apparatus, an analysis conducted in the context of its history, is not entirely unfounded. The joint research project of British Telecom, Illuminations Television, and the University of Nottingham, known as "Inhabited Television" and conducted under the supervision of John Wyver, which combines television broadcasts with virtual reality, allowing the viewers to telematically inhabit the bodies of the characters participating in the events that occur in one particular virtual spacetime, might be considered the first attempt at merging television, the Internet, cinema, and virtual reality into one coherent whole.[7]

Let me conclude this fragment of the discussion at hand with the following remark. All the processes detailed above contribute to a severe detachment of film (and predominantly cinema) from its previous, "unexpanded" structure. Traditional cinema is losing its former, dominant position in the landscape of contemporary audiovisuality. At the same time, scattered in a diaspora of sorts, the properties of cinema and film not only persist, but are even developing, practically unperturbed. In consequence, we are currently facing not so much the final obliteration of cinema and film, but rather an ever more likely possibility of its further dispersion and dissolution among the plethora of the media increasingly remote from it, in forms marked by less and less similarity. Cinema—the source of audiovisual art—is slowly ceasing to be its goal,

losing the autonomy of defining and delineating its paradigm. Nevertheless, cinema is still active in shaping new forms of audiovisual arts.

Television and Video

As stated above, television and other new electronic media and multimedia carry their own distinct ontology and logic of structural organization, in addition to inspiring new recipient behavior. The range of these innovations depends on the particular medium, since they manifest themselves in various aspects of the work and vary according to the situation in which the reception occurs; likewise, the transformations in different media are often incomparable. The video, or computer-generated animation, while introducing a new ontology into the domain of audiovisuality, retains the domination of the work's structure over the process of reception that is characteristic for film, whereas the art of interactive multimedia overturns this hierarchy, offering entirely new methods of organizing the process of artistic communication.

Television and the video share the ontology of the image. The remaining aspects of the two, such as the dispositive, bear a limited resemblance to each other (their possession of common features alongside the qualities that are decidedly dissimilar results in the entire system's attaining a different character in each instance). The image serves different purposes in the two media: in the case of video, it is "within reach," and touch unexpectedly becomes the sense of fundamental importance. Video is a medium of intimacy, of close contact, encouraging intrapersonal communication. As far as television is concerned, the substance of the image and sound, as well as their ontic structure, serves the function of transmitting (transferring between remote points) audiovisual information concerning events occurring in distant locations but made manifest in real time, or of presenting previously prepared programs. Telepresence—the basic quality of television as a medium of communication—is becoming one of the crucial qualities (i.e., categories) of electronic art. A television presentation (transmission) of a film transforms the medium into a sort of home cinema (telecinema).

The emergence and development of video has influenced the situation of the cinema theater more than that of film as such: the most fundamental changes offered by video, as a new medium of cinema/film, concern the dispositive, while the least important transformations have occurred in the area of film textuality. The range of innovations introduced by video proves to be much

broader when one considers the reception process rather than the structure of the work and the poetics of film. The invention of the videotape introduced new possibilities of its reception in private space, at home, in circumstances far removed from the classical cinematic reception, and yet entirely different from the standard television-watching (i.e., viewing a film included in the program). In the case of video, the cinematic spectacle—the presentation of the film—has been replaced by a process that might be described as "reading" the film. The condition of the viewer in the cinema has been compared to that of a person immersed in a dream; this, among other things, accounts for the specificity of the cinematic processes of identification-projection. In contrast, the reception in domestic circumstances is characterized by dispersed attention, observed already by Walter Benjamin. As a result, the consciousness of someone watching a film on a video display is far less dominated by the cinematic world and the magic of participation than if he were viewing the same film during a cinema projection.

The liberation of the viewer from the sway of the cinema screen is facilitated by the susceptibility of tape-recorded film to various kinds of manipulation: stopping, fast-forwarding, playing the film in slow motion or rewinding it. The recipient has therefore acquired a means of influencing the course of his experience ("living" the film). Thus, the structure of a film viewed with recourse to the video dispositive loses—within the limits of the recipient's experience—its finality and inviolability (although the finality of the film's shape is still invariably inscribed into its definition).

This property of the video dispositive is perhaps what makes it essentially different from the cinema. Seen from this perspective, video art appears as yet another stage in a transformation process tending toward interactive art. As has been said above, the reception of film has transmogrified into reading, a linear (yet irregular in its course), multifunctional process of perception and comprehension.

Similarly as in the past, when, after valiant efforts seeking to negate the new medium, cinema finally acknowledged television as an alternative method of disseminating film production parallel to cinema distribution, it has now accepted video as yet another cinematic medium (a film medium, to be precise). The expansion of the domain in which film functions has caused a peculiar split (stratification) in video textuality, leading to the appearance both of genuine video realizations (effected by means of this medium) and the transfer of cinema films onto videotape. It is here that one can trace the origins of the

process that has ultimately led to the blurring of the borders between the two media (i.e., between a film work and a video work). In addition, it is worth emphasizing the consequences of the invention of the video projector: with its help, video realizations may be shown to large audiences, in spacious rooms, in the conditions resembling a cinema séance (involving screening rather than emission). Although the image quality in video projections is still far removed from cinema standards, perfectly credible promises of eliminating this obstacle are currently being made. In this way, among others, the cinematic system is attempting to absorb the video and make it the future of cinema. As stated above, this type of intermedial connection is encountered very frequently in the contemporary world.

Interactivity/Deconstruction—Cyberculture

Placing computer technologies at the disposal of the motion-picture arts has created entirely new possibilities. Moreover, if we assume that the essence of each art form is defined by its distinctive features (or a system of features), then computer art begins a new chapter in the history of artistic culture.[8]

Interactivity—appearing in its very rudimentary form in the case of video, or perhaps appearing merely as proto-interactivity, a possibility of recipient behavior, motivated not so much by the work's structure as by the manifold needs of the viewer (including extra-aesthetic ones)—may acquire its fullfledged form in computer art. This means that interactivity is becoming the internal principle of the work, and the recipient—if he or she is willing to concretize it—must undertake actions that will result in forming the object of his or her perception. Interactivity in art, understood as a dialogue of sorts, communication between the interactor and the artifact,[9] occurring in real time and mutually influential, is becoming one of the essential features of contemporary culture.[10] Interaction calls into being a peculiar work of art— theoretically (and, with increasing frequency, also practically) unique in every instance of an individual, creative activity of the recipient-interactor. We are faced with a reversal of the ontological order of the elements constituting the process of artistic communication. What is created in the first place and as a result of the artist's activity is the context of the work and not the work itself (in the traditional sense). The artwork emerges afterward, as the product of the recipient, created by him or her within the context delineated by the artist.

One may assume that both objects, that is, the artifact and the work of art, connected by the interactor's receptive-creative actions, jointly constitute the final product of complex, multisubject artistic practices. Thus, the product acquires a processual character, becoming a complex communicative situation rather than a subject structure, while its organization may possess the character and order of a game (in the broad sense of the term). This final creation may be called—in keeping with tradition—a (broadly understood) work of art. Alternatively, it may, more adequately to the character of interactive art, be termed a field of interactive artistic communication. The situation also occasions the following question: to what extent, if any, is the process that has driven artistic practice toward its present state the peculiar apex of the tendencies leading toward the dematerialization of art, toward substituting the art object with a (hyper)text or a complex of (hyper)textual practices?

In reflecting on cyberculture and the assorted phenomena that constitute it (the most prominent among which is interactivity as such, as well as the interactive media arts), one may observe two radically opposing tendencies.[11]

The first current draws together those who would like to consider interactive art in the context of earlier concepts of art and with reference to the basic categories that construct the traditional, modernist aesthetic paradigm. The principal dogmas of this system are representation, expression, and the conviction that the artist-author dominates over both the artwork itself (the most characteristic view being that art equals whatever is designated as such by an artist) and its meaning (content), which is ultimately tantamount to the domination over the recipient and the perceptive-interpretative process. As a result of such an attitude toward interactive art, the experienced interaction is discussed not in terms of communication with the apparatus/artifact (or an artificial, intelligent system), but is seen as an intermediary interaction with the human (or humans) who made the work or its software. The communicative possibilities of such an interaction ought to be evaluated—according to Margaret Morse (1993)—by the standards of human communication. This kind of attitude can be identified in countless remarks on the subject of interactive art, regardless of the language used by the authors and the amount of new terminology they employ (which is constructed and used primarily to point out and describe the new properties of the contemporary condition of art and culture). Very frequently the inventive, innovative character of these categories is annulled in an attempt to adapt them to the requirements of the traditional aesthetic paradigm.

The representatives of the other trend are characterized by a proclivity to overemphasize those aspects of the new artistic phenomena which transcend traditional canons and which tend toward their cancellation. According to these critics, the crucial feature of cyberart and cyberculture is the abandonment of the idea of representation. Such a view leads to a radical transformation of the role assigned to the artist, who—instead of creating, expressing, and communicating content or meaning—becomes a designer of contexts in which the recipient is to construct his or her experiences, their references and meanings (Ascott 1993).

A significant philosophical-methodological context for a discussion of interactivity and interactive art, particularly useful in analyzing the above juxtaposition of the tendencies in cyberculture research, is provided by the deconstructivist philosophy of Jacques Derrida.

One of the principal assumptions in Derrida's theory is the claim that the logophonocentric attitude (logocentrism—a tendency toward meaning, sense; phonocentrism—the prevalence of spoken language over written text) as a method of approaching text, language, communication, and interpretation, has thus far been the dominant—if not the only—mode in Western culture (Derrida 1972). This stance is expressed in a conviction that the meaning of everything that exists was defined once and for all as presence (only what exists can be thought and expressed), and therefore remains eternally precedent and superior to any attempts at objectification or materialization (Derrida 1967). Thus, an interpretation of a text is reduced to decoding the sense already present, which differs from the text and essentially "extraneous" to it. The meaning dominates over the text and conditions it; the text functions merely as a neutral (more or less transparent) vehicle for the meaning prior to it.

Generally speaking, a classical logophonocentric interpretation reduces a given work, employing categories of representation and expression, in search of the work's ultimate truth or the intentions of the creator. Communication is therefore understood as conveying readymade meanings by various methods. The identity and presence of the subjects of the communication process (the author-sender and the recipient) are assumed before the communicative operation commences. The object of communication—the message and its meaning—cannot be established or modified during the communicative process. The notion of communication is inextricably linked to the function of representation and expression, since representational thinking precedes and

governs communication, which merely transmits ideas, meanings and content. Thus, communication equals conveying what is already known.

The attitude toward interactive art that was presented above as constitutive for the first of the two tendencies is rooted in this above theory, which is here termed "modernist." Obviously, nowadays it seldom manifests itself in its extreme form; the majority of the theoreticians asserting their connection with the traditional aesthetic paradigm agree that the meaning offered to the recipient by an interactive work is largely modified in the course of the reception (the same researchers, however, are reluctant to accommodate the notion of meaning as a never-ending process). In their theories applying to interactive art, the domination of meaning over the work's relational (i.e., communicative) structure is not as pronounced as in more traditional artistic forms; their proponents draw the line at accepting meta-interactivity as a sine qua non of a work's artistic dimension.[12] The interpretation of an artwork is also liberated from the supremacy of meaning established or communicated *a priori*, while the rigors of communication are considerably softened, producing what one is tempted to call open communication. The "softening" and "openness" notwithstanding, the essence of the phenomenon remains unchanged: according to the theoreticians of this tendency, the process of interactive artistic communication occurs predominantly in the shadow of the author and his primal, fundamental presence. Not only does the authorial presence transform an object into art, but it also suffuses the work with meaning and value, defining—in a somewhat softened form—all aspects of the interaction.

Derrida's deconstructivism, on the other hand, appears as a methodological matrix for the type of reflection championed by the second tendency outlined above. This theory releases the artwork from all dependency (derivativeness) in relation to any communicated (a priori) meaning: the work occupies the primary position. Attention is paid to its structure, the process of its formation. Understood in this way, the work of art requires a different type of reception—an "active interpretation," resembling a game, promoting a transformative activity oriented toward "nonfinality," "nonultimacy." The reading of the sense is replaced by a creational reception of the work, that is, navigating through the artifact (hypertext). The work, therefore, as a communicative process, assumes the character of a game (the rules and the roles, nonetheless, need not be ultimately or explicitly defined). The epistemological function is here complemented by the auto-epistemological aspect, while comprehension

assumes the form of coparticipation. Creative reception–communication is a process of creating meaning, a significantly creative activity. Ultimately, both processes merge into one common syndrome.

Interactive media art appears to be the perfect example of the new, deconstructive, postmodernist, cybercultural understanding of an artwork and of artistic communication. Rejecting traditional dogmatism, it does not substitute it with a new scheme, which petrifies the world of art. Derrida did not replace logocentric ideology with graphocentrism, but reduced the role of the author to one of the interpretative contexts; similarly, interactive art has demythologized the role of artist-as-demiurge, ascribing to him the function of context designer who prepares the ground for creative reception. Currently, the notion of the author is being replaced with the notion of dispersed authorship—the joint aim of the so-called artists and the so-called recipients. Seen from this angle, art is no longer a form of presenting a readymade, finalized and a priori given world. To construct art in cybersphere, according to Roy Ascott, is to construct reality, to design cyberspatial communication systems, which support our desire to strengthen human collaboration and interaction in an endless process of constructing the world (Ascott 1993).

There is much adjacency between deconstructivist philosophy and the logic of interactive multimedia arts. One may infer that deconstructivism could become the methodological context for the research of interactive arts and cybernetic culture. Deconstructivist categories seem capable of grasping and enabling the analysis of all new features found in interactive multimedia arts. With their help, interactive communication may free itself from the traditionally understood notions of representation and expression, from the idea of meaning preceding communication, as well as from the modernist interpretations of concepts such as the author and the recipient. Interactive artistic communication could thus become a multidimensional, multiform, unceasing process in which values and meanings, as well as new realities, are created in cooperation.

Both strategies of comprehending interactive art, discussed above, ought to be perceived in terms of theoretical models. As models, they may indicate the most general properties of cyberculture and of the interactive media arts, as well as the most universal methods and techniques of their interpretation. Nonetheless, the space delimited by these two polarized perspectives contains a plethora of notions, theories, actions, and works. One can encounter there artists working in the area of interactive arts and concurrently believing their

duty to be the expression of their own views and the shaping of human minds; one can also find critics and theoreticians who, by analogy, claim that every artwork (the interactive ones included) is exclusively (or primarily) an extension of the artist's imagination, sensitivity, knowledge, and desires. However, there is no shortage of artists and researchers who contend that interactivity is tantamount to sharing the responsibility with the viewer and liberating the work of art from all its ties, including that to the artist.

It ought to be emphasized that the juxtaposition of the two models proposed above is not explicitly crypto-evaluative. We are faced with two different projects of introducing interactivity into the realm of culture; concerning their value, we may only state that the project allowing the recipients to act in a space characterized by reduced authorial restrictions respects the internal logic of interactivity and leads to the emergence of "pure" interactive artifacts. Concurrently, we may observe that this is the only way that could lead the recipient toward a truly creative position, one that fulfills the expectations regarding interactive art. The other project, on the other hand, is an endeavor to situate interactivity in the context of the modernist theory of art and culture, with all its attendant categories and principles. In this case, nevertheless, the creativity of recipient behavior—perceived as broadly as it is customary with regard to interactive art—appears to be little more than wishful thinking.

Interactive Art—Hypertext Art

The new media (multimedia), functioning in accordance with the principle of interactivity, have therefore accomplished an interiorization of deconstructivist logic. As a result, considerable shifts have occurred as regards the roles and the range of their respective competences. The artist-author ceases to be the sole creator not only of the work's meaning, but also of its structure, its shape; the work is thus being cocreated by the recipient in a process of interacting with the artifact. The artist's task is now the creation of this artifact: a system/context in which the recipient/interactor constructs the object of his or her experience as well as its meaning. The recipient is no longer merely an interpreter of readymade meaning that awaits comprehension, or a subject perceiving a finalized material artwork; it is on his or her activity and creativity that the structure of the renewed aesthetic experience hinges. Let us therefore restate that both the structure of the work and the evoked meanings are cocreated by the recipient, who thus becomes a cocreator.

However, the interactive works currently created, like our entire culture, exist under the influence of both paradigms: the modernist and the postmodernist. As a consequence, and depending on which of the two is more prominent in a particular case, the resulting works are to a greater or lesser extent the artist-author's form of expression and (in an inverse proportion) the outcome of the recipient-cocreator's activity. Despite this duality of paradigmatic references and the resulting compromises, the influence of interactivity is broad enough for researchers to admit that the situation encourages the establishment of new research tools and their accompanying rules of application. Within the framework of this freshly designed research, particular attention would be paid to those features and ingredients of the new aesthetic situation that concern the relation between the individual participants of artistic communication, and to the questions of artwork analysis and interpretation.

Interactivity is the fundamental feature of the general process that leads to transformations both in the substantial and the semantic status of art. As mentioned above, the process occurs as a result of—among other things—separating the work from the artifact and the latter becoming hypertextual in character.

Regardless of the complexity of its internal organization, the text always offers a determined (linear) direction (route) of exploration. Above, this method of interpretation has been called "reading"; its ultimate goal is the discovery (or negotiation) of the work's (text's) meaning and the revealing of its as yet sort of hidden entirety. Conversely, hypertext—a multilevel, multielement structure—does not determine or privilege any direction of analysis or interpretation (i.e., comprehension). The journey through it is termed "navigation" (see, e.g., Barrett 1989; Berk and Devlin 1991; Bolter 1991; Aarseth 1997).

It is predominantly the structure of the hypertext—along with the material that fills it: images, texts, sound—which becomes the object of the artist's creative work (in addition to the interface and the elements connected with the genre of the realization). Hypertext in its entirety, however, is never the object of the recipient's perception or experience, but rather—as mentioned above—the context of this experience. The technical-constructional characteristics and the properties of the medium employed by the hypertext artist delineate the standard circumstances of reception, in which the hypertext user, repeatedly faced with the necessity of choice-making and actualizing the selected elements, exploits only a slight portion of the work's potential.

The sum of these choices defines the work—the joint product of the artist (provider of material and choice rules) and the recipient (selector of material and creator of the work's final structure).

It is tempting to risk the statement to the effect that interacting with a hypertext transforms it into a text, since the ultimate result is invariably a complete, finalized structure—the upshot of the recipient's selections. Such a statement, nonetheless, would be incorrect: the recipient/hypertext-user, who perceives the outcome of his or her interaction, that is, the work, also experiences his or her own choices, as well as their contexts (the software, the interface, the spatial arrangement, etc.). When he or she considers the navigation concluded, and decides that the result is the final work, he or she also experiences (often consciously) the nonfinality, nonultimacy inscribed into the nature of interactive art.

It could therefore be validly argued, and that if the work were to be equated with the text, then in the case of interactive art we are not dealing with a work of art at all. Consequently, we must decide whether hypertext ought to be treated as an artwork (albeit one whose entirety cannot be grasped in an aesthetic experience), or perhaps agree with the verdict that the work does not exist, or, finally, assume that interactive art invokes a new type of artwork: one which materializes exclusively during a receptive (creative-receptive) interaction and is not identical with the result of the artist's creational actions. Moreover, it is not intersubjectively identical, seeing as each recipient experiences the unique outcome of his or her own interaction.[13]

One may also argue, as previously in this discussion, that the ultimate object of analysis is not the work itself, regardless of the definition, but the field of interactive artistic communication, where the work, along with other elements (the artist, the recipient/interactor, the artifact, the interface) becomes entangled in an intricate, multidimensional complex of communication processes. Such a perspective is the one I prefer.

In the domain of interactive art, which employs the structure of hypertext, the analytical-interpretative issues take an entirely different form. It is difficult to speak of analyzing a phenomenon that exists only during the process of reception, since one of the premises of analysis is a certain durability of the work under inspection, the repeatability of its experience, as well as the possibility of returning to the analyzed object. The same is true for interpretation; both procedures ought to be verifiable to a certain extent. What is more, both analysis and interpretation assume the immutability—even a limited one—of the

examined object, the persistence of its meaning. None of these requirements can be met, however, by a consistently interactive work, as it endures only at the time of the interactive process. A subsequent activation of the hypertext, even performed by the same recipient/interactor, is bound to conjure a new work. Both the analysis and interpretation of an artwork thus understood must be parallel to the process of its reception, its (co-)creation; it must be identical with it. Reception, creation, analysis, and interpretation become one and the same complex of processes, occurring in the field of artistic communication.

It is only natural, given the circumstances, to doubt the necessity and validity of analyzing and interpreting a work of interactive art. These procedures, understood traditionally, seek their justification in epistemological and educational needs. If the knowledge produced by them is not intersubjectively verifiable, and its object is not intersubjectively available, the same analytical-interpretative actions lose their status of isolated, autonomous critical or scientific procedures. They might then be treated merely as a peculiar manifestation of the work's autotelicity, a symptom and proof of its internal metadiscourse, since the work appears in the process of its creative reception, or—to formulate this hypothesis more radically—the work is identical with its reception. Therefore, logically, it is identical with its interpretation.

What remains as the possible object of analysis is the aforementioned field of interactive artistic communication. These problems, however, shall be discussed elsewhere.

The number of interactive works produced today is increasing with inconceivable speed. The works represent not only the two model attitudes discussed above; we are faced with a multitude of realizations resulting from the concurrent influence of the two indicated paradigms. Interactivity is becoming the essential and most representative property of contemporary culture. Both of its models affected very seriously the artistic practice of the twentieth century's last decade and the beginning of a new one, and there is no reason to suppose that either will disappear in the foreseeable future, since contemporary culture is becoming increasingly more, rather than less, diverse.

What this amounts to is not merely the coterminous functioning of a wide spectrum of interactive works, but also their coexistence with the works belonging to the noninteractive and proto-interactive culture. Among the latter, one may encounter numerous qualities, notions, and structures that prefigure interactive art and culture. From the contemporary perspective, we may

even observe a certain *sui generis* logic in the development of forms, attitudes, concepts, and theories which comprise the process leading from the neo-avant-garde (happening, conceptualism, Fluxus, etc.) toward the current paradigm of electronic, digital, interactive, multimedia culture.

Notes

1. For the purposes of this study, the term "cinema" will denote, in keeping with the established tradition (owing to its heterogeneity and internal diversity, however, each reference to it inevitably becomes an interpretation, a choice of a variant) its basic apparatus and its dispositive (these two interconnected instances of cinema will henceforth be termed "apparatus in a general sense"), whereas the term "film" will apply to the textual-artistic aspect. The basic apparatus is the sum total of devices, techniques, and operations used in producing a film and creating its subject, and—in its broader meaning—an array of contexts that are connected with them, i.e., social, cultural, ideological, economic, etc. The dispositive, on the other hand, comprises the mechanisms, processes (technical as well as psychological), their arrangements and contexts, which jointly constitute the projection and perception of the film. Together they form the institution of cinema. See Baudry 1970; Comolli 1971–1972; Heath 1981; Kuntzel 1976.

2. The principal effect of this is the blurring of the distance from reality in order to conceal its being constructed rather than presented or reproduced.

3. Another aspect of this situation is a certain virtualization of reality, which appears to be the long-term effect of the media worlds' existence and their influence on the perception of reality.

4. This term is understood here as a channel of dialogic communication between the recipient/interactor and the artifact, as the device enabling interaction. The basic function of an interface is the creation of communication possibilities between parties employing different languages.

5. The immersion of the senses means that the subject assumes—within limits defined by the engaged senses—the internal (diegetic) point of view.

6. Contemporary researchers of cyberculture regard cyberpunk novels as a highly legitimate source of information concerning postmodernism and the social transformations occurring as a result of the emergence of new information-communication

technologies. An extreme opinion in the matter is held by Doug Kellner, who contends that cyberpunk fiction offers far more insight into postmodern processes than the work of cultural critics such as Jean Baudrillard (Kellner 1995). A more balanced view is that of Mike Davis, who argues that William Gibson's novels and short stories are excellent examples of science fiction functioning as a prefiguration of social theory (Davis 1992).

7. In the preface to the presentation of *Out of This World* (the first, prototypical realization employing the "Inhabited Television" technology, performed in the Green Room Gallery, Manchester, on 6–7 September 1998, as part of the 9th International Symposium of Electronic Arts), John Wyver himself remarked that the event was tantamount to the birth of a new medium.

8. Despite an ontological perspective distinct from cinema and the video, computer animation, restricted as it is—similarly to video—to producing moving images, remains part of the previous epoch, merely enhancing the expressive means characteristic for the two aforementioned media. This hypothesis was confirmed very forcibly, though perhaps unwittingly, by Yvonne Spielmann in her paper entitled "Is There an Avant Garde in Digital Art?," presented during the 9th International Symposium on Electronic Art, Liverpool-Manchester 1998. The attempt to isolate the defining qualities of digital arts by referencing exclusively the video and computer animation resulted in conclusions to the effect that there exists an aesthetic proximity (or even adjacency) between digital media arts and analog media arts.

9. An artifact, in reference to interactive art, is here taken to be the product of an artist's creative activity, a structural connection of selected elements (and aspects) of the dispositive and the interface. Seen from another perspective, the artifact is the structure of the hypertext, including the material constituting its basis: images, sounds, and texts, i.e., the foundation of a work's textuality. Therefore, the artifact also fulfills the function of the work's context. The context-artifact is the product of an artist, who—instead of presenting the viewer with a traditional artwork, a meaningful object of interpretation and a source of aesthetic experience—creates a space for interaction; see Kluszczynski 1997.

10. If "interaction" is interpreted more generally and the notion of the artifact is not restricted to artistic references, interactivity appears as the crucial feature of all communication processes; communication, in turn, attains the status of the principal social relation. As a result, the social structure itself must be termed "information society"; see, e.g., Lyon 1988; Jones 1995.

11. These tendencies are radically opposed on the theoretical plane as different models. In research practice, however, elements belonging to both models may appear within the same program. This may stem from a lack of theoretical precision on the part of the particular author, or—a more likely possibility—from a instability within the paradigm of the contemporary reflection on art as a result of its remaining at the stage of fundamental transformations.

12. Interestingly enough, this notion is accepted by representatives of both tendencies.

13. Obviously, these remarks refer to a model work that would fully respect the logic of interactivity. In the case of a realization influenced by both paradigms—the modernist and the postmodernist—the situation is more complex. To describe it adequately, one would be forced to combine the research tools specific to each of the indicated perspectives.

References

Aarseth, Espen J. 1997. *Cybertext: Perspectives on Ergodic Literature*. Baltimore: The John Hopkins University Press.

Ascott, Roy. 1993. From Appearance to Apparition: Communication and Culture in the Cybersphere. *Leonardo Electronic Almanac* (October).

Barrett, Edward, ed. 1989. *The Society of Text: Hypertext, Hypermedia, and the Social Construction of Information*. Cambridge, Mass.: MIT Press.

Baudry, Jean-Louis. 1970. Cinéma: Effects ideologique produits par l'appareill de bas. *Cinétique* 8.

Berk, Emily, and Joseph Devlin, eds. 1991. *The Hypertext/Hypermedia Handbook*. New York: McGraw-Hill.

Bolter, Jay David. 1991. Topographic Writing: Hypertext and the Electronic Writing Space. In *Hypermedia and Literary Studies*. Ed. Paul Delany and George Landow. Cambridge, Mass.: MIT Press.

Comolli, Jean-Louis. 1971–1972. Technique et idéologie. *Cahiers du cinéma* 234–235.

Davis, Mike. 1992. *Beyond Blade Runner: Urban Control, the Ecology of Fear*. Westfield, N.J.: Open Magazine Pamphlets.

Derrida, Jacques. 1967. *De la gramatologie*. Paris: Minuit.

Derrida, Jacques. 1972. *Positions*. Paris: Minuit.

Heath, Stephen. 1981. The Cinematic Apparatus: Technology as Historical and Cultural Form. In his *Questions of Cinema*. London: MacMillan.

Jones, Steven G., ed. 1995. *Cybersociety: Computer-Mediated Communication and Community*. Thousand Oaks, Calif.: Sage Publications.

Kellner, Doug. 1995. Mapping the Present from the Future: From Baudrillard to Cyberpunk. In *Media Culture: Cultural Studies, Identity, and Politics Between the Modern and the Postmodern*. London: Routledge.

Kluszczynski, Ryszard W. 1997. The Context Is the Message: Interactive Art as a Medium of Communication. In *Seventh International Symposium on Electronic Art Proceedings*. Ed. Michael B. Roetto. Rotterdam: ISEA.

Kuntzel, Thierry. 1976. A Note Upon the Filmic Apparatus. *Quarterly Review of Film Studies* 1 (3).

Lyon, David. 1988. *The Information Society: Issues and Illusions*. Cambridge: Polity Press, Basil Blackwell.

Morse, Margaret. 1993. Art in Cyberspace: Interacting with Machines as Art at Siggraph's "Machine Culture—The Virtual Frontier." *Video Networks* 17 (5) (October/November).

Paul, Christiane. 2003. *Digital Art*. London: Thames and Hudson.

The Passage from Material to Interface

Louise Poissant

Translated by Ernestine Daubner and Jason Martin

> Now the artist develops, under our eyes, the very technique of the
> mind; he gives us a kind of mold or cast which we can both see
> and touch.
> —HENRI FOCILLON[1]

The passage from material to interface suggests the creation of a cartography
that would make an inventory of points of transition and rupture the trans-
formation or even the drift of the continents that compose the territory of clas-
sical art history. We must locate the most prominent islands, the current's
flow and direction, explore possible worlds, and prepare the migration toward
a universe of bits.

Many conceptual steps and technological discoveries have contributed to
the reconfiguration of the art world. In this sense, art has participated in a
complex phenomenon that it, for that matter, announced and, in part, pro-
voked. Indeed, artistic modernity celebrated the change. Declared carriers of
social and genetic determinism, as noted at the beginning of the twentieth
century, modern human beings put themselves to the test by assuming their
future and thus investing in a program for change. Now the renewal of art
forms has materialized through a series of iconoclastic gestures, which has
introduced new materials that were first borrowed from the industrial world
or from everyday life and progressively from the domain of communications
and technology. This has had the effect of transforming approaches and
know-how.

Certainly, there was then an exaltation of freeing oneself from inscribed values in the forms inspired by the aesthetics of taste. However, one observes that the renewal in materials accompanies a more profound research for reinventing the role of the constituting elements of an art. In this sense, search for new materials, and eventually for the immaterial, translated into a profound reorganization of artists' positions at the three constituting poles of art. (1) artists' commitment became one of representing their vision of the world, their emotions, offering a picture of reality, exalting a spiritual, political value, etc. (2) Work on the material of an artwork can also reveal changes in the distribution of diverse roles, in which the artists feel invested as: visionary, creator, denunciator, consciousness-raiser, absorber of an era's sensibility, partner in a process, etc. (3) And finally, the new materials point to the reorganization of the relationship between artists and spectators aiming, for over a century, for an increased empowerment of the spectator, one who is now called upon to intervene in a determining way in the processes of the creation of the artwork, as it has become the case in interactive artworks. In this sense, the changes that occur in the material offer us precious indications as to the nature and depth of the reorganization, which they translate and produce. The development and the choice of material and its treatment are symptomatic of the representations that the subjects have of themselves and of their dispositions. But the material and the tools that they control also determine the questions and answers that they, and we, are able to conceive.[2] "Everything becomes a nail to the hand with a hammer." Every material carries with it an approach, a way to relate and to be related to, a horizon of expectation, of the "attentional"[3] mechanisms and an environment and posture that awake certain neuronal, emotional, cognitive circuits. There is no innocent material.

Until the apparition of new media arts, artistic activity was associated with the creation of forms. With the gradual abandonment of solid materials and "the decline of the object"[4] to the profit of what Lyotard named "immaterials," the emphasis shifted progressively from the process to the experimentation of devices inviting the spectator to connect on another level and to eventually interact with the artwork and its environment. The interest in process opened the way for a whole series of considerations and trials of techniques. As Isabelle Rieusset-Lemarier pointed out: "The technique is an interactive mirror."[5] To this, the technique restores for us the state of advancement of our knowledge, crystallized in the tools that we have shaped but also our way of asking questions, of looking at solutions and of our way of representing

a situation, its context and its issues. There would be a whole technogenesis linking human development to technical innovations and to the materials produced. McLuhan said: "We shape our tools and afterwards our tools shape us." Locating and examining the transformation provoked by the advent of a technique on the senses are twice as instructive: they allow us to survey their origins, and by doing so, they reveal the dimensions of the actual state of things. So this operation is even more complex, as it is in many cases, for what we have metabolized is the knowledge in question; it has been integrated into our way of seeing, sensing, and thinking. In 1945, the ballpoint pen represented a fine technology and an important social change in 1945. The pen was one of the main vector of infiltration of the consumer society because it is not refillable, which obliges us to have several for various colors, and thus it became one of the first "disposable objects." It became quickly widespread because it adapted itself to all the alphabets and was mass-produced, which made it very affordable.[6] We tend to forget this until it doesn't work.

The Intellectual Climate

It is important to signal a few elements of the intellectual and cultural context of the era in which the transition went from the material to the medium and the interface. Various social sciences have contributed to the creation of conceptual conditions, which where favorable to the redefinition of the role and limits of art. A few thoughts were particularly determinant, and though it is impossible to go through all of them or even signal all the movements having an influence, some positions shed light on the fundamental issues of new media arts.

Notably it is the case of Wittgenstein's works which made a determining displacement. He was one of the first to operate the passage from logic to philosophy of language, a passage equivalent to what we are interested in here: materials to interfaces. We cannot emphasize enough the impact of his famous "Meaning is use." Leaving the register of subjectivism or of the position from which language "expresses" thought—where thought exists beyond language—Wittgenstein put the emphasis on both the notion of involved action and the constituent roles of context, including the partners in the construction of meaning. The notion of a "language game" reinforces the idea that to speak is to accomplish an action, which goes beyond communicating an idea or expressing oneself. Wittgenstein gives the following examples:

Review the multiplicity of language games in the following examples, and in others:
Giving orders, and obeying them—
Describing the appearance of an object, or giving its measurements—
Constructing an object from a description (a drawing)—[7]

His intuition prepared the way for the famous *How to Do Things with Words* by J. L. Austin,[8] a posthumous work published in 1962, which emphasized the performative character of language. Austin broke with the logical approach, which questioned the condition of possibility and of the truth of the utterance and reoriented the philosophy of language upon ordinary language by insisting that certain acts can only be accomplished through language, for example: to baptize, to marry, to swear. Austin came to the conclusion that every utterance has a performative dimension, and he proposed five categories: verdictives, exercitives, commissives, behabitives, expositives.

These two approaches deployed what Charles Morris had clearly defined in the 1930s as the pragmatic dimension of language by emphasizing the relation between signs and interpreters.[9] The meaning of an utterance would reveal not only the link between words and things but also the relation between speakers. Wittgenstein and Austin took a step forward by leaving the strict register of interpretation of signs and introducing the dimension of activity, and therefore, implicitly, the interaction between partners in a communicational exchange. It is this last pragmatic dimension which new media arts later came to exploit by insisting on the fact that an artistic phenomenon sets the conditions and a relational context with the goal of provoking an exchange between the artist and the spectator that could take different forms.

Françoise Armengeaud[10] has synthesized well the three basic concepts of language pragmatics, which found an echo in the art world:

• The concept of the act: to speak is not only to represent, it is also to act upon others. Thus the notion of interaction, of transaction.
• The concept of context: the concrete situation where words are uttered (the place, the time, the interlocutor's identity) and can influence the exchange.
• The concept of performance, that is, the accomplishment of an act in a context, which allows the actualization of competences.

Parallel to and in a position very close to that of pragmatics,[11] Umberto Eco published *The Open Work* (1962) in which he announces that the "inter-

pretative process" represents an "individual and tacit form of execution of the artwork," underlining the active role of the reader or the listener, and transferring a part of the creation toward the pole of reception. This remarkable work, which was acknowledged by the art world as soon as it was published, has without doubt been a vector of awareness as to the dimensions of transfer toward the pole of the spectator. It is interesting to see how in many circles until the 1980s when various types of formalism reigned, people, who were touched by art, firmly reacted against the possible bond between art and communication. Marc Lebot's famous *L'art ne communique rien à personne*,[12] which can be translated as "Art communicates nothing to no one," sums up quite well the position that reduced communication to the transmission of a message, concealing entirely the relational dimension. In this context, Umberto Eco's book announced other possible perspectives even for the most recalcitrant. The pragmatic tumble was anticipated with the tacit promise of an emancipation of the spectators and their empowerment with regard to new roles.

Transposed to the domain of new media arts, the main ideas of pragmatism summarize well the major issues relating to the aesthetics of action, which were grafted onto new media arts and which replaced the aesthetics of taste. One understands the urgency to align the artistic project not on the petrified solidity of traditional materials but on the nervous mobility of relations and connections. Pragmatism emphasizes the creation of meaning through the single act of an exchange with the other, renouncing the disclosure of privileged meaning which the artists would have instilled into their artwork—a meaning so sought after by hermeneutics as well as by all other approaches tied to the theory of representation.[13] From now on, this quest for meaning will be of secondary importance, replaced by the primacy of a relation that counts on the active and creative role of the spectator. Condemned to vagabondage, the meaning of an artwork will now be one of the *ways* by which spectators and artists join together. A whole series of devices polarizing the attention on exchange modalities and the forms of experimentation will take over from this dimension once so central to meaning.

Also a few considerations are essential to the determinant notion of interactivity in new media art. We can trace back to the 1960s the practice of interactivity in arts, although the concept itself did not appear in French before 1980, and we can just find it seldom documented even in recent dictionaries. It is surprising for anyone who frequents the art world where this practice seems to have become so banal to the point of being outdated. The

notion itself is linked to the domain of computing: "The act *of dialogue between an individual and information given by a machine.* 'Interactive,' which seems slightly anterior, is defined as a term from the domain of computing: *Which allows to use a conversational mode.*" The verb "to interact" (from inter- and action) appears on the psychological scene and in communication theories in 1966: "to have a reciprocal action or also to interact: To exercise an interaction."[14]

One understands that it is through interactivity that the passage from materials to interfaces arises. It is no longer sufficient to give something to see, nor to touch transformed material. It is necessary to have spectators experience other forms of sensations and up to a certain point other forms of life so as to be able to connect differently to the environment and to others. Thus the necessity to go through mediums, by these transmission belts, these agents of connection. So we must perfect interfaces, exploring each one or many aspects of one medium. But before tackling this notion, a few historical remarks are necessary.

The Forerunners of Art

Various devices led spectators to occupy a role more and more active in the production of the artwork, managing progressively to implicate them in the creation process. There are numerous ways to reach the public and many degrees of interactivity. Since the beginning of the century, it was understood that one of these approaches consisted in bringing the show off the stage, reaching out to the spectators directly in the theater space, so as to include them in the spectacle. Electricity and the resulting lighting effects no doubt represent a first attempt in this direction. As early as 1909, futurists Bruno Corra and Arnaldo Ginna stage-designed a projection, in part, onto spectators dressed in white for a performance with a colored organ. In 1910,[15] Scriabin imagined a similar stage design for his production of *Prometheus*. Drenched in the same light, spectators and the stage seemed to be part of the same action. In this way, by their movements and attitude, spectators contributed to the animation of the scene. These experiences deserve attention because therein one finds the seed of many elements to be developed later in new media arts. This direct inclusion of the spectators in the spectacle, even though demanding minimal participation from them, transforms the dynamic fundamentally by introducing new performative parameters. Using the projection screen, the

spectators become literally what there is to see: they become the scene of a live projection, a place to appear in, a live support, and a mobile and polymorphic part of the show. They stop being contemplative observers and instead play an active role, converting themselves into props and actors. Moreover, the projection has here an inciting or vocative function: it calls on the spectators and emphasizes their instrumental role as partners.

If notable experiments mark the first half of the twentieth century, it is mostly after the 1960s that these experiments find a resounding echo. Without recourse to technologies, many art movements broke from a "contemplative" practice to directly invest the public in an interactive process. Alan Kaprov[16] initiated a series of happenings (1959) in which the spectators were called on to intervene as actors. Augusto Boal, who was the first to coin the term spect-actor, developed a Theater Forum asking the spectators to intervene in the middle of the performance by establishing a dialogue with the actors with a view to orient the course of the performance.

Among the works of art that employ technology, we can mention, in different domains, a few emblematic works that initiated transformations. The installations of Nam June Paik,[17] regrouped and entitled from 1963 as *Participation TV*, allowed spectators in a gallery to act upon a televised image with the help of a microphone or a magnet, thus altering the electromagnetic fields and producing image distortions. The video environments of Lee Levine,[18] Bruce Nauman, and Peter Campus, which integrated the spectators' image into the closed circuit video recording insisted on the notion of the spectators' point of view and on the active dimension of feedback found in the televised device. In 1967, Radúz Çinçera[19] had imagined an interactive video projection that contained pauses during which different alternatives were presented to the spectators for the continuation of the story. These various experimentations are just a few expressed desires to include the spectators in the creation process. And if these works only allowed a limited role, for example cranking a handle or finding oneself included in the artwork against one's will, one understands these to be the very first steps toward a more complex interactivity, inviting more creative interaction.

Finally, one senses that the notion of interaction is slowly shifting toward a more refined notion of "alteraction." The notion is even more interesting since it puts the emphasis not only on the action but also on the encounter with the other, who, in the context of cyberspace, risks becoming evanescent because this "other" is not necessarily there, present on the screen. Some artists,

notably Reynald Drouhin, use the term for those artworks that encourage the community of spectators to contribute. But many incorporate it into their work without naming it, convinced that the active role of the other is the best route to the artwork's existence and durability, if not the only way.

Certainly various degrees and levels of interactivity exist. From the gadget to the simple tool, we arrived at the instrument that allows, by means of feedback, to measure reality, as foreseen by Gilbert Simondon. We are now entering the era of the interface, which allows the users or the spectators to feel part of the process. Henceforth, new media arts create environments where it is allowed to surpass instrumentality and to explore other behaviors and ways of connecting with each other.

The Interfaces: Shifters

In the context of new media arts where it is the intention to convert the spectators into actors, one understands that a good part of the operation must be made through interfaces, devices that link humans to machines. The interfaces become a sort of conductor, participating in the production of an artwork, just as one says in linguistics that the "shifters" (I, you, etc.) participate in the production of an utterance. It is through these "apparatuses" that interactivity is established and where the roles between the artists who initiated the process and the participating inter-actors are distributed. The examination of a few works of art should reveal various degrees or different approaches. One's interest in questioning the interfaces inscribes itself in the fact that they condense themselves to the state of knowledge, know-how, and creativity at play; the degree of openness with regard to chance,[20] to the others and to the environment; and to methods of control.

In new media arts, one finds six principal categories of conductor interfaces:

Sensors: From microphones to datagloves, from photovoltaic sheets to ultrasound detectors. Sensors are used to perceive data of various types relating to the environment, the state of a system, or the reactions of a partner during a performance. Multiple sensors for force, light, heat, movement, humidity, perspiration, stress level, analog and digital, serve as basic devices for interactivity between the spectators and the artwork's operation. Virtual reality installations, new stage designs involving sound and lighting effects controlled by the movements of the performers, and research of proprioperception depend on these extensions of our senses.

Figure 12.1 Bill Kaminsky and Jim McGeel, *Tennis Racquets Equipped with Electronic Components*, 1966. Two objects: 68 × 22.5 × 4.1 cm. each. Props used in Robert Rauschenberg's performance *Open Score* as part of the 9 Evenings: Theater and Engineering festival, The Armory (New York, N.Y.), 13–24 October 1966. 9 Evenings: Theater and Engineering fonds, accession number: 200101, The Daniel Langlois Foundation, Montreal, Canada. © The Daniel Langlois Foundation.

Recorders: From the photo camera to the mechanical phonograph and digital memory. Recorders provide a sample of reality or traces of an activity and fix them on a support more or less reliable and durable. Unlike analog technologies that fix light and sound waves, binary treatment introduces the possibility of converting to a numeric value (0/1) the samplings of sound or images or kinetic images by means of video. Likewise, to the possibilities of analog treatment, one can add all manipulations, combinations, and hybridizations of sound and images by digital processes. From interface of transmission or of recording, digital technology becomes an interface for creation associated with the possibility of the computer. Recording becomes a transformable memory, an extension of a faculty.

Actuators: From pneumatic, hydraulic, or electric devices, allowing the possibility to move a robot or one of its parts up to the muscular electrodes used in art and biotechnology. Some actuators mix with the material of the artwork such as is found in sculptures made with shape memory alloys that have the

Figure 12.2 Bill Kaminsky and Jim McGeel, *Tennis Racquets Equipped with Electronic Components* (detail), 1966. Two objects: 68 × 22.5 × 4.1 cm. each. Props used in Robert Rauschenberg's performance *Open Score* as part of the 9 Evenings: Theater and Engineering festival, The Armory (New York, N.Y.), 13–24 October 1966. 9 Evenings: Theater and Engineering fonds, accession number: 200101, The Daniel Langlois Foundation, Montreal, Canada. © The Daniel Langlois Foundation.

property of adopting its form in relation to weather conditions, light, and so on. Others called "smart materials" allow the sculpture or construction to adopt an "attitude" with regard to the environment and can in return act on it. These interfaces procure the installation a certain autonomy so it can manage its exchanges with its environment.

Transmitters: From the telegraph to the Internet and to performances by telepresence. The abolition of distances, a consequence of the electric telegraph, opened the way to a whole series of interfaces of transmission (fax, television, teleportation, etc.) that artists can use. The telematic arts proposed new aesthetic considerations of time and space, and introduced new types of presence (ranging from specter to clone), interventions (the first cybercafés, telepresence performances), and interactions (art networks on the Internet, on interactive television, etc.) redefining the roles.

Figure 12.3 Marey invented a graphic recording method based on pneumatic transmission. Sensors placed on specially designed shoes emitted impulsions as long as the weight of the body would maintain them on the ground. These signals were then printed on a kymograph.

Diffusers: From the magic lantern to interactive high-definition television, from the barrel organ to digital acoustics. Audiovisual broadcasting goes through a projection screen linked to sources of audio reproduction (electrostatic membranes). Flat screens (plasma, LCD, thermal imaging), projection screens (cinema, television), touch-screen monitors, and high-definition television open the way to broadcasting image and sound while adding samplings from reality as was the case of the "that-has-been" of Roland Barthes with elements from digital simulation. Representations in 2-D and 3-D led toward holographic video, which combines holography and computer graphics.

The integrators: From the automaton to the cyborg. Projects of artificial creatures result in various interface integrations, which attempt to reproduce the living. Situated at the intersection of research in tissue culture engineering, nanotechnology, various prostheses, and artificial life aiming to repair, improve, or redesign the human, artists multiply manipulations and adapt interfaces deriving from the domain of the biomedical laboratory. From Vaucanson's

automatons to Waseda's organic androids and including Jacques-Droz's musicians, the integration of technologies in the contemporary cyborg is the next phase of the living machine myth: a global interface between the universe and conceptual thought.

Each of these interfaces allows the articulation of a particular form of interactivity and the investing of the receptors as partners. Mediology could be developed for each interface in order to understand its precise functioning and to grasp the displacements that it operates on the receptors as well on the artists themselves. Some of them join or contribute to an aesthetic and cultural paradigm shift.

Five Functions

For forty years, interfaces—intermediaries between two languages or two systems—have been infiltrating themselves everywhere. These agents of liaison or of passage, these filters of translation between humans and machines announce changes that are still hard to delineate although one anticipates that they are quite substantial. Interfaces multiply, incorporate in various devices, making their use increasingly natural. No need for buttons or cranks. Screens will soon be transparent, controls invisible. Quite paradoxically, this massive invasion is made discreetly and quietly. Technology becomes invisible by infiltrating itself everywhere. We forget the "good" interface precisely because it is transparent. Its visibility—often synonymous with dysfunction—interests only the specialists, artists or engineers who are curious in knowing how they work.

Artists have mostly directed their research around the five functions of interfaces. They can be alternately extendible, revealing, rehabilitating, filtering, or the agent of synesthetic integration. These functions are moreover not exclusive to one or the other; it is even frequent for an interface to fulfill more than one of them. Their essential role consists in carrying out smooth mediations between thought and matter, thought and sensibility.

As an extension, they lengthen and increase a sense by allowing it to capture and record elements from reality. So they give access to other layers of reality, to other portions of matter, from the universe to humans, without which these would be inaccessible. Let's take the telescope and microscope as illustrations of paradigms: both of them open us up to worlds, allowing us to redefine ourselves. The former relativizing our position, the latter establishing

continuity between different kingdoms: animal, vegetable, and mineral. A large number of interfaces developed by artists fulfill similar functions. The dataglove, the sensor-enabled suit, the video camera serve as "electronic organs," which extend a sense. We are now predicting clothing with more complex functions. Clothing becomes a sensor for recording bodily information and increasing exchanges with the environment. We already know that these exchanges will surpass strict sensoriality and act more globally on humans.

But through artistic applications, we realize that even interfaces destined to serve an extension of a faculty, memory, judgment, or imagination, must pass through senses. It is here where we see things that we think. Painting understood this. We could even say, by acknowledging the multiple research in tactile interfaces, it is here where we touch that we feel touched. And the more we intervene as a spectator, the more deeply we feel concerned. Besides, it is logical for us to have the urge to develop extensions for a feeling of proximity; we try to get closer to things that we cannot reach. What we learn more or less confusedly is that there is a lot to discover in this area which has not yet been explored enough, and this is likely because it is most intimate.

It is in this sense that we can talk about *dévoilement*. Some interfaces allow one to reveal conditions or reports, which we cannot conceive or objectify otherwise. In the continuation of communication theory and cognitive science studies, we attempt to understand phenomenon and mechanism differently by emphasizing the constitutive dimension of interaction between humans and the environment. This is notably the case with various interactive materials used in architecture, which allow the exploitation of unsuspected relations, undoubtedly always present but of which we were unaware and in which current technologies permit one to participate. Ted Krueger insists on this aspect, which, if one examines it more closely, leads to a revision of the cognitive apparatus:

Pask (1969) posited that the domain of architectural design was not the determination of the form of the building but the structuring of the social context in which humans interacted with their environment and with each other. He used the term "mutualism" to designate a kind of symbiotic relationship between the architecture and its inhabitants. This relationship draws closer with the development of intelligent machines and requires a more detailed phenomenological analysis than Pask provided. This symbiotic relationship is of interest, not only in the context of what has

traditionally been considered the domain of the discipline of architecture, but is fundamental to all aspects of human-machine interfaces, to all efforts towards the structuring of systems that serve cognitive processes.[21]

Examination of the interfaces must take into account an ergonomic complex including the users, their degree of sensibility, and the context of use as well as the interface and its functionality. Acceleration of technological changes promoted this type of ecological examination since the sensorimotor system is found relentlessly jostled by the appearance of new devices making certain ways of doing things outdated and unsuitable. As one says in psychoanalysis, things happen where there is resistance. This is just as true for technologies since we realize more and more that various pockets of resistance have provoked a whole series of investigations revealing forgotten, neglected, or rejected dimensions. And if in the past each tool constituted its own ecology implying a corporal schema and a cultural context, one was far from suspecting the scale and depth of its impact. Actual interface studies have the merit of revealing many dimensions and an unrecognized complexity.

Interfaces operate also on a *rehabilitation* of forgotten, neglected, or lost sensoriality. As such, they restore or reestablish ways of perceiving, inciting one to connect differently others and the world, but allowing first the rediscovering of dimensions and bodily functions that have become obsolete. Annick Bureau insists on this aspect: "One of the essential contributions of contemporary technologies was—in a first phase—to make us conscious of our body, to bring us to reflect upon our modes of perception, to question ourselves on the nature of the space in which we are in, in short to redefine ourselves as humans. Interfaces—understood as sensorial organs—first engendered a deconstruction of our usual modes of perception, a sort of fragmentation/ dislocation of the body."[22]

Many phenomena contribute to this rehabilitation. First, there is research aiming to repair the body by changing its parts, research on whichever prosthetics have shed light on the complexity of the functions of the eye, hand, teeth. To take just one obvious but quite complex example, the multiple actions of the hand are much more difficult to reproduce than formerly believed. Abduction, adduction, flexion, and extension of the hand, and its various grasping, prehensile, retention, pronation, and supination functions which make possible the multiple movements (pinching, caressing, scratching, rubbing, pushing, hitting, etc.), defy any return to the simple appearance

of the hand. And we are far from a complete inventory of the connections involving over forty muscles with all their tendons and thousands of nerve endings that make it possible to coordinate the hand with the forearm, arm, and body. All the research that aims to reproduce the hand's twenty-three degrees of mechanical freedom[23] in order to simulate the actions of the hand in the context of a virtual environment already poses numerous problems. One can imagine how distant the integration of various neurophysiologic functions still is. Robotics, artificial intelligence, and all sciences of movement (kinesthesis, ergonomy, neurology) are interested in this. From now on one understands that interfaces, reproducing whichever functions, condense the state of knowledge, the desire to simulate the function, and the representation of an exchange between the organ and the sensation. Each new attempt corrects the approximation, so as not to hang onto the heresy of the moment, convinced that this is the way it works. The examination of interfaces is very instructive in this regard. It reveals the state of our expectations and finitude.

In other respects, one is witness to a global rehabilitation of certain forms of sensoriality and in particular of the haptic function, which the tradition of writing had, if not inhibited, at least relegated to a secondary place, far behind the hegemony of vision. Printing and alphabetization made the world a book to be read, favoring abstraction and various formalizations, which science and the arts of the twentieth century espoused. Actual research in the domain of interfaces, particularly in art, make one think that one aims more for a redeployment of a 3-D world. One wants to touch, feel, relearn gestures, rediscover new forms of sensations, other layers or sensoriality, and other dimensions of space.

Investigation of the sensorial domain leads to the notion of *synesthesia*[24] evoked by a few artists since the beginning of the twentieth century, notably Scriabin and Kandinsky. Some interfaces indeed favor the translation, the passage of a sensation to another sense—to see with our fingers, hear with our bones, caress with our sight. Many artists cultivate devices allowing an interpenetration of two or more sensorial fields, which the common computer makes almost natural by converting any such data into image, sound, or text. By doing so, the computer joins another way of perceiving in a multimedia way and reveals to us that this approach is finally anchored in us, despite the tendency in art, throughout the last centuries, to specialize in distinct fields.

But synesthesia also plays a role in an entirely different scene. Artists and scientists explore devices that allow connecting the senses among themselves.

Biofeedback installations allow respiration and vision to merge through a device for visualizing brainwaves. The creation of avatars with traits and characteristics of real people also opens up new communicational perspectives. Thus we can experiment with sensations in zones otherwise inaccessible. Avatars procure an immunity, which makes possible a sensorial transfer that humanizes virtual characters on one hand and on the other divides the subject in two.

We then discover "I am legion": that many of the possibilities we realize only through a very thin layer can thus manifest themselves. This experience of splitting in two, of entering the skin of the other, so to speak, is one of the essential conditions of cultural interbreeding, and in this sense, simulation devices are catalysts of racial, cultural, and geophysical integrations.

Synesthesia that operates on interfaces can finally bring to a more global level the translation or conversion of sensitivity into representation and vice versa. This usage of interfaces summarizes quite well one of the essential dimensions of art, and in particular of new media arts, where the raw material, one must say, is algorithmic and abstract and at the same time composed of a communicational flux made of sensations, emotions, ideas, and exchanges.

The complexity of exchanges creates an urgent need for a *filter* at different levels. We live in an era of profusion with instruments inherited from a traditional culture. We are underequipped to deal with this profusion and to orient our choices. We have lost our sense of orientation. Everyone feels confusedly that the global rules are being changed, that at this moment in time humans are acquiring the means to reprogram themselves though they have neither the maturity nor the understanding of the issues. And we realize we were wrong to believe that abundance would stem anxiety. It simply changed appearance and name and is now called "depression" or "panic attack." The interfaces to perfect will play an absolutely determining role here, responding to various needs.

Thus the need to filter in order to manage profusion. The Internet represents the space of profusion par excellence; unfortunately right now, we do not have a precise map or a user's guide. More and more intelligent search engines allow one to direct one's consultation according to the pertinence of the information for the user, and numerous research projects are underway aiming to create automata, a sort of seeker that will be flexible and adaptable to the context of the search. This is not to mention that users had the reflex to regroup into communities sharing interests, through various forms of chatting, news groups, or MUDs, aimed at exchanges and eliminating intruders

and gray pollution, the kind that pours out with pseudo-informational rubbish.

The need to filter, to orient oneself: Certainly, interactivity in art remains one of the major filters used to thwart the expectation of the consummation phase by leading toward other creative or expressive behaviors. Artists understood this very well, perfecting a series of devices that address spectators, if not as partners, then at least as intervening individuals in a process that would be meaningless without their intervention. A whole new rhetoric needs to be developed, to describe not rhetorical figures but the rising conditions affecting spectators and human beings in general. Interactivity provides markers indicating the dark areas, the pockets of resistance, and offers a tryout field. Small laboratories of life, new media arts, in this way, help one to identify the impasses, locate which roads to take, discover a horizon, allowing one to orient oneself.

Conclusion

With the invention of various devices and interfaces, artists are experimenting with behaviors adapted to the emergence of new forms of community, which explains the hesitations, the trials and errors. We know how disappointing these experiments can sometimes be. Poorly interactive, they at times enclose one into a schema of manipulation[25] rather than propose a real space for dialogue. And in that, they renew what we can already do so well: move around one spot while maintaining the illusion of advancing. They announce or promise more than they can offer. Sometimes alteractors are not perfectly aligned. In a range of degrees of implication, from the participation to the transaction, emphasizing the fact that there is a passage from one to the other, to the bidirectional cooperation of exchange and to the commitment that necessitates an effort, there are many expectations to satisfy and solve. More even when we propose an experiment aiming at the validation of a model and necessitating a performance of the alteractor. All the more so since these trials are not solitary as they were previously for aesthetic experience, even when it involved a group reception, as was the case in performance art. The audience's reception could exert an influence, but the ecstasy or disgust remained intimate emotions that were difficult to share.

In interface experiences that put interactivity into play, the complicity of the alteractor is required for the dialogical artwork to take place. The project

initiator must conceive and put into place an enclosure and a device through which visitors will feel called on to discover and add content and functionality to the artwork, to penetrate with the sensibility of another or of partners. Spectators will eventually be brought to consider the reactions of a group on which they will have to modulate their own intervention. In these types of art forms, the other is central. The other becomes the key figure with whom it is essential to unite. As in bridge, one must find the best hand of the teammates. It is not necessarily my spade or the diamond of the other; it is the strongest hand both combined. There are many more conventions to imagine in order to perfect what concerns, after all, a game much more serious than what is played in the small artistic laboratories: the invention of new forms of community life.

Interest in interfaces awakening other forms of sensoriality appears when we see emerge the specter of the cyborg, this mutant half-man, half-technology whose destiny seems essentially cerebral. The desire to animate sensorialities makes itself felt in this way when one is afraid of losing a humid and perishable slice of humanity. The body remains a source of information and of incomparable delectation. One associates tastes, colors, and perfumes with it, and when one says that everything happens in the brain, one knows that this is shorthand, and that the pleasure of tasting a wild strawberry cannot be reduced to a mere cerebral stimulation. At a time when chemistry and cognitive sciences meet and reveal interconnections more and more complex, modulating our adaptability, disposition, and mood, one realizes that the body is much more than a simple envelope, a receptacle for the spirit. It is itself the scene of multiple exchanges, regulation devices, and renewal-guaranteeing adaptations. Besides, the development of media interfaces allows one to envisage certain bodily functions, which would have passed unnoticed before. As if our representations remain attached to our ways of seeing. The clock, which we thought for a long time to be the most perfect mechanism, inspired the body-machine: mechanical and well-ordered, just as cybernetics made it possible to conceive a body engaged in a systemic ecology. Recent research in neurophysiology and cognitive sciences also concur with the intuitions that new media artists have explored for the last few decades. And there is a lot more to do and to say about this field that is opening up to the arts.

It is true that new media arts have paid particular attention to sensoriality, without doubt in reaction to a long purgatory where abstract and conceptual art relegated the senses, by privileging only one, subordinate to others. Art was meant to be thought about and not felt, or to be felt through the many

detours of intellectualization. What the communicational arts privilege on the contrary is the multiplication of channels of reception by intersecting media. It is also to involve the spectators' body as intervening actors through action, waging that they will be more deeply touched and joined by their other if they get involved and physically committed. "You are under the water" as Bill Viola said.[26] The possibility of soaking up and entering the world of the other, allows the interactors to get closer. Especially through the sense of proximity: feeling and touching modify the link and favor closeness and unexpected transfers, recalling that "The other, another, is always someone immense beside me."[27]

Notes

1. Henri Focillon, *The Life of Forms in Art* (New York: Wittenborn, 1964), 44.

2. Claude Lévi-Strauss was inspired by an intuition similar when he wrote in 1962: "[The *bricoleur*] has to turn back to an already existent set made up of tools and materials, to consider or reconsider what it contains and, finally and above all, to engage in a sort of dialogue with it and, before choosing between them, to index the possible answers which the whole set can offer to his problem" (*The Savage Mind* [Chicago: University of Chicago Press, 1966], 18).

3. I borrow this notion of "attentional mechanism" from Francisco Varela, Evan Thompson, and Eleonor Rosch, *L'inscription corporelle de l'esprit* (Paris: Seuil, 1993), 144. The context of use is here widened if we compare it to cognitive sciences notably by Carpenter and Grossberg.

4. Frank Popper, *Le déclin de l'objet* (Paris: Chêne, 1975).

5. Isabelle Rieusset-Lemarier, *La société des clones à l'ère de la reproduction multimédia* (Paris: Actes sud, 1999).

6. "In fact, the idea of the ballpoint pen dates back to 1865. From improvement to improvement, the first true ballpoint pen appeared in Argentina, thanks to Hungarian named José Ladislav Biro. The first model was sold at Reynolds in New York, October 1945. It was in fact a copy of Biro's ballpoint pen. But in 1952, Bic's 'Cristal' appeared on the market." Jean-Pierre Moeglin, "The Ballpoint Pen Writes an Important Page in History," http://www.decofinder.com/decofinder/_daz/_BUREAU/stylobille_histoire_alsapresse.htm/.

7. Reporting an event—

 Speculating about an event—

 Forming or teasing a hypothesis—

 Presenting the results of an experiment in tables and diagrams—

 Making up a story; and reading it—

 Singing catches—

 Guessing riddles—

 Making riddles—

 Making a joke; telling it—

 Solving a problem in practical arithmetic—

 Translating from one language into another—

 Asking, thanking, cursing, greeting, praying.

 (Ludwig Wittgenstein, *Philosophical Investigations* [New York: Macmillan, 1965], 23–24)

8. J. L. Austin, *How to Do Things with Words* (Cambridge, Mass.: Harvard University Press, 1975). (In 1962, the first edition was published two years after his death. It gathered together twelve conferences.)

9. In an important work in 1938, *Foundations of the Theory of Signs*, Charles Morris separated semiotics in three dimensions:

- The relation between signs and objects: semantic dimension
- The relation between signs among themselves: syntactic dimension
- The relation between signs and interpreters: pragmatic dimension

Pragmatism was interested in the links between interlocutors, while the semantic dimension focuses on the link between signs and object, and the syntactic dimension, the relation among signs. Charles Morris, "Foundations of the Theory of Signs," in *International Encyclopedia of Unified Science* 1 no. 2, ed. Otto Neurath (Chicago: University of Chicago Press, 1938).

10. Françoise Armengaud, *La pragmatique* (Paris: PUF, 1985).

11. Umberto Eco himself recognized to have practiced pragmatism without knowing it in Lector in Fabula (Paris: Grasset, 1979), p. 5.

12. Marc LeBot, "L'art ne communique rien à personne," in *Art et communication*, ed. Robert Allezaud (Paris: Éd. Osiris, 1986).

13. Just to name a few: iconology, semiology, art sociology, psychoanalysis, hermeneutics, and various forms of art history.

14. *Le Petit Robert*, 2005 edition. See also the article by Yolla Polity, "Eléments pour un débat sur l'interactivité," http://ri3.iut2.upmf-grenoble.fr/TPS_interactivite.htm/. She presents a few definitions and the date of appearance of this notion in the French dictionaries.

It is stunning to realize that the word does not appear as an article in numerous dictionaries. It is the case of the important *Dictionnaire critique de la communication*, ed. Lucien Sfez (Paris: PUF, 1993). The notion does not figure in the index; it is the same for "interaction." The same thing goes for *Dictionnaire des sciences cognitives*, ed. Guy Tiberghien (Paris: Armand Colin, 2002).

15. The creation of *Prométhée ou le Poème du feu* for a grand orchestra and piano with organ, chorus and lights piano (op. 60) in Moscow, under the direction of Serge Koussevitsky, 15 March 1911. Alexandre Mozer, constructor of the keyboard with lights, was not ready for this performance. About this subject, see the article by Nathalie Ruget-Langlois in the section "Pionniers d'Olats," http://www.olats.org/pionniers/pp/scriabine/scriabine.shtml/. The first performance with lights was held in New York in 1915. Cf. the article by William Moritz, "The Dream of Color Music, and Machines That Made It Possible," http://www.awn.com/mag/issue2.1/articles/moritz2.1.html/. In USSR, the premier was held only in 1962. Cf. The article by B. Galeyev and I. Vanechkina, "Was Scriabin a Synaesthete?," http://prometheus.kai.ru/skriab_e.htm/.

16. Allan Kaprow, "18 Happenings in 6 Parts," 1959. See the excellent fifth article by Inke Arns, "Interaction, Participation, Networking Art and Telecommunication," http://www.medienkunstnetz.de/themes/overview_of_media_art/communication/3/.

17. Exhibition held March 1963 in a gallery hosted by the architect Rolf Jährling in his private residence.

18. *Slipcover*, videotape time-delay projection. When the audience entered the room, five seconds later they were able to see a video projected image of themselves entering the room. Already in 1968, the American Levine in *Photon: Strangeness 4* arranges, in a room filled with metal wiring, mirrors that move and television cameras in such a way that the spectator is captive in the middle of the images of himself, recorded at different angles.

19. At Expo 67 in Montréal, Radúz Çinçera presented his apparatus, the "Kinoautomat" (movie vending-machine), for the first time to a larger audience. The Kinoautomat was developed with directors Jan Rohac and Vladimir Svitacek, and scenographer Josef Svoboda. See http://www.medienkunstnetz.de/artist/cincera/biography/.

20. This is a position that John Cage advocated. For Cage, chance and indetermination represented toward the end of the 1940s a real opening up of the artwork to extra-musical domains: the texture of the paper oriented the composition, he borrowed from the I Ching, the site of the execution of the performance became part of the composition, etc.

21. Ted Krueger, "Interfaces to Non-Symbolic Media," in *Interfaces et sensorialité*, ed. Louise Poissant (Ste.-Foy: Presses de l'Université du Québec, 2003), 127.

22. Annick Bureaud, "Pour une typologie des interfaces artistiques," in *Interfaces et sensorialité*, ed. Louise Poissant (Ste.-Foy: Presses de l'Université du Québec, 2003), 32.

23. Claude Cadoz, "Contrôle gestuel de la synthèse sonore," in *Interfaces homme-machine et création musicale*, ed. Hugues Vinet and François Delalande (Paris: Hermès, 1999), 177. In the same work, Marcello Wanderley and Philippe Depalle in "Contrôle gestuel de la synthèse sonore" discuss the six degrees of liberty related to translation and rotation along the three axes (X, Y, and Z). See p. 153.

24. Synaesthesia is a form of pathology of perception that represents a valorized approach, one searched for in art. We can count thirty-two types of combination that we can group in three great categories: bimodal synesthesia, multimodal synesthesia, categorical or cognitive synesthesia. See http://www.users.muohio.edu/daysa/types.htm/ and http://tecfa.unige.ch/tecfa/teaching/UVLibre/9900/bin19/types.htm/.

25. Influenced by Alexei Shulgin, Lev Manovich explains from a Russian point of view that interactive installations reproduce manipulation schema similar to the imposed totalitarian ideology in the Eastern Europe countries, in "On Totalitarian Interactivity," 1996, http://www.manovich.net/.

26. "... I wanted the viewer to be inside the image with their body, not with their intellect, not regarding it from a distance where it is framed off from you. [...] you are not standing over the side of the pool and looking at the ripples on the water, someone pushed you from behind and you are under the water, you are the water, you become the water." Clayton Campbell, "Bill Viola interview," *RES ARTIS worldwide network of artist residency*, http://www.resartis.org/index.php?id=95/.

27. Joseph-Louis Lebret, cited in L. Avan, M. Falardeau, and H.-J. Stiker, *L'homme réparé: Artifices, victoires, défis* (Paris: Gallimard, 1988), 42.

The Myth of Immateriality: Presenting and Preserving New Media

Christiane Paul

The process-oriented nature of the digital medium poses numerous challenges to the traditional art world, ranging from presentation to collection and preservation. The standards for presenting, collecting, and preserving art have been tailored to objects for the longest time and few of them are applicable to new media works, which constitute a shift from object to process and differ substantially from previous process-oriented or dematerialized art forms. New media art in its multiple manifestations has become an important part of contemporary artistic practice that the art world cannot afford to ignore, but accommodating this art form within the institution and "art system" raises numerous conceptual, philosophical, and practical issues. New media art seems to call for a distributed, "living" information space that is open to artistic interference—a space for exchange, collaborative creation, and presentation that is transparent and flexible. The latter certainly does not describe the framework of the average museum today, and in order to make a commitment to new media art, institutions need to develop alternative approaches to presentation, collection, documentation, and preservation. Among the issues that will be discussed in this essay are the inherent challenges that the digital medium poses to the existing art system; the ways in which the roles of artists, audiences, and curators are changed through digital culture and practice; and different models for presenting and preserving new media art.

The challenges posed by new media art are often discussed in the context of the art form's "immateriality"—its basis in software, systems, and networks. From an art historical perspective, new media art has strong connections to the

often instruction-based nature of previous movements such as Dada and fluxus and continues the "dematerialization" of the art object that lies at the core of conceptual art. While immateriality and dematerialization are important aspects of new media art, it would be highly problematic to ignore the art's material components and the hardware that makes it accessible. Many of the issues surrounding the presentation and particularly preservation of new media art are related to its materiality. For example, museums and galleries commonly have to build structures or walls to hide "ugly" computers and need to assign staff to the ongoing maintenance of hardware. Bits and bites are ultimately more stable than paint or video, and preservation challenges all too often arise from the fact that ever-faster computers and displays with higher resolution are released on the market at short intervals, profoundly changing the experience of artworks that were created for slower computers and lower screen resolutions.

The title of this essay provocatively suggests a "Myth of Immateriality" that admittedly falls into the category of hyperbole: immateriality is not a fiction but an important element of new media that has profound effects on artistic practice, cultural production, and reception, as well as the curatorial process. At the same time, this immateriality cannot be separated from the material components of the digital medium. A more productive approach to understanding this tension may be Tiziana Terranova's definition of immateriality as "links between materialities."[1] Probably more than any other medium for art, the digital is embedded in various layers of commercial systems and technological industry that continuously define standards for the materialities of any kind of hardware components. At the same time, the immaterial systems supported by the digital medium and its network capabilities have opened up new spaces for cultural production and DIY culture. From the macrocosm of cultural practice to the microcosm of an individual artwork, the (immaterial) links between materialities are at the core of digital media. The presentation and preservation of new media art therefore needs to be discussed against the background of the tensions and connections between the material and immaterial.

Characteristics of the Digital Medium: Challenges and Opportunities

New media art is a continuously evolving field and the development of possible taxonomies for the art form has been a much-discussed topic and an elusive

goal. The fact that new media art successfully evades definition is one of its greatest assets and attractions, but at times the art seems more alive than its practitioners want it to be. The characteristics of new media discussed in the following are by no means inclusive and can be considered a preliminary and flexible construct for outlining some of challenges in presenting the art. Curator and theorist Beryl Graham has compiled a more comprehensive comparison of the taxonomies developed by new media festivals, theorists, and practitioners, such as Lev Manovich and Steve Dietz, which is available online.[2]

A lowest common denominator for defining new media art seems to be its computability, the fact that it is computational and based on algorithms. Other descriptive adjectives commonly used for characterizing new media art are process-oriented, time-based, dynamic, and real-time; participatory, collaborative, and performative; modular, variable, generative, and customizable. Each of these distinguishing features of the digital medium—which do not necessarily all surface in one work and are often used in varying combinations—seems to pose its own set of particular challenges. The time-based and dynamic nature of new media projects is not medium-specific but applies equally to many video works or performances. The latter have been an exception to the mostly object-based art world rather than the rule and even though video seems to have found an established, safe place in the art world after approximately three decades, the relationship of museums to performance, sound art, or other "nonmaterial" art forms remains a problematic one. Artworks that require an extended viewing period are problematic per se—since museum and gallery visitors tend to spend only a minimal amount of time with a work—but the time-based nature of new media art is far more problematic than that of film or video owing to the inherently nonlinear qualities of the digital medium. The viewer may be looking at a database-driven project that continuously configures itself over time or a visualization that is driven by real-time data flow from the Internet (and will never repeat itself). At any given point in time, the viewer might only see one possible configuration of an essentially nonlinear project. New media works tend to be more context-dependent than many other art forms since they require information about which set of data (in the broadest sense) is being shown, where it is coming from, and according to which logic it is configured. It is essential to a successful presentation of new media art to provide viewers with a sufficient context for understanding the basics of a process-oriented system, even if their viewing time is very short.

The potentially interactive and participatory nature of new media projects—which allow people to navigate, assemble, or contribute to an artwork in a way that goes beyond the interactive, mental event of experiencing it—runs counter to the basic rule of museums: "Please do not touch the art." For the longest time, visitors of museums and galleries have entered art spaces with the expectation to contemplate objects. Many works of new media art require not only active engagement but a certain familiarity with interfaces and navigation paradigms. While new media art festivals tend to draw a more specialized audience that is largely knowledgeable in "interface culture," one cannot presume that the broader museum audience consists of new media experts.

Interaction and participation are key elements in transforming new media works into "open systems." The openness of the system differs substantially from one digital artwork to the next, and one could argue that the degree of openness is directly related to the investment of time the viewer–participant has to make and the amount of expertise necessary to engage with it. Some works are open to navigation but still "informationally closed" (a term I borrow from N. Katherine Hayles[3]) since viewers navigate through a (visual, textual, aural) system that has been configured by an artist, responds to its internal organization, and is not open to reconfiguration. Openness increases in projects where artists have established a framework that allows participants to create a contribution to the system, such as Josh On's *They Rule*,[4] which allows users to create maps for the interconnectedness of the board of directors of corporations. This type of work is more open on the level of experience and perception than technologically, since it is constantly evolving and is conceptually shaped by the contributions of participants. The type of openness where any contributor can also reconfigure the system and its framework or build on it mostly occurs within the realm of open-source software development, be it in an artistic context or not. An example would be *Processing*, a visual programming environment and electronic sketchbook for developing ideas initiated by Ben Fry and Casey Reas.[5] Reconfigurable and expandable new media projects ask for an involved engagement on the participants' end and are not easy to integrate into the gallery space unless they are presented mostly as a "documentation of concept."

The presentation of new media art involves the creation of platforms of exchange, between the artwork and audience or the public space of a gallery and the public space of a network, and so on. The practical challenges of creating

these platforms include a need for continuous maintenance and a flexible and technologically equipped exhibition environment, which museum buildings (traditionally based on the "white cube" model) do not necessarily provide. Among the more conceptual challenges are the facilitation of audience engagement and the need for continuing educational programs in order to make the public more familiar with the still emerging art form.

There is no doubt that digital technologies have profoundly shaped the landscape of cultural production. Compared to media such as radio, video, or television—which mostly rely on a relatively defined technological superstructure of production, transmission, reception, and a one-to-many broadcasting model—the modularity and variability of the digital medium constitutes a far broader and more scattered landscape of production and distribution. The networked environment of the World Wide Web supports content distribution by any individual through numerous channels, ranging from websites to weblogs, or Wikis.[6] Participation and collaboration are inherent to the networked digital medium, which supports and relies on a constant exchange and flow of information, and are an important element in multiuser environments, among them chat rooms, 3-D worlds or massive multiplayer games that allow their inhabitants to extend and "build" the virtual space. Owing to the modularity of the digital medium, the plethora of available technologies and softwares (commercial or open source) can also potentially be manipulated or expanded. As a result, there are numerous potential points of intervention for artistic practice and cultural production in general. Digital technologies and networks have opened up new spaces for autonomous producers and DIY culture—through the process of copying, sharing, and remixing—as well as for the industry of market-driven media. Artistic production oscillates between the poles of openness of systems and restrictions imposed by protocols and the technological industry. This changed landscape of cultural exchange has a direct influence on the creation, presentation, and reception of art and affects the role of everyone engaged in these aspects.

Collaborative Exchange and the Changing Roles of Artists, Audiences, and Curators

Collaborative exchange has become a fundamental part of artistic new media practice and has affected notions of the artwork and authorship, which in turn

have fundamental consequences for curatorial practice and the presentation of the art. The artistic process in new media creation to a large extent relies on collaborative models, which manifest themselves on various levels. New media works often require a complex collaboration between artists, programmers, researchers, designers, or scientists, whose role may range from that of a consultant to a full collaborator. As opposed to a scenario where artists hire people to build or create components for their work according to instructions, new media practice brings together collaborators who are often very much involved in making aesthetic decisions regarding the work. Another level of cooperation occurs in projects where an artist establishes a framework in which other artists create original works. Lisa Jevbratt's *Mapping the Web Infome*[7] and *Carnivore*[8] by Alex Galloway and the Radical Software Group (RSG) are perfect examples of this approach. In both works, the artists set certain parameters through software or a server and invited other artists to create "clients," which in and of themselves again constitute artworks. In these cases, the artists begin to play a role similar to that of a curator, and the collaborations are usually the result of extensive previous discussions, which sometimes take place on mailing lists specifically established for this purpose. While artists groups and collectives are by no means a new phenomenon that emerged along with digital media, they certainly have not been in the majority when it comes to artistic creation, and the art world in general has traditionally been focused on the model of a single creator and "star." Works that have been created by multiple authors in varying combinations over longer periods of time also necessitate new strategies for documentation, which will be discussed later in this essay.

A further level of participatory exchange—depending on the "openness" of the work—occurs on the level of audience input. While the artists still maintain a certain (and often substantial) control over the visual display or underlying framework of the project, works such as Mark Napier's *P-Soup*[9] or Andy Deck's *Open Studio*,[10] an online multiuser drawing board, would consist of a blank screen without the audience's contribution. These projects are software "systems" in which the creation of the "manifestation" of the work relies on the content contributed by the audience. The artist becomes a mediatory agent and facilitator—both for collaboration with other artists and for audiences' interaction with and contribution to the artwork. Any new media artist who creates a system that is open to public contribution has to consider

the "socialization" of the work and the most effective framework for social interaction.

The collaborative exchanges outlined above have profound implications for the curatorial process. In the organization of an exhibition presenting new media art, a curator may play a role closer to that of a producer—particularly if the work is commissioned—supervising a team of creators and the public presentation of the work. Collaboration requires an increased openness of the production and presentation process as well as an awareness of process. The success and results of an exhibition are less predictable and highly dependent on the "platform" that the curators and artists establish for exchanges with the audience.

The openness of digital technologies also potentially allows for more audience involvement in the curatorial process. The development of ideas of "public curation" is currently still in the experimental stages but is increasingly gaining momentum within the museum world through initiatives that attempt to go beyond feedback in online discussion forums. The project *(Your Show Here)*[11]—shown at the Massachusetts Museum of Contemporary Art (MASS MoCA) in 2001—invited gallery visitors to use a curatorial software program that allowed them to filter and choose from a database of images of over 100 digital images of twentieth-century works of art (fig. 13.1), write a statement about their choices, title their show, and project their selections onto the walls of the gallery. A similar system was developed in a class at the Interactive Telecommunications Program (ITP) at New York University, organized in conjunction with the Whitney Museum and devoted to the development of interfaces that would enhance the experience of visitors to the Whitney. The project—*Connections*, by Jon Alpert, Eric Green, Betsy Seder, and Victoria Westhead—consisted of three display walls with screens and one interaction wall, which used the metaphor of the mechanical switchboard. Users could plug a cable into the socket corresponding to an image from the Whitney collection, preview the image, and make it appear on one of the screens on the display walls. Both projects use the possibilities of instant recycling, reproduction, and archiving facilitated by the digital medium to propose an alternative model of presenting and viewing art that moves away from a traditional prescripted model and allows the art to take on new meanings in multiple contextual reconfigurations. The models for "public curation" outlined above still consist of predefined archives but blur the boundaries

Figure 13.1 *Your Show Here*, Massachusetts Museum of Contemporary Art, 2001. Close-up of the interface with five containers for visitors' selections at the bottom. See plate 10. Courtesy of Scott Paterson.

between public and curator, allowing for models that potentially could establish a more direct reflection of the demands, tastes, and approaches of an audience. Owing to the increasing development and popularity of mobile technologies, public response to and discussion of art has also begun to evolve on a self-organized grass-roots level. Students of Marymount Manhattan College recently created "unofficial" audio tours for artworks at New York's Museum of Modern Art in the form of podcasts, and made their *MoMA Audio Guides* available at the website of Art Mobs,[12] an organization dedicated to exploring the intersection of communication, art, and mobile technology. The public is invited to create their own audio guides and submit them to the site. The more sophisticated models of public curation have been developed within the online environment and will be discussed within the context of online presentation.

One could argue that the changes in the roles of artists, audiences, and curators that have been brought about by collaborative models largely relate to the immateriality of systems, exchanges, and cultural production in general. At the same time, all parties involved are establishing links between the virtual space of the work, with its communicative and participatory interaction, and the respective site of interaction, be it a gallery space or one's own home.

New Media in the Gallery: From Installation to "Mobile" Art

It seems inherently misguided to address a topic outlined as "presenting new media," which suggests that new media might represent a unified field or that there might be a "silver bullet" or perfect approach to installing the work. New media art is an extremely hybrid practice, and each of the different manifestations of the art—from installation and virtual reality to software art, net art, and mobile media—poses its own set of challenges and requires an often distinctly different approach. The presentation and physical environment of a new media project ultimately should be defined by the conceptual requirements of the artwork itself.

When it comes to general models, one can make a distinction between "integration" of new media in the galleries together with other art forms or their "separation" in a specific new media space or lounge. The latter has often been criticized as a "ghettoization"—contributing to the separation of the art form from more traditional media and epitomizing the uneasy relationship that institutions tend to have with new media at this point in time. The major disadvantage of the lounge model is that new media art will not be experienced in the context of works in other media and becomes marginalized with regard to the "(hi)story of art" unfolding in the other galleries. The presentation of new media in a separate "black box" or lounge area with computers and screens is not necessarily driven by concept but often brought about by technical requirements—the fact that the art might need a dark space, or a lack of network connections throughout the museum—or by the fact that the lounge has been financed by a sponsor. However, the lounge model also has certain advantages. If museums have designated (sometimes sponsored) spaces for new media art, they are also obliged to offer continuous programming for these galleries, which translates into regular exposure for the art rather than an occasional presentation over the course of several years. The setup of computers and screens in a lounge invites people to spend more time with the works than they would invest while standing in a gallery.

Interfacing new media within the museum or gallery space always entails a certain recontextualization and often reconfiguration. Many new media art projects are inherently performative and contextual—networked and connected to the "outside"—and feel decontextualized in the "white cube" that was intended to create a "sacred" space and blank slate for the contemplation of objects. The "black box" does not always provide better conditions and

often is not required by the work itself: unless a new media project depends on specific lighting conditions—because it strives to create an immersive space or incorporates light sensors—it could equally be shown in a lit gallery space. However, this would require extremely strong and therefore costly projectors, which many institutions cannot afford. Since all forms of new media art tend to be process- rather than object-oriented, it is of crucial importance to communicate the underlying concept and context of the respective process to the audience, be it through labels or the configuration of the gallery space.

Installations of digital art sometimes need to be set up according to specified parameters (such as height, width, defined lighting requirements, etc.) in order to create a distinct presence in physical space. However, the variability and modularity inherent to the digital medium also means that a work—be it an installation, net art, or software art—can be reconfigured for a specific space and shown in very different ways: the same work might be presented, for example, with installation components, as a projection, on a screen, or within a kiosk setup. This applies to software art, in particular, which is by nature focused on the algorithmically driven process of the "virtual object" rather than its display mechanisms. The basic arrangement of a laptop or computer screen on a desk may provide the "natural environment" in which people usually interact with computers or surf the Internet, but this setup usually seems out of context within a museum space and creates an undesirable office environment. In a gallery space, curators and artists are confronted with the question of whether it is desirable to hide the materiality of the computer (by constructing pedestals or walls) or to expose it, which may be essential for works that address the hardware itself.

The variability of new media installations also means that the same work might not ever be installed again the same way as it travels from venue to venue. The net art project *Apartment*[13] by Martin Wattenberg and Marek Walczak, for example, has been shown as installation/projection in various configurations in galleries in the United States and Europe. The work was inspired by the Memory Palace/Theater, an old mnemonic device and strategy that is based on the connection between physical and mental space. In the second century BCE, the Roman orator Cicero imagined inscribing the themes of a speech on a suite of rooms in a villa, and then delivering that speech by mentally walking from space to space. One part of the project consists of a 2-D component where words and texts typed in by viewers create a two-dimensional floor plan of rooms, similar to a blueprint. The architecture is

Figure 13.2 Marek Walczak and Martin Wattenberg, *Apartment*, Whitney Museum of American Art, 2001. One user station and projection. Artist sketch (left) and installation shot (right). Courtesy of the Whitney Museum of American Art.

based on a semantic analysis of the viewers' words, reorganizing them to reflect the underlying themes they express. This structure is then translated into navigable 3-D dwellings composed of images, which are the results of Internet searches run for the words typed in by the viewer. As part of the "Data Dynamics" exhibition at the Whitney Museum of American Art in 2001, *Apartment* was shown as a single-user workstation where visitors would create the 2-D apartment, while the 3-D interface was projected onto the museum wall (fig. 13.2). The projection established the connection to the memory palace (mentally inscribing words onto a wall) as an original source of inspiration. The installation at the Whitney Museum is the only variant to date that allowed visitors to print out their apartments and take them home. In the same year, the piece was installed at the Ars Electronica Festival in Linz, Austria, with two input stations for the 2-D and the 2-D and 3-D components projected next to each other on the wall, as well as an "archive" station, which stored all the combined apartments (fig. 13.3). The adjacent projections of the two components gave them the same experiential impact and established a more direct connection between a 2-D apartment and the naming of the images in the 3-D version. At the Electrohype Festival in Sweden, the 2-D component was projected onto a single table (fig. 13.4). In each of its different variants, the experience of the work substantially changes.

Whether a project was created for a single user or multiple participants (or could be transformed from a single- into a multiuser project) is an important

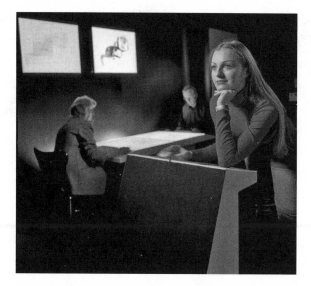

Figure 13.3 Marek Walczak and Martin Wattenberg, *Apartment*, Ars Electronica Festival, Linz, 2001. Installation shot with twin 2-D input stations, 2-D and 3-D projection, and archive station with user (front). Courtesy of Marek Walczak and Martin Wattenberg.

Figure 13.4 Marek Walczak and Martin Wattenberg, *Apartment*, Electrohype Festival, Sweden, 2002. Single projection onto table. Courtesy of Marek Walczak and Martin Wattenberg.

issue for presenting any type of new media art. It can be a frustrating experience to watch someone else navigate a work and wait for one's turn—similar to giving someone else control over the TV remote control and watching them surf channels—and multiuser projects tend to create more engaging environments in public space. Nevertheless, the "performance" of a single user also has its positive effects: visitors who are less familiar with interfaces and would have been hesitant to take over the input device and explore a work often learn and get engaged by watching other people. For any type of work that has a simultaneous presence in the gallery space and online, it becomes important to establish a connection between the physical and virtual space, be it through contextual information or by making the Web component accessible in the gallery space. The decisions that need to be made in establishing connections between virtual and physical space ultimately have an effect on the aesthetics of the work and ideally should be the result of collaborations between the curator and artist(s).

The form of new media art that is both most alien to the museum context and best exemplifies the idea of the museum without walls is mobile or locative media art—art that has been created for networked devices such as cell phones and Palm Pilots; or incorporates "wearables" such as clothing or accessories equipped with sensors or microprocessors; or makes use of the Global Positioning System (GPS) and wireless networks in order to deliver content specific to a location. Unless these works have been specifically created for a gallery space, they naturally transcend the physical boundaries and walls of the museum. In the case of mobile devices that the audience brings to a museum (such as cell phones or Palm Pilots), the institution becomes an access point or node in the network—for example, through setting up a beaming station. In order to communicate the inherent concept of these projects, it often makes sense to establish a larger network for the artwork by collaborating with other organizations that could serve as additional nodes. Some mobile or locative media projects require leaving the museum space behind and moving into public space.

Mobile media works tend to be performative and often require the organization of an ongoing event. Projects that incorporate wearable computing can only be used by a limited number of people at any given time, and often require the presence of the artist(s) or facilitators who can assist the audience. One option of showing wearable projects is to arrange for scheduled "performances" during which the audience can experience the work. In addition to

these scheduled events, it is crucial to provide documentation that translates the project to the audience during the time periods when the piece cannot be actively used.

One of the most challenging scenarios for presenting new media art is the integration of Internet art within the museum or gallery space. Since net art has been created to be seen by anyone, anywhere, anytime (provided one has access to the network), it does not necessarily need a museum to be presented or introduced to the public. While net art exists within a (virtual) public space, it seems to be particularly difficult to "connect" it to the public space of a gallery. There have been multiple approaches to showing this art from, which all have their advantages and disadvantages. Some works of net art lend themselves to presentation through installation and/or physical interfaces because they address notions of space. Others work well as a projection—these are often works that have not been created for a browser window and beg to get out of it. Yet others need to maintain their inherent "netness" and require one-on-one interaction through the physical setup of a computer with monitor. The latter is supported by the lounge model where visitors either access each work on its dedicated computer or have a number of computers available, each of which provides a portal to all the works in the exhibition.

Decisions about the presentation of a new media work within a gallery always have to be made on a case-by-case basis, and there are no specific methods for installing each of the different forms of new media that will automatically ensure a successful exhibition.

Models for Online Presentation

In the case of net art, in particular, the discussion surrounding presentation cannot be limited to the space of the physical gallery but also needs to consider the "natural habitat" of the art, the online environment. When net art officially came into being with the advent of the World Wide Web in the early 1990s, an online art world—consisting of artists, critics, curators, theorists, and other practitioners—immediately developed in tandem with the art and outside of the institutional art world. One of the inherent promises of net art was the opportunity to establish an "independent" art world that could function outside of the framework of the institution and its systems of validation. Even though it may not be their explicit goal, independent online exhibitions implicitly challenge the structures of legitimation created by the

museum system and traditional art world. A broader art audience may still place more trust in the selection undertaken by a prestigious museum, but in the online environment, the only signifier of validation may be the brand recognition carried by the museum's name. In the late 1990s, institutions also began to pay attention to net art as part of contemporary artistic practice and slowly incorporated it into their programming. Presentation of net art began to unfold not only independent of institutions—through Web projects created by independent curators and (artist) collaboratives—but also in an institutional context—through websites affiliated with museums, such as the Walker Art Center's *Gallery 9*,[14] SF MOMA's *e-space*,[15] and the Whitney Museum's *artport*.[16] The presentation of net art within these different contexts—institutional or noninstitutional—differs substantially when it comes to the interpretation of selection, filtering, and "gatekeeping" as fundamental aspects of the curatorial process.

The "online only" exhibition of net art seems to have advantages in that it preserves the original context of how the art is supposed to be seen, but poses the problem that one has only limited control over how a work is experienced by the viewer. Net art projects often require specific browser versions, plug-ins, or a minimum screen resolution, and the inability to view a work becomes more of an issue when viewers "visit" an online exhibition organized by a museum or arts organization, which they hold responsible for providing a certain quality of the experience of art.

The online presentation of net art still involves many of the traditional aspects of curation—selection of works, organization of the exhibit and its art historical framing—but also has to acknowledge the specifics of its environment and its shifting contexts. The Internet is a contextual network where a different context is always only one click away, and everyone is engaged in a continuous process of creating context and recontextualizing. The embeddedness of online art into a rich contextual environment blurs boundaries between "categories" of cultural production (fine arts, pop culture, entertainment, software, etc.) and creates a space for specialized interests with a very narrow focus. While an exhibition shown in physical space has a specific opening and closing date, requires a visit to a physical locality, and, after its closing, becomes part of the "cultural archive" through its catalog, documentation, and critical reception, an online exhibition is seen by a translocal community, never closes, and continues to exist indefinitely (until some party fails in sustaining it). It exists within a network of related and previous exhibitions that

can be seen directly next to it in another browser window, becoming part of the continuous evolution of the art form. In addition, the artworks included in the exhibition (through linking) may continue to evolve over time. Online presentation has to acknowledge the distributed model of the networked exhibition environment: an exhibition of net art on a website, be it that of an institution or individual, inhabits a "living," discursive environment with multiple perspectives beyond those of a single institution or organization.

The Walker Art Center's online exhibition space *Gallery 9*, developed from 1997 until 2003 under the direction of its founding director Steve Dietz, acknowledged this need from its inception and was created as an online venue for both the exhibition and contextualization of Internet-based art. As Steve Dietz explains in his introduction to the site, the space features "artist commissions, interface experiments, exhibitions, community discussion, a study collection, hyperessays, filtered links, lectures and other guerilla raids into real space, and collaborations with other entities (both internal and external)." *Gallery 9* also became a permanent home for content that was not originally created by the Walker Art Center, such as Benjamin Weil's *äda'web*, an online gallery and digital foundry (created in 1995) that featured work by net artists as well as established artists, for instance Jenny Holtzer and Julia Scher, who expanded their practice with the new medium. After *äda'web* lost its financial support, the gallery and its "holdings" were permanently archived at *Gallery 9*. Another part of the gallery's archive is G. H. Hovagimyan's *Art Dirt*, an online radio talk show that was originally webcast from 1996–1998 by the Pseudo Online Network. While sites such as *Gallery 9* or the Whitney Museum's *artport* are geared toward creating a contextual network, they still follow a traditional model in that they are overseen by a single curator rather than open to a multiplicity of curatorial "voices." These institutional sites find their counterpart in online exhibitions that are organized by individual, independent curators—not affiliated with an institution—and often tend to take more experimental formats. Since these curatorial efforts are mostly distributed throughout the specialized community of the online art world, they do not necessarily need to consider a broader audience and museum patron who might not be familiar with net art but visits an online gallery since it is affiliated with a major institution.

A shift from the model of the single curator to that of multiple curatorial perspectives is more likely to be found at websites of nonprofit organizations devoted to online art. The British website *low-fi net art locator*,[17] run by a col-

laborative team, regularly invites guests to "curate" a selection of online projects within a theme of the guest's choice. The selections are accompanied by a curatorial statement and brief texts on each of the projects. Over time, *low-fi* has grown into an impressive curatorial resource, consisting of numerous online exhibitions. A range of perspectives can also be found at *turbulence*,[18] a project of New Radio and Performing Arts and its co-directors Helen Thorington and Jo-Anne Green, which, in addition to commissioned projects, features curated exhibitions (often organized by artists) as well as "Artist Studios" that present artists' works and provide context for them through writings and interviews.

Some of the most advanced implementations of multiple curatorial perspectives and "public curation" have occurred in projects that explicitly consider software as a framework for curation, such as the software art repository *runme.org*[19] and Eva Grubinger's *C@C—computer aided curating.*[20] Within a technological framework, curation is always mediated and agency becomes distributed between the curator and the public, and software is involved in the filtering process. Eva Grubinger's *C@C* (1993), with software development by Thomas Kaulmann, probably was the earliest attempt at creating a software-driven framework and tool that responded to the needs of artistic and curatorial practice in an online environment. *C@C* was visionary at its time in that it developed a space that combined the production, presentation, reception, and purchase of art and thus erased several boundaries between delineated practices within the art system. The concept included individual artist studios with built-in editing tools; a branching social network structure in which artists could introduce other selected artists; an area for discussion by the public and curators; and spaces that could be "purchased" by art dealers in order to present and promote their activities.

The idea of "automated curation" and software-based filtering becomes more pronounced in the *runme* software art repository, an open, moderated database that emerged out of the *Readme* software art festival (first held in Moscow in 2002) and was launched in January 2003. The site is an open database to which anyone can submit his or her project accompanied by commentary and contextual information. Selection only occurs in the reviewing process conducted by the members of the *runme* "expert team" who evaluate whether a project fits the basic objective of the site and makes an interesting contribution before making the work available for viewing to the public through the Web interface. Although the team has final say over the inclusion of a project,

the basic criteria for submission are fairly broad, and the initial filtering process certainly could not be described as highly selective. Further filtering occurs in the classifying and labeling that occurs through the taxonomical system established for the site: projects are classified according to a list of categories of software art as well as a "keyword cloud" that further describes projects and allows viewers to navigate them. Both the categories and keywords are open to additions and revisions by the public, so that classification occurs in a process where agency is distributed between automation and "human input." In different ways and to varying degrees, all of the above models for online presentation illustrate the changes that the "immaterial systems" of the online environment have brought about for concepts of the exhibition.

Preservation Strategies: From Materiality to Immaterial Process

The nature of new media projects and the inherently collaborative processes employed in their creation and presentation make it necessary to develop new models and criteria for documenting and preserving process and instability. In both Europe and the United States, several initiatives are striving to create standards for the preservation of media works. Among them are the Variable Media Network[21] (a consortium project of the University of California, Berkeley Art Museum and Pacific Film Archive, the Solomon R. Guggenheim Museum, Cleveland Performance Art Festival and Archive, Franklin Furnace Archive, and Rhizome.org) and INCCA[22] (International Network for the Preservation of Contemporary Art). Main issues that have to be addressed by these initiatives include the development of vocabulary for catalog records, standards that allow the interoperability of the metadata gathered by institutions; and tools for the cataloging of "unstable" and process-oriented art. Among the latter is the Guggenheim's "Variable Media Questionnaire," an interactive questionnaire that enables artists and museum and media consultants to identify artist-approved strategies for preserving artworks and to define the behaviors of artworks in a media-independent way. The behaviors defined by the questionnaire are *installed*, *performed*, *reproduced*, *duplicated*, *interactive*, *encoded*, *networked*, and *contained*. Other tools include Franklin Furnace's primarily performance-oriented archive cataloging database; and the Digital Asset Management Database (DAMD),[23] developed at the University of California Berkeley Art Museum, which consists of seven related databases that store files and the objects they represent, integrate sets of descriptive metadata

from institutions' Collection Management System, and support their export to different formats.

The challenges of documenting and preserving new media art illustrate most poignantly the concept of immateriality as links between materialities—the connections between hardware and software components and processes initiated by humans and machines that form an immaterial system of their own. As previously mentioned, some of the main issues of preservation are not related to a deterioration of bits and bytes but rather arise from the fact that hardware is almost obsolete as soon as it becomes available on the market (the next system already being in development) and operation systems and software constantly keep changing. The most inelegant and impractical strategy for addressing this situation is to collect software and hardware, which would turn any art institution or organization into a "computer museum." Another method of preservation is that of using emulators, computer programs that "re-create" the conditions of hardware, software, or operating systems, so that the original code can still run on a newer system. Yet another approach is "migration"—an upgrade to the next version of hardware or software. The latter may work well for some projects but turn out to be problematic for others, which might still look "dated" in their re-creation: if the latest technology had been available to the artists at the time of the work's creation, they might have done a different project in the first place.

In the spring of 2004, the Guggenheim Museum in New York presented a groundbreaking exhibition called "Seeing Double—Emulation in Theory and Practice,"[24] which paired new media artworks (as well as others created in now endangered media) with their re-created doubles—a version of the original upgraded to a newer medium or platform. Organized by Jon Ippolito, Caitlin Jones, and Carol Stringari, the show included works by Cory Arcangel, Mary Flanagan, Jodi, Robert Morris, Nam June Paik, John F. Simon, Jr., Grahame Weinbren, and Roberta Friedman. The term emulation was interpreted in a broad sense since some of the works were technically migrations. John F. Simon, Jr.'s *Color Panel v1.0*, for example—originally created for a 1994 Apple PowerBook 280C stripped of its casing and embedded in a white acrylic frame—was migrated to a G3, and the artist had to "slow down" the speed at which the program originally was running (fig. 13.5). The circuitry of the 280C, which is visible on the frame in the original piece, does not exist in the G3 any more, and Simon decided to glue the original circuitry, now without any function, on the G3's frame. In some cases, where the original

Figure 13.5 John F. Simon, Jr., *Color Panel v1.0.1*, 2004 (left). C code, altered Apple Power-Book G3 laptop, and acrylic. *Color Panel v1.0*, 1999 (right). C code, altered Apple PowerBook 280c laptop, and acrylic. Courtesy of the artist and Sandra Gering Gallery.

work consists of a hardware manipulation that makes the specific hardware itself a focus of the project, the artists and organizers left the artwork untouched. Artist Cory Arcangel, for example, has created a whole body of work that involves a reengineering of Nintendo cartridges and plays with the aesthetics of Nintendo games. The project would become meaningless if upgraded. The exhibition, supported by the Daniel Langlois Foundation for Art, Science, and Technology, gave its audience a unique opportunity to compare an original to its recreated version. Detailed documentation about the show is available at the accompanying website.

As mentioned earlier, the variability and the collaborative nature of new media have the effect that the artwork often undergoes changes in personnel, equipment, and scale from one venue to the next. Current vocabularies and tools for describing and documenting artwork hardly accommodate the various mutations that new media art undergoes. In his essay "Death by Wall La-bel,"[25] Jon Ippolito uses the wall label (the art institution's standard method for "defining" a work) as a starting point for exploring the documentation problems posed by new media art's variable authors, titles, and media. Using the vocabulary of the Guggenheim's "Variable Media Questionnaire," Ippolito develops an alternative to the standard vocabulary of the wall label.

A documentation tool that specifically addresses the issue of mutability is *The Pool* (fig. 13.6), developed by Ippolito, Joline Blais and collaborators at the

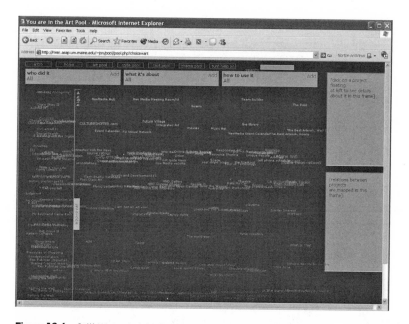

Figure 13.6 Still Water Lab at the University of Maine, *The Pool,* interface screenshot. Courtesy of Still Water Lab.

University of Maine's Still Water Lab.[26] *The Pool* was specifically designed as an architecture for asynchronous and distributed creativity and documents the creative process in different stages: the "Intent," a description of what the artwork might be, an "Approach" to how it could be implemented, and a "Release" of the artwork online. The architecture also includes a scaling system that allows visitors to the site to rate any given project. *The Pool* supplies descriptions of projects' versions, reviews of the projects, and relationships to other works in the database. Tags to contributors make it possible to credit all the artists who have worked on a project at any given stage. *The Pool* illustrates the shifts in the paradigm of culture production induced by the digital commons where a whole culture can be built on seeds of ideas and different iterations of a particular project.

One of the most difficult challenges of preserving new media and net art, in particular, arises from the immateriality of context in the hyperlinked environment of the Internet and the ephemeral nature of links—a phenomenon often referred to as "link rot." Olia Lialina's early net art piece *Anna Karenina Goes to Paradise,*[27] for example, sets up three "Acts"—"Anna Looking for

Love," "Anna Looking for Train," and "Anna Looking for Paradise." The content for each act is provided by pages that list the results that search engines returned for the words love, train, and paradise at the time of the work's creation. Lialina's piece (which is already contextualized by *Anna Karenina*, the novel) was meant to point to constant shifts of context, which ultimately are the focus and content of the artwork. If one visits the work today, most of the links will be "dead"—the piece has been reduced to its concept while the implementation is inaccessible. Even if one would rewrite the piece so that it allows returns "live" search results, the previous versions of the piece would be lost unless their documentation—for example, through screenshots of all the sites that are linked to—is "programmed" into the piece itself. Artists usually have neither the time nor the money to engage in long-term preservation of their work, and institutions or tools developed by preservation initiatives could fulfill an important function in this type of context preservation.

There always have been and will be art objects that can rely on an established cultural "system" of presentation and preservation (museums, galleries, collectors, conservators), and new media art does not threaten to supersede these objects. However, if new media art will find its place in the art world through a support system that accommodates its needs, it will expand the notion of what art is and can be. Picking up where conceptual art and other "movements" that reconsidered concepts of the art object left off, new media art has the potential to broaden our understanding of artistic practice.

Notes

1. Tiziana Terranova, "Immateriality and Cultural Production" (presentation at the symposium "Curating, Immateriality, Systems: On Curating Digital Media," Tate Modern, London, June 4, 2005). Online archive at http://www.tate.org.uk/onlineevents/archive/CuratingImmaterialitySystems/.

2. Beryl Graham, "A Small Collection of Categories and Keywords of New Media Art," http://www.crumbweb.org/crumb/phase3/append/taxontab.htm/.

3. N. Katherine Hayles, "Liberal Subjectivity Imperiled: Norbert Wiener and Cybernetic Anxiety," in her *How We Became Posthuman: Virtual Bodies in Cybernetics, Literature, and Informatics* (Chicago: University of Chicago Press, 1999).

4. Josh On, *They Rule*, http://www.theyrule.net/.

5. Benjamin Fry and Casey Reas, *Processing*, http://www.processing.org/.

6. A Wiki is a Web application that allows users to add content, as on an Internet forum, but also allows anyone to edit the content. The term Wiki also refers to the collaborative software used to create such a website.

7. Lisa Jevbratt, *Mapping the Web Infome*, http://www.newlangtonarts.org/network/infome/.

8. Alex Galloway and Radical Software Group (RSG), *Carnivore*, http://www.rhizome.org/carnivore/.

9. Mark Napier, *P-Soup*, http://www.potatoland.org/p-soup/.

10. Andy Deck, *Open Studio*, http://draw.artcontext.net/.

11. Tara McDowell and Letha Wilson (project coordinators), Chris Pennock (software design), Nina Dinoff (graphic design), and Scott Paterson (information architecture).

12. Art Mobs, http://mod.blogs.com/art_mobs/.

13. Martin Wattenberg and Marek Walczak, *Apartment*, http://www.turbulence.org/Works/apartment/.

14. *Gallery 9*, Walker Art Center, http://gallery9.walkerart.org/.

15. E-space, San Francisco Museum of Modern Art, http://www.sfmoma.org/espace/espace_overview.html/.

16. *Artport*, Whitney Museum of American Art, http://artport.whitney.org/.

17. *Low-fi net art locator*, organized by Kris Cohen, Rod Dickinson, Jenny Ekelund, Luci Eyers, Alex Kent, Jon Thomson, and Chloe Vaitsou; other members include Ryan Johston, Pierre le Gonidec, Anna Kari and Guilhem Alandry. See http://www.low-fi.org.uk/.

18. *Turbulence*, New Radio and Performing Arts, http://www.turbulence.org/.

19. *Runm*e software art repository, developed by Amy Alexander, Florian Cramer, Matthew Fuller, Olga Goriunova, Thomax Kaulmann, Alex McLean, Pit Schultz, Alexei Shulgin, and The Yes Men. See http://www.runme.org/.

20. Eva Grubinger, *C@C Computer Aided Curating*, http://www.aec.at/en/archives/festival_archive/festival_catalogs/festival_artikel.asp?iProjectID=8638/.

21. See http://www.variablemedia.net and http://www.bampfa.berkeley.edu/ciao/avant_garde.html/.

22. See http://www.incca.org/.

23. Digital Asset Management Database (DAMD), http://www.bampfa.berkeley.edu/moac/damd/DAMD_manual.pdf/.

24. "Seeing Double—Emulation in Theory and Practice," Solomon R. Guggenheim Museum, New York, http://www.variablemedia.net/e/seeingdouble/home.html/.

25. Jon Ippolito, "Deathy by Wall Label," in *Presenting New Media*, ed. Christiane Paul (Berkeley, Calif.: University of California Press, forthcoming).

26. *The Pool*, http://river.asap.um.maine.edu/~jon/pool/splash.html/.

27. Olia Lialina, *Anna Karenina Goes to Paradise*, http://www.teleportacia.org/anna/.

III

Pop Meets Science

Autumn Flux I real-time frame capture from Ephemere (1998)
© 2000, Char Davies/Immersence Inc. & Softimage Inc.

Plate 1 Charlotte Davies, *Éphémère,* 1998. By kind permission of the artist.

Plate 2 Karl Sims, *Genetic Images,* 1993. By kind permission of the scientist.

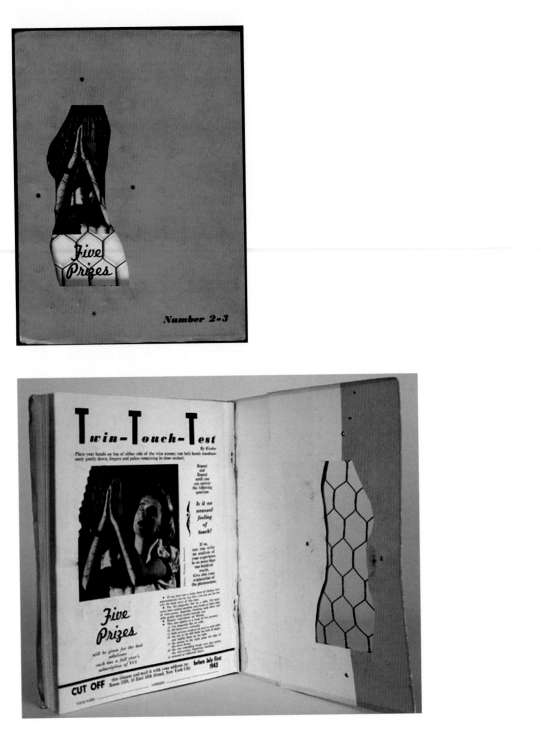

Plate 3 Frederick Kiesler and Marcel Duchamp, *Twin-Touch-Test,* 1943.

Plate 4 Professor Machiko Kusahara and Erkki Huhtamo experimenting with Christa Sommerer and Laurent Mignonneau's *Mobile Feelings I* (2001) at Ars Electronica 2001. Photos by Christa Sommerer.

Plate 5 Zoe Beloff, *Influencing Machine*, 2002. By kind permission of the artist.

Plate 6 Rosangela Rennó, *Experiencing Cinema,* installation, 2005. By kind permission of the artist.

Simplify Mutate

Plate 7 Berndt Lintermann, *SonoMorphis,* CAVE installation, 1999. By kind permission of the artist.

Plate 8 Michel Bret, Marie-Hélène Tramus, and Alain Berthoz, *The Virtual Tightrope Walker,* 2004. The virtual tightrope walker interacting with a real tightrope walker. Copyright Michel Bret. By kind permission of the artists.

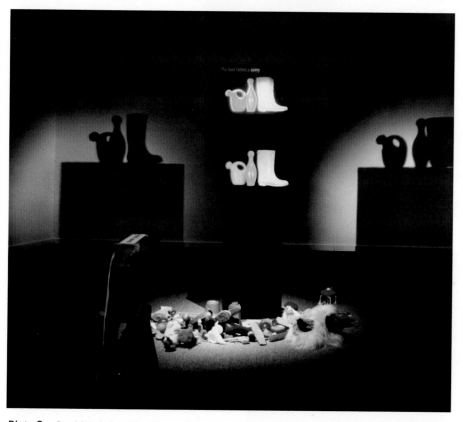

Plate 9 David Rokeby, *The Giver of Names,* 1991–. By kind permission of the artist.

Plate 10 *Your Show Here,* Massachusetts Museum of Contemporary Art, 2001. Close-up of the interface with five containers for visitors' selections at the bottom. Courtesy of Scott Paterson.

Plate 11 Toshio Iwai + NHK Science & Technical Research Laboratory, *Morphovision—Distorted House,* 2005. Photo by Machiko Kusahara. (At Tokyo Metropolitan Museum of Photography.)

Plate 12 Golan Levin, *Yellowtail,* 2002.

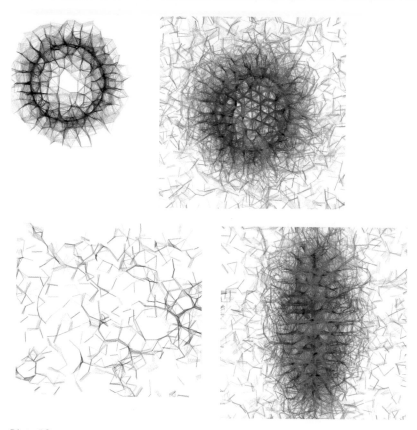

Plate 13 Casey Reas, *Articulate,* 2003.

Plate 14 Individual profile and database within the genealogy tool: Sample profile for Stanford Biochemistry faculty member, James Spudich. Clicking on the "Discussion" tab allows viewers to engage in discussion with the author about his or her work and career. The profiled person receives and can respond to discussion commentary via email.

Plate 15 Detail of a morpho butterfly wing, imaged on film with a macro lens and camera. The wing appears blue because of its surface structure, reflecting mostly blue wavelengths of light. © Felice Frankel.

Plate 16 A digitally colored scanning electron micrograph (SEM) of the same morpho butterfly wing as in plate 15. © Felice Frankel.

Plate 17 *Eagle Nebula,* M16, false-colored Hubble Space Telescope (HST) visible light image. Image produced by P. Scowen and J. Hester.

Plate 18 Comparison between HST visible light image of M16 (see plate 17) and same area of space taken with a ground-based telescope, ESO Very Large Telescope (VLT) in Chile, reading the near-infra-red part of the spectrum. (Right image by McCaughrean & Andersen.)

Plate 19 David Hall, *A Situation Envisaged: The Rite II (Cultural Eclipse),* 1988–90. By kind permission of the artist. The broadcast image reveals its function as light source, a projection of electronic light modulated from invisible radio to visible light waves.

Plate 20 Gina Czarnecki, *Nascent,* 2005. By kind permission of the artist. In Cazrnecki's large-scale digital projection bodies project in space and time, simultaneously present and absent, deliriously beautiful and at the same time burdened with a pain they shine onto the audience.

Device Art: A New Approach in Understanding Japanese Contemporary Media Art

Machiko Kusahara

Introduction

Earlier in the history of the term, "art" meant a much wider range of human activities and resulting products related to creative or refined use of technique. Today creative activities such as "applied" or "low" art, as well as craft, design, entertainment, and commercial products are considered outside what "art" is. The paradigm formed itself as modern society was established in the West.

Obviously art cannot remain independent from society. Artists respond to society through their works while the society frames what "art" means. At the same time, science and technology influence art through different layers, directly and indirectly, while they play crucial roles in changing the society.[1] Thus what art means to society is subject to change within the network of influences.[2]

Information technology has had a deep impact on the infrastructure of society since the second half of the twentieth century. It has meant a transition from a material-based value system to a system in which immaterial information controls physical reality. Today digital media technologies are changing our life and culture. According to the discussion above, the paradigm of art will not be able to remain the same.

The signs are already visible. For the past decades artists working with digital technologies have been facing problems with the existing system of art. This system almost contradicts the nature of digital technology, which invites

interactivity and limitless identical copies of artworks, not to mention art forms using "immaterial" media such as the Web. Also, the border between "art" and its neighboring fields is no longer solid. An increasing number of designers, architects, filmmakers, and new media artists are creating artistic works with commercial features. How should we classify creators such as Philippe Starck or Chris Cunningham?[3] Are their works not "art" if they are commercially distributed, or massively reproduced, or "designed" for certain purposes, or entertaining?

Earlier artists such as Marcel Duchamp and Andy Warhol already questioned the traditional paradigm many years ago, challenging the border between art and commercial products. Duchamp made his *Rotoreliefs* (1920) commercially available, while Warhol called his studio "The Factory." Performances and happenings since the 1950s, led by celebrated artists such as John Cage, Robert Rauschenberg, Nam June Paik, and Yoko Ono, denied the concept of artwork as based on physical objects to be kept. Still, the authenticity and the rarity of physical objects seem to remain the basis of the art system. We need a new approach to the art paradigm in the age of massive and identical reproduction technologies. In the seventy years since Walter Benjamin's analysis, reproduction technologies—both digital and industrial—have not yet found their appropriate place in the art marketplace.[4]

Another question to be raised is the validity of an art history based solely on the "Western" notion of art. As discussed earlier, what "art" means is different in societies with different histories and different cultural backgrounds. Non-Western, "alternative" approaches may help us to examine what art means today. It is well known that biodiversity is extremely important when the environment faces a drastic change. Likewise, "cultural biodiversity" will help us to explore wider possibilities in coping with our changing society.

Art and artists are not limited to playing a passive role in society. As McLuhan points out, they visualize changes taking place in society by picking up the slightest signs, to allow people to prepare for the blow.[5] As clearly seen with Duchamp, Cage, and Paik, artists, also question the validity of existing value systems and through their activities propose new ways of coping with the rapidly changing society. Japanese artists are no exception. They examine what digital technologies mean to art-making and to society with a special awareness of the Japanese cultural and historical background.[6] Issues such as identity, originality, space, the notion of life, and communication, as well as

the notion of art, are conceived in a more or less different manner from how they are thought of in the West.

The aim of this essay is to analyze the nature of "art" in the Japanese tradition and propose a new point of view that would explain certain phenomena in media art today. The concept of *Device Art* is proposed, which is derived from an analysis of contemporary Japanese media art and developed into an art movement led by a group of artists and researchers including myself. I hope to offer an alternative aspect in the discussion on a new paradigm of art in the digital information society.

Understanding Japanese "Art"

The Japanese term corresponding to "art" is *bijutsu*, which means visual fine art, whereas *geijutsu* means art in a wider sense including music, theater, and so on. These terms were coined in the second half of the nineteenth century when the concept of art was imported from the West in the process of Japan's rapid modernization.[7] The notion had not existed until then.

This does not mean, however, that artistic activities did not exist in Japan until the nineteenth century. On the contrary, centuries of peace under the Shogunate allowed the Japanese to develop sophisticated forms of visual culture that was shared across the wealthier classes, from richer citizens to feudal lords.[8] Appreciating artistic works was often integrated into everyday life rather than being considered something special. The best painters were commissioned to paint on screens and sliding doors for temples and the houses of the nobles. Sophisticated design was appreciated on such daily commodities as tableware.[9] Although hanging framed pictures on the walls was not a part of Japanese tradition, there would be a special wall space (usually less than a meter wide) to hang a picture or calligraphic writing according to the season.[10]

By the mid-eighteenth century the development of inexpensive woodblock-printing technology allowed prints and illustrated novels to spread widely. They were meant to be consumed for temporal entertainment, playing a role similar to that of magazines today, while better prints were kept for appreciation, or used to decorate screens or storage boxes at households.[11] A distinction between art, entertainment, and commercial products did not exist; there simply was no such categorization. For example, Hokusai, whose prints depicting Mt. Fuji are known worldwide today, illustrated card sets used for

the game of "poem match."[12] Visual entertainment was also closely related to literature in Japanese culture. A community of intellectuals, including painters, writers, poets, and medical doctors who had access to Western science and visual culture, existed by the late eighteenth century when the country's still borders were closed. Western-style realistic painting was already known and experimented with among them.[13]

Thus there was a colorful visual culture, from the more common woodblock prints to the painted screens reserved for the rich, before "art" arrived from the West. Why, then, did the word "art" not exist?

"Art" is not a self-evident notion that would automatically develop into the same paradigm in any society. "Art" as the Western concept did not form itself in Japan. Instead of separating "fine art" from applied art, design, or entertainment, the Japanese embraced these fields as a continuous form of visual culture.[14] Concepts such as "high art" and "low art" did not exist either.[15] Although such distinctions have been considered essential in Western art history, a different way of seeing "art" is possible given a different cultural background, such as that of Japan.

Japan-ness in Contemporary Art

In the late nineteenth century, the Westernized system of art and art education was introduced and became the standard in Japan.[16] After over a hundred years since then, the mainstream of Japanese contemporary art appears to be international, without much visible trace of historical background.[17] Among the younger generation of artists today, however, there is increasing attention to what is "Japanese" in art-making. In contemporary art "Japan-ness" has typically been associated with the use of material such as paper, wood, or stones, or with the use of certain forms or colors.[18] Recently, though, we see a different approach emerging.

Contemporary artist Takashi Murakami questions such issues as the originality and authenticity of images through the production and distribution process of his works. Having grown up reading comic books, Murakami went on to be trained academically in traditional Japanese painting. His work reflects these two visual traditions on several levels.

Murakami's works are produced through a factory system with assistant painters and student interns, while his sculptures such as girls with big eyes

and exaggerated breasts—representing typical *anime* (Japanese animation) taste—are commissioned from professional modelers.[19] This type of factory system was standard with both traditional *Kano-ha* painting and woodblock printing, and is used by popular comic artists and animation studios today. Murakami's production system is his commentary on "art," referring both to Japanese notions of originality, art, entertainment, and commercial products, and to Duchampian concepts of appropriation and the ready-made.

Murakami went a step farther in 2003 by publishing miniature versions of ten of his sculptures including *Ms. ko2* and *Hiropon.*[20] Resized models were created by the same professional modelers who did the "originals." This means they are original Takashi Murakami works as well if the original full-scale versions are so. The difference is that the miniatures were produced in quantity (15,000 pieces each, numbered), each of them packed in a sealed box as a giveaway with a piece of bubble gum, and sold exclusively at convenience stores at the price of 350 yen (approximately three dollars).[21] Officially presented as a mere extra to chewing gum, sold on the same shelf with other candies, a miniature's identity as an object of art is stripped from it—although they immediately became collectibles.[22] Because customers cannot tell which character they will find in a sealed box, they end up buying many boxes until they get all the characters. Thus art met the culture of collection, chance, and commercialism.[23]

A series of Louis Vuitton bags with Murakami's characters is another extreme form of commercializing art. While an irony must be part of the concept—Louis Vuitton has become a synonym of "brand" among Japanese young women—the artist consciously revives the tradition of "applied art."[24]

Not as aggressive as Murakami, though, another internationally known artist, Yoshitomo Nara, also consciously appropriates images from Hokusai and others, and commercializes his characters as stuffed toys and daily commodities such as ashtrays.

The key issue is that these are conscious decisions of the artists regarding their artistic activities, not just "licensing" images to manufacturers of the goods. In their attempts, industrially produced semi-mass (both in terms of production and its target) versions of their works are juxtaposed with "authentic" original versions that museums and collectors would buy.[25] The traditional Japanese approach to art (or, to "applied" art) is used consciously in playfully questioning the Western notion of art and its value system.

Japanese Media Art and the Technology Scene

In recent years works by Japanese artists have been widely shown in the field of media art. Not only works by artists such as Toshio Iwai, Kazuhiko Hachiya, or Maywa Denki, but also a wide variety of works by the younger generation are being shown internationally.[26]

It is often observed that many of these works from Japan share certain features. Probably the most notable feature is a playful and positive attitude toward technology, rather than a negative or critical stance. Work by Toshio Iwai is an example. Participants are invited to enjoy eye-opening experiences with his works, made possible with technologies he develops and combines (from the low-tech zoetrope to more sophisticated combinations of digital technologies). Although the technologies are not hidden and interaction is transparent—viewers understand what is happening—the result is just amazing, as in the case of his recent work *Morphovision—Distorted House* (fig. 14.1). In this piece a miniature house and its surroundings (including simplified

Figure 14.1 Toshio Iwai + NHK Science & Technical Research Laboratory, *Morphovision–Distorted House*, 2005. See plate 11. Photo by Machiko Kusahara. (At Tokyo Metropolitan Museum of Photography.)

human figures) on a rotating table becomes distorted in many different ways as participants freely modify how the table rotates and the way in which the stroboscopic light flashes or stops.[27] This transparency of technology can be observed in most of Iwai's works. The artist designs his own hardware-based interfaces to allow a wide range of interaction.[28] Rather than inviting participants to navigate through the world the artist has created, each work is more like an arena in which the participant's actions determine the work's content. For example, Iwai's *SOUND-LENS* (2001) allows participants to dynamically turn arbitrary light patterns (such as colored graphics prepared by the artist, closed-circuit video showing participants, or landscape scenes) into sound sequences through an optoelectronic circuit, as they walk around freely with the small device in hand. The artist designed both the hardware and the software (a program that turns light patterns into sound) that allow users to enjoy their own music.

These features are not limited to Iwai's art. Highly open interaction supported by original hardware and a positive attitude toward technology is characteristic of many Japanese works.[29]

Kazuhiko Hachiya's *Inter DisCommunication Machine* (1993–) lets two participants "exchange" their sight and sound by means of a proprietary HMD (head-mounted display) designed by the artist (fig. 14.2). Each HMD has a wireless video and sound input–output system—the audiovisual input is sent from the other HMD. The artist carefully arranges the setting, but the content of the experience is up to the participants.

Figure 14.2 Kazuhiko Hachiya, *Inter DisCommunication Machine*, 1993. Courtesy of the artist.

Figure 14.3 Hiroo Iwata, *Floating Eye*, 2000. Photo courtesy of Ars Electronica.

Such open interaction is observed with Hiroo Iwata's *Floating Eye* (2000) as well (fig. 14.3). A participant wears a spherical display on his or her head, which replaces one's own sight with a panoramic vision seen from above. A blimp floats high over the participant's head, attached with a string to a backpack also worn by the participant. Live video footage from the blimp is sent to the spherical screen through a computer inside the backpack. Thus the participant achieves the feeling of having a "floating eye" that replaces one's normal vision, as he or she walks around using the vision from above, always observing him- or herself underneath. A recognized researcher and engineer in the field of virtual reality, Iwata explores human perception through his artworks, using the latest technologies which he develops himself.

In fact, Japanese researchers and students in engineering often produce works with artistic or entertaining features, rather than demonstrating their inventions in a typical academic manner. Projects from Japan have become undoubtedly visible over the past years at the SIGGRAPH conference's Emerging Technologies (E-Tech) exhibition, which is considered a highlight of SIG-

GRAPH (the Association for Computing Machinery's Special Interest Group on Graphics and Interactive Techniques), the most important international conference in computer graphics and its applications.[30] In 2005 more than half of the projects selected for E-Tech were from Japan, including several students' works.[31]

The program showcases experimental works and projects in collaboration with SIGGRAPH's Art Gallery, which showcases artwork using digital technologies.[32] Japanese researchers and engineers have been particularly successful in developing original hardware-based human interfaces to realize mixed-reality environments, sharing the approaches taken by artists' interactive works.[33] It is no coincidence that artworks using off-the-shelf systems such as the CAVE virtual reality system are almost nonexistent in Japan, although CAVE itself exists in many labs.[34] There seems to be a tendency among artists, researchers, and engineers to focus on tangible experiences that connect physical and virtual worlds.[35] Another interesting feature of virtual and/or mixed reality and human-interface applications is the focus on more experimental and less "serious" use in Japan, often in connection with art and entertainment, compared to applications developed in the United States. For example, advanced use of VR and MR technologies for arcade games has been widely seen in Japan. Examples include simulators using force feedback for driving, fishing, skiing, or dog-walking, and games involving body movement such as the internationally successful DDR (Dance Dance Revolution).[36] Introduction of latest technologies for entertainment purposes can be seen in mobile phones and amusement robots as well. In fact it has been a conscious strategy in robotics, a field that is strongly supported by the government. Success of Sony's "partner robot" AIBO has proven the legitimacy of the approach, paving the way to realize the Aichi World Exposition 2005 as a "Robot Expo."

Where does this "love for technology" come from? What role does it play in the relationships between art and technology, art and science, art and entertainment, and art and commercialism in Japan?

Historical Aspects of Technology

In his book *Inside the Robot Kingdom: Japan, Mechatronics, and the Coming Robotopia* (1988), Frederik Schodt points out the cultural difference between Japanese and Americans in the process of introducing industrial robots.[37]

Industrial robots are usually just heavy metallic "arms" that do not resemble human beings. In the United States—in the automobile industry, for example—they were treated as machines to perform certain rather simple tasks human workers used to do. In contrast, in the early stages of introducing robots in Japan, some factories invited Shinto priests for a ceremony to welcome the robots and wish for good luck.[38] Schodt also reports that Japanese workers gave a name to each of their robotic colleagues.[39] This story became known internationally, and it is often associated with the animism of traditional Japanese culture. However, a simplified understanding such as "the Japanese treat robots as living entities because of their culture's animism" is both misleading and problematic.[40] Rather than analyzing the Japanese approach to nature, or to artificial life, the Japanese attitude toward machines, or to technology in general, must be discussed.

Tools as Devices

Analyzing how tools are regarded in Japan will help in our understanding what technology means to the Japanese.

Historically, professional tools such as kitchen knives for cooks or scissors for gardeners were considered something special.[41] In short, a tool was not considered a mere means to a result. In Japanese tradition the process and manner of using the tools are as important as the result itself. A tool used by carpenters to draw straight lines is both functionally and aesthetically designed, representing this special relationship between the tool and the user.[42] This appreciation of tools is well illustrated by the tradition of the tea ceremony.

It is obvious that drinking a cup of green tea is not the final goal of the ceremony. Tools that are fully functional and yet aesthetically beautiful are appreciated, while they represent the taste or even personality of the owner.[43] Naturally a playfulness of elements is regarded favorably. For example, tea bowls with an unexpected design or choice of material are highly appreciated, if they function well.[44]

Today, such tradition is continued in the rich variety of daily commodities and gadgets such as designed office tools, "straps" for mobile phones, or even memory sticks in unusual forms such as sushi. Consumers pay extra money for such items, to make everyday life a little more enjoyable, or to demonstrate one's taste and identity, or to use as "conversation pieces."

These objects function as "devices" rather than tools, in the sense in which Barbara Stafford uses the word in her exhibition catalog from the show at the Getty Center in 2001.[45] Things such as "wonder cabinets" and their contents, or optical toys to show illusion, and other scientific gadgets, were "devices of wonder" that went beyond the physical realities they carried. Likewise, a tea bowl is a device that opens a door to another experience.

Technology as Entertainment

In the late Edo era a most exciting way to serve a cup of tea was to use a tea-carrying automaton. Clocks had been brought in from Europe and had been familiar for a long time. Based on the clock's technology—substituting metal parts with wood—a variety of automata were designed and used. There was even a popular textbook on automata design.[46] The "tea-carrying boy" was the most popular type of automaton, which was used not only in rich households but also at teahouses in town for less wealthy people.[47] The precursor of robots would automatically start "walking" when a teacup was placed in its hands, stop in front of the guest when the cup was picked up, and then would stand and wait. When the empty cup was placed back the doll would turn 180 degrees and move back to the host, stopping again as the host takes the cup. Several models still exist today, suggesting its popularity. "Arrow-shooting boy" is an extremely sophisticated automaton, mechanically realizing a series of actions to shoot arrows one by one at a target a few feet away. The inventor Hisashige Tanaka was later commissioned to manufacture machines for the Meiji Government, and he started an engineering company, which eventually developed into Toshiba.

Without doubt, these automata represented the most advanced technology the Japanese had in the first half of the nineteenth century. Why was earlier technology used only for entertainment purposes? How is it connected to the "techno-optimism" in media art today?

It is no coincidence that these automata were small (tea-carrying automata are about one foot high) and modeled after little boys. Technology was a marvel, but it was not frightening, or larger than human beings. The Japanese attitude toward technology can be said to be signified by this concept of harmless, mechanical little boys.

Until the mid-nineteenth century, peace was maintained in Japan for 250 years, while the country was under strict control on the use of new

technologies. Developing war technology was out of the question (and was not needed anyway). New applications for industrial purposes were also strictly regulated by the central government in order to prevent feudal lords from acquiring extra power. Under such circumstances the latest technologies brought by the Dutch were mainly used for entertainment, which was a major industry in such a stable society.

After the Meiji Restoration, the industrial revolution took place in a short time, led by the government. It meant modernization and globalization. Conflicts between the capitalists and workers, as vividly described in films such as Fritz Lang's *Metropolis* and Charlie Chaplin's *Modern Times*, remained rather minimal.[48] The nightmare of the industrial revolution and automation did not exist in Japan. Their positive attitude toward technology continued even after the war that ended with atomic bombs being dropped on Hiroshima and Nagasaki. The Japanese reaction was to recognize the power of science and technology, and to hope for the better use of them.[49]

Thus historical differences can be observed between the West and Japan in the attitude toward technology. It is also clear that use of the latest technologies for entertainment has a long history in Japan. The convergence of art, entertainment, and technology in Japan today can be more easily understood from such a point of view.

Device as Art

The above discussion reveals some historical and cultural background features seen in Japanese media art such as a flexibility in defining "art," an appreciation of tools and process, an openness to interaction, and a positive attitude to technology.

Device Art is a concept derived from the Japanese approach to media art. It has been proposed by a group of artists, researchers, and engineers including myself, based on the analysis as above. It helps us understand not only features frequently found in Japanese media artworks in cultural and historical contexts, but also collaborations between artists and engineers on new works. The relationship between art and technology in Device Art can be summarized as follows.

Works of Device Art involve hardware specifically designed to realize a particular concept. The functional and visual design of such hardware, or a device, is an essential part of the artwork. Material and technology are explored

Figure 14.4 Sachiko Kodama and Minako Takeno, *Protrude, Flow*, 2001. Courtesy of the artist.

and used in an original and innovative manner, as is familiar from the Japanese tradition of respecting tools. The material chosen is important for users to keep in touch with the real world. Sometimes participants–users are invited to discover an unexpected nature of a particular material, which has become visible through the artist's idea with the help of media technology. For example, Sachiko Kodama and Minako Takeno's *Protrude, Flow* (2001) is an interactive piece using magnetic fluid.[50] The combination of the fluid, electromagnetic field, and sound input system creates a dynamic real-time animation of the black, shining fluid that changes according to the sound input (fig. 14.4). While information technologies become more invisible and ubiquitous in our daily life, artists help to reveal what is happening inside the black box of technology. In that sense Device Art has an educational side—to make people interested in the nature of technology.

Japanese artists are often criticized for their positive attitude toward technology. Being critical is important in art, but it is not art's only goal. Being critical does not mean being negative. It is important that an artist who understands the nature of media technologies create a space where viewers–

participants can share such understanding through their own experiences. Artists visualize what technology means to us. This is another form of being critical. As in Nam June Paik's *Zen TV* and *Participation TV* (1963), in which he altered normal TV monitor circuits, device artists make it possible to see beyond the off-the-shelf, commercially available technologies, with devices they create themselves. The result may be either ironical or playful, as art has no straightforward, practical purpose. Japanese pieces are often playful because of the historical reasons already mentioned. Moreover, media artists generally choose to use particular technologies because they find them interesting, rather than disgusting or useless. It is still possible to be critical of society or the way technology is used, while keeping a positive attitude toward technology itself. Japanese artists often take a playful and humorous approach in performing criticism through their art. The unique-looking musical instruments created and used in performance by Maywa Denki provide one such example (fig. 14.5). The sense of irony and criticism of capitalism are felt either through the artist's performance or through the interaction by participants. Maywa Denki's work and background will be discussed later.

Bridging Art, Entertainment, and Commercial Products

Device Art is a type of media art at the very edge of the changing notion of art. The concept is derived from recent Japanese media art and culture scenes, but it has a universal scope that may help us to understand some of the nature of media art today. The term may sound strange or controversial, but this is intended: The aim of the concept is to question the traditional Western notion of art that is so influential in contemporary media art. The relationship between art, science, and technology, as well as that between art, design, entertainment, and commercial activities, needs to be seen from a different angle.

It is both appropriate and inspiring that Stafford used the word "device" to represent a wide range of artifacts, including natural objects that have been reassembled by human beings, that serve the purpose of generating a sense of wonder.[51] A device is considered a small instrument or mechanism to serve a particular purpose, whereas (fine) art is not supposed to serve a particular purpose, or to have a function. (If it is art that is meant for certain purposes or functions, it should be categorized as applied art, design, a commercial product, etc.) Therefore, by definition art and device contradict each other.

Figure 14.5 Maywa Denki, Tsukuba Series. Courtesy of the artist. Photo by Ars Electronica.

To understand how the word is understood today, we can check popular Web dictionaries. They define "device" as follows.

Device Noun 1. device—an instrumentality invented for a particular purpose; "the device is small enough to wear on your wrist"; "a device intended to conserve water" 2.—something in an artistic work designed to achieve a particular effect 3.—any clever (deceptive) maneuver; "he would stoop to any device to win a point" 4.—any ornamental pattern or design (as in embroidery) 5.—an emblematic design (especially in heraldry); "he was recognized by the device on his shield" (Http://www.thefreedictionary.com/)

Wikipedia (http://www.wikipedia.org/) shows what many of us take to be the current notion of device. According to it devices are typically one the following.

Figure 14.6 Ryota Kuwakubo, *VIDEO BULB*. Courtesy of the artist.

- an instrument
- a small appliance such as a TV set
- a machine or functional part of a machine
- a component of a computer such as a printer or network card
- an information appliance such as a cell phone or PDA

On either definition, the term "device" does not seem to have anything to do with art. However, a work of an artist can in fact take the form of a typical device.

Figure 14.6 shows a *VIDEO BULB*, a commercially available product developed by the artist Ryota Kuwakubo. The product is distributed by Yoshimoto Kogyo Co. Ltd., which has nothing to do with electric appliance or computer business, but is an extremely well-known operation in Japan for its dominant role in supplying standup comedians to TV shows and theaters.[52] The reason such a company distributes an artist's works will be given later.

VIDEO BULB is actually a memory device. When it is plugged into the video input of a TV monitor, an animation sequence created by the artist appears on the screen. Nothing could be simpler. The animation consists of large pixels that represent a virtual human figure who dances, runs, and does other actions. The artist developed the animation software as well. The idea originally came from a large wall-display system for performance that Kuwakubo developed for Maywa Denki, with whom he used to collaborate. Its small-scale wearable version is also commercially available as *BITMAN*, also from Yoshimoto Kogyo.

Maywa Denki, which means Maywa Electric Company, is an art unit founded by two brothers, Masamichi and Nobumichi Tosa.[53] After Masamichi retired "because of his age," Nobumichi took over as "president" of the company and its "employees," who in fact are professional musicians and student interns. Behaving as if it were a real typical minor manufacturing company typical minor manufacturing company producing small electric appliances, they present "product demonstrations" of the strange musical instruments they invent. The title of Tosa is "CEO" instead of "artist." Uniforms typically worn by electric engineers are worn during the performance. The company's "products" are commercially available in the form of inexpensive key holders or a series of amusing toylike gadgets, as well as large-scale robotic instruments. The "Maywa Workers' Union" publishes a cheap-looking newsletter every month for its fans. What Maywa Denki makes special is the status of the artist. Several years ago the brothers made the decision to be hired by Yoshimoto Kogyo, Japan's largest production company in the field of standup comedies. Tosa is officially an entertainer who is paid a salary by the company along with comedians who perform on TV or on stage. Maywa Denki has made a conscious decision to put forth a multilayered message concerning the relationship between art, entertainment, business, commercialism, and society. Their ironical performances are always extremely entertaining, and are supported by enthusiastic fans.[54]

Kazuhiko Hachiya's *ThanksTail* is another example of commercial "art" product. "ThanksTail," a unique communication tool for car drivers, is manufactured and distributed by a subsidiary of Takara, a major toy company known for unique products such as E-kara and Bowlingual.[55] A soft doggy "tail" is attached to the back of a car. The mechanical tail wags as the driver sends a signal to thank another driver for yielding the way. The long-term project of the artist was finally commercialized in 2004 when wireless transmission became feasible. For Hachiya the concept would only make sense by being commercialized, so that anyone who likes the idea could use it. Showing the prototype at an exhibition was not his goal; the artist wanted his new communication tool to be enjoyed by people. He advertised the idea on his website calling for a business partner.

What the artist of *ThanksTail* and the previously introduced *Inter DisCommunication Machine* made famous in Japan is *PostPet*.[56] The email/virtual-pet software he developed in 1996 became a smash hit nationwide. "Momo" the pink teddy bear and his colleague *PostPets* communicate with

the user, play with their own friends after delivery (i.e., other email messages have to wait until the pet "comes home"), and leave their rooms to go to Post-Pet Park if they are not treated well by their owners.[57] As in the case of AIBO, *PostPet* fascinates users because of the autonomous behavior and personal characteristics of the artificial life. The fun is in encountering unexpected situations with the "pet" while it nevertheless functions as an email software.

Toshio Iwai's *Electro Plankton* is an artwork on Nintendo DS, published in the spring of 2005.[58] The piece allows users to freely draw on one of the screens to play with ten different types of "planktons." The software's packaging does not have a word saying "game," respecting the artist's intention. The artist has combined image and sound in original yet clear ways for years. *SOUND-LENS* is one of them. The *TENORI-ON* series allows a user to play music by placing dots on a screen. It has been realized on different platforms including Bandai's pocket-game platform WonderSwan and NTT Docomo's cell phones. The idea goes back to *Music Insects* of the early 1990s, which he developed for Exploratorium in San Francisco and later published as the game software package *SimTunes from* MAXIS (1996).[59] Iwai says the idea originally came from a music box, the sort that produces a series of sounds using the arrays of pins. Instead of prefixed metal pins, his *TENORI-ON* allows users to electronically place dots. His Prix Ars Electronica–winning piece *Music Plays Images x Images Play Music* (1996), conceived and performed with Ryuichi Sakamoto, was another realization of the idea. Now the final version is prototyped in collaboration with Yamaha and has been shown at exhibitions including SIGGRAPH05 Emerging Technologies and Art Gallery. It is a simple-looking but beautifully designed device with a matrix of button-shaped LEDs, which function both for input and output. The handy panel is transparent, so that while a user pushes the buttons the light pattern can be seen on both sides, by both the user and the audience. The artist plans to make the product commercially available through Yamaha in near future.[60]

There are certain features shared among these "art products" such as *VIDEO BULB*, *BITMAN*, *ThanksTail*, or *TENORI-ON*. Other devices created by the above mentioned artists—and others—share these features. They are user-friendly and make transparent their use of technology. Design is simple without decoration. Industrial materials such as metal and plastic are used. They look simple and practical, but the idea and the function originate from artistic concepts. They are devices that invite users to discover a new mode of

creativity, an unexpected channel of communication, or an alternative view-point in understanding media. Users enjoy these products on their own, at any time, anywhere, instead of having only limited access at a gallery or a museum.

In the age of mass-reproduction technologies, designed objects made of plastic or other common, inexpensive materials are manufactured in countless copies, so that anyone can enjoy them as a part of his or her lifestyle. Digital technologies make possible identical copies with no distinction between what is the original and what is the copy. The question that Benjamin asked is now at an even more critical stage: What is the "aura" of a work of art in the age of mass-reproduction technologies?

An artist may ask: If selling an artwork to a collector (at a tremendous price) is a respectful, correct act, why should delivering many of them to younger enthusiasts at an inexpensive price through more accessible channels be considered outside "art"? Isn't it more fair and meaningful? And, if art-works could be reproduced and distributed (even at a convenience store, as in Murakami's case) widely, what will be the distinction between art, design, and other daily commercial products? These are not easy questions to answer, but we need to face them.

From Postwar Art History to Device Art

Artists who explore new media art forms challenge the traditional paradigm of the art market as well. In fact, these questions have been already asked, and in a sense answered, by artists such as Marcel Duchamp, with his *Rotorelief* that was made commercially available, and Fluxus artists with their *Year Boxes*. Nicolas Schoffer not only used his light sculpture system *Lumino* (1968) in performance but also had it commercialized by Philips for those who would enjoy changing light patterns at home. However, these experimental attempts remained relatively rare and unsuccessful.

If we examine the art world of post–World War II Japan from the 1950s to the '70s, it is clear that the denial of the traditional art form was practiced in an even more radical manner than the contemporary movements that took place in America and in Europe.

Gutai artists actively participated in "actions" in the 1950s, experimenting with "anything but painting meant to be preserved." These actions would

later be considered the prototypes of happenings by Allan Kaprow in his major text, *Assemblage, Environments, and Happenings*.[61] The performances by the Gutai artists took place before happenings became commonplace worldwide—two years before those practiced by Kaprow, who is regarded as a pioneer in the field. The Gutai action was an intervention between material (mud, wood, paper, light bulbs, etc.) and body. They made use of everyday material without changing its nature, while new physical (for the artist–performer) and visual (for the audience) experiences arose through the intervention.

In 1956, the Gutai leader Jiro Yoshihara summarized the concept as follows:

With our present awareness, the artworks we have known up to now appear to us in general to be fakes fitted out with an affectation.... Gutai Art does not change the material. Gutai Art imparts life to the material. Gutai Art does not distort the material. In Gutai Art, the human spirit and the material shake hands while confronting each other. The material never compromises itself with the spirit. The spirit never dominates the material. When the material remains intact and exposes its characteristics, it starts telling a story, and even cries out. To make the fullest use of the material is to make use of the spirit. By enhancing the spirit, the material is brought to the height of the spirit.[62]

One of the most active members, Atsuko Tanaka created pieces using electric circuits such as *Bell* (1955) and *Electric Dress* (1956).[63] With *Bell* people could interact with a switchboard to ring a series of electrically connected bells in the gallery space. Tanaka made her *Electric Dress* by connecting many light bulbs in different shapes and colors, and she wore the "dress" as a performance. The dress was exhibited while she was not wearing it, with drawings for *Electric Dress*, in different stages from the conceptual level to a more concrete plan, exhibited on the wall. These pieces have an interesting similarity to Device Art. Later Tanaka focused on paintings based on these drawings.

The focus of the Gutai artists eventually shifted to action painting—possibly because the art world was not quite ready for their experimental activities—and they sought an international link.[64] However, their "action painting" was more focused on the process than the result. It provides an interesting contrast to Jackson Pollock, for whom painting was a personal process rather than a performance.[65]

Even though their approach shifted toward the end, their original attitude toward material should be noted, especially as it was formed independently from the global art scene. This is not to state that Gutai had a direct influence on Device Art. There are clear differences—in fact, Gutai artists were always aware that they were in the field of fine, high art, whereas device art challenges the border between art and other fields. Still, their respect for material and its nature, clearly seen also with Mono (also called Mono-ha, *Mono* meaning material and *ha* meaning a group), suggests that there is something in Japanese culture that helped the idea of device art to emerge. Like the root of a bamboo bush that forms an invisible network underground and raises shoots in different places and times, there seems to be an underlying cultural mechanism that drives both artists and the audience to enjoy material and its nature.

Mono-ha artists in the 1970s were also known for their use of natural material such as wood and rocks. The respect for the nature of various materials and the refined use of them is a tradition in Japanese design, craft, and architecture garden design. This interest toward natural forms and their variety is in resonance with the traditional Japanese attitude toward nature. Nature and the materials it brings us are to be respected as they are, rather than considered as something to be conquered or as mere "resources" for human activities. We can find interesting forms or elements among them and use them creatively for our purposes, or even manipulate them to enhance their natural beauty—all without changing their nature. This attitude as a *basso continuo* in Japanese culture can be understood easily through many examples such as garden architecture using natural stones, in pottery that uses natural grazing, or bonsai trees. The clear contrast between a typical European geometric garden and a Japanese garden suggests the difference in their attitudes toward nature. It is not the aim of this essay to analyze the reasons behind such differences in culture. However, it is important to introduce a widely accepted understanding that the somewhat regular arrival of unexpected and unavoidable natural disasters, such as typhoons, earthquakes, and eruptions of volcanos, probably underlies the Japanese culture.

There is no direct relationship known between Gutai or Mono and what we see in Japanese media art today; contemporary media artists are typically not directly influenced by the 1960s and '70s art movements in Japan. Rather, what we find is a root that has grown deep in the Japanese cultural soil, and which has let artists, designers, and craftspersons, as well as consumers, be aware of the use of material.

Looking further through postwar Japanese art history, practices by the Yomiuri Independent artists in the early 1960s also provide interesting insights into the tendencies in Japanese art at that time.

The Yomiuri Independent (1949–1963) was an annual art exhibit in Tokyo sponsored by Yomiuri, Japan's largest newspaper company. Since it was nonjuried, the Independent became a showcase of works by young and experimental artists that would not be exhibited at galleries or museums otherwise. They were also free from the academic paradigm, which had influenced the Gutai artists to some extent. As a result, several interesting features emerged, such as the use of everyday objects including empty bottles or cloth pins, combining performance and installation; and an awareness of media appearances.

The Hi Red Center, a group formed by three Tokyo-based artists that emerged from the Yomiuri Independent shows, further developed these features with a stronger commitment to social issues. As many of their activities (happenings) were carried out anonymously, the borders between life and art, or between ordinary objects and art projects, were intentionally blurred.[66]

It is not the aim of this essay to discuss in detail how the Japanese avant-garde art movement developed after the war, when no small number of artists moved to New York because they felt the freedom during the postwar era (including the Yomiuri Independent show) had been lost. These artists joined the Fluxus movement and eventually became a part of today's media art.[67] Further analysis is still needed. However, these movements from 1950s to '70s share interesting similarities, or parallels, to what is proposed by Device Art today. These similarities—a specific attitude toward material, an openness to technology, the renunciation of the existing art system—can be at least partly understood as a result of shared background, that is, the Japanese cultural and historical background. The major difference is the society in which they take place. Duchamp's *Rotorelief* and Schoffer's *Lumino* did not succeed in a society in which art was divided from everyday life. Today both art and entertainment are consumed as a part of popular culture. Digital technology and the "global" economy have changed the relationship between the original and the copy, by allowing us to immediately produce and deliver identical copies all over the world. The interaction between art and technology will continue to develop. Device Art is a new concept of the digital era, but at the same time it is a continuation of what we have seen in past art and cul-

ture, including what avant-garde artists experimented with both in Japan and worldwide.

Notes

1. Walter Benjamin pointed out the impact of media technologies on art in "The Work of Art in the Age of Mechanical Reproduction" (1936), in *Illuminations*, trans. Harry Zohn (London: Fontana, 1973). Science and technology support and change society while their development is largely defined by society and its cultural conditions. The interrelationship between art, science, technology and the society is a complex one. It is not the aim of this essay to provide a definitive and complete analysis of the theme.

2. For example, discoveries and inventions in optics directly influenced art through the establishment of realism, while technology made possible by scientific discoveries including telescopes and microscopes changed people's vision of the world and gradually reformed society itself.

3. Chris Cunningham's music video for Bjork's "All Is Full of Love" was in fact shown at Venice Biennale in 2001.

4. Although Benjamin raised the question of the nature of "aura" in the age of mechanical reproduction technologies, the art market responded by numbering prints and focusing on "original prints," thus denying or ignoring possibilities raised by the technologies. As long as the art system is based on physical objects to be bought by museums or collectors, with unique or limited editions that function to raise the value, digital art does not have much chance.

5. Marshall McLuhan states artists' role as vaccinating the society in preparation to blows brought by media technology in his seminal book *Understanding Media: The Extensions of Man* (New York: McGraw-Hill, 1964).

6. For example, artists Toshihiro Anzai and Rieko Nakamura started *Renga* in 1992, inspired by the ancient tradition of collaborative linked verse. *Renga*, literally meaning "linked images," is a wordplay on the traditional renga as linked verses. "Ga" means both verse and image, although they are different when written in Chinese characters. (See http://www.renga.com/renga.htm/.) It challenges the Western notion of originality and seeks for new modes of creativity on the Net. More detail can be found at http://www.renga.com/. Toshihiro Anzai, "Renga Note," originally included in *Proceedings of*

the IMAGINA Conference, INA, Paris/Monaco, 1994, http://www.renga.com/archives/strings/note94/index.htm/.

7. Japan closed its border to foreign countries (except China and Holland) for nearly 250 years after visits by Jesuit missionaries had a considerable impact on the society. A recent exhibition at the Los Angeles County Museum of Art (a smaller-scale show traveled from the National Museum of Japan) shows how the Meiji Government sought the equivalent of "art" in existing visual culture. See *Japan Goes to the World's Fairs: Japanese Art at the Great Expositions in Europe and the United States, 1867–1904*, exhibition catalog, Tokyo National Museum, 2004. The original exhibition in Japan was titled "Arts of East and West from World Expositions, 1855–1900: Paris, Vienna, and Chicago" (2004).

8. By the mid-eighteenth century, artists and their supporters were networked across the country.

9. The number of pieces furniture was kept to a minimum. The idea of interior decoration was very different in Japan from that in the West, contrasting especially with Victorian home decoration. Westerners who visited Japan were often surprised to see how "very modest" Japanese houses looked.

10. The space is called "toko-no-ma." A picture or a calligraphy that suits the season is selected and hung. While not in use it is kept as a roll and stored in a wooden box. Seasonal change of life was considered important.

11. Since papers were precious they were recycled in various ways. There is the famous episode in which impressionist painters discovered woodblock prints that were used as packing material, when Japan exhibited at the World Exposition in Paris in 1867 for the first time. Although not verified, the story reveals how prints were somehow equivalent to the newspapers and magazines of today.

12. The game, which goes back to medieval times, is considered a highly cultural entertainment played even among nonwealthy people. Actually Nintendo started as a publishing house of these cards in 1889. On the game culture in Japan see Machiko Kusahara, "They Are Born to Play: Japanese Visual Entertainment from Nintendo to Mobile Phones," *Art Inquiry* 5 (14), Cyberarts, Cybercultures, Cybersocieties, ed. Ryszard W. Kluszczynski (2003).

13. The inventor, writer, and painter Gennai Hiraga (1728–1779) mastered oil painting and etching, and taught Western painting methods to others. The well-

rounded inventor is best known for the invention of electric generator, which he discovered how to make from a Western source and realized as a device of surprise and entertainment (e.g., an electric shock as an amusement).

14. Not only the meaning of "art" but also its surrounding concepts differ according to culture. The social scientist Mitsukuni Yoshida analyzes the nature of entertainment in Japan in Mitsukuni Yoshida et al., *Asobi: The Sensibilities at Play* (Hiroshima: Matsuda Motor Corp., 1987). Also see Kusahara, "They Are Born to Play."

15. There was an "official" school of painters (Kano-ha) for the court, but they met the demands of townspeople as well. Also, the appreciation of calligraphic Chinese ink drawing would make such a distinction between "high" and "low" impossible.

16. On the struggle between "Western-style" and Japanese classicism in the late nineteenth century in Japanese art education see Machiko Kusahara, "Panorama Craze in Meiji Japan," in *The Panorama in the Old World and the New: 12th International Panorama Conference New York 2004*, ed. Gabriele Koller (to be published in 2006).

17. Actually the Gutai and Mono movements in the 1960s and '70s have interesting features that can be better understood by taking the Japanese attitude toward material and space, their appreciation of the ephemeral, etc. into consideration. The concept of device art does make reference to these movements, but there is not enough space for an analysis in this essay.

18. Artist-designer Isamu Noguchi is an example.

19. The traditional Japanese approach to originality and creativity is discussed in my essay "On Originality and Japanese Culture—Historical Perspective of Art and Technology: Japanese Culture Revived in Digital Era" (http://www.worldhaikureview.org/5-1/whcj/essay_kusahara.htm/).

20. "Takashi Murakami's SUPERFLAT MUSEUM" was a joint project among Takara (a leading toy company), Kaiyodo (the best-known "miniature figures" production company), and Murakami's factory. The artist conceived the project when his "original" sculpture *Ms. ko2* was sold at a surprising price of $567,500 in May 2003 at Christie's in New York. The price was beyond the expectation of the artist himself. The project has many ironies. The price of the miniature version refers to the earlier fixed rate between dollar and yen, which symbolizes the postwar relationship between Japan and the United States. Chewing gum also has a symbolic meaning associated with the American soldiers who occupied Japan, and the American culture that

flooded Japan in a short period. While adults were shocked by the habit—chewing something all the time was considered impolite—kids accepted it easily as soldiers threw pieces of bubble gum as they drove. The miniatures (or officially pieces of bubble gum) were said to have sold out immediately as young Murakami fans cued up at convenience stores.

21. These "shokugan" (food + toy) have become an important part of Japanese popular culture. Almost anything can be miniaturized to be packed with candies.

22. The Japanese love for miniatures and small objects can be observed in the popularity of these collectibles.

23. There were actually three series, including a version which was only available at Roppongi Hills, Tokyo's new center of art, culture, and IT business. Murakami designed characters for the complex.

24. The context is also carefully transferred, as screens and sliding doors (which belong to families and fixed spaces) are substituted with bags (which are individual and portable), reflecting the modern life of women.

25. Semi-mass, because both Kaiyodo's miniatures and Vuitton bags are produced by something between handicraft and a mass-production system. The customers, as well, are not members of an exclusive aristocracy, yet they believe in being "connoisseurs" of design, art, etc. This belief symbolizes the nature of pop culture.

26. Further information on Hachiya and Maywa Denki (Nobumichi Tosa) is available at http://www.petworks.co.jp/~hachiya/works/index.html, http://www.maywadenki .com/index.html/.

27. The piece, resulting from years of research by Iwai, was finally completed and shown in 2005 in collaboration with NHK. Technical information is available (in Japanese) at http://www.nhk.or.jp/pr/marukaji/m-giju148.html/.

28. While such interaction is realized worldwide, it is much more common among Japanese artists.

29. While artists such as Rafael Lozano-Hemmer, Christa Sommerer, and Laurent Mignonneau create works with much "openness," interactive works do not necessarily leave much space for freedom in participants' experiences. For example, in Eduardo Kac's *Genesis*, participants help bacteria to mutate by turning on a UV lamp, but

each participant has little to do with the cause of the event. A participant observes the installation, tries to understand what the artist is aiming at with the piece, and only later learns the result, which is anticipated by the artist. Each participant's experience is similar to everyone else's.

30. SIGGRAPH is the most important international conference and exhibition in the field of digital imaging technologies including computer graphics and virtual reality.

31. Three works by students were realized through IVRC 04 (Inter-college Virtual Reality Contest) organized by the Virtual Society of Japan. The competition focuses on convincing concepts realized by experimental but not expensive technologies, encouraging collaboration between art and engineering students.

32. This year's call for entries announces: "SIGGRAPH 2005 Emerging Technologies is searching for work that moves beyond digital tradition, blurs the boundaries between art and science, and transforms social assumptions. . . . experimental work that focuses on the convergence and transformation of art and science will be given special consideration. Emerging Technologies and the Art Gallery are coordinating interactive submissions."

33. Hiroshi Ishii, who leads the Tangible Media Group at the MIT Media Lab, is another example of a researcher whose works have been shown at media art exhibitions.

34. CAVE is a room-sized, multiuser, standardized virtual reality environment with 3D real-time image and audio developed at the University of Illinois and NCSA. See http://archive.ncsa.uiuc.edu/SCD/Vis/Facilities/.

35. It has been pointed out that the border between "real" and "not real" remains much more open in Japanese culture. This might be part of the explanation why mixed reality is more accepted in Japan. However, what still requires further analysis is why virtual reality art is less popular while games that invite users into cyberspace have been widespread in Japan. On the other hand, mixed reality technologies have been used fully at video arcades. The trend has been recently introduced to personal game consoles and pocket games with some success, as in case of EyeToy (Sony).

36. Konami's DDR was first introduced to arcades in Japan in 1998.

37. Frederik Schodt, *Inside the Robot Kingdom: Japan, Mechatronics, and the Coming Robotopia* (Tokyo: Kodansha International, 1988).

38. Shinto is a traditional Japanese religion that retains traces of animism.

39. It is interesting and perhaps unsurprising that male workers gave female names to their robots.

40. By pointing to animism as the major cause, the discussion ends there with something mysterious. Even worse, there is a widely shared Western idea that animism belongs only to primitive societies and is inferior to established religions such as Christianity. This sort of evaluation prevents people from logical thinking.

41. A connection to animism is found in traditional ceremonies to accompany the discarding of used tools. The ceremony allows users to thank their old tools (which are now useless) and send them to another world (psychologically) instead of destroying them as mere useless objects. Yet, it does not mean that the user believes the tool has a spirit. Isn't it rather universal that people tend to feel attached to personal things they have used comfortably for years, such as musical instruments, sports shoes, cameras, cars etc., and hesitate to just throw them into a trash bin?

42. Making these tools requires craftsmanship, which is also an important part of the history of Japanese technology.

43. There are several types of scissors used for flower arrangement. They are all simple but beautiful, and the design is defined by each school. If you join a school you need to use the "right" tool that represents the school's aesthetics.

44. For example, irregular shaped yet aesthetically interesting and perfectly functional tea bowls could be highly valued. Unexpected or appropriated use of material is another form of playfulness. Some simple Korean rice bowls for daily use were "discovered" to serve well and became the most expensive bowls for tea ceremonies.

45. Barbara Maria Stafford and Frances Terpak, *Devices of Wonder: From the World in a Box to Images on a Screen* (Los Angeles: Getty Trust Publications, 2001).

46. Yorinao Hosokawa, *Karakuri Zui* (1796).

47. There are descriptions of encountering such automata at teahouses. Ihara Saikaku, a major writer of the Edo era based in Osaka, described the wheel mechanism of a doll serving tea in his haiku and accompanying text in a book published in 1675. A haiku by Kobayashi Issa, a major haiku poet who lived during the Edo era in a rural town

from the late eighteenth century to the early nineteenth century, is about a tea-carrying doll. Timon Screech writes about Japanese automata (*karakuri*) in his wonderfully inspiring and also informative book *The Western Scientific Gaze and Popular Imagery in Late Edo Japan* (Cambridge: Cambridge University Press, 1996).

48. Comparing Lang's *Metropolis* to Osamu Tezuka's version, which is now available as an animation film produced by Katsuhiro Otomo and others, will explicitly reveal the opposite attitudes toward robots.

49. Osamu Tezuka's *Astro Boy* (original title: *Atom*) represents such feeling.

50. Http://cosmos.hc.uec.ac.jp/protrudeflow/works/002/.

51. Stafford and Terpak, *Devices of Wonder*.

52. Http://www.yoshimoto.co.jp/.

53. Originally Maywa Denki emerged from the "Art Artist Audition" that Sony Music Entertainment (SME) organized experimentally for several years in the early 1990s. They won an artist-in-residence system offered by SME. When the program ended, they were approached by Yoshimoto, which was interested in new forms of entertainment. They accepted the offer to go one step further in their challenge, officially being hired by the entertainment production company and receiving a monthly salary. This is the background of their "products" being distributed by Yoshimoto. Such a situation could not possibly take place if there were no common understanding between the art and entertainment business.

54. Actually the name of the company is a tribute to their father who had founded and run an engineering company under the name but lost against larger enterprises. A series of "low-tech" instruments they create using old-fashioned switches, light bulbs, and other electric devices—"100 volt current—dangerous!" is the motto—signifies those small-scale manufacturing companies and their workers who supported the Japanese postwar economical growth, but failed to survive the electronic age.

55. E-kara is a microphone-shaped handy all-in-one karaoke system. Bowlingual "translates" the dog's language for human beings, while Meowlingual works for cats. These high-tech toys play an increasingly important role in Japanese popular culture.

56. PostPet is not included in the category of device art, as it is software-based.

57. It runs on a variety of platforms on the Sony Communication Network (SCN). It has become a nationwide hit and has been used as the "mascot" of the Sony Group. Although it was designed as a commercial service, its success clearly comes from Hachiya's use of the concept of communication. Further analysis can be found in Machiko Kusahara, "The Art of Creating Subjective Reality," *Leonardo* 34 (2001).

58. Http://electroplankton.com/. Nintendo released the software as one of the major contents for DS, with a series of TV commercials.

59. Http://ns05.iamas.ac.jp/~iwai/simtunes/. It was originally planned to be published by Nintendo. Iwai published another "game" software, *Bikkuri Mouse* (2000), more a collaborative drawing tool than a game, developed in collaboration with the art unit Uruma Delvi for Sony's PlayStation.

60. Actually Iwai had done commercial work much earlier in early 1990s with Fuji Television. He developed the first PC-based real-time animation/image composition system connected to a Nintendo game controller. The program "Ugo Ugo Lhuga" became a phenomenal success, and prompted the use of PC-based systems in other TV stations.

61. Shinichiro Osaki, "Body and Place: Action in Postwar Art in Japan," in *Out of Actions: Between Performance and the Object, 1949–1979*, ed. Paul Schimmel and Kristine Stiles (London: Thames and Hudson, 1998), 125–126.

62. Jiro Yoshihara, "The Gutai Art Manifesto," *Geijutsu Shincho* (December 1956).

63. *Bell* was re-created in 2005 and was shown at InterCommunication Center in Tokyo.

64. Yoshihara's original background as a painter could be a reason. His encounter with the French critic, art dealer, and leader of the art informel Michel Tapie probably enhanced the direction. Tapie put an importance on "painting" as something that could last and become part of a collection. Later Tapie made a suggestion to neo-Dadaist action painter Ushio Shinohara to create his action sculptures in bronze, instead of destroying all his works at the end of his performances.

65. Osaki, "Body and Place," 148–149, 155. Their activity seemed to have emerged parallel to Jackson Pollock's action painting.

66. For example, in 1964 they cleaned Tokyo's sidewalks while wearing white uniforms and as posing scientists during the Tokyo Olympic Games. Later, founding member Genpei Akasegawa—who is still active today both as an artist and a writer—photocopied one thousand yen bills as an art project, which resulted in a court case he eventually lost. The case involved many artists, critics, and writers who supported the artist.

67. Besides painters from the groups mentioned here, artists such as Yayoi Kusama, Mako Idemitsu, Yoko Ono, Takahiko Iimura, Shigeko Kubota, and Fujiko Nakaya were active both in Japan and in New York.

Projecting Minds

Ron Burnett

Interactive Dilemmas

One of the central metaphors at the heart of the activities of new media is "interactivity." This is a powerful trope, since it suggests not only that something new is going on but also that interactivity is what distinguishes "old" from new media. Most analyses of new media celebrate the role of interactivity, and the term has sewn its way into the fabric of present-day discourses about digital technologies somewhat like the spiders that trawl the Web to classify and assemble information for search engines. It seems inconceivable to talk about modern digital technologies without referencing their interactive components. And to be fair, there are obviously radical differences between watching a *Star Wars* movie in the theater and playing a *Star Wars* game; the distinctions become even more pronounced with online games, which often involve hundreds of thousands of players.[1]

At the heart of how new media analysts talk about interactivity is a set of assumptions about human experience. These include, for example, that manipulating characters or avatars within the multidimensional planes of a television screen gives players power over those characters (Salen and Zimmerman 2004, 57–67). To some degree, this is correct, and Salen and Zimmerman's work is exemplary in its depth and the degree to which they try to gain some control over interactivity as a concept and creative practice. But from my perspective, the more interesting process that needs examination is the *imaginative* work of projection, anticipation, identification, and interpretation that

players engage in to achieve some authority over the game and its outcome. Projection has some similarities with telepresence, which is the physical sensation of being elsewhere, a sensation that is aided by computer technology. However, it is important to recognize that telepresence, immersion, and projection are also active parts of "conventional" experiences with any number of media and with the written word and in fact, with other kinds of game-playing, including board games. The difference is that digital technology enhances and extends already existing processes and desires on the part of viewers, and facilitates ever more sophisticated forms of participation and interaction.

Interaction, whether it be through the generation of mental images, tearfully watching a character die in a film, or whipping through a mystery novel to find the resolution to its plot, is all about various levels of player or spectator projection and identification. Some of this can be overtly interactive, and some of it is far more subtle because the internal thinking and reaction of audiences to various challenges is not necessarily a visible aspect of their behavior.

How can the complexities of thought and projection be visualized by viewers, let alone by analysts? Aren't film viewers and videogame players engaged in exploring conceptual and emotionally multifaceted feelings, as well as real spaces and worlds? After all, the virtual (even as successful a virtual game space as *Second Life*) is no more than a sophisticated construction, artifice taken to a level of great complexity, but artifice that only works because participants believe in what they are doing. Interactivity then cannot be predicated on or predicted by the design of the game or any medium. The challenge, from an analytical point of view, is not to make too many assumptions about the behavior of players or viewers. Yet, the behavioral model remains dominant, not only within the critical community, but also in the artistic community. At the same time, embodied forms of interaction through augmented reality systems, CAVES, and immersive forms of entertainment suggest that some fundamental changes are underway, re-creating notions of audience and participation. Nonetheless, even efforts to measure the physiological responses of participants will not indicate too much about the intricate and multilevel nature of human experience within interactive environments.

Christa Sommerer and Laurent Mignonneau have for many years been in the forefront of thinking about interactivity and digital technologies. Aside

from collaborating on many articles and books, they are also practicing artists. In 1999 they said the following:

While exploring real-time interaction and evolutionary image processes, visitors to the interactive installations become essential parts of the systems by transferring their individual behaviors, emotions and personalities to the works' image processing. Images in these installations are not static, pre-fixed or predictable, but "living systems" themselves, representing minute changes in the viewers' interactions with the installations' evolutionary image processes. (Sommerer and Mignonneau 1999, 165)

They describe their work as process-oriented and not object-oriented. For them, digital tools offer visitors (their term) the chance to participate in the creation of evolutionary image experiences that transform their installations when they are used and viewed. The difficulty with their position is that claims about what happens to "visitors" are just that—claims. This is an example of the tendency in the discourse about new media to work from the behavior of participants toward theoretical speculations about states of mind, reactions, and outcomes, with the result that the tone becomes prescriptive. There is also a fear that theoretical speculation that is not grounded in experience will be meaningless. Many different theories are invoked without the depth of analysis and historical overview that is needed to give the claims credibility.

Sommerer and Mignonneau also make claims about evolution and interaction that are fascinating but are based on the programming logic of their installations. They believe that there are concrete links among intention, design, and outcome and that the outcomes can be derived from observing participants.

Trans Plant is an interactive computer installation we developed in 1995 for the Tokyo Metropolitan Museum of Photography as part of the museum's collection. *Trans Plant* was realized with the support of Advanced Telecommunications Research (ATR) Laboratories, Japan. In *Trans Plant*, visitors enter a semi-circular room and become part of a virtual jungle that starts to surround them. As visitors step forward into the installation, they will see themselves projected onto a screen in front of them. By walking freely and without any devices, they soon see on the screen in front that grass grows wherever they walk, following each step and movement. When a visitor stops and stays still, trees and bushes grow where he or she stands. Changing the speed and

frequency of one's movements, one thus creates a biotope full of different plant species. The size, color, and shape of these plants depend only on the size of the person—small children will usually create different plants than will their parents. By holding out one's arms, the size of the plants can be increased; by moving the body slightly backward or forward, the color density can be changed as well. *Because each visitor creates different plants, the result on the screen is one's own personal forest that expresses one's personal attention and feeling for the virtual space.* As the growth gets more and more dense and the space more and more full of different plant species, the visitor also becomes deeply engulfed in this virtual world. (Sommerer and Mignonneau 1999, 8; emphasis added)

It is necessary to critique the way in which participants are described in this quote and in the world of new media. Suffice it to say that any discussion of how participants may feel when they experience an interactive installation faces the same challenges that ethnographers or sociologists have when they take a close look at how people encounter different cultural phenomena in their own and other societies. This is not just a methodological issue. Many of the assumptions that interactive creators bring to their works are steeped in myths about audiences. But, where do these myths come from? Why are they so powerful? Part of the challenge of this essay will be to delineate historical antecedents in other media, particularly photography, in order to clarify and contextualize some of these unexamined assumptions. There is a long history to the "fabrication" of audiences that gained currency and importance with the rise of mass media in the latter part of the nineteenth century. Photography and film were crucial to this development and continue to be so.

Avatars, Games, and Images

Many of these dilemmas are heightened when the discussion shifts to video-games. Videogames integrate projection and physical manipulation into a powerful and potentially interactive mix that is distinguished from conventional forms of spectatorship by the use of controllers and joysticks.[2] The type of hand–eye coordination that is required to remain "in control" of games is very specific, needs to be learned, and is precisely the kind of feedback loop that distinguishes videogames from watching a sitcom. In fact, in order to understand the plethora of creative and technology-based efforts in the new media area, it would be necessary to examine a wide variety of tools and technologies that have been used to achieve this effect of interactivity. I

say effect, because for the most part any process of interaction between the user of a computer and a computer screen, or between two individuals talking to each other or within the context of an installation is to varying degrees interactive. This is all about degrees of subtlety. The boundaries between interaction and noninteraction are fluid. Issues of how an analyst, observer, or creator can know that interaction has occurred still remain a central problem. But, this is an example of how the general understanding of interactive media is at a very early stage of development. Claims about a new kind of spectator were also prevalent in 1898 when the cinema was only three years old. It was assumed that the novelty of the screen and the venues in which films were shown were changing how viewers saw the world and how they saw themselves. The problem is that there is no substantive way of knowing whether the claims were true or whether they could have been validated.

For example, the challenge of engaging with an avatar in a game will only be successful if the player believes that there will be some effect to his or her actions on both the avatar and the game itself. Similarly, a conversation between two people will go nowhere without some belief in its purpose and outcome. In both instances, the investment of time and effort is huge, but it is generally based on the hope or the anticipation that the outcomes will somehow match some initial assumptions about the process of interaction. The gap between what might have been anticipated and what finally happens is as much about presence as it is about absence. This gap is located within a participant and is only partially visible to an outside observer. It is of course far easier to try and match input to outcome, but that only tells part of the story.

It is an irony that spectators at a theater or a film often gain great pleasure from the tragic circumstances of the characters they watch. The pleasure comes from the fictive aspects of the experience. It is easy to feel the pain of another if you do not "actually" have to feel the pain. To suggest that viewers such as this are not interacting with the stage or the screen is to misunderstand the ubiquity of a variety of expressive media that have been built on audience expectation and projection. *Interaction is about the interplay between fiction, the reality of the moment, and projection.* In videogames players teleport themselves into a screen by using their imaginations in a manner that is not too different from what a spectator does in a traditional theater or cinema. Humans have learned this sense of being within a character or being part of a scene over many centuries of interaction with a variety of complex methods of display and presentation. A similar process occurs when two people talk. They interact based on

a fluid set of assumptions about each other, about what they are saying and about what they are not saying: "They are playing a game. They are playing at not playing a game. If I show them I see they are, I shall break the rules and they will punish me. I must play the game of not seeing I see the game" (Laing 1970, 1). The problem is that conventional media have been seen as static when in fact, they are quite the opposite, and in particular traditional media evolve with their audiences in a variety of ways. What is needed is a typology of interactive processes that will have enough breadth to allow for what happens in a religious ceremony, as well as what happens in a sophisticated virtual reality experiment of the sort produced by artists like Char Davies and Janet Cardiff.

For example, what is the relationship between the structure of a game and playing it? Can the experiences of playing be understood by observing the players? Is the use of controllers and joysticks one of the clear markers that distinguish digital games from other media forms? As this essay unfolds, I will explore these and related issues by examining the connections between photography, cinema, and videogames with some parallel considerations given to the concepts of interaction, projection, immersion, and identification. I begin with a discussion of photography and the nineteenth-century base upon which so much of the critical discourse of new (and old) media has been built and then go on to a fuller exploration of projection as a concept that I hope will have some value in understanding the specific attraction of new media. Videogames are one facet of new media; there are also many other media and cultural forms being created, presented, and disseminated within this evolving digital ecology (Wilson 2002).[3]

New Media/Old Media

In order to explore the connections between old and new media, I would like to revisit some arguments about the ways in which the cinema became an important part of most cultures in the nineteenth and early twentieth centuries. A common assumption at the time of the invention of the cinema was that films were made up of moving pictures. This rather universal and familiar definition came into being in the late nineteenth century as a way of connecting the relatively new technology of photography to the even newer technology of the cinema. Yet, it has always been clear that a strip of celluloid is not reducible to a series of stills when *projected*, but is, in fact, the sum total of a *limited*

number of frames. Nevertheless, the individual frame continues to be a marker for the cinema, a sign of the photographic nature of an entire film. This trajectory has remained quite powerful for a long time. For example, the approach to the study of the cinema in the late 1960s and 1970s (from *Screen Magazine* to the work of Christian Metz 1974) was dominated by the examination of individual frames and the application of a semiotic approach to both criticism and interpretation. There is of course the convenience of extrapolating information from the frame itself, and this was done to greatest effect in the analysis of films by Alfred Hitchcock (Bellour 1979). But it is precisely the attraction of the frame as a marker that has to be carefully examined largely because the information in a frame is so fragmentary. It is not without justification that Jean-Luc Godard has spent much of his career complaining about the profound differences *and* intimate links between photography and the cinema (Godard 1972). For Godard the relationship between photography and the cinema is as problematic as that between literature and film, but is also a necessary foundation and tension upon which both mediums depend. Moving images have always been a challenge, largely because there is no easy way of distilling or extracting all of the components of a film. The same can be said of new media. The wealth of detail can be reduced to a still image, but the fragment here has a great deal of difficulty standing in for the whole. The tensions between still and moving images have been endlessly replayed since the late nineteenth century. In most cases as different media have appeared over the last hundred years or so, the dominant trope has always been the still image.

The links between photography and the cinema have continued to strengthen over the last one hundred years, even though an argument could be made that the two technologies are quite distinct. Both the cinema and photography have been at the core of a broadening media ecology that is now accelerating ever more quickly, as digital technologies increasingly become a part of the fabric of everyday life. The popularity of digital cameras (68 million were sold in the U.S. in 2004), for example, the transformation of cell phones into multimedia devices, and the arrival of podcasting mean that conventional critical strategies derived from the study of mass communications in the 1960s and 1970s may not be that useful in understanding the breadth and impact of this new media ecology. A great deal of confusion remains about how time-based media are experienced. ("We agree with veteran game designer Warren Spector, that 'It is absolutely vital that we start to build a vocabulary that allows us to examine with some degree of precision, how games

evoke emotional-intellectual responses in players'" (Salen and Zimmerman 2004, 2).

At the same time of singular importance to this essay is the interaction among a variety of media and the ways in which traditional forms of expression and digital technologies have found common ground. This interaction needs to be untangled if only to avoid the homogenizing impact of the term "new media." In the same way as I ask some questions about the guiding assumptions that led to the invention of photography and the cinema, my goal is to show how strong the historical links are among the various technologies that are in use today. In my opinion, digital technologies, and especially videogames, are in the same state of transition and development as film was during the period from 1895 to 1915. There are *contemporary* tensions similar to the ones between photography, cinema, and the visual arts during that bridging period between the nineteenth and twentieth centuries. These include differences between digital creators, for example, and traditional visual artists, and between new media and conventional modes of media presentation (e.g., television). The fact that the connections are not that visible is due to the fact that the discourses surrounding new media have not been codified or at least not to the same degree as other more traditional media. It is an irony that videogame production, has become more and more like film production in terms of cost and the size of the teams that are needed to create the games. This also happened with great rapidity during the early days of film production. As within film the level of experimental activity in videogames has declined as more and more small companies have been taken over by larger corporations. Another striking similarity is the rush to realism in early cinema which is mirrored in sports videogames is realism, from the motion of the characters right through to the sounds that they make and to the rules of the games as if the videogames are capable of reproducing what happens in a stadium. Of course, the real marker here is the way television broadcasts the games.

Photographers and filmmakers in the nineteenth century were also more concerned with reproduction than with experimentation. Photographs were used to record events, people, landscapes, buildings, and a wide variety of everyday phenomena. Film introduced time and movement into the equation, but to begin with it was equally conservative. The narrative structure of early cinema was built on assumptions about the best way to promote realism based on photographic effect (with rare exceptions like Méliès). The technology of

the cinema was developed on the foundations created by photography, but also by theater and music as well as performance, and this eventually led to more interesting experiments with the form. The other technologies of the nineteenth century that had an impact on the evolution of film and photography were the telegraph, railroads, and electrification in general. Videogames have been influenced by all of these technologies, but both creators and critics are not conscious enough of the historical heritage they use in their reflections on videogames.

Many of the standard definitions of images currently in use are derived from the confluence of these technologies and their impact (Burnett 1995). This points out the degree to which the initial development of new technologies tends toward duplicating previous modes of expression that are already in place. It takes some time to overcome this, but eventually dramatic shifts do occur both in the discourses about the technologies and in their application. For example, it could be argued that "portability" (smaller cameras) had more of an influence on the early development of photography than concerns for the quality of images. Conversely, quality became more of an issue when photography was accepted as an art form in the middle of the twentieth century and single-lens reflex cameras became more widely available. New technologies transform media. The connections that link media, human experiences, and new devices are not linear or even predictable, but continuity as well as significant shifts can coexist. This is why the move to digital photography has been accompanied by changes in the role of computers from information processors to information repositories. The core elements of computers and cameras have remained even though the digital image is really a video image, which is why it is possible to move from the camera to the computer. As I suggested earlier, the impulses here are at one and same time evolutionary and ahistorical. Digital cameras are still physically engineered to make it possible to capture scenes with as much realism as possible. Clarity and reproduction, not distortion and fuzziness, are considered to be crucial to the integrity of the technology.

In the same way, videogame creators are still working on the physics of movement within their games (hit a ball and it goes in the "anticipated" direction, fly a plane and it banks correctly) as well as the physical look and feel of their characters and how well the characters fit into the plots that are created for them. Game creators are still trying to meet the technological challenges of realism that will take them beyond outcomes determined by their programming and mapping of the storyline (Theodore 2004). Once these

issues are resolved, the challenges of quality storytelling will become ever more central to their creative endeavors.

A long-term challenge continues to be the assumptions about what makes images photorealist: "The game industry's no-nonsense definition of realism is basically 'what we see in TV and movies'" (Theodore 2004, 48). Theodore goes on to ask what makes games look *real* and concludes that the definitions and explanations are at best superficial and derivative of the existing look and feel of other media. The same issues were present in early cinema's appropriation of photographic realism and led to debates that were not dissimilar to what is happening among videogame creators in relation to the cinema.

The counterargument to this is that videogames are simply a medium for the creation of fantasy narratives and that realism is beside the point since players will attempt to gain control over the games irrespective of their content. Precisely the same statements were made in 1896 about Auguste Lumière's short films on current events. Lumière's first film, *The Arrival of a Train*, was shot so that the train arrived at a diagonal to the screen, enhancing the illusion that the train was about to go offscreen and enter the film theater. Even though it was a carefully constructed "effect" and calculated to impress audiences, the power of the artifice made it seem all the more real. There was nothing about the artifice which dissuaded audiences from viewing Lumière's films, largely because he made use of photographic conventions (aesthetic and formal) that audiences had experienced many times before. No firm conclusions should be drawn from this other than that photography had filtered into the lives of so many people, so quickly. Artifice challenges realism and vice versa—a conundrum the videogame industry is still struggling to understand.

As I mentioned earlier, the belief that the cinema is a series of still pictures that are transformed by mechanical means has maintained a long-lasting hold on viewers as well as analysts. Part of the reason for this is the priority that is given to the machine, especially the camera, as an *autonomous* creator of images. Early advertisements for the Kodak box camera in the late nineteenth century emphasized not only ease of use but also the powerful role of the camera in making any shot perfect. These claims made it seem as if a technically difficult task could be easily handled by anyone. In principle, that approach is understandable. One of the goals of technology use is transparency as well as naturalization—a refined absence, which actually makes the usage even more dependent on the tools. The irony is that as sophisticated technologies, for ex-

ample, become more and more layered into everyday life, as they disappear because they are so natural, users lose the power to change their character let alone how they are made. So, digital cameras are designed to optimize paper print quality to maintain the traditional output of photography just as digital movies continue to be projected to maintain the established screen experience. It is therefore not surprising that the vast majority of digital entertainment is created using storyboards, as if that inherited nineteenth-century strategy to story development is an effective way of producing narratives. Storyboards, like still images, strengthen the sense that meaning can be fixed into something readable.

The issue here is that projection whether in a theater or on a computer screen dissolves the materiality of still images into screen-based temporal forms of expression and experience. It is this dissolution that tests conventional notions of the sign and makes the analysis of screen-based media very challenging. *Projection allows audiences to visualize the effects of frames in motion.* It must be remembered that there are over 190,000 frames in the average feature film. Television has even more "frames" and videogames even more than television. Would it then be correct to say that frames are markers for meaning and plot development? The attraction of the still is that it gives the illusion of control to viewers, analysts or players, control over a process that is internal to each individual and not fully understandable either by him or by other observers. Visualization by viewers and players is a complex mixture of elements that are internal to the user as well as the result of their imaginations. It is this combination or blend of imagination, playing, and the desire for control that constitutes one part of interactivity in all media.

The relationship that has been sustained between moving and still pictures has influenced the ways in which a variety of other media have been created and analyzed up to the present time. This is perhaps because cameras have remained the primary vehicles for producing images, although that is changing in the world of animation and videogames. It is not unusual for videogame creators to talk about camera position in relation to the characters and stories they produce, even though in practice the camera is a digital creation and is virtual.

First-person shooters are games designed around camera position and camera movement, both of which provide players with the capacity to explore the carefully mapped environments or worlds generated by game engines. So,

even though it is possible to create a game without the use of a nineteenth-century tool, and to work within an entirely digital environment, the central reference points remain photographic as well as photorealist and cinematic, driven by notions of camera placement (which is really meant to be a *replacement* for the eyes of the viewer).

Camera placement is about spectator or player viewpoint—it must be remembered that the more a game is played, the more viewpoint becomes central to the process of playing. Viewpoint is as much a product of game design as it is a suggestive indicator of the players themselves and their dispositions and is one of the ways in which players imaginatively reconstruct the games they are playing. The extent to which a game becomes personal to the player is a sign of the degree of ownership that he or she hopes to exercise over its rules and outcome. The beauty of this imaginary process is evidenced by the efforts of players to "teleport" themselves into the games, and as video capture becomes more sophisticated avatars may well look like the gamers themselves. This will extend the process of projection and visualization even further.

For example, the EyeToy USB camera, manufactured by the Sony Corporation, sits on top of a television and captures the face and body of the player and places him or her into the game. It is still quite primitive, but the games being made for it are the next stage in transforming the relationship between the virtual and the real. Yet, can one claim that this is more interactive than any other medium? Is the imaginative projection of oneself into a traditional story so different?

The core assumption in all of this is that "images can symbolize processes of thought" (Rhode 1976, 91). It is this assumption that also governs so much of the work in interactive design and art. The supposition is based on something that is not known, that is, how the mind operates and how relations of thought, perception, vision, and knowledge produce a wide range of human experiences (Burnett 2004). In fact, the new-generation game consoles (Playstation 3 and Xbox 360) are being touted as the most powerful ever produced *because* they will generate such extraordinary photorealist effects. Photorealism in this case refers to the duplication of "camera signs" created and sustained within the context of mainstream cinema. In other words, videogame creators are reproducing the realism that they have witnessed and experienced in the cinema and on television.[4] And all of this is directed toward matching action, reaction, and participation in the games.

When we say we want our games to be non-linear, we mean that we want them to provide choices for the player to make, different paths they can take to get from point A to point B, from the game's beginning to its end. We can mean this in a number of ways: in terms of the game's story, in terms of how the player solves the game's challenges, in terms of the order in which the player tackles the challenges, and in which challenges the player chooses to engage. All of these components can contribute to making a game non-linear, and the more non-linearity the developer creates, the more unique each player's experience can be. (Rouse 2001, 125)

Compare this quote to one by Hugo Munsterberg writing in the early twentieth century about the cinema: "Depth and movement alike come to us in the motion picture world not as hard facts, but as a mixture of fact and symbol. It is as if the outer world were woven into our mind and were shaped not through its own laws, but by the acts of our attention" (Munsterberg 1916, 74). Rouse and Munsterberg both assume, without any substantive evidence, that there is a relationship between the design of image-based environments and how they are experienced. The aesthetic organization of images is mirrored in the user or participant.

I would like to return for a moment to the still frame or still photo. The reason that the frame or still came to *represent* the cinema can be traced to the excitement at the invention of daguerreotype photography, but also to William Henry Fox Talbot's calotypes and Hippolyte Bayard's extraordinary use of light-sensitive chemicals on paper, and to the role that photography in general played in defining the nature of images in the nineteenth century. The general enthusiasm about the ability of the technology to "capture" and create an "imprint" of the real world was an important statement about its reproductive capacities and about the cultures that were ready to accept it as a new medium of expression. It was also a reflection of the evolution of human thought about the role of images in everyday life.

The idea that a small piece of paper or a strip of celluloid could both represent and reflect an object or a human being was learned over many years of apprenticeship through exposure to paintings, panoramas, theater, and literature. It was therefore inevitable that the cinema would be seen as an extension of the photographic medium, an extension of one of the most powerful inventions of the period. This was aided by the fact that film frames taken in isolation "appear" to look like photographs. Even the limited montage practiced

in the 1890s cut celluloid at its frame markers and was bound by the logic of the still frame as a relational device. It wasn't until twenty years later that Sergei Eisenstein redefined and transformed montage into a creative process more akin to music than to photography.

Photography as a medium was as much a site of controversy in the nineteenth century as it was a defining moment in the history of visual media. Daguerreotypes were as fascinating as they were ephemeral. For example, they could only be copied by rephotographing the original, and although this was widely practiced, the results were at best of poor quality. Even given these constraints, photography grew rapidly. Very soon after Daguerre's invention Bayard and others made it possible for photos to be printed on paper. Photo albums appeared in great quantity in the 1860s and were very elaborate, often bound in leather with gold inlay and other embellishments.

In the nineteenth century, it was not unusual to see many daguerreotypes lined up in stores or in homes in an attempt to generate some sequential relationships between sometimes connected and often disconnected images. This was an effort to bring time back into the relationship between pictures, even though observers or spectators were the only ones who could generate the temporal connections through the viewing process. Photographs do not intrinsically require a succession of images, whereas projected celluloid depends on placement, flow, and sequence. Much of the controversy about the issues of time and about freezing the world into a framed environment continued until the middle of the twentieth century.

Photography was always considered a secondary art, more a practice of popular creation and consumption than a carefully articulated view of the world with aesthetic values equivalent to the traditional fine arts. The same arrangement is now being applied to new media. This was largely because the mechanics of photography seemed to remove the photographer from the process. There were many complaints in the literature of the time, for example, that the machine did all of the creative work, even while, as I have mentioned, the machine made it easier for people to gain access to using the technology. The influence of photography on successive waves of new technology was so pervasive that the potential empirical status of the photograph became a significant part of many disciplines from architecture through to the sciences. Photography's impact can best be understood as a function of its *resistance* to time, so it is not surprising that time-based media both reflect and work against the standards set by photographic images. Nevertheless, inventors

and creators continuously worked on the use of still images for more all-encompassing time-based forms of participation.

For example, Louis Daguerre ran a diorama before he helped invent (with Nicephore Niépce) the silver-plated process of capturing light through chemical means. He understood the need to present the outsized panoramas in his diorama with as much accuracy as possible, especially because spectators were in motion on a slow-moving platform as they watched the scenes presented to them. As a result, Daguerre used a *camera obscura* to faithfully produce the large paintings that made dioramas so popular during the later eighteenth and early part of the nineteenth century. (Careful attention had to be paid to perspective; otherwise the placement of the paintings would not have created the requisite illusion of realism.) In all this Daguerre knew that the framed images in the diorama had to depict recognizable landscapes, people and objects. However, the keys to the success of the diorama were the viewing relationships established between the movement of spectators and the fixed location of the images. Physical movement brought time back into the equation, at least from the perspective of the viewer. The connections between dioramas and modern-day immersive and virtual reality installations are quite strong (Grau 2003).

Daguerre understood the need to create cultural environments that would attract masses of spectators. But, he also understood the importance of motion and the paradox that a moving platform could make it seem as if the images in a diorama were themselves in motion. This use of trompe d'oeil to create the illusion of movement generated many intimate connections between artifice and the different ways in which the scenes were depicted.

All of this activity resulted in millions of people adapting their lives to the role of images as chroniclers of everyday life and of the stories they loved. By the time the cinema became popular (1920s), nearly every home in North America had made use of photographic images in some way or other. By 1905 millions of viewers regularly attended the cinema in a variety of venues. Taken together, the immense popularity of these two media cannot be solely the result of the stories they told or environments or people pictured. Rather, the speed and extent to which they were taken up suggests that the attraction was linked to needs and desires that both preceded and anticipated the invention and spread of both media.

In a sense, the diorama put the spectator in the position of a projector, casting a wary eye from a distance on scenes that came to life because of size and

movement. The impulse was to make the images tell an entire story—hence the desire for realism and use of the *camera obscura* to support "capturing" the world in as plausible and visible a way as possible. This desire for realism had an impact on the development and invention of all image-based technologies.

Daguerre had learned that realism was an effective selling point for images. This founding moment did not root vision in the dreamlike world of the imagination and did not result in a technology that transformed the world into the *opposite* of what the photographer saw with his or her eyes. The entire process was built on expectations that cameras reproduce what is seen within their viewfinders. The impressionists eventually countered this instrumental logic. They painted *against* the technology of reproduction and actively sought what the eye could not immediately see.

Dioramas and panoramas were popular because they were immersive in much the same way as videogames and some digital media are today, but Daguerre was unhappy with the time and effort needed to produce the images that he used. He wanted to invent a process that would be quick and mechanical and would capture the real world in an instant. The daguerreotype became an immediate hit when it was introduced in 1839, and by the 1850s there were millions of silver-tinged images in circulation throughout Europe and North America. Portraits, both individual and familial, were of particular importance and in some respects became ubiquitous. Ironically, glass negatives and the albumen print soon replaced daguerreotypes and increased the speed with which images could be moved from cameras to prints.

George Eastman understood this need for quickness—shoot, develop, and print—as a practical technological challenge and as a popular need. Eastman started the Kodak Company in the 1880s to realize his vision, and by the early twentieth century his little box cameras were an integral part of everyday life.

It was the reproductive power of the photographic device that linked it to memory, preservation, and history. But it was also the sheer mystery and magic of the bond that is created by taking a photograph and getting the printed output that was and still remains a central part of the devotion that people feel for photography. To some degree, cameras take pictures without the complete control of the user (even more so in the digital age) and the enchantment comes as much from the expectation that the machine will reproduce an original intention as it does from the unexpected look and feel of the outcome.

It goes without saying that the early cinema was not explained as a series of *moving paintings*. The power of the metaphor of *moving pictures* comes from the role played by machines as supposedly impartial tools for the reproduction of motion and reality (this was further reinforced by Eadweard Muybridge's studies of men running and horses in motion, which used successive stills to show how human and animal bodies worked). A variety of devices to capture the world appeared in the nineteenth century (as well as earlier), but none was as powerful as the many technological and chemical processes that were used to bring photography (both still and moving) into the mainstream. As photographs became omnipresent, they delineated new ways of thinking about both natural and constructed environments.

The existing history of visual instruments (Stafford and Terpak 2001) was as much a part of this shift to the photographic as the rise of the sciences during the nineteenth century. This process of acculturation took place over a long period. As lenses became more sophisticated, expectations about what could be seen both in the microscopic and macroscopic world became more intense. The arrival of moving images only accentuated this powerful wave of interest.

Instruments like the magic lantern preceded most technologies of projection in the nineteenth century and were used to demonstrate everything from landscapes to scientific experiments. It took nearly three hundred years, from Galileo through to Lumière, for various cultures to learn about and legitimize images as purveyors of truth and information in contrast to images as sites of worship or as icons (Stafford and Terpak 2001).

Another powerful direction that was brought to the forefront of nineteenth-century thought was the impulse to bring the invisible into some form of "visibility," which as Stafford and Tepak (2001) have so astutely commented had been central to the work of many disciplines and artistic forms prior to the nineteenth century. Within the same context, Etienne-Jules Marey invented "chronophotography" (the taking of a set of photographs of a moving object at regular intervals) in response to this desire to make visible the unseen. He photographed people in motion using a camera that allowed him to take up to forty-two shots in one second. Thus it became possible to examine the physiology of humans as they walked or ran. In the 1890s he studied how liquid reacts to objects passing through it, recording a process that no human eye had ever seen before. Marey legitimized the scientific value of research using

moving images along with Muybridge, but also set the cultural stage for moving images as legitimate forms of expression and representation. Marey wanted to make the flight of birds visible and took many hundreds of pictures per second in order to be able to render a slow-motion version of movement. His work foreshadowed the invention of the cinema. The combination of light, time, and writing is very suggestive. These impulses are about inscription, about the need to transform the world into a variety of creative and information-based forms, to move information from the natural environment into one that is filtered through artifice, which is foundational to notions of art and creativity.

Artifice. So many of the challenges in understanding both traditional media and new media are centered on the building of worlds. Digital media are not seeking a different outcome from a painting or a photograph. In all cases, the goal is to recreate a variety of environments and situate people, actions, and landscapes within the confined frames of images. Marey understood this better than most because he linked writing to image creation. He understood that the process of image creation was about inscription, in his case the inscription of light onto celluloid. His efforts to understand motion are startlingly similar to the early efforts of videogame creators to reproduce walking and running. It has taken the invention and use of sophisticated motion capture studios to replicate what Marey generated using relatively primitive cameras. In Marey's case and among game creators, the challenge was to bring the world into a cabinet, into something where some new characteristics of the human and natural environment could be visualized. Artifice only works if people are ready to accept its limitations and those limitations can only be acknowledged if the imaginative mind and body of viewers are activated.

The preservation of a moment in time was an essential part of the photographic image in the nineteenth century. The goal was to heighten the powers of the visible, but what may have been lost was an understanding of the relationship between the visible and invisible. Visibility is also about bringing the inanimate to life. The earliest fully animated film appeared in 1906 and reinforced the notion that the transformation of stillness into movement through the use of frames was at the heart of the cinema. I think it would be fair to say that even in the age of the digital camera (in which the "pictures" taken are really video images) photographs are pivotal markers and tropes for every form of image production because of this powerful ability to reanimate the world. Animation proves that the sum total of a series of frames enables

projected images to be created and shown. For most of the twentieth century, animation was very much about the magical transformation of frames into projections.

Some recent research in the computer sciences centers on how to develop software that will show fluids that have been animated in as realistic a way as possible. Marey would have been very excited about this. Simulations of this sort transform computer graphics into an exacting science of the visible for the purposes of cultural creation that is not dissimilar to experiments in the nineteenth century.[5]

Notwithstanding the depth of the drive for realism, photographic images were never seen as "complete." There was the sense that something was missing. A realist painting seemed more capable of capturing the truth of a scene or environment because of the intensity and breadth of the observations required to reproduce the world with fidelity. Photographs were moments in time, parts of a whole and realistic, but only up to a point. The framed photograph fragmented the world.

In this context, the arrival of the cinema seemed like a needed cultural step because the apparatus not only captured scenes that looked very real, but also made it appear as if anything could be moved from its place in the world *onto* the screen. It was therefore natural to assume that photographic images had been liberated from the constraints of stillness. The linking of the frozen frame and the moving photograph to the cinema connected it to the history of other media, but also paradoxically constrained if not restricted analyses of the specificity of the cinema itself (a challenge that was only taken up by film theory in the 1970s).

Gilles Deleuze, writing in the 1980s, tried to weave the issues of time and movement in the cinema into a cohesive theory. To some degree he succeeded in developing a rich discourse about images. Deleuze (1986) discusses how moving pictures turn into something that he calls an intermediate image. In previous work of mine, I have described this as a middle zone between the materiality of the frame and the imaginary work of spectators. Moving images create an environment that encourages the wonderful and ironic fantasy that the content and form on the screen is responsible for the viewer's experience. Rather, it is the combination of content, form, screen, and spectator that together makes interaction possible, desirable, and often inevitable. Deleuze's intermediate zone is the ground within which the viewer takes control of the experience. It is the viewer who transforms stillness into movement. Moving

pictures are an illusion, but one that viewers everywhere want to share of irrespective of culture or background. I would strongly suggest that projection, the desire to be inside images, is a process within this intermediate zone and that interactivity is only possible if spectators, users, or players *feel* that they can take images into themselves and manipulate their properties.

Italo Calvino said: "fantasy is a place where it rains" (Calvino 1988, 81). Calvino was referring to a phrase from Dante in which he is "meditating on images that form directly in the mind" (ibid.), and his belief that the source of the images is God. It is this conjuncture of time, inscription, fantasy, and images that forms the basis for my discussion of projection in the next section of this essay. Suffice to say that the combination of imaging of the passing of time, both through the use of light and the more immaterial world of fantasy and the imagination, is at the heart of nearly any activity within visual and so-called interactive media.

Projection

I have been discussing the early cinema and nineteenth-century photography with the aim of demonstrating how so many of the debates about the legitimacy and value of those media in that period mirror the analyses and arguments about the direction of videogames and digital technologies in the late twentieth and early twenty-first centuries. I also ended the previous section with a focus on the communal desire of viewers to transform the illusion of movement in the cinema into a pleasurable experience through projection and the imagination. This desire did not appear out of the blue, but as I have suggested was learned over a long period of time. Although videogames only arrived in the 1970s as an invention and as a mass medium in the 1990s, the *links* between photography and the evolution of film into television, and the transformation of computers from research instruments into game-playing environments are, in my opinion, very strong.

One of the impulses at the heart of this evolution is the desire to be *inside* images and screens, that is, to share the stories and events from within the space and time of the medium. Telepresence, immersion, and the exponential growth of videogames reflect an increasingly strong cultural desire for fully embodied experiences with screen-based media. In other words, it is not and never has been enough to just look at screens or even photographs from a distance.[6] Imaginary projection has always been one of the ways of identifying

with screen-based experiences. If there is anything new about new media, it is that what Daguerre imagined for the diorama and what many nineteenth- and twentieth-century artists hoped for in the theater, music, cinema, and performance is now more easily realized through digital technologies. Everything from stereoscopic glasses to datagloves, sensors, and other tactile equipment, as well as the use of CAVEs, surround sound, multiple screens, and haptic devices, suggests that screens no longer exist as objects but are more of a "site" or an ecology within which humans learn to create, watch, participate, and interact.

The art historian Frank Popper made the following comment in an interview: "For a long time I was satisfied by considering that the basic aesthetic triangle, the artist, the work of art and the spectator, was developing towards one that interrelated the conceptor, the creative process and the active participant" (Nechvatal 2004, 69). I asked Canadian artist Liz Magor to comment on this quote, and she replied:

If he is saying that the basic aesthetic triangle of artist/object/viewer has given way to a new triangle of producer/process/active receiver; a triangle in which the producer and the active receiver eschew the object, replacing it with creative process, and that in their meeting in the creative process they may overlap and perhaps swap roles, then yes, I agree that this is a contemporary condition. And yes, it may have something to do with technology. Contemporary art is increasingly interested in "references" to the point where the object is not presented for formal or aesthetic purposes but as a repository for signifiers and references. The active viewer unpacks the bundle. Often the references are extremely esoteric and require a very informed viewer (e.g. Mike Kelley, Sam Durant, Simon Starling, Jeremy Deller). Of course we are all more potentially "informed" due to the ease with which we can search for a definition or answer on the internet, so the mode of contemporary (gallery) art reflects very closely the mode of the web; both can be seen as an archive of information which is organized according to the interests of specific audiences. This new type of contemporary art does not depend on a "general" audience, but instead seeks a culturally informed, specific audience that doesn't necessarily come from the traditional art world, but overlaps. The audience may be from skate culture or music culture etc. This kind of work has been termed "post-production" by Nicolas Bourriaud because the artists work with material that has already made its way through the system. They "mix" these ready-made references. This formal strategy also reflects the web in the way people can seek and connect with their peers without concern for place or location.[7]

Both Popper and Magor are talking as much about a shift that is defined by the impact of digital technologies as they are about audiences whose expectations are closely linked to greater control and participatory activity.

They are also talking about expressive forms that more fully recognize the role of spectators in unbundling works of art. In videogames this unbundling is always carefully circumscribed by the programming logic of the game engine. As gamers move from level to level in games, the outcome is rarely in doubt. This is liberating because a conclusion is always in sight, but it is also constricting because the core parameters of the games cannot be changed. Projection, the imaginary placement of self within this process, liberates players from these constraints in the same way as an art work that is highly self-referential puts the onus for the discovery of meaning on the viewer. As new media like videogames become more open, they are likely to come close to improvisational theater and music where a variety of elements are put together without a defined outcome as the central goal. This will have an important impact on viewers and players and how both see their roles within digital cultures.

This change in the audience reflects both the rise in importance of networked technologies and the World Wide Web and the fragmentation of the very notion of audiences into smaller and smaller interest groups. A further illustration of the shift in audiences is the way blogs and podcasting have evolved to the point where it would be incorrect to use the term audience since most blogs, for example, have a readership that is often less than twenty, but with the *potential* for more. Podcasting is as much of a hit-or-miss proposition as blogs. Both are narrowcast media forms that have evolved out of variety of experiments in community radio and video over the last thirty years. All of these phenomena intersect around issues related to technology, art, everyday life, and the shifting and unstable media ecology of the early twenty-first century. Conventional notions of audience break apart with unpredictable results because there are so many different ways in which individuals can now establish small communities with shared concerns. The complaint by people like Jean Baudrillard (2001) has been that this volatile ecology transforms reality into a virtual world, upending established distinctions between artifice, artificiality, and nature.

However, even if the virtual becomes the real, it has always been possible for humans to envision that they can project themselves into any context through the use of their imaginations. In fact, virtual reality is a misnomer.

The worlds built by computer programmers have an infrastructure that is almost entirely based on visual and nontactile experiences. "It is true that today's virtual reality provides very limited tactile feedback, almost no proprioceptive feedback (as would be provided by walking on a sandy beach or on rough terrain), rare opportunities to smell, and little mobility. However, it is just getting started" (Kreuger 2002).

Various technologies are merely adding to an existing mental and physical infrastructure for the exploration of imaginary worlds. I don't want this argument to sound overly essentialist, but the ability that viewers, users, and players have to visualize themselves inside a screen suggests that cultural production is always trying to catch up with the evolving complexity of human projection processes and not the reverse. *Projection allows individuals to visualize a variety of different experiences either through fantasy or the use of prostheses. So, the use of a virtual reality helmet to walk through an artificial coral reef depends not only on the technology, but also on the capacity of the user to fill in the gaps between what is there and what cannot be there.* To me, this is not that different from reading novels, which is very much about filling in stories with mental images of places and characters. What is dissimilar is the way the technology enhances the visualization process and accentuates if not legitimizes activities of imaginative reconstruction through body movement.

The evolving media ecology of the twenty-first century is changing the way humans communicate with each other and the manner in which humans interact with art and culture. In the past, for example, it was possible to talk about paintings in terms of what the paintings did or did not represent. Representation linked cultural production to processes of creation and intention. This continues, but the practice of visualization is like a laminate that contains old and new ways of connecting the many different layers that constitute mediatized worlds. Visualization encourages people to *foreground* internal mental activities, to use and trust imaginative strategies that may have little to do with the space or objects being experienced.

A virtual coral reef isn't only about the representation of a reef, since its creation is not entirely dependent on an original. It might be best to think of virtual creations like this as a series of overlays, a living archeology that is layered with a variety of histories, none of which has immediately recognizable points of reference but whose overall effect is to open a space for visualization. Keep in mind that any metaphor makes it possible to make a variety of claims, and that in this case, "virtual" as metaphor encourages some sort of gap with

the real. It might be better to think of visualization as cutting across all of this and making it possible to think of media ecologies as hybrids where reality, imagination, and projection coexist in a continuum.

Let me introduce a distinction here between images and projection in order to further clarify the role that visualization plays in nearly all interactions with cultural creations. The former is what is on the screen and the latter is the relationship that is developed among the many elements that constitute seeing, feeling, hearing, and thinking in relationship to what is on the screen. To say that projection is a relational process means that walking in a virtual world is also about creating it. Projection is the way the human imagination works at externalizing what might otherwise be internal and hidden. New digital technologies give shape and feeling to this activity of externalization. This may well be one aspect of a new kind of interactivity.

I began this essay with some reflections on the fuzziness of terms like interactivity and new media. This lack of clarity is largely the result of the tectonic shift that modern culture is undergoing today. New media and all of the cultural, technological, and social activities that surround it are in a very early phase of development. It is important to link this phase to other periods in the history of technology. It is equally important to situate the changes within specific cultural moments. The dilemmas of defining and elucidating how interactivity works are similar to the challenges of trying to explain simulation and immersion. In the nineteenth century one of the criticisms of photography was that it was too real and therefore robbed people who were photographed of their integrity and their souls. In the same way new media are often described as overwhelming. Digital images seem to have enough power to overcome their inherent artificiality.

The impulse to simulate a variety of worlds is not that different from what early painters did in the caves at Lascaux (Krueger 2002). The desire to reproduce the world in any number of ways has a long and wonderful history. New media creators using algorithms can render the facial characteristics of characters with a realism that approximates pre-Renaissance painting. Even with programs like Maya, which allows faces to be built pixel by pixel and in which the face simply becomes a pattern of information, the ability to do with a computer what has been done for centuries with paint and brush remains limited. I am not trying to suggest that the genuinely revolutionary importance

of computers for digital creation is somehow suspect. Rather, that both the discourse to explain these changes and the creative effort need to realize the output is only now beginning to achieve some results that will take the process far beyond previous forms of cultural production.[8]

At least part of the challenge is to make sense of media ecologies. Whereas traditional media were concerned with mass audiences, new media are both born into and sustain intense differentiation among many audiences of varying sizes. This media ecology is as much about customization as it is about mushing, rearrangement, and transformation. The tools of communication have changed and many of those tools can now be used to create messages and music and outputs that can be distributed by anyone. This is the heart of interactivity, which is more about *navigating* through the landscape of available technologies than it is about pursuing a character in a game. Interaction is about communication processes, which link meanings together in ways that are not predictable. Perhaps part of the strategy to all of this change is to accept the fact that conventional notions of screens, computers, and digital technology in general do not in and of themselves explain why they are so attractive and enticing to people everywhere. The increasing importance of networked cultures, emergent forms of community growth and development, software that is relatively simple to develop and use and hack, has in Steven Johnson's words created a new kind of hybrid, "a fusion of artist, programmer, and complexity-theorist—creating interactive projects that challenge the mind and the thumb at the same time" (Johnson 2001, 177). This hybrid person simultaneously watches television, plays videogames, authors simple patches and mods for those videogames, sends text messages and surfs the Internet. The artificial worlds of cyberspace are imaginary (Holzman 1997), but that has not kept anyone from exploring them. The newness of new media may reside not so much in the medium of expression (as was the case with the advent of photography and film) as in the overall impact of putting creative tools into the hands of so many people. As this essay has tried to show, many of the foundational concepts for a medium like photography carried over into other forms of expression. This continuum of connections, which was so characteristic of modernity, may now be breaking up, and with this shift has come a deeper recognition of how audiences have always transformed and altered the expectations of creators. The ubiquity of digital tools and computers means that the role of imagination and projection as fundamental attributes of any

cultural experience will be in the hands of creators and audiences. This more than anything else may finally broaden and deepen the interactive potential of all audiences and lead to radical changes in the cultural understanding of authorship.

Notes

1. Lev Manovich's influential critique of interactivity in new media is based on the term's broadness and diffuse character. However contradictory it may be, the term interactivity has entered the public imaginary and therefore cannot be dismissed. Manovich (2001) offers no clear alternative.

2. For a wonderful history of controllers and a family tree, see http://www.axess.com/twilight/console/.

3. The use of game engines to make films is a powerful indicator of the convergence of many different media forms. See http://www.machinima.com, a website that describes the evolution of game engines as creative tools for film production:

> Machinima's a new form of filmmaking that uses computer games technology to shoot films in the virtual reality of a game engine. Rather than picking up expensive camera equipment, or spending months painstakingly tweaking even more expensive 3D packages, Machinima creators act out their movies within a computer game. We treat the viewpoint the game gives them as a camera—"Shooting Film in a Virtual Reality," as we've been known to put it in their more slogan-high moments—and record and edit that viewpoint into any film we can imagine. (Http://www.machinima.com/article.php?article=186/).

4. I am indebted to Ian Verchere, game and interactive designer for the phrase "camera signs." "Environment mapping, dynamic lighting, etc. are all digital efforts to reproduce the world realistically, but also tempered by the way in which we view the world through the cinema" (personal communication, 2005).

5. See the doctoral thesis of William Franklin Gates at the University of British Columbia, entitled "Animation of Reactive Fluids" and available at http://www.cs.ubc.ca/~gates/phd.html/.

6. Fan culture is another way of overcoming that distance through the building of communities of interest. Screens cease to be the only sites of importance and exploration (Jenkins 1992).

7. Personal communication (2005). Karen Moss, Director of Exhibitions and Public Programs at the San Francisco Art Institute, was interviewed with Bourriaud while he had an exhibit at SFA and during that exchange she said:

> in your book *Post-Production*, you talk about the sampler, the hacker and the programmer as different mechanisms for assembling the toolbox of history in a new context. Because of the conundrum of not being able to produce anything new, I find it interesting that your proposal for art is post-production, mining previously made work and recontextualizing it. That is what, if anything, could be considered new, the recontextualization of the already-made. (See http://www.stretcher.org/archives/i1_a/2003_02_25_i1_archive.php/, accessed July 12, 2005)

8. I am grateful to Ronny Siebes who works and does research at the Free University of Amsterdam for pointing out that over thirty years of computer use has made it almost natural for people to click on a button on the screen with the assumption that the some information will pop up. "What now perhaps seems to be counter-intuitive can become very intuitive after 10 years because (for example) people are so used to the fact that when one clicks on the "start" button, an overview of tasks appear and therefore intuitively assume that a button on the left bottom on a screen functions to reveal a pop-up list, a menu of possibilities. I believe that people adapt very quickly and when they get used to a structure (which perhaps could have a very bad ergonomic design), they are happy to work with it" (personal communication).

References

Baudrillard, Jean. 2001. *Selected Writings*. Ed. Mark Poster. Stanford, Calif.: Stanford University Press.

Bellour, Raymond. 1979. *L'analyse du film*. Paris: Albatross.

Braun, Marta. 1992. *Picturing Time: The Work of Etienne-Jules Marey*. Chicago: University of Chicago Press.

Burnett, Ron. 1995. *Cultures of Vision: Images, Media, and the Imaginary*. Bloomington: Indiana University Press.

Burnett, Ron. 2004. *How Images Think*. Cambridge, Mass.: MIT Press.

Calvino, Italo. 1988. *Six Memos for the Next Millennium*. Cambridge, Mass.: Harvard University Press.

Deleuze, Gilles. 1986. *Cinema 1: The Movement-Image.* Trans. Hugh Tomlinson and Barbara Habberjam. Minneapolis: University of Minneapolis Press.

Godard, Jean-Luc. 1972. *Godard on Godard.* New York: Viking Press.

Grau, Oliver. 2003. *Virtual Art: From Illusion to Immersion.* Cambridge, Mass.: MIT Press.

Holzman, Steven. 1997. *Digital Mosaics: The Aesthetics of Cyberspace.* New York: Touchstone.

Jenkins, Henry. 1992. *Textual Poachers: Television Fans and Participatory Culture.* New York: Routledge.

Johnson, Steven. 2001. *Emergence: The Connected Lives of Ants, Brains, Cities, and Software.* New York: Scribner.

Krueger, Myron. 2002. Myron Krueger Live. Interview by Jeremy Turner. *Ctheory.* Http://www.ctheory.net/text_file.asp?pick=328/ (last accessed July 29, 2005).

Laing, Ronald. 1970. *Knots.* London: Tavistock Publications.

Metz, Christian. 1974. *Film Language: A Semiotics of the Cinema.* New York: Oxford University Press.

Munsterberg, Hugo. 1916. *The Photoplay: A Psychological Study.* New York: Dover.

Manovich, Lev. 2001. *The Language of New Media.* Cambridge, Mass.: MIT Press.

Nechvatal, Joseph. 2004. Frank Popper and Virtualized Art. *Tema celeste* 101: 48–53. Available at http://www.eyewithwings.net/nechvatal/popper/FrankPopper.html/ (last accessed July 29, 2005).

Rhode, Eric. 1976. *A History of the Cinema from Its Origins to 1970.* London: Alan Lane.

Rouse, Richard. 2001. *Game Design: Theory and Practice.* Plano, Texas: Wordware Publishing.

Salen, Katie, and Eric Zimmerman. 2004. *Rules of Play: Game Design Fundamentals.* Cambridge, Mass.: MIT Press.

Sommerer, Christa, and Laurent Mignonneau. 1999. Art as a Living System: Interactive Computer Artworks. *Leonardo* 32 (3): 165–174.

Stafford, Barbara, and Francis Terpak. 2001. *Devices of Wonder: From the World in a Box to Images on a Screen*. Los Angeles: Getty Trust Publications.

Theodore, Steve. 2004. Beg, Borrow and Steal. *Game Developer* 11 (5): 48–51.

Wilson, Stephen. 2002. *Information Arts: Intersections of Art, Science, and Technology*. Cambridge, Mass.: MIT Press.

Abstraction and Complexity

Lev Manovich

What kind of images are appropriate for the needs of a global informational networked society—the society which in all of its areas needs to represent more data, more layers, more connections than the industrial society preceding it?[1] The complex systems which have become supercomplex;[2] the easy availability of real-time information coming from news feeds, networks of sensors, surveillance cameras—all this puts a new pressure on the kinds of images human culture already developed and ultimately calls for the development of new kinds. This does not necessary means inventing something completely unprecedented—instead it is apparently quite productive to simply give old images new legs, so to speak, by expanding what they can represent and how they can be used. This is, of course, exactly what the computerization of visual culture has been all about since it began in the early 1960s. While it made production and distribution of already existing kinds of images (lens-based recordings, i.e., photographs, film and video, diagrams, architectural plans, etc.) efficient, more importantly the computerization made it possible for these images to function in various novel ways by "adding" interactivity, by turning static images into navigable virtual spaces, by opening images to all kinds of mathematical manipulations that can be encoded in algorithms.

This short essay of course will not be able to adequately address all these transformations. It will focus instead on a particular kind of image, namely, software-driven abstraction. Shall the global information society include abstract images in its arsenal of representational tools? In other words, if we take an abstraction and wire it to software, do we get anything new and useful

beyond what already took place in the first part of the twentieth century—when the new abstract visual language was adopted by graphic design, product design, advertising, and all other communication, propaganda, and consumer fields?[3]

After Effects

Let's begin by thinking about abstraction in relation to its opposite. How did the computerization of visual culture affect the great opposition of the twentieth century between abstraction and figuration? In retrospect, we can see that this opposition was one of the defining dimensions of twentieth-century culture since it was used to support so many other oppositions—between "popular culture" and "modern art," between "democracy" and "totalitarianism," and so on. Disney versus Malevich, Pollock versus socialist realism, MTV versus the Family Channel. Eventually, as the language of abstraction has taken over all of modern graphic design while abstract paintings have migrated from artists' studios to modern art museums as well as corporate offices, logos, hotel rooms, bags, furniture, and so on, the political charge of this opposition has largely dissolved. And yet in the absence of new and more precise categories we still use figuration–abstraction (or realism–abstraction) as the default basic visual and mental filter though which we process all images that surround us.

In thinking about the effects of computerization on abstraction and figuration, it is much easier to address the second term than the first. While "realistic" images of the world are as common today as they were throughout the twentieth century, photography, film, video, drawing, and painting are no longer the only ways to generate them. Since the 1960s, these techniques were joined by a new technique of computer-image synthesis. Over the next decades, 3-D computer images gradually became more and more widespread, gradually coming to occupy a larger part of the whole visual culture landscape. Today, for instance, practically all computer games rely on real-time 3-D computer images—and so do numerous feature films, TV shows, animated features, instructional videos, architectural presentations, medical imaging, military simulators, and so on. And although the production of highly detailed synthetic images is still a time-consuming process, as the role of this technique is gradually expanding, various shortcuts and technologies are being developed to make it easier: from numerous ready-to-use 3-D models available in online libraries to scanners that capture both color and shape

information and software that can automatically reconstruct a 3-D model of an existing space from a few photographs.

Although computerization has "strengthened" the part of the opposition occupied by figurative images by providing new techniques to generate these images—and even more importantly, making possible new types of media that rely on them (3-D computer animation, interactive virtual spaces)—it has simultaneously "blurred" the "figurative" end of the opposition. What do I mean by this? Continuous developments in "old" analog photo and film technologies (new lenses, more sensitive films, etc.) combined with the development of software for digital retouching, image processing, and compositing eventually completely collapsed the distance that previously separated various techniques for constructing representational images: photography, photocollage, and drawing and painting in various media, from oil, acrylic, and airbrush to crayon and pen and ink. Now the techniques specific to all these different media can be easily combined within the metamedium of digital software.[4]

One result of this shift from *separate representational and inscription media* to a *computer metamedium* is a proliferation of *hybrid* images—images that combine traces and effects of a variety of media. Think of a typical magazine spread, a TV advertisement, or a home page of a commercial website: maybe a figure or the face of a person against a white background, some computer elements floating behind or in front, some Photoshop blur, funky Illustrator typography, and so on. (Of course looking at the Bauhaus graphic design we can already find some hybridity as well similar treatment of space combining 2-D and 3-D elements—yet because a designer had to deal with the actual media, the boundaries between the elements of different media were sharply defined.)

This proliferation of hybrid images leads us to another effect—the liberation of the techniques of a particular medium from its material- and tool-specificity. Simulated in software, these techniques can now be freely applied to visual, spatial, or audio data that have nothing to do with the original media.[5] In addition to populating the tool palettes of various software applications, these virtualized techniques came to form a separate type of software—filters. You can apply reverb (a property of sound when it propagates in particular spaces) to any sound wave; apply depth of field effects to a 3-D virtual space; apply blur to type; and so on.

The last example is quite significant in itself: the simulation of media properties and interfaces in software has made possible not only the development of

numerous separate filters but also whole new areas of media culture such as *motion graphics* (animated type that exists on its own or combined with abstract elements, video, etc.). By allowing the designers to move type in 2-D and 3-D space, and filter it in arbitrary ways, the development of After Effects Software has affected the Gutenberg universe of text at least as much if not more than Photoshop affected photography.

The cumulative result of all these developments—3-D computer graphics, compositing, simulation of all media properties and interfaces in software—is that the images that surround us today are usually very beautiful and often highly stylized. The perfect image is no longer something that is merely hoped for or expected in particular areas of consumer culture—instead, it is an entry requirement. To see this difference you only have to compare an arbitrary television program from twenty years ago to one of today. Just as the actors who appear in current TV shows, all images of today have been put through a plastic surgery of Photoshop, After Effects, Flame, or similar software. At the same time, the mixing of different representational styles which until a few decades ago was found only in modern art (think of Moholy-Nagy photograms or Rauschenberg's prints from 1960) has become the norm in all areas of visual culture.

Modernist Reduction

As can be seen even from this brief and highly compressed account, computerization has affected the figurative or "realistic" part of the visual culture spectrum in a variety of significant ways. But what about the opposite part of the spectrum—pure abstraction? Do the elegant algorithmically driven abstract images, which began to populate more and more websites in the late 1990s, have a larger ideological importance? Are they comparable to any of the political positions and conceptual paradigms that surrounded the birth of modern abstract art in the early 1920s? Is there some common theme that can be deduced from the swirling streams, slowly moving dots, dense pixel fields, mutating and flickering vector conglomerations coming from the contemporary masters of Flash, C++, Java, and Processing?

If we compare 2004 with 1914, we will in fact see a similar breadth of abstract styles: a strict northern diet of horizontal and vertical lines in Mondrian, the more flamboyant circular forms of Robert Delaunay working in Paris, the even more emotional fields of Wassily Kandinsky, the orgy of motion vectors

of Italian futurists. The philosophical presuppositions and historical roots that led to the final emergence of "pure" abstraction in the 1910s are similarly multiple and diverse, coming from a variety of philosophical, political, and aesthetic positions: the ideas of synesthesia (the correspondence of sense impressions), symbolism, theosophy, communism (abstraction as the new visual language for the proletariat in Soviet Russia), and so on. And yet it is possible and appropriate to point to a single paradigm that both differentiates modernist abstraction from realist painting of the nineteenth century and simultaneously connects it to modern science. This paradigm is *reduction*.

In the context of art, the abstraction of Mondrian, Kandinsky, Delaunay, Kupka, Malevich, Arp, and others represents the logical conclusion of a gradual development of the preceding decades. From Manet, impressionism, post-impressionism, symbolism to fauvism and cubism, the artists progressively streamline and abstract the images of visible reality until all recognizable traces of the world of appearances are taken out. This reduction of visual experience in modern art was a very gradual process that began in the early nineteenth century,[6] but in the beginning of the twentieth century we often see the whole development replayed from the beginning to the end within a single decade—such as in Mondrian's paintings of a tree from between 1908 and 1914. Mondrian starts with a detailed, realistic image of a tree. By the time he has finished his remarkable compression, only the essence, the idea, the law, the genotype of a tree is left.[7]

This visual reduction that took place in modern art between approximately 1860 and 1920 perfectly parallels the dominant scientific paradigm of the nineteenth and early twentieth centuries.[8] Physics, chemistry, experimental psychology, and other sciences were engaged in the deconstruction of the inanimate, biological, and psychological realms into simple, further indivisible elements, governed by simple and universal laws. Chemistry and physics postulated the levels of molecules and atoms; later on, physics broke atoms down further into elemental particles. Biology saw the emergence of the concepts of cell and chromosome. Experimental psychology applied the same reductive logic to the human mind by postulating the existence of further indivisible sensorial elements, the combination of which would account for perceptual and mental experience. For instance, in 1896 E. B. Titchener (former student of Wundt, who brought experimental psychology to the U.S.) proposed that there are 32,800 visual sensations and 11,600 auditory sensory elements, each just slightly distinct from the rest. Titchener summarized his

research program as follows: "Give me my elements, and let me bring them together under the psychophysical conditions of mentality at large, and I will guarantee to show you the adult mind, as a *structure*, with no omissions and no superfluity."[9]

It can be easily seen that the gradual move toward pure abstraction in art during the same period follows exactly the same logic. Similarly to physicists, chemists, biologists, and psychologists, the visual artists have focused on the most basic pictorial elements—pure colors, straight lines, and simple geometric shapes. For instance, Kandinsky in *Point and Line to Plane* advocated a "microscopic" analysis of three basic elements of form (point, line, and plane) claiming that there are reliable emotional responses to simple visual configurations.[10] Equally telling of Kandinsky's program are the titles of the articles he published in 1919: "Small Articles about Big Questions. I. About Point," and "II. About Line."[11]

While the simultaneous deconstruction of visual art into its most basic elements and their simple combinations by a variety of artists in a number of countries during the first two decades of the twentieth century echoes the similar developments in contemporary science, in some cases the connection was much more direct. Some of the key artists who were involved in the birth of abstraction were closely following the research into the elements of visual experience conducted by experimental psychologists. As experimental psychologists split visual experience into separate aspects (color, form, depth, motion) and subjected these aspects to a systematic investigation, their articles begin to feature simple forms such as squares, circles, and straight lines of different orientations, often in primary colors. Many of the abstract paintings of Mondrian, Klee, Kandinsky, and others look remarkably similar to the visual stimuli already widely used by psychologists in the previous decades. Since we have documentation that at least in some cases the artists were following the psychological research, it is not unlikely that they directly copied (consciously or unconsciously) the shapes and compositions of the psychology literature. Thus abstraction was in fact born in psychological laboratories before it ever reached the gallery walls.

Complexity

The reductionist method appears to rule the science of the twentieth and early twenty-first centuries and artistic evolution in the same period. But while

Malevich, Mondrian, and others were pushing reduction in art to its logical conclusion during the 1910s and 1920s, different paradigms which are not based on reduction already appeared in the sciences during this time. Freudian psychology is no longer trying to understand the mind in terms of interaction between simple elements. Similarly, instead of simple laws that govern the world in Newtonian physics, quantum mechanics deals with probabilities and accepts the Heisenberg uncertainty principle. Other examples of non-reductionist thinking in sciences in the decades that follow include work by John von Neumann on cellular automata in the late 1940s and 1950s, and the work of Lewis Fry Richardson on what is now known as fractals in the same period.

Beginning in the 1960s, scientists in fields other than physics gradually realize that the classical scientific approach, which aims to explain the world through simple universally applicable rules (such as the three laws of Newtonian physics), cannot account for a variety of physical and biological phenomena. Toward the end of this decade, artificial intelligence research which was trying to reduce the human mind to symbols and rules, also ran into difficulties. At this time, a new paradigm begins to emerge across a number of scientific and technical fields, eventually reaching popular culture as well. It includes a number of distinct areas, approaches, and subjects: chaos theory, complex systems, self-organization, autopoiesis, emergence, artificial life, neural networks, the use of models, and metaphors borrowed from evolutionary biology (genetic algorithms, "memes"). While distinct from each other, most of these fields share certain basic assumptions. They all look at complex dynamic and nonlinear systems and they model the development and/or behavior of these systems as the interaction of a collection of simple elements. This interaction typically leads to emergent properties—*a priori* unpredictable global behavior. In other words, the order that can be observed in such systems emerges spontaneously; it cannot be deduced from the properties of elements that make up the system. Here are the same ideas expressed in somewhat different terms: "orderly ensemble properties can and do arise in the absence of blueprints, plans, or discrete organizers; interesting wholes can arise simply from interacting parts; enumeration of parts cannot account for wholes; change does not necessarily indicate the existence of an outside agent or force; interesting wholes can arise from chaos or randomness."[12]

According to the scientists working on complexity, the new paradigm is as important as the classical physics of Newton, Laplace, and Descartes, with

their assumption of a "clockwork universe." But the significance of the new approach is not limited to its potential to describe and explain the phenomena of the natural world that were ignored by classical science. Just as classical physics and mathematics fitted perfectly the notion of a highly rational and orderly universe controlled by God, the sciences of complexity seem to be appropriate in a world that on all levels—political, social, economic, technical—appears to us to be more interconnected, more dynamic, and more complex than ever before. So, in the end, it does not matter if frequent invocations of the ideas of complexity in relation to just about any contemporary phenomenon—from financial markets to social movements—are appropriate or not.[13] What is important is that having realized the limits of linear top-down models and reductionism, we are prepared to embrace a very different approach, one that looks at complexity not as a nuisance which needs to be quickly reduced to simple elements and rules, but instead as the source of life—something that is essential for the healthy existence and evolution of natural, biological, and social systems.

Let us now return to the subject this essay is about—contemporary software abstraction and its role in a global information society. I am now finally ready to name the larger paradigm I see behind the visual diversity of this practice—from stylish animations and backgrounds that populate commercial websites to the online and offline works that are explicitly presented by their creators as art. This paradigm is complexity. If modernist art followed modern science in reducing the media of art—as well as our sensorial experiences and ontological and epistemological models of reality—to basic elements and simple structures, contemporary software abstraction instead recognizes the essential complexity of the world. It is therefore not accidental that time-based software artworks often develop in a way that is directly opposite to the reduction that took place over the years in Mondrian's paintings—from a detailed figurative image of a tree to a composition consisting of just a few abstract elements. Today we are more likely to encounter the opposite: animated or interactive works that begin with an empty screen or a few minimal elements that quickly evolve into a complex and constantly changing image. And while the style of these works is often fairly minimal—vector graphics and pixel patterns rather than an orgy of abstract expressionism (see my "Generation Flash" for a discussion of this visual minimalism as a new modernism[14])— the images formed by these lines are typically the opposite of the geometric essentialism of Mondrian, Malevich, and other pioneers of modern abstraction.

The patterns of lines suggest an inherent complexity to the world that is not reducible to some geometric phenotype. The lines curve and form unexpected arabesques rather than traversing the screen in strict horizontals and verticals. The screen as a whole becomes a constantly changing field rather than a static composition.

When I discussed modernist abstraction, I pointed out that its relationship to modern science was twofold. In general, the reductionist trajectory of modern art that eventually led to a pure geometric abstraction in the 1910s parallels the reductionist approach of contemporary sciences. At the same time, some of the artists actually followed the reductionist research in experimental psychology, adopting the simple visual stimuli used by psychologists in their experiments for their paintings.

Since designers and artists who pursue software abstraction are our contemporaries and we share the same knowledge and references, it is easy for us to see the strategy of direct borrowing at work. Indeed, many designers and artists use the actual algorithms from scientific publications on chaos, artificial life, cellular automata, and related subjects. Similarly, the iconography of their works often closely followed the images and animations created by scientists. And some people manage to operate simultaneously in the scientific and cultural universes, using the same algorithms and same images in their scientific publications and art exhibitions. One example is Karl Sims who, in the early 1990s, created impressive animations based on artificial life research that was shown at Centre Pompidou in Paris which he also described in a number of technical papers. What is less obvious is that in addition to the extensive cases of direct borrowing, the aesthetics of complexity is also present in the works that do not directly use any models from complexity research. In short, just as was the case with modernist abstraction, the abstraction of the information era is connected to contemporary scientific research both directly and indirectly—through a direct transfer of ideas and techniques, and indirectly as part of the same historically specific imagination.

Here are some examples, all drawn from an online section of the Abstraction Now exhibition. This unique exhibition presented in Vienna in 2003 included an approximately equal number of software-driven and more "traditional" abstraction works.[15] Thus it created an environment for thinking about software-driven abstraction within the larger context of modern and contemporary art. I decided to test my hypothesis by systematically visiting every online work in the exhibition in the order in which they were presented

Figure 16.1 Golan Levin, *Yellowtail*, 2002. See plate 12.

on the website, rather than selecting only a few works that would fit my pre-conceived ideas. I have also looked at all the accompanying statements—none of which as far I can see explicitly evokes the sciences of complexity. My experiment worked even better than I expected since almost all pieces in the online component of the show follow the aesthetics of complexity, invoking complex systems in the natural world more often and more literally than I had anticipated.

Golan Levin's *Yellowtail* software amplifies the gestures of the user, producing ever-changing, organic-looking lines of constantly varying thickness and transparency (see fig. 16.1). The complexity of the lines and their dynamic behavior make the animation look like a real-time snapshot of some biologically possible universe. The work perfectly illustrates how the same element (i.e., a line) that in modernist abstraction represented the abstract structure of the world now evokes instead the world's richness and complexity. (Similar effects are at work in the piece by Manny Tan.) In other words, if modernist abstraction assumes that behind the sensorial richness of the world there are simple abstract structures that generate this richness, such a separation of levels is absent from software abstractions. Instead, we see a dynamic interaction of elements that periodically leads to certain orderly configurations.

Insertsilence by James Paterson and Amit Pitaru starts with the few tiny lines moving inside a large circle; a click by the user immediately increases the

complexity of the already animated line cob, making the lines multiply, break, mutate, and oscillate until they "cool down" to form a complex pattern which sometimes contains figurative references. While the artists' statement makes no allusion to the complexity sciences, the animation in fact is a perfect illustration of the concept of emergent properties.

As I have already noted, software artworks often deploy vector graphics to create distinctly biological-looking patterns. However, a much more modernist-looking rectangular composition made from monochrome color blocks can also be reworked to function as an analogue to the complex systems studied by scientists. The pieces by Peter Luining, Return, and James Tindall evoke typical compositions created by students at Bauhaus and Vhkutemas (the Russian equivalent of Bauhaus). But again, with a single click by the user the compositions immediately come to life, turning into dynamic systems whose behavior no longer evokes the ideas of order and simplicity. As in many other software pieces that subscribe to the aesthetics of complexity, the behavior of the system is neither linear nor random—instead it seems to change from state to state, oscillating between order and chaos—again, exactly like the complex systems found in natural world.

While some of the software pieces in the Abstraction Now exhibition adopt the combinatorial aesthetics common to both early modernist abstraction and 1960s minimalism (in particular, the works by Sol LeWitt), this similarity only makes more apparent a very different logic at work today. For instance, instead of systematically displaying all possible variations of a small vocabulary of elements, *Arp* code by Julian Saunderson from Soda Creative Ltd. constantly shifts the composition without ever arriving at any stable configuration (fig. 16.2). The animation suggests that the modernist concept of "good form" no longer applies. Instead of right and wrong forms (think for instance of the war between Mondrian and Theo van Doesburg), we are in the presence of a dynamic process of organization that continuously generates different forms, all equally valid.

If the works described so far were able to reference complexity mainly through the dynamic behavior of rather minimal line patterns, the next group of works uses algorithmic processes to generate dense and intricate fields which often cover the whole screen. Works by Glen Murphy, Casey Reas, Dexto, Meta, and Ed Burton (also from Soda) all fit into this category. But just as with the works described so far, these fields are never static, symmetrical, or simple—instead they constantly mutate, shift, and evolve.

Figure 16.2 Julian Saunderson, *Arp*, 1990.

I could go on multiplying examples but the pattern should be quite clear by now. The aesthetics of complexity which dominates the online works selected for the Abstraction Now show is not unique to them; a quick scan through works regularly included in other exhibitions such as (whitneybiennial.com, curated by Miltos Manetas), Ars Electronica, or Flash Forward demonstrates that this aesthetics is as central for contemporary software abstraction as reductionism was for early modernist abstraction.

I have chosen this particular exhibition for my analysis because the software works it presented can be thought of as the direct equivalent of modernist abstract practice. They are neither functional nor do they claim to represent anything external to them. However, other explicitly functional areas of contemporary digital art and design—such as information visualization or Flash interfaces—often use the same visual strategies. So while my examples come from the area of "pure abstraction," the paradigm of graphical complexity also operates in the realm of design. This is similar to the way in which modernist visual abstraction was developed and employed. The abstract impulse was simultaneously pushed further and further in the nineteenth and early twentieth centuries in both art and design. And when pure abstraction was achieved in the 1910s and early 1920s, different artistic movements such as suprematism and De Stijl immediately applied it across many areas—from paintings and graphics to two-dimensional and three-dimensional design and architecture.

The space limitations of this essay do not allow me to go into the important question of what is happening today in abstract painting (which is a very

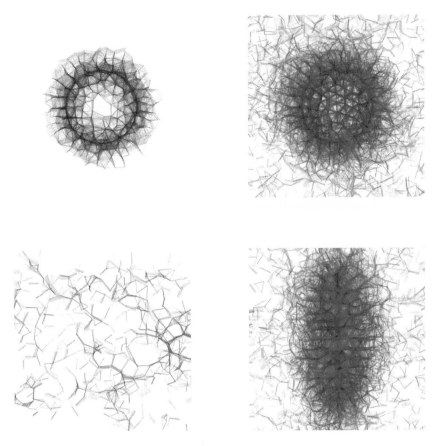

Figure 16.3 Casey Reas, *Articulate*, 2003. See plate 13.

active scene in itself) and how its developments connect (or not) to the developments in software art and design as well as to contemporary scientific paradigms. Instead, let me conclude by returning to the question I posed in the beginning: what sorts of representations are adequate for the needs of a global information society, characterized by new levels of complexity (in this case understood in descriptive rather than in theoretical terms)? As I have suggested, practically all of the developments in computer imaging so far can be understood as responses to this need. But this still leaves open the question of how to represent the new social complexity symbolically. While software abstraction usually makes more direct references to the physical and biological than the social, it may also be appropriate to think of many works in this paradigm

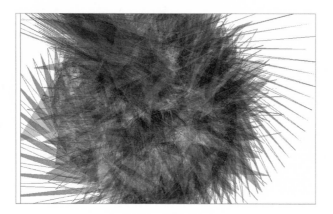

Figure 16.4 Meta, *Graf*, 2002.

Figure 16.5 Lia, *Withouttitle*, 2003.

as such symbolic representations. For they seem to quite accurately and at the same time poetically capture our new image of the world—as the dynamic networks of relations, oscillating between order and disorder—always vulnerable, ready to change with a single click of the user.

Notes

1. I rely here on the influential analysis of Manuel Castells who characterizes the new economy that emerged at the end of the twentieth century as informational, gobal and networked. See Manuel Castells, *The Rise of the Network Society*, vol. 1: *The Information Age*, 2nd ed. (Malden, Mass.: Blackwell, 2000), 77.

2. Lars Qvortrup, *Hypercomplex Society* (New York: Peter Lang Publishing, 2003).

3. I am grateful to Christiane Paul who carefuly reviewed this essay and offered a number of valuable suggestions.

4. The notion of computer as metamedium was clearly artciculated by the person who, more than anybody else, was responsible for making it a reality by directing the development of GUI at Xeroc Parc in the 1970s—Alan Kay. See Alan Kay and Adele Golberg, "Personal Dynamic Media" (1997), in *The New Media Reader*, ed. Noah Wardrip-Fruin and Nick Monfort (Cambridge, Mass.: MIT Press, 2003), 394.

5. In *The Language of New Media* I describe this effect in relation to the cinematic interface, i.e., the camera model, which in computer culture has become a general interface to any data that can be represented in 3-D virtual space. But this is just a particular case of a more general phenomenon: the simulation of any media in software allows for the "virtualization" of its interface. Lev Manovich, *The Language of New Media* (Cambridge, Mass: MIT Press, 2001).

6. Consider, for instance, the exhibition "The Origins of Abstraction," Musee d'Orsay, Paris, November 5, 2003, to February 23, 2004. See Norbert Pfaffenbichler and Sandro Droschl, eds., *Abstraction Now* (Vienna: Camera Austria, 2004).

7. I am again grateful to Christiane Paul, who pointed out to me that the reduction applies to modernist abstraction before World War II. From the 1940s, we see a different aesthetics at work as well, which Paul characterizes as "expansive" and "excessive" (de Kooning, Pollock, Matta, and others).

8. For a detailed reading of modern art as the history of a reduction that parallels the reductionism of modern science and in particular experimental psychology, see the little-known but remakable book *Modern Art and Modern Science*. This section is based on the ideas and the evidence presented in this book. Paul Vitz and Arnold Glimcher, *Modern Art and Modern Science: The Parallel Analysis of Vision* (New York: Praeger Publishers, 1984).

9. Quoted in Eliot Hearst, "One Hundred Years: Themes and Perspectives," in *The First Century of Experimental Psychology*, ed. Eliot Hearst (Hillsdale, N.J.: Erlbaum), 25.

10. Wassily Kandinsky, *Point and Line to Plane* (1926) (New York: Solomon R. Guggenheim Foundation, 1947).

11. Yu. A. Molok, "'Slovar simvolov' Pavla Florenskogo. Nekotorye margonalii." (Pavel Florensky's "dictionary of symbols." A few margins.) *Sovetskoe Iskusstvoznanie* 26 (1990), 328.

12. See http://serendip.brynmawr.edu/complexity/complexity.html/.

13. For examples of works that apply the ideas of complexity to a range of fields, see Manuel de Landa, *A Thousand Years of Nonlinear History* (New York: Zone Books, 1997); Howard Rheingold, *Smart Mobs: The Next Social Revolution* (Cambridge, Mass.: Perseus Publishing, 2002); Steven Johnson, *Emergence: The Connected Lives of Ants, Brains, Cities, and Software* (New York: Scribner, 2001).

14. Available at http://www.manovich.net/.

15. Abstraction Now, curated by Norbert Pfaffenbichler and Sandro Droschl, Kunstlerhaus, Vienna, 2003.

Making Studies in New Media Critical

Timothy Lenoir

Science studies researchers have recently been challenged to participate in the large-scale and heavily funded efforts by U.S., Canadian, and European governments to develop nanoscience and nanotechnology applications. The federal funding of nanotechnology in the United States alone is over \$3 billion, and with predictions by the National Science Foundation (NSF) and other agencies that the global marketplace for goods and services using nanotechnologies will grow to \$1 trillion by 2015, industry participation is growing daily. Indeed, more than five hundred commercial products are already being sold that claim they are engineered with nanoscale materials.

Our role as science studies researchers in these projects is to address issues related to the societal, economic, and ethical implications of the nanoscience technologies resulting from government-funded efforts. Two recent studies by Michael Cobb and Jane Macoubrie funded by the NSF and a further study by Macoubrie recently released by the Woodrow Wilson International Center in Washington as part of its Project on Emerging Nanotechnologies provide solid supporting data for the rationale behind including a societal and ethical implications component in all current U.S. nanotechnology projects.[1] Their studies used experimental issue groups with a sample of 1,250 citizens in three different U.S. cities. Participants took a pre-study survey followed by sessions where they were provided with background materials on nanotechnology and scenarios depicting possible developments projected for nanotech. The surveys collected data on citizen awareness and perceptions of nanotechnology, including their trust in government to manage risks, and expectations of the benefits

versus risks of nanotechnology. The survey data showed that most people participating in the study had little initial awareness of nanotechnology. Answering the pre-study questionnaire, 54 percent professed to know almost nothing, 17 percent felt they knew something about nanotechnology, and 26 percent said they knew a little. Asked if nanotechnology is predicted to become another industrial revolution (true), 75 percent said "don't know," and 24 percent answered "true." If they did have any prior knowledge most respondents had either heard about it from public television, from a friend, or from science fiction and films.

In the post-study survey, the highest interest was in medical applications, particularly to target disease without invasive surgery, collateral damage, or side effects. However, in two regions of the country (west coast and midwest), these applications also evoked the lowest trust in government to manage the risks. Although there was little support (about 8 percent after the study) for banning research on nanotechnology, the public was not at all certain that benefits would exceed risks. In fact, after participating in the study about 15 percent believed risks would exceed benefits, while 38 percent expected risks and benefits to be about equal; 40 percent believed benefits would exceed risks. The public did not seem to be fearful of nanotechnology itself, but rather was highly aware of past failures to gauge and manage risks found to be associated with other new technological "breakthroughs" from which significant downsides later emerged. An overwhelming 95 percent of the participants in the experimental issue groups expressed little or no trust in government and no trust (also 95 percent) in industry to manage risks associated with nanotechnology. The similarity of these results is striking. Moreover, higher education (college degree or higher) was related to lower trust in government to manage risks. No other demographic variable showed any significant link. Among the preferred ways the experimental groups believed the government and industry could increase public trust, 34 percent (government) and 28 percent (industry) thought better safety testing was advisable, while 25 percent (government) and 28 percent (industry) thought that more information about these products should be disseminated so that people could choose.

The government agencies involved in promoting nanotechnology science and technology in the United States and Europe have taken these public perceptions seriously, and they have realized that attempts to communicate their scientific and technological visions to the public will be unsuccessful unless

the cultural attitudes and preconceptions of the public are fully engaged at the outset. Both in the United States and Europe a major concern has been to prevent a negative climate from enveloping nanotechnology. In Europe experiences with genetically modified crops have led governments to be more engaged with educational efforts and at ways of involving the public more in the decision process. At the same time, citizens' groups and nongovernmental organizations have become more concerned about potential hazards and disadvantages of emerging technologies to their own interests, and they have welcomed the opportunity to address these problems upstream while the science is in the making.[2]

With these issues in mind science studies researchers have been called to the table to address the societal and ethical implications of emerging nanotechnology in the several nanotech projects around the United States. My own role in this effort has been devoted to issues related to bionanotechnology, nanomanufacturing, and nanomedicine. My projects have been motivated by the belief *first*, that ethical, societal, and legal considerations are more likely to be relevant if they are not undertaken in reaction to research or its applications after the fact. It is important for researchers and the public to consider ethical and societal questions proactively, before the research is *fait accompli*. The projects I am engaged with aim to integrate concerns about societal, ethical, and legal issues into, rather than in conflict with, nanobiotechnological research and applications in their earliest design phase. *Second*, proactive analysis of ethical and social issues arising from work that has not yet been made public or not even yet conducted requires face-to-face dialogue that includes nano researchers, scholars in societal and ethical issues (SEI), and others, including persons outside the academy. The relation between SEI and nano research cannot be a one-way conversation among SEI scholars; an effective consideration of ethical and societal issues requires collaboration with nanoscientists and engineers. Inclusion of nano researchers in discussions about ethical and social issues will enhance both the analysis of these issues and the conduct of nanobiotechnological research by fostering realistic and timely policy discussions and guidance.

The goals outlined above call essentially for democratic forms of knowledge production. Accomplishing them can best be achieved with the aid of social media. A *third* motivation in the work discussed here—the motivation in fact behind this essay's title—is to use new media for purposes of documentation and critical debate suitable to the creation of socially responsible scientific

knowledge. Several exciting modalities of new media, including weblogs, wikis, social network software, streamed media content using RSS (rich site summary or really simple syndication) feeds for delivering podcasts, massive search engines such as Google Scholar, and tools for dynamic mapping and data visualization offer capabilities for empowering massively participatory peer-generated content. Wikipedia and OhmyNews are just two of the better-known successful examples of massively collaborative peer production networks deploying new media tools to draw on all layers of available expertise from the grass roots lay person to the highly specialized expert in the production of content. Such tools leverage collective "swarm" intelligence that Howard Rheingold has characterized as "Smart Mobs" and Michael Hardt and Antonio Negri have advocated as the hope for democracy on a global scale.[3]

Infrastructure and resource building As the studies by Cobb and Macourbie make evident, one of the top priorities is educating both the public and policymakers about nanotechnology. The ability to address the larger societal and ethical implications of bionanotechnology and manufacturing will require building resources to enable scholars from the social sciences and humanities as well as the broader public to understand what nanotechnology is and where it is coming from, developments in science and engineering that have taken place at a breathtaking rate in less than two decades. Current work in nanotechnology is based on a convergent synergistic combination of four major domains of science and technology (NBIC), each of which is currently progressing rapidly: (a) nanoscience and nanotechnology; (b) biotechnology and biomedicine, including genetic engineering; (c) information technology, including advanced computing and communications; and (d) cognitive science, including cognitive neuroscience. This convergence of diverse technologies is based on material unity at the nanoscale and on technology integration "from the bottom up." To provide background and context for addressing the societal and ethical implications of current efforts in bionanotechnology, the historians of science forming part of the Center for Nanotechnology in Society at the University of California, Santa Barbara[4] (namely, Patrick McCray, Cyrus Mody, Tim Lenoir, plus others as our project grows) are researching the very recent history of the key technologies and scientific developments that are enabling NBIC convergence. Building on our combined previous work in the histories of bioinformatics, PCR, sequencing tech-

nology for genomics, fluorescent activated cell sorting, and combinatorial chemistry, we are researching topics such as the development of MEMS (micro-electro-mechanical systems) technology from the late 1980s up through the development of the first "laboratory on a chip system" in 1997, just part of the dazzling explosion in the development of all sorts of microanalyzers, from microchips, bioelectric chips, and gene chips, to microarray technologies, technologies of microfluidics, and related systems that have set the stage for bionanofabrication.

Our project will also concentrate on emergent technologies related to spintronics research, one of the major research areas of the UC Santa Barbara NanoSystems Institute.[5] Relevant publications, technical documents, lectures and conference reports, videos, interview transcripts, and so on related to the recent history of bionanotechnology and bionanofabrication will form one key component of our digital archive, accessible via our website. Appropriate links will also be established between the electronic archive and the NanoBank being constructed at the California NanoSystems Institute with facilities at UC Santa Barbara, UCLA, and within the past few months at the National Bureau of Economic Research (NBER) in Cambridge, Massachusetts. (NanoBank will be an integrated database and Web-deployed digital library containing currently disparate datasets, such as articles, patents, firm financial reports and directory listings, and university data.) In addition to the recent historical origins of nanomanufacturing, we will also explore and document the recent development of work on DNA engineering, such as the use of self-assembly of DNA nanostructures for biomolecular computing and nanofabrication.

Integrating societal and ethical concerns into nanoresearch While scientists frequently lead the way in calling attention to the potential benefits and risks of their work, it is difficult to impose on them the requirement that they imagine the policy context that might affect how their research is done or applied in addition to foreseeing their work's full range of societal consequences, intended or otherwise. In areas of convergent science and technology such as bionanomanufacturing where the work is highly interdisciplinary, being attentive to all the possibly relevant perspectives is difficult if not impossible. Our goal is to assist nanoscientists and engineers in identifying and addressing potential societal and ethical implications of their work by bringing them together with groups of knowledgeable partners from the fields of ethics, research policy, law, intellectual property, and environmental studies

who might help formulate and manage potential ethical and social impact issues arising from their work in nanotech. We envision several interrelated project components to facilitate our goals of (1) assisting the nanoscientists we work with in proactively identifying and addressing potential ethical issues in their work and its broader societal impact, and (2) making the public aware of these issues and involving them as deeply as possible in the dialogue.

One approach to such dialogues is the NanoJury being attempted in Great Britain. The NanoJury UK brings together twenty randomly chosen people from different backgrounds to hear evidence about a wide range of possible futures, and the role that nanotechnologies might play in them. The experiment began this past year. Over a period of five weeks, the jurors heard from a variety of witnesses with widely varying perspectives, which they will draw on in coming up with a set of recommendations to be made public at a later date (as of 20 September 2005 the report has not appeared). These will inform debates over how this emerging and potentially revolutionary technology should develop. It is sponsored by the Interdisciplinary Research Collaboration (IRC) in Nanotechnology at the University of Cambridge, Greenpeace UK, the *Guardian*, and the Policy, Ethics and Life Sciences Research Centre at the University of Newcastle.[6]

The aims of NanoJury are similar to those of our own projects:

- to provide a potential vehicle for people's informed views on nanotechnology to have an impact on policy;
- to facilitate a mutually educational dialogue between people with diverse perspectives and interests, including critical and constructive scrutiny of the hopes and aspirations of those working in the nanotech-related sectors by a wider group of citizens; and
- to explore the potential for deliberative processes to broaden discussions about nanotechnology research policy—both in terms of the range of issues and the diversity of people who are given a say.

Our approach to achieving these goals is to couple the face-to-face meetings of the sort used by the NanoJury with web-based new media technology aimed at facilitating wider collaboration, and in some cases virtual "town meetings" around specific topics. New media technologies allow us to couple the face-to-face meetings with a growing body of literature, legal opinions, blogs, and other related Web-based content through the combined use of video annota-

tion, "podcasts" with audio-blogging, and semantic Web technology. Our approach to opening up the black box of the lab has two related components, discussed below.

Our first concern is to get "inside the lab." A critical component of the Nanotechnology Initiative is to enable more direct public participation in the internal workings of new science and technology while it is still in the making—to make publicly funded science visible and accessible. Among the distinctive ways our project attempts to address these imperatives is through a series entitled "Inside the Lab." Inside the Lab will feature monthly interviews with the nanoscientists and engineers we are affiliated with in our project. We use this venue to learn about their work, the motivations they have for doing it, how they approach their projects, and the impact they hope their work will have. The interviews will be conducted by SEI scholars and students working in the field of ethics in engineering and science, and will be made available on our website through a video annotation application that allows viewers to comment on the interviews and pose questions to the scientists and interviewers about their work.

A second, and we think most exciting direction we pursue, is what we call "Benchside Consultation." Analogous to clinical consultations where bioethicists and ethics committees meet at the bedside for real-time discussion, analysis, and resolution of ethical issues in the clinical setting, we are attempting to implement a series of face-to-face dialogues between SEI researchers and nanoresearchers about their work. These sessions would involve one or more researchers in the projects we are attached to with SEI scholars and outside experts, including members of the wider community as appropriate. The consult session we hope will provide a forum in which to identify, discuss, and decide how to act on potential ethical and policy issues that may arise within ongoing or planned research projects but are not addressed by other institutional mechanisms. The entire session would be recorded either as video or audio and made accessible initially to the nano and SEI researchers for annotation, comment, and reaction through a web-based video/audio annotation module developed by our SEI team for the Stanford NIH-CIRGE (Center for Integrating Research on Ethics and Genetics) project and for our iPod courses at Duke. (See fig. 17.1.) A digital library of relevant supporting background documents will be assembled from ethics, law, and policy case studies in the biomedical and engineering fields as guidance for establishing precedence. The outcome of a consultation would be a summary brief with a policy

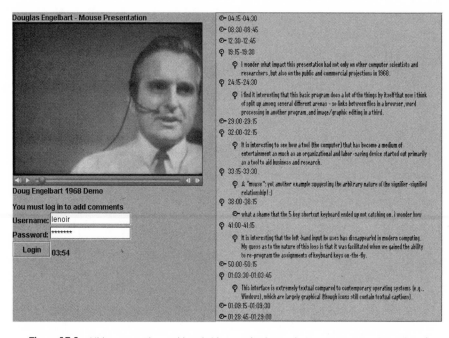

Figure 17.1 Video annotation and benchside consultation tool. An mpeg4 streaming video of an event is hosted in a Wiki. Time-stamped comments, and extended threaded commentary can be attached to specific time-locations in the video. Each commentator is allowed to edit his or her own annotations. As the video scrolls forward existing annotations open automatically, and close automatically after an extended period.

recommendation. These modules can be drawn on for later use and, if they pass screening for issues of confidentiality and nondisclosure, made available to the wider public for viewing and commentary. The most interesting among them will be expanded and shaped into publishable case studies and educational modules in science and engineering ethics courses.

Informed dialogues of the sort we envision for nanotechnology are most profitably conducted with knowledge of the recent history of science and technology as supporting context. Informed discussion will benefit from understanding what nanoscience and nanotechnology are, the origins of the research generating the numerous scientific and technological threads of contemporary developments, profiles of the scientists and engineers doing the work and where they are located, the sorts of interdisciplinary cross fertilizations and collaborations fueling networks of new innovation, and the roles

of industry, state, and the federal government in financing and supporting this work. While most materials would be concentrated on developments of the past decade, a truly useful resource would involve historical materials on developments in biotechnology, genomics, materials science, photonics, and information technology (just to name the most obvious areas) stretching back into the 1980s and 1970s. However, there are several issues to be addressed in building relevant archives and tools to support a knowledge environment of the sort described. In the following section I describe these problems and some of the social media tools we have developed to support knowledge communities.

Documenting the history of contemporary science Historians face new challenges in documenting and researching the history of recent science and technology. A prominent feature of contemporary technoscience is its multi-disciplinary character, the complexity of the organizations that create it, and its close linkage to entrepreneurial activity. Scientific and technical innovation in academic settings can be seen as emerging from a rich symbiosis between regional industrial clusters and federally funded research. Increasingly, part-nerships between academic scientists and industry brokered by government agencies have been important for basic scientific research. Interdepartmental and cross-school collaborations between units in, for instance, medical and engineering schools are important sources of innovation; just as important are the stimuli given to academic research through licensing and consulting arrangements established around university-generated intellectual property.

There are important stakes in understanding the symbiotic-collaborative networks driving academic-industrial-entrepreneurial innovation systems. In order to understand in detail how academic research contributes to economic growth, we need to go beyond the traditional single-researcher framework of historical scholarship to encourage collaborative research among historians of science and technology, sociologists and economists. Moreover, the rapid pace of advance, the number of different disciplines, and the large number of scien-tists engaged in most advances in recent science require a new approach to collecting and documenting the history of technoscience. The small numbers of professional historians are simply incapable of capturing and commenting on the history of recent science. To address this problem we need to engage the scientists themselves in documenting and commenting on their own work. But in addition to these stakes and opportunities special new problems

for historians of recent science and technology are posed by the fact that al-
though almost all of it was actually born digital, it exists in formats that are
difficult to preserve and render with current technology. The materials we
need to write the history of contemporary science are rapidly disappearing
into the "digital dark ages." We need new tools to address these problems of
preservation, access, and collaboration in researching the history of contempo-
rary technoscience.

I will draw on two recently completed projects to illustrate these issues as
well as demonstrate approaches to community and tool-building with infor-
mation technology that can facilitate collaborative research and open up new
avenues for understanding networks of innovation in contemporary techno-
science. The first project was funded by the Alfred P. Sloan Foundation and
the Dibner Foundation, both at MIT, and it was oriented explicitly toward
collecting and documenting the history of recent science and technology using
Web-based technology. The second project was a collaborative history bring-
ing together historians of science and technology with economists at Stanford
University to coauthor a history of Stanford's relationship to Silicon Valley.

History of Bioinformatics: A Field Representative of the Problems in Researching Contemporary Science

The goal of this project was to use Web-based tools to initiate construction
of the documentary base for building the history of a field of contemporary
science, bioinformatics. A second primary objective of the project was to use
Web-based tools to gain the collaboration of the scientists, mathematicians,
and engineers who are building the field of bioinformatics involved in docu-
menting the history of their field. Given the rapidity of scientific advance, the
number of different disciplines and large number of scientists engaged in most
advances in recent science, the relatively few professional historians are simply
incapable of capturing and commenting on the history of recent science with-
out engaging the scientists themselves in documenting their own work. Our
objective has been to use Web-based technology to enlist the scientists who
have been involved in building the discipline of bioinformatics to document
their history.

The field of bioinformatics was selected because of its importance as a major
contributor of research tools to the emerging biomedical domains of genomics
and proteomics. Another reason for selecting bioinformatics is that as a field

it is less than two decades old and still very much in formation as a scientific discipline, with standardized texts and teaching programs only emerging since 1995. Such a field offers a challenge to traditional methods of archiving and historical research. Bioinformatics is a highly multidisciplinary field, which draws on work in mathematics, computer science, molecular biology, and genetics. The tools, techniques, publications, and most of the modes of communication shaping this discipline have been born digital and evolved in conjunction with the development of the World Wide Web. Historians need to acquire new tools and new strategies for coping with these materials.

Historians of science and technology who focus on the period from roughly 1965 to the present are faced with the problem that while much of the material in this period was born digital—and since the late 1980s it all has been "born digital"—it exists in formats that are no longer readable by current machines, and the machines used originally to produce the material have increasingly become obsolete and disappeared. But even when the machines are preserved, for older material saved on data tape, the rapid deterioration of the original material renders it unusable. Historians need to develop new skills for preserving, accessing, and rendering digital materials. Discussion of these issues most frequently focuses on the very important issue of preservation. But it is important not only to have the bits stored for access; even more important for purposes of historical research is to be able to re-render the digital information in the programs the historical actors themselves accessed and used. It is important to see the way the programs worked, the affordances and difficulties they presented, and the levels of interaction among members of the community.

A useful designation for the tools and techniques needed to retrieve these materials from "the digital dark ages" is that of tools of "information archaeology." Historians will need to add new tools of information archaeology to their tool-kit in order to write the history of recent science and technology born digitally. Among the types of tools we need are, for instance, emulators of older systems, such as the IBM 360, and other machines, such as Burrough's machines, Osborn's, and others that do not have legacy systems maintained by large companies or successor firms. Even early-generation Silicon Graphics machines that appeared in the late 1980s and early 1990s are becoming scarce today. In order to research the programs that ran on these machines, we need to construct emulators that run on current generation machines. Beyond this we need to render the original programs in forms

readable by current disk drives and other data-reading technologies. While genealogies of software and software languages are being constructed, more attention will have to be devoted to the history of software languages and their implementations. For future information archaeologists, resources such as Brewster Kahle's Internet Archive or (if possible, due to its proprietary nature) Goggle's Internet archive will be the digital sites analogous to the physical sites explored by cultural anthropologists. One of the reasons for our selection of bioinformatics as an appropriate field of study is the fact that some ex-tremely interesting projects, such as the Stanford DENDRAL and MOLGEN projects, fall within this category of important work potentially lost to the "digital dark ages."

Additional challenges confront the information archaeologist hoping to re-search the digital dark ages. While federal governments have been the major funders of academic research, more than 60 percent of research and develop-ment in American science and technology since the late 1980s has been funded by industry. In addition to this shift in funding sources for science, partnerships between academic science and industry have been important for basic scientific research, particularly in the biomedical sciences, and in emerg-ing new areas such as nanotechnology and material science research. Research of potential historical interest conducted in this zone of academic-industrial collaboration is frequently lost to the historian owing to commercial concerns of protecting proprietary rights and the disinterest among most private firms in archiving their records. Even when modern firms have a policy of archiving their research, it is rarely made available to historians of science and technol-ogy. An additional objective in selecting bioinformatics as the field of study my team and I undertook was to address the challenges of working with a scientific field that has been deeply imbedded in commercial applications. In-deed one of the key contributors to shaping the field in its infancy was a small startup company, IntelliGenetics.

Approaches We adopted several approaches for engaging the community of bioinformatics scientists. We began with the methods familiar to all historians of science and technology who work with paper archives. Our point of departure was oral history interviews with several pioneers of the field, including Douglas Brutlag, Edward Feigenbaum, Joshua Lederberg, Russell Altman, and Peter Friedland. We also identified and collected Milestone documents: We built a large collection of approximately one hundred articles

that were considered important contributions to the field by the bioinformatics community. Our goal in building this collection was not only to document the history of the field but to build a resource the community would use for teaching introductory courses.

We built a large body of digital archival materials related to the DENDRAL, MOLGEN, and earlier projects at Stanford, going back to the original ACME project in the early 1960s constructed by our informants. These materials supplement the set of archival materials Joshua Lederberg has made available on his NIH website.

Our archival collection was almost entirely derived by digitizing the paper printouts of research proposals, technical reports, published articles, memos, and correspondence related to DENDRAL, MOLGEN, Genbank, and Bionet that existed on the SUMEX-AIM (Stanford University Medical Experimental computer for Artificial Intelligence in Medicine). The SUMEX-AIM resource was a large online computer environment that pioneered many features, such as hyperdocument linking, online computation, email, and sequence analysis that have come to be the standard operating environment for the bio- and medical informatics communities. The SUMEX-AIM system originally ran on a Digital Equipment Corporation PDP-10 and later a PDP-11 minicomputer, which ran a Tenex operating system. The ideal solution we hoped to accomplish in our project was to restore and mount the entire SUMEX-AIM resource. This would not just allow us to see results and bits and pieces of the various projects spanning more than a decade, but enable us to see and experience the system in operation and study how the various elements of the technical system had evolved, were modified, and had adapted to the community of users. Such an approach would also enable us to see how the work practices of the scientific community we now call bioinformatics were created. We worked with Tom Rindfleisch, who was the project manager for SUMEX-AIM, in remounting the original system. At the conclusion of our project (July 2003) Rindfleisch had yet to be successful in completely porting the system to a new Web environment. He continues to work on this project, however, and we hope to include it in a future update to the site—which we plan to maintain at Stanford. For the moment, however, after substantial effort, the core of the project—the technoscientific system itself—remains buried in the digital dark ages.

In addition to the technical challenges of data and system retrieval that are confronted by the historian of born digital materials, my project revealed other

barriers having to do with institutional culture. A major part of the archive we constructed relates to the archive of IntelliGenetics, the first company in the field of bioinformatics. IntelliGenetics was formed to provide access by commercial firms, such as pharmaceutical companies, to the tools of bioinformatics. The company also managed Genbank, the first online gene and protein database for bioinformatics and early genomics. Including the correspondence, project proposals, and other documents related to Genbank required a Freedom of Information Act (FIMA) request. We were not able to complete this aspect of our project until July 2004, when we received the final set of documents forthcoming from our FIMA request. We also collected, cataloged, archived, and digitized approximately 1,000 documents, including business plans, interviews with company founders, software manuals, correspondence, and internal memos related to company growth of IntelliGenetics, the first company to enter the field of bioinformatics.

We also began by creating a digital and paper archival repository of documents for several major projects, including DENDRAL, MOLGEN, the archives of IntelliGenetics, Bionet (the first online resource for bioinformatics), and Genbank. These documents provide a major resource for future scholarship in the field. Finally, our initial approach included a small collection of articles written by bioinformatics scientists about the history of their field in addition to some recent articles by historians of science that treat aspects of the history of the field.

Engaging the Scientific Community: Interactive Timeline of Key Events in the History of Bioinformatics

In order to engage the community of bioinformatics researchers we decided on building a multidimensional interactive timeline. To support the project, my team engineered novel software that enables a community to enter event descriptions, upload documents, engage in discussion around any event, edit the timeline based on the results of discussion, and draw links between events with commentary. The timeline is obviously not the final word on the history of the field. Rather it is an interface to a growing archive of materials, discussions about important events, and concepts. It is intended as a sounding board for reconstructing the history of the field. Because it is capable of being edited and modified by the community, the timeline, like Wikipedia, increases in accuracy over time. All of these materials are organized in the open-source

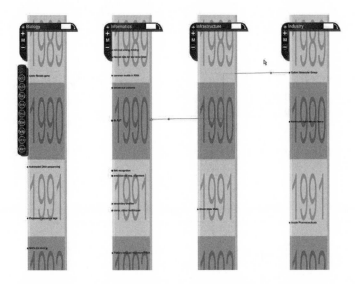

Figure 17.2 Interactive timeline. Users can add categories of events, such as "Biology," "Infrastructure," etc. Within categories events can be added as points on a timeline. Each point contains a pop-up window that provides a short event description and link to a document or other event. Interconnections between events in different categories can be indicated by drawing an arrow between the events, along with a brief description of the significance of the connection being indicated. Events can be "flagged" as important with an indication of the person flagging the event.

MySQL database. Our software has evolved since this early first phase, and we are now using improved versions (discussed below) to support work on integrating ethics and genetics research (the Stanford CIRGE project), as well as the historical developments related to nanotechnology outlined earlier.

The timeline was intended to be the primary way we would engage bioinformatics scientists in collaborating with us in documenting their field. The timeline was constructed with multiple event threads (see fig. 17.2), consisting of (1) a timeline of key documents that have shaped the field of bioinformatics based on a citation study of the literature to identify the core texts of the field of bioinformatics. We also consulted with several leading bioinformatics scientists about the "core set" of milestone documents. In addition we compared the bibliographies of the leading textbooks in the field to identify the core set of milestone documents. These texts are arranged in temporal sequence and displayed as events on our timeline; (2) a timeline related to the

Figure 17.3 Commenting on an event in the interactive timeline: Clicking on an event allows the user to post a comment. Other users can add further commentary in a threaded blog. Links to archived documents are automatically attached. Links to documents outside the collection can be added to the comment. New threads of discussion related to a different theme can be added to the event as well.

infrastructure of the field, such as important meetings where critical issues were raised and discussed in the community, formation of the Society for Bioinformatics, and so on; (3) a timeline of relevant larger context-setting events, such as the funding of Genbank and later the Human Genome Project; and (4) events related to the biotech industry.

The timeline was designed to allow the community of bioinformatics scientists to post events, such as the publication of key documents, descriptions of meetings, and so on, and to open up a threaded multiple-participant discussion on each of those events. (See fig. 17.3.) The data structure is in xml and completely archived in a MySQL relational database. The comments and discussion material entered in the timeline are completely searchable. Events can be anchored to documents in our database, and links to outside material on the Web are also supported. We launched the project with a basic set of parallel timelines, as described above, but this structure was by no means intended to be final. The user community was given the ability to add new categories of events as they saw appropriate. A separate category of, for instance,

government-funded projects, could be added if the group chose to do so, and they would not require our permission to add this new feature.

We anticipated that most participants would not devote much time to commenting and adding data to the site. We attempted to accommodate for these different levels of interest and commitment by creating different ways of engaging in the timeline, ranging from lengthy personal comments to simply flagging events listed by others as important or not. "Flags," for instance, can be attached to events considered important. The person flagging the event is identified in a pop-up window which displays when a viewer "mouses" over the flag. A comment on why the event is considered important is not required. The entire timeline can be filtered to represent the views of different participants and groups of participants in terms of the events they consider key events.

Persons who have posted a comment in the timeline are notified by email when someone else has commented on their posting. A link is contained in the email that redirects them to the appropriate place in the site where the reply has been posted. In this way we hoped to keep our participants returning to the site to add additional information and commentary.

A further feature of the timeline is the ability to draw links between events listed in different timeline segments. The rationale for this additional layer of information is to enable users to indicate deeper causal connections between different events in the same timeline segment or in a parallel timeline. In addition to providing a brief description of the link between events, it is possible to open a threaded discussion about the events linked.

Disappointments and Mid-Course Adjustments

While we were successful in building a useful archive to launch a community-based approach to the history of bioinformatics, an archive that we believe will be a starting point for future developments, we failed to reach our major objective, which is to gain online collaboration of our scientist community in building the history of their discipline. We sent out numerous invitations to key members of the community encouraging their cooperation. In email responses we received from them, as well as in responses in personal interviews or by phone, they all indicated an interest in supporting this project. Many were extremely enthusiastic. Most were extremely gracious in making time to talk with us, and they were willing to be interviewed in an oral-history-styled interview. But they never did visit our website and upload material or

take part in an online discussion. We queried several members about the reasons for this. The general response we got was that most of them felt uncomfortable commenting on events they were involved with. Such commentary they felt might appear to be personal promotion. These individuals preferred a face-to-face interview.

The most typical response we received, however, was the lack of time. Repeatedly our target scientists would respond that they would check into our site as soon as they had completed their grant proposal. We decided that most of our core group of scientists are still very active in their careers; indeed, most are in their forties. These people are active members in a high-profile field with little time for much else than doing their research and managing their graduate students.

However, we were impressed by the willingness of bioinformatics scientists to respond to our emails quickly with valuable responses to our questions. We concluded that while they might be interested in the project, they would not take the extra time to visit our website to enter data. In order to adjust to their communication preferences we decided to add an additional feature to our timeline. We wrote a program that allows a person receiving an email with text from a timeline posting to simply respond to the email directly. Our software strips the text portion of the email and posts it to the correct location in the timeline as a threaded comment to the original comment in the timeline. Unfortunately this feature took some skilled programming and it only became available at the end of our project. We continue using it, however, and have implemented it in the Stanford and the Silicon Valley Project described below.

Genealogy tool Another mid-course correction we made was to cooperate in any way we could with our scientists by building a platform they wanted and would use for their own purposes rather than asking them to participate in our program. This led to the development of perhaps our most innovative collaborative Web tool, an interactive Web-based genealogy program. In response to our inquiry about what sort of history collection mechanism they would like to see, some of the scientists in our study indicated it would be valuable to have a genealogy of persons linked around various projects. We responded to this by building on the platform of the timeline software, modifying it to handle genealogies in which members of a community can upload their own professional profiles, including relationships to their teachers, students, and

Figure 17.4 Genealogy tool: Genealogies of Stanford Biochemistry Department professors, graduate students, and postdocs who have worked with them. Selected "family trees" (e.g., "Robert Baldwin"), multiple trees (e.g., "Baldwin" + "Berg") can be represented, as well as the entire departmental genealogy. Individuals can upload their own personal profiles and curriculum vitae. All of the individual's published documents are automatically generated from PubMed and attached to that person's "publications." Searchable documents are part of the departmental archive along with other documents, such as minutes from faculty meetings, memos, and so on.

postdocs. We experimented with this project with Stanford's Department of Biochemistry. We have constructed a genealogy of the department beginning in 1958 with the arrival of Arthur Kornberg, Paul Berg, and several others from Washington University, St. Louis, at Stanford in 1958. (See fig. 17.4.) The genealogy includes all of the departmental publications since the beginning, more than 90 volumes of papers at 300 or so pages per volume, totaling some 3,000 documents. Our program uses Medline metadata in a bibliography file and links to the original documents in our database. For more recent articles existing in online publications, it is possible to link directly to the

source. Each entry in the genealogy has a personal history, which is essentially a snapshot CV of the individual and his or her major accomplishments. A listing of the students of that individual is also included, and it is possible to jump to that student profile immediately.

Perhaps the most interesting feature of the genealogy program is the capability we built in of tracking quantitative measures of the group and its impact. In the menu "data tools," for instance, it is possible to graph the number of students per faculty member per year, the total number of students in a given year, and other similar relations. It is also possible to graph data on the total dollar amount of research generated per faculty member per year, and we hope in the next iteration of our project to add an "impact measure" of the work of the department on the field by using science citation data. We are currently working on these quantitative tools.

A major advantage of adding these quantitative data tools, we believe, is that it encourages the faculty and their students to update their profiles. In presentations of preliminary versions of this project to the Stanford Department of Biochemistry which did not have the full data set represented, we were impressed by the way in which individuals were eager to have their profiles fully updated so as to reflect their standing in the department and field. We believe incentives like this might assist in getting our scientists to document their work, or at least have them assign an assistant to manage this problem. We are, however, quite enthusiastic and hopeful about the success of the genealogy project and see it as one among several ways to develop tools that will assist future historians in having access to a documentary base for the history of contemporary science. Other groups have shared our enthusiasm for this approach and are adopting it for their own research purposes. For instance, the Stanford NIH-CIRGE is using the timeline in documenting the history of research on autism.[7] There have been two main paradigms organizing the field. For decades autism has been regarded as a behavioral and psychological illness. Recently, however, the emerging paradigm for treating autism holds that it is genetic. The Stanford autism project uses the interactive timeline in documenting these two competing approaches to autism and their relations to one another.

But there have been other disappointments that highlight a major problem for future historians of technoscience. As I have mentioned, one of the central features of the project on the history of bioinformatics was the centrality of the MOLGEN project at Stanford, which evolved into a commercial company

Figure 17.5 Individual profile and database within the genealogy tool: Sample profile for Stanford Biochemistry faculty member, James Spudich. Clicking on the "Discussion" tab allows viewers to engage in discussion with the author about his or her work and career. The profiled person receives and can respond to discussion commentary via email. See plate 14.

IntelliGenetics. IntelliGenetics was acquired by a large biotechnology firm in 1994 and then a few years later by Accelrys, a large British-based firm specializing in applied genomics and proteomics. Although there is little in the early IntelliGenetics files that is of commercial value today, and while there are no issues of intellectual property at stake (for reasons having mostly to do with allocation of resources and the time it would take them to go through the large collection to sign off on each document), the lawyers for Accelrys have not given us permission to make all these early files available on the Web for other researchers. Given the number of high-level projects currently underway that involve collaborations between commercial firms and academic institutions, this is potentially a serious problem for future scholarly work on science and technology with important societal and economic impact.

Future Plans for Extending Web-based Collaboratories

While we have been very successful in building a documentary base for initiating work on the history of bioinformatics and have extended that general approach to collective group genealogies, we were disappointed not to achieve our primary goal of engaging the community of bioinformatics scientists to collaborate with us in building the history of their own discipline. We are hoping that in this new phase of NSF-sponsored projects explicitly calling for open collaboration among scientists and scholars working on the societal and ethical implications of nanotechnology, some of these initial barriers will be overcome. Most of the younger scientists in this community seemed too busy to devote time to history activity they viewed as nonessential. The older community members who did have time to devote to this effort seemed more interested in traditional modes of commenting on the history, primarily in the form of personal oral history.

We believe several factors have contributed to changing the environment for this type of Web-based collecting activity and that our current efforts in the Center for Integrating Research on Ethics and Genetics and at the Center for Nanotechnology and Society have greater chances of success. To begin with, the projects described above all preceded the blogging phenomenon, Wikipedia, and the recent widespread enthusiasm for participatory peer production. Indeed, the climate has changed radically within the past few months. In addition, as indicated at the outset of this essay, the NIH and National Nanotechnology Initiative have both mandated that societal and ethical considerations be built into the framework of new scientific explorations funded by these agencies. But independently of such mandates, there is evidence that scientists and engineers in academe and industry are increasingly concerned about these issues and are interested in using panels of experts for consultation in framing their work.[8] The enthusiasm that has greeted these ideas and the fledgling efforts we have made suggest that the project of using the Web to collect the history of contemporary science does have a future, and we intend to continue contributing to those efforts.

However, we are currently modifying aspects of our approach to collaborative workspaces and supporting materials. Our initial approach with the timeline and genealogy was to store documents in a MySQL database with metadata represented in XML. While the approach works well for the specific relation modeled, namely, the genealogical relation of "dissertation director/

Ph.D. student or postdoc," it is not possible to model and graphically display other types of relationship, such as relationships to startup firms, inventions, and other data that would automatically generate measures of, for instance, the impact of the groups' work on others in the field, or in different fields. A much richer source for mapping multiple types of relationships among objects is provided by a Semantic Web in which objects are tagged with XML meta-data and embedded within a Resource Description Framework (RDF).[9]

It is beyond the scope of this essay to go into detail about this new approach, but it is extremely powerful. We are currently using such a scheme, for instance, to extract relationships among patents, inventors, their institutions, scientific and technical literature in the field of bionanotechnology. These relationships, with links to the documents are given a variety of visual representations that reveal the emergence over time of competing technology platforms, such as, in one of our current studies, for instance, the different microarray platforms driving the field of genomics today, and the flows of persons between projects and firms that are producing these technologies. We use such representations to produce a schematic structural history of the field that suggests the "hot spots" of key activity and helps us identify individuals we should interview in connection with our "Inside the Lab" series (described above). Apart from its ability to map much richer sets of relationships over time, this approach using Semantic Web tools allows us to be driven less by anecdotal research focused around "local heroes" and to capture more of the distributed global flow of contemporary knowledge production in science.

Conclusion: Cautionary Tales for the Future

In this discussion I have attempted to call attention to the problems of constructing the history of science and technology in the information age. Two major problems stand out: the need for tools that enable interdisciplinary collaboration with scientists on the part of the social scientists and historians engaged in collecting and interpreting the history; and second, the need for tools to enable us to emerge from a "digital dark ages" rapidly settling upon us, tools such as data-mining techniques, Semantic Web technologies, and tools for visualizing the dynamic flow of knowledge construction. For most persons who may not be directly interested in mapping the history of contemporary science, concern about preserving some of these large-scale projects in researchable form may seem an indulgence in exotic antiquarianism. I want to

conclude with an anecdote from a research project I recently completed which suggests that the concerns about information archaeology are a lot closer to home than we may be inclined to think.

In 2001 I undertook a collaboration with my Stanford colleagues, economists Nathan Rosenberg and Henry Rowen, together with several graduate students and two postdoctoral researchers. Our project was to produce a report for Charles Kruger, the dean of research at Stanford, on the relationship of Stanford research in science, engineering, and medicine to that of the Silicon Valley from roughly 1950 to the present. The project was not unusual as a collaboration in the social sciences. The historians of science and technology in the project were to contribute case studies illuminating the sources of development of several key Stanford technologies from different periods and their relation to Silicon Valley. The economists undertook a study of Stanford patents and licenses in order to see where pockets of innovation are located in the university, and they studied the licensing of patents by firms in the Silicon Valley in order to gauge the penetration of those patents into industry nationally as well as locally in Silicon Valley. In addition a survey of inventors (including faculty, graduate students, researchers, and staff) filing invention disclosures with Stanford's Office of Technology Licensing was undertaken in order to assess their history of consulting, founding of companies, and similar entrepreneurial activities. All of the separate components of the research were the basis for a synthetic narrative quantitatively documenting the history of Stanford's relationship to federal and private funding sources and to the generation of Stanford entrepreneurial activity in the Silicon Valley.

An important aspect of the work of this project involved a detailed investigation of the financial records of the departments of Stanford University. We used this data to reconstruct comparative financial snapshots of different departments in the engineering, medical, and humanities and sciences schools in order to gauge the relative inputs of federal funding versus other funding sources for the operations of the university. This information was also useful in linking up pockets of innovation in different areas with specific programs of federal funding. Our studies were facilitated by the nicely detailed records that have been registered in the annual reports of the university since 1963. (For earlier periods the recovery of accounting practices is more difficult and less standardized.) In the late 1980s, with operations approaching the $2.5 billion mark, much of the detailed accounting was removed from the annual printed financial report. By 1993 the entire accounting system used for the

university was done online in a special database system and the printed version of the annual report became summary rather than including detail (now requiring two thick volumes). In the course of our research we asked to have access to the archived versions of the annual financial reports and the data sheets from which these reports were assembled. From 1993 onward these materials at Stanford have been stored in what is referred to as the "Data Warehouse." When we tried to access these data, we were delighted to find that for most recent years the reports are in file formats accessible to programs such as Microsoft Excel. The earlier reports were done in a Stanford proprietary system, however, and are not accessible.

Here we encounter head on the issue of the digital dark ages: If relatively straightforward financial records of our institutions, which assumedly do not require hardware emulation or special software solutions in order to answer questions relevant to historical reconstruction, are inaccessible, how will we write the history of university-based technoscience in the future?[10] Clearly we need to think about issues of information archaeology described above in areas less exotic than one might have first imagined. In order not to have to simply reenter all the data (assuming we can ever get it preserved in a non-digital form), and in order to be able to make comparisons not only among divisions of the same organization, such as a university, but also comparatively on a national scale, it is imperative to address issues of software preservation and forward compatibility.

Notes

1. See Jane Macourbie, "Informed Public Perceptions of Nanotechnology and Trust in Government" (Report of the Project on Emerging Nanotechnologies, Washington, D.C., Woodrow Wilson International Center, September 2005), http://www.nanotechproject.org/. See also Michael D. Cobb and Jane Macoubrie, "Public Perceptions about Nanotechnology: Risks, Benefits, and Trust," *Journal of Nanoparticle Research* 6 (2004): 395–405.

2. For the launch of the national discussion on this theme, see M. C. Roco, "Broader Societal Issues of Nanotechnology," *Journal of Nanoparticle Research* 5 (2003): 181–189.

3. See Howard Rheingold, *Smart Mobs: The Next Social Revolution* (New York: Basic Books, 2003); Michael Hardt and Antonio Negri, *Multitude: War and Democracy in the*

Age of Empire (New York: Penguin, 2004). See also http://www.wikipedia.org/ and http://www.ohmynews.com/.

4. See http://www.cns.ucsb.edu/.

5. For more on the goals of spintronics research, see J. A. Gupta, R. Knobel, N. Samarth, and D. D. Awschalom, "Ultrafast Manipulation of Electron Spin Coherence," *Science* 292 (2001): 2458–2461; S. A. Wolf et al., "Spintronics: A Spin-based Electronics Vision for the Future," *Science* 294 (2001): 1488–1495.

6. IRC in Nanotechnology at the University of Cambridge, http://www-g.eng.cam .ac.uk/nano/; Greenpeace UK, http://www.greenpeace.org.uk/; *Guardian*, http://www .guardian.co.uk/life/; Policy, Ethics and Life Sciences Research Centre at the University of Newcastle, http://www.nc.ac.uk/peals/dialogues/.

7. For a description of the project, see http://cirge.stanford.edu/autism.html/.

8. This perception is based in part by the requests that David Magnus and Mildred Cho, the directors of the Stanford Center for Biomedical Ethics and the CIRGE project, report receiving. Similar experiences are reported by Robert Cook-Deegan, the director of Duke's Center for Genome Ethics Law and Policy, and by Elizabeth Kiss, the director of the Keenan Institute for Ethics at Duke.

9. For an overview, see Tim Berners-Lee, James Hendler, and Ora Lassila, "The Semantic Web: A New Form of Web Content That Is Meaningful to Computers Will Unleash a Revolution of New Possibilities," *Scientific American* (17 May 2001). For general overviews of this technology, see Grigoris Antoniou and Frank van Harmelen, *A Semantic Web Primer* (Cambridge, Mass.: MIT Press, 2004); Shelley Powers, *Practical RDF* (Sebastopol, Calif.: O'Reilly Media, 2003).

10. For a similar problem see David Kirsch's efforts to preserve the business plans and litigation histories of the dot-com era, http://www.businessplanarchive.org/, and David Kirsch, "Creating an Archive of Failed Dot-Coms," *Journal of Higher Education* (15 April 2005).

IV

Image Science

Image, Meaning, and Discovery

Felice Frankel

First and foremost, I am a creator of images, a practitioner, and as such can sometimes feel like an interloper in the study of art, as I do here among this impressive collection of scholars. Furthermore, the subject I write about is not, in fact, art. If one's work is defined by intention, then the images I make and describe here should be defined as visual representations of scientific phenomena. The curious viewer who delves a bit deeper into the subjects of the images will realize something more: that these pictures are also visual representations of deep and complex ideas in science. And finally, as he comes to understand how scientific representations are made he will find powerful support for a broader conclusion: in nature, there are neither simple answers nor simple questions.

Understanding the Process

A scientific representation is different from an artistic one, and it is important to understand the difference. Images in science, unlike images that constitute a piece of visual art, have as their primary purpose the *representation* of a thing, phenomenon, or concept, and this representation must meet an important standard—the image must be honest and faithful to the scientific data. The creation of a science image must match the rigor of scientific investigation, which requires that a minimum of interpretation be applied during its making and processing.

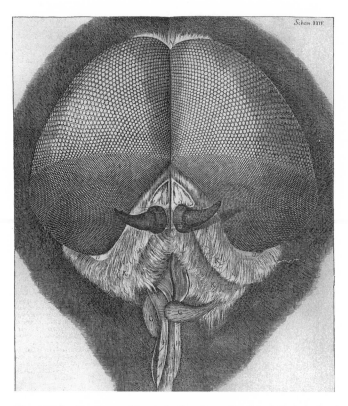

Figure 18.1 *The Eyes and Head of a Grey Drone-Fly*, Robert Hooke's drawing from his observations under a microscope.

All images in science, of course, must be subjected to some processing and decision making if the visual expression of the information is to be seen. The data being represented may have been acquired by observation, as in this stunningly detailed drawing of a fly's eye by Robert Hooke[1] (fig. 18.1). The image may be the product of an optical imaging system, as in representations of a morpho butterfly wing made on film or on a CCD[2] (charge-coupled device) (fig. 18.2), or it may be a collection of electrons, as in this scanning electron micrograph (SEM)[3] (fig. 18.3), again of a morpho butterfly wing. Hooke's observations formed an image when he translated and "processed" what his eye was seeing to pen and paper. His thoughtful decisions about what to include and what not to include contribute to our clearly seeing the significant details of the structure. In the second image, light (photons) from the wing hit

Figure 18.2 Detail of a morpho butterfly wing, imaged on film with a macro lens and camera. The wing appears blue because of its surface structure, reflecting mostly blue wavelengths of light. © Felice Frankel. See plate 15.

Figure 18.3 A digitally colored scanning electron micrograph (SEM) of the same morpho butterfly wing as in figure 18.2. © Felice Frankel. See plate 16.

the colored layers of gel in the film in my camera. In the image-making process I made decisions, as did Hooke, concerning composition, framing, and magnification, in order to clarify what was important for the viewer to see. In the third image, the SEM "read" the electrons as numbers as they scattered off the sample. But first, some computer scientist somewhere had to create an algorithm to *process* those numbers, in order to "see" the data as an image.

So it is true that what we see in a science image is a translation—an *expression* of the thing. But we in the science community carry the extra burden of needing to be as objective as possible in the processing of our images, of eschewing expression of the image-maker's point of view. Such objectivity does not underlie most images made by contemporary artists. In fact, objectivity is often in direct contradiction to the process of making contemporary art. Images in art *are* about the creator of the image—the image *is* the artist.

In this image of a yeast colony (fig. 18.4), I intended to communicate its extraordinary form and detail and to bring your attention to its structure. I invite you to consider the decisions I made in capturing and communicating the image. In this case I "permitted" myself to digitally delete the petri dish from the original image (fig. 18.5).[4] Gerry Fink at MIT's Whitehead Institute, whose research included this study, was pleased that the image appeared on the cover of *Science* magazine.[5] However, he believed that by digitally altering the image, I deleted pertinent information about the size of the colony. He suggested that those in the science community, experienced with working with petri dishes, could have approximated important information—the size of the yeast colony—if I had retained the borders of the dish. I counter that size may be easily described in a caption. My deletion of what I considered to be a distraction in the image encourages the viewer to *look* at this amazing structure, with all its complexity and intricacy. By communicating to you my thinking about the process of making images I am inviting you, the viewer, to participate—to look, to pay attention to the process, yet still to be as awestruck as I was when I first saw this remarkable phenomenon in nature. But I believe I am also doing something more. I am inviting you to *think* visually. If I were a writer and had the talent to describe to you this most stunning structure, you might have created a picture in your mind and perhaps imagined the form of the colony, even with all its detail. However, I am convinced that *seeing* the colony and being privy to the decisions I made in making the image is a means of seeing the profound underlying *idea* in the image—the yeast cells in this particular colony have organized themselves

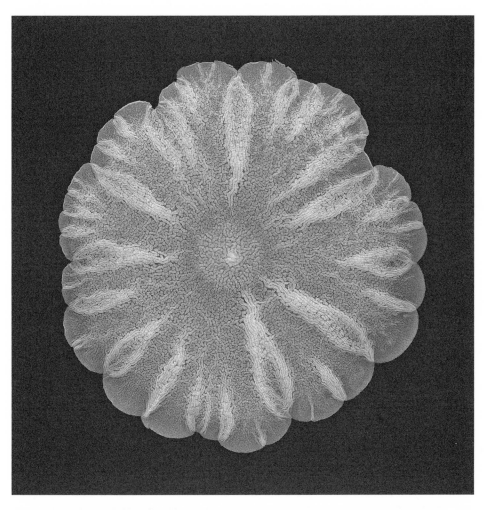

Figure 18.4 A yeast colony growing in a low glucose medium. The petri dish is digitally deleted. Researchers: T. Reynolds, G. Fink (The Whitehead Institute). © Felice Frankel.

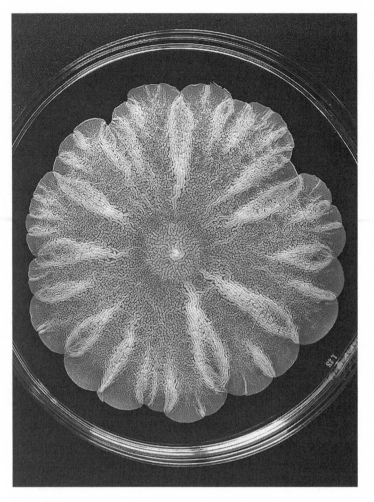

Figure 18.5 Same image as figure 18.4 without any digital alteration. © Felice Frankel.

into a complex structure! Visually engaging you in the process, with an understanding of why one makes certain decisions in order to communicate a particular representation, offers you a new approach to asking questions about science. It might well be an important step in alleviating what seems to be the public's apparent discomfort with asking those questions.

Take, for another example, this extraordinary 1995 image of the Eagle nebula (fig. 18.6), one of the most memorable pictures taken by NASA's Hubble Space Telescope of newborn stars emerging from dense pockets of interstellar

Figure 18.6 *Eagle Nebula*, M16, false-colored Hubble Space Telescope (HST) visible light image. Image produced by P. Scowen and J. Hester. See text for details. See plate 17.

gas, 6,500 light-years from Earth. Scientists with Hubble's Wide Field and Planetary Camera 2 team used color in processing the image in a way that highlights variations in the nebula's physical properties. In an interview for my column *Sightings* in *American Scientist* magazine, the researchers for this project, Jeff Hester and Paul Scowen, described how they created the image:[6]

The image is constructed out of 32 separate images made using four different filters.... Making the final image involved: *(1)* calibrating each frame and removing various "instrumental signatures" ...; *(2)* identifying and rejecting various artifacts

Image, Meaning, and Discovery

such as the streaks left by cosmic rays as they passed through the detectors; *(3)* combining all of the images taken through a given filter into a single frame . . . ; and *(4)* combination of the different single-filter mosaics into a color image.

In the final image, blue represents light in an emission line . . . from doubly ionized oxygen. Green represents light in the distinct wavelength emitted when a proton and electron combine to make a hydrogen atom. Red represents light [from] singly ionized sulfur atoms. So the colors show variations in the level of ionization and excitation from place to place. It is a map of the physical properties of the gas. It turns out that it is also closer to what you might see through a telescope with your eye than is a picture taken with color film present in the image.

. . . The real issue when you look at an image like this is that there is one hell of a lot of information present. Interpreting that information is not like interpreting a simple plot or graph. Instead, you have to look at the relations between different aspects of the image, as well as the variations in physical properties of the gas from place to place. Interestingly, the beauty of the image is not happenstance. When people talk about "beauty," they are talking about the presence of pattern in the midst of complexity. Pattern recognition is so important to humans that perceiving patterns in the midst of complexity is pleasurable to us. To a great degree, the same patterns present in the image that make it aesthetically pleasing also make it scientifically interesting.

Our reason for combining the data in this fashion was not to make a pretty picture just for the sake of making a pretty picture. Rather, it is by combining the data into a "pretty picture" that we present the information in a form that the human brain can more readily perceive. In short, we use color in the image in much the same way that an artist uses color. We use it as an interpretive tool to present our observations of the world in a way that other humans can more readily understand.

Does our knowing all about the making of the image detract from its beauty and wonder? I don't think so. In fact, knowing more about how the researchers represented this place in space contributes to an even greater sense of awe; it adds to our knowledge and insight into the process of discovery. Look at the right side of image (fig. 18.7), the identical area of the cosmos.[7] In this case, using a filter that allows us to read only the near-infrared part of the spectrum gives us a different image. Here, we are not seeing those mysterious and gloriously colored clouds. Still, this image helps us understand the other and provides an important revelation—an understanding of how the choice of a

Figure 18.7 Comparison between HST visible light image of M16 (see figure 18.6) and same area of space taken with a ground-based telescope, ESO Very Large Telescope (VLT) in Chile, reading the near-infra-red part of the spectrum. (Right image by McCaughrean & Andersen.) See plate 18.

certain "tool" affects what we see. Who knows what other tools we will soon develop as we look further and ask more questions? We will literally continue to "see" new things, in different "lights" and with brand-new perspectives.

Asking Questions

It is difficult for one not ordinarily involved with science to comprehend that the choice of a particular filter or instrument can yield different information— in this case, different images. The difficulty of grasping such complexities can contribute to the public's discomfort with science and the yearning for simple answers. Unfortunately, the research community's insistence on using an inaccessible vocabulary doesn't help—and could be frightening the public away from science. Scientists are too worried about "dumbing down"

information—leaving out something important. But the researcher's concern to express what he believes is the complete and honest story, by including every "necessary" relevant detail, dangerously weakens scientists' ability to persuade the public that the stunningly fascinating complexity of nature will someday be scientifically explained. By using an unapproachable language, the research community is inadvertently encouraging the public to look for an "easier" and more comfortable way to understand the world—to look for simple answers to simple questions.

There are no simple questions, and all the terabytes of genomic data, images of nanostructures and astronomical maps of pulsars can be so difficult to understand and discomfiting that the public is, in fact, *not* asking questions. There is just too much *stuff*, and, unfortunately and importantly, one just has to work too hard to figure out what questions to ask.

It is difficult to imagine, for example, how four billion years of random molecular collisions and natural selection might produce a child with blue eyes. And that yes, given this enormous and unimaginable amount of time (it is certainly difficult for me to imagine four billion years!) and massive numbers of accidental molecular collisions, pairs of chemical bases can, in fact, find themselves ordered in just the right way to form the template of a message for curly hair. Probability and randomness are extremely difficult concepts to grasp, and yet they might someday explain the beginning of and the complexity of life, without the explanation having to include the participation of an intelligent designer. How interesting it would be to develop some sort of *accessible* visual representation of randomness or probability! Often my colleagues working in quantum mechanics suggest that if we could teach these concepts to our first graders, perhaps some of us (including myself) would have more of an understanding of this most counterintuitive field of research. A better grasp of randomness would certainly help clarify the profound ideas of Charles Darwin.

I am not suggesting that coming up with simplistic visual expressions of complicated phenomena is the answer to society's discomfort with science. Nor am I suggesting that educating people about what filters we use, how we "see," and the decisions we make about what we choose to see, will clarify the complexity of nature. What I do suggest is that, if we can better communicate the *process* of scientific investigation by inviting nonscientists to participate in scientists' thinking through a more *accessible* visual language, more people will comprehend and respect the rigor of scientific methodologies and

systems of evaluation. That understanding will, in turn, clarify the profoundly important argument that we simply cannot, in the same discourse, discuss the existence of an intelligent designer as an aspect of scientific theory. Speculations about the actions of a designer's hand are in direct conflict with the standards we in the science community impose on ourselves, a process to which the research community adheres in order to advance scientific thinking. It is imperative for the public to understand the differences between scientific thinking on the one hand and philosophical and religious discourse on the other. If we are to advance as a society, it is the responsibility of the scientific community to develop a language to enable the public to grasp the differences and to understand that the two worlds cannot be intermingled.

As I write this essay, many of us are grappling with the serious concern that motivated the two preceding paragraphs: society's dangerous inability to distinguish a scientific theory, Darwin's theory of evolution, from an unscientific so-called theory, "intelligent design." Emails are flying, discussions in the hallways of our institutions continue, and op-ed articles are being written. I am privileged to be part of the conversation with researchers and others who share my frustration and seek ways to raise the level of understanding of what is and is not science and scientific evidence. Rosalind Reid, Editor of *American Scientist*, recently reminded me that one of the characteristics that makes the scientific image a unique expressive vehicle—the scientist's paired goals of conveying precision and nuance—is an important tool in communicating scientific reality to a society seduced by simple answers:[8]

We "communicators" need to show scientists that these very goals can be achieved by words and pictures that use the vernacular. There's indeed danger in "dumbing down" science, because its essence is in the details. You've got to be able to depict and describe the building blocks of the theory of evolution if you expect people to understand the many ways in which ID [intelligent design] is *not* an "alternative scientific theory." The details, I believe, can be pretty interesting—cool, even.

John Berger wrote: "We only see what we look at. To look is an act of choice."[9] The research community must have more confidence in the public's ability to understand that to ask the more complicated questions about nature, we must develop a language that enables them first to *look* and then to find, within that language, the questions to ask.

Notes

1. Robert Hooke, *Micrographia* (London: J. Martyn and J. Allestry, 1665).

2. Morpho butterfly wing detail, Felice Frankel and Georges M. Whitesides, *On the Surface of Things, Images of the Extraordinary in Science* (to be reprinted by Harvard University Press, 2007).

3. Morpho butterfly wing, colored SEM, Felice Frankel, "The Power of the Pretty Picture," *Nature Materials* 3 (July 2004).

4. Felice Frankel, *Envisioning Science: The Design and Craft of the Science Image* (Cambridge, Mass.: MIT Press, 2002).

5. Felice Frankel, cover for *Science* (2 February 2001).

6. Felice Frankel, "Seeing Stars," *American Scientist* 92 (5) (September–October 2004).

7. Modified from figure 12.7 in Jay Pasachoff and Alex Filippenko, *The Cosmos: Astronomy in the New Millennium*, third edition (Boston: Brooks/Cole, 2007).

8. Private communication.

9. John Berger, *Ways of Seeing* (London: Penguin, 1995).

There Are No Visual Media

W. J. T. Mitchell

"Visual media" is a colloquial expression used to designate things like TV, movies, photography, painting, and so on. But it is highly inexact and misleading. All the so-called visual media turn out, on closer inspection, to involve the other senses (especially touch and hearing). All media are, from the standpoint of sensory modality, "mixed media." The obviousness of this raises two questions: (1) why do we persist in talking about some media as if they were exclusively visual? Is this just a shorthand for talking about visual *predominance*? And if so, what does "predominance" mean? Is it a quantitative issue (*more* visual information than aural or tactile?) Or is it a question of qualitative perception, the sense of things reported by a beholder, audience, viewer-listener? (2) Why does it matter what we call "visual media"? Why should we care about straightening out this confusion? What is at stake?

First, let me belabor the obvious. Can it really be the case that there are no visual media despite our incorrigible habit of talking as if there were? My claim can, of course, easily be refuted with just a single counterexample. So let me anticipate this move with a roundup of the usual suspects that you might want to propose as examples of purely or exclusively visual media. Let's rule out first, the whole arena of mass media—television, movies, radio—as well as the performance media (dance and theater). From Aristotle's observation that drama combines the three orders of *lexis*, *melos*, and *opsis* (words, music, and spectacle) to Barthes' survey of the "image–music–text" divisions of the semiotic field, the mixed character of media has been a central postulate. Any notion of purity seems out of the question with these ancient and modern

media, both from the standpoint of the sensory and semiotic elements internal to them and what is external in their promiscuous audience composition. And if it is argued that silent film was a "purely visual" medium, we need only remind ourselves of a simple fact of film history—that the silents were always accompanied by music, speech, and the film texts themselves often had written or printed words inscribed on them. Subtitles, intertitles, spoken and musical accompaniment made "silent" film anything but.

So if we are looking for the best case of a purely visual medium, painting seems like the obvious candidate. It is, after all, the central, canonical medium of art history. And after an early history tainted by literary considerations, we do have a canonical story of purification, in which painting emancipates itself from language, narrative, allegory, figuration, and even the representation of nameable objects in order to explore something called "pure painting" characterized by "pure opticality." This argument, most famously circulated by Clement Greenberg, and sometimes echoed by Michael Fried, insists on the purity and specificity of media, rejecting hybrid forms, mixed media, and anything that lies "between the arts" as a form of "theater" or rhetoric that is doomed to inauthenticity and second-rate aesthetic status.[1] It is one of the most familiar and threadbare myths of modernism, and it is time now to lay it to rest. The fact is that even at its purist and most single-mindedly optical, modernist painting was always, to echo Tom Wolfe's phrase, "painted words."[2] The words were not those of history painting, or poetic landscape, or myth, or religious allegory, but the discourse of theory, of idealist and critical philosophy. This critical discourse was just as crucial to the comprehension of modernist painting as the Bible or history or the classics were to traditional narrative painting. Without the latter, a beholder would be left standing in front of Guido Reni's *Beatrice Cenci the Day before Her Execution*, in the situation of Mark Twain, who noted that an uninstructed viewer who did not know the title and the story would have to conclude that this was a picture of a young girl with a cold, or young girl about to have a nose bleed.[3] Without the former, the uninstructed viewer would (and did) see the paintings of Jackson Pollock as "nothing but wallpaper."

Now I know that some of you will object that the "words" that make it possible to appreciate and understand painting are not "in" the painting in the same way that the words of Ovid are illustrated *in* a Claude Lorrain. And you might be right, and it would be important to distinguish the different ways that language enters painting. But that is not my aim here. My present

task is only to show that the painting we have habitually called "purely optical," exemplifying a purely visual use of the medium, is anything but that. The question of precisely how language enters into the perception of these pure objects will have to wait for another occasion.

But suppose it were the case that language could be absolutely banished from painting? I don't deny that this was a characteristic desire of modernist painting, symptomatized by the ritualistic refusal of titles for pictures, and the enigmatic challenge of the "untitled" to the viewer. Suppose for a moment that the viewer could look without verbalizing, could see without (even silently, internally) subvocalizing associations, judgments, and observations. What would be left? Well, one thing that would obviously be left is the observation that a painting is a handmade object, and that is one of the crucial things that differentiates it from (say) the medium of photography, where the look of mechanical production is so often foregrounded. (I leave aside for the moment the fact that a painter can do an excellent job of imitating the machinic look of a glossy photo, and that a photographer with the right techniques can, similarly, imitate the painterly surface and sfumato of a painting.) But what is the perception of the painting as handmade if not a recognition that a nonvisual sense is encoded, manifested, and indicated in every detail of its material existence? (Robert Morris' *Blind Time Drawings*, drawn by hand with powdered graphite on paper, according to rigorous procedures of temporal and spatial targeting which are duly recorded in hand-inscribed texts on the lower margin, would be powerful cases for reflection on the quite literally nonvisual character of drawing.)[4] The nonvisual sense in play is, of course, the sense of touch, which is foregrounded in some kinds of painting (when "handling," impasto, and the materiality of the paint is emphasized), and backgrounded in others (when a smooth surface and clear, transparent forms produce the miraculous effect of rendering the painter's manual activity invisible). Either way, the beholder who knows nothing about the theory behind the painting, or the story or the allegory, need only understand that this is a painting, a handmade object, to understand that it is a trace of manual production, that everything one sees is the trace of a brush or a hand touching a canvas. Seeing painting is seeing touching, seeing the hand gestures of the artist, which is why we are so rigorously prohibited from actually touching the canvas ourselves.

This argument is not, by the way, intended to consign the notion of pure opticality to the dustbin of history. The point is, rather, to assess what its

historical role in fact was, and why the purely visual character of modernist painting was elevated to the status of a fetish concept, despite the abundant evidence that it was a myth. What was the purification of the visual medium all about? What form of contamination was being attacked?—in the name of what form of sensory hygiene?[5]

The other media that occupy the attention of art history seem even less likely to sustain a case of pure opticality. Architecture, the impurest medium of all, incorporates all the other arts in a *Gesamtkunstwerk*, and it is typically not even "looked at" with any concentrated attention, but is perceived, as Walter Benjamin noted, in a state of distraction. Architecture is not primarily about seeing, but about dwelling and inhabiting. Sculpture is so clearly an art of the tactile that it seems superfluous to argue about it. This is the one so-called visual medium, in fact, that has a kind of direct accessibility to the blind. Photography, the latecomer to art history's media repertoire, is typically so riddled with language, as theorists from Barthes to Victor Burgin have shown, that it is hard to imagine what it would mean to call it a purely visual medium. Photography's specific role in what Joel Snyder has called "Picturing the Invisible"—showing us what we do not or cannot see with the "naked eye" (rapid body motions, the behavior of matter, the ordinary and everyday) makes it difficult to think of it as a visual medium in any straightforward sense. Photography of this sort might be better understood as a device for translating the unseen or unseeable into something that looks like a picture of something we could never see.

From the standpoint of art history in the wake of postmodernism, it seems clear that the last half-century has decisively undermined any notion of purely visual art. Installations, mixed media, performance art, conceptual art, site-specific art, minimalism, and the often-remarked return to pictorial representation has rendered the notion of pure opticality a mirage that is retreating in the rearview mirror. For art historians today, the safest conclusion would be that the notion of a purely visual work of art was a temporary anomaly, a deviation from the much more durable tradition of mixed and hybrid media.

Of course this argument can go so far that it seems to defeat itself. How, you will object, can there be any mixed media or multimedia productions unless there are elemental, pure, distinct media out there to go into the mix? If all media are always and already mixed media, then the notion of mixed media is rendered empty of importance, since it would not distinguish any specific

mixture from any purely elemental instance. Here I think we must take hold of the conundrum from both ends and recognize that one corollary of the claim that "there are no visual media," is that *all media are mixed media*. That is, the very notion of a medium and of mediation already entails some mixture of sensory, perceptual, and semiotic elements. There are no purely auditory, tactile, or olfactory media either. This conclusion does not lead, however, to the impossibility of distinguishing one medium from another. What it makes possible is a more precise differentiation of mixtures. If all media are mixed media, they are not all mixed in the same way, with the same proportions of elements. A medium, as Raymond Williams puts it, is a "material social practice,"[6] not a specifiable essence dictated by some elemental materiality (paint, stone, metal) or by technique or technology. Materials and technologies go into a medium, but so do skills, habits, social spaces, institutions, and markets. The notion of "medium specificity," then, is never derived from a singular, elemental essence. It is more like the specificity associated with recipes in cooking: many ingredients, combined in a specific order in specific proportions, mixed in particular ways, and cooked at specific temperatures for a specific amount of time. One can, in short, affirm that there are no "visual media," that all media are mixed media, without losing the concept of medium specificity.

With regard to the senses and media, Marshall McLuhan glimpsed this point some time ago when he posited different "sensory ratios" for different media. As a shorthand, McLuhan was happy to use terms like visual and tactile media, but his surprising claim (which has been mostly forgotten or ignored) was that television (usually taken to be the paradigmatically visual medium) is actually a *tactile* medium: "The TV image ... is an extension of touch,"[7] in contrast to the printed word, which in McLuhan's view, was the closest any medium has come to isolating the visual sense. McLuhan's larger point, however, was definitely not to rest content with identifying specific media with isolated, reified sensory channels, but to assess the specific mixtures of specific media. He may call the media "extensions" of the sensorium, but it is important to remember that he also thought of these extensions as "amputations" and he continually stressed the dynamic, interactive character of mediated sensuousness.[8] His famous claim that electricity was making possible an extension (and amputation) of the "sensory nervous system" was really an argument for an extended version of the Aristotelian concept of a *sensus communis*, a coordinated (or deranged) "community" of sensation in the individual,

extrapolated as the condition for a globally extended social community, the "global village."

The specificity of media, then, is a much more complex issue than reified sensory labels such as "visual," "aural," and "tactile." It is, rather, a question of specific sensory ratios that are embedded in practice, experience, tradition, and technical inventions. And we also need to be mindful that media are not *only* extensions of the senses, calibrations of sensory ratios. They are also symbolic or semiotic operators, complexes of sign-functions. If we come at media from the standpoint of sign theory, using Peirce's elementary triad of icon, index, and symbol (signs by resemblance, by cause and effect or "existential connection," and conventional signs dictated by a rule), then we also find that there is no sign that exists in a "pure state," no pure icon, index, or symbol. Every icon or image takes on a symbolic dimension the moment we attach a name to it, an indexical component the moment we ask how it was made. Every symbolic expression, down to the individual letter of the phonetic alphabet, must also resemble every other inscription of the same letter sufficiently to allow iterability, a repeatable code. The symbolic depends upon the iconic in this instance. McLuhan's notion of media as "sensory ratios" needs to be supplemented, then, with a concept of "semiotic ratios," specific mixtures of sign-functions that make a medium what it is. Cinema, then, is not just a ratio of sight and sound, but of images and words, and of other differentiable parameters such as speech, music, and noise.

The claim that there are no visual media, then, is really just the opening gambit that would lead toward a new concept of *media taxonomy*, one that would leave behind the reified stereotypes of "visual" or "verbal" media, and produce a much more nuanced, highly differentiated survey of types of media. A full consideration of such a taxonomy is beyond the scope of this essay, but a few preliminary observations are in order.[9] First, the sensory or semiotic elements need much further analysis, both at an empirical or phenomenological level, and in terms of their logical relations. It will not have escaped the alert reader that two triadic structures have emerged as the primitive elements of media: the first is what Hegel called the "theoretic senses"—sight, hearing, and touch—as the primary building blocks of any sensuous mediation; the second is the Peircean triad of sign-functions. Whatever sorts of sensory–semiotic "ratios" are deployed will be complexes of at least these six variables.

The other issue that needs further analysis is the question of "ratio" itself. What do we mean by a sensory–semiotic ratio? McLuhan never really devel-

oped this question, but he seems to have meant several things by it. First: the notion that there is a relation of dominance–subordination, a kind of literal realization of the "numerator–denominator" relation in a mathematical ratio.[10] Second, that one sense seems to activate or lead to another, most dramatically in the phenomenon of synesthesia, but far more pervasively in the way, for instance, the written word appeals directly to the sense of sight, but immediately activates audition (in subvocalization) and secondary impressions of spatial extension that may be either tactile or visual—or involve other, "subtheoretic" senses such as taste and smell. Third, there is the closely related phenomenon I would call "nesting," in which one medium appears inside another as its content (television, notoriously, treated as the content of film, as in movies like *Network*, *Quiz Show*, *Bamboozled*, and *Wag the Dog*).

McLuhan's aphorism, "the content of a medium is always an earlier medium," gestured toward the phenomenon of nesting, but unduly restricted it as a historical sequence. In fact, it is entirely possible for a later medium (TV) to appear as the content of an earlier one (movies), and it is even possible for a purely speculative, futuristic medium, some as yet unrealized technical possibility (like teleportation or matter transfer) to appear as the content of an earlier medium (I consider *The Fly* the classic example of this fantasy, but the ritual request to "beam me up Scottie" on almost every episode of *Star Trek* renders this purely imaginary medium almost as familiar as walking through a door). Our principle here should be: any medium may be nested inside another, and this includes the moment when a medium is nested inside itself—a form of self-reference that I have elsewhere discussed as a "metapicture" and that is crucial to theories of enframing in narrative.[11]

Fourth, there is a phenomenon I would call "braiding," when one sensory channel or semiotic function is woven together with another more or less seamlessly, most notably in the cinematic technique of synchronized sound. The concept of "suture" that film theorists have employed to describe the method for stitching together disjunctive shots into a seemingly continuous narrative is also at work whenever sound and sight are fused in a cinematic presentation. Of course, a braid or suture can be unraveled, and a gap or bar can be introduced into a sensory–semiotic ratio, which leads us to a fifth possibility: signs and senses moving on parallel tracks that never meet, but are kept rigorously apart, leaving the reader-viewer-beholder with the task of "jumping the tracks" and forging connections subjectively. Experimental cinema in the 1960s and '70s explored the desynchronization of sound and sight,

and literary genres such as ekphrastic poetry evoke the visual arts in what we loosely call a "verbal" medium. Ekphrasis is a verbal representation of visual representation—typically a poetic description of a work of visual art (Homer's description of Achilles' Shield being the canonical example).[12] The crucial rule of ekphrasis, however, is that the "other" medium, the visual, graphic, or plastic object, is never made visible or tangible *except* by way of the medium of language. One might call ekphrasis a form of nesting without touching or suturing, a kind of action-at-distance between two rigorously separated sensory and semiotic tracks, one that requires completion in the mind of the reader. This is why poetry remains the most subtle, agile master-medium of the *sensus communis*, no matter how many spectacular multimedia inventions are devised to assault our collective sensibilities.

If there is any shred of doubt lingering that there are no visual media, that this phrase needs to be retired from our vocabulary or completely redefined, let me clinch the case with a brief remark on unmediated vision itself, the "purely visual" realm of eyesight and seeing the world around us. What if it turned out that vision itself was not a visual medium? What if, as Gombrich noted long ago, the "innocent eye," the pure, untutored optical organ, was in fact *blind*?[13] This, of course, is not an idle thought, but a firmly established doctrine in the analysis of the visual process as such. Ancient optical theory treated vision as a thoroughly tactile and material process, a stream of "visual fire" and phantom "eidola" flowing back and forth between the eye and the object.[14] Descartes famously compared seeing to touching in his analogy of the blind man with two walking sticks. Vision, he argued, must be understood as simply a more refined, subtle, and extended form of touch, as if a blind man had very sensitive walking sticks that could reach for miles. Bishop Berkeley's *New Theory of Vision* argued that vision is not a purely optical process, but involves a "visual language" requiring the coordination of optical and tactile impressions in order to construct a coherent, stable visual field. Berkeley's theory, based in the empirical results of cataract operations that revealed the inability of blind persons whose sight had been restored after an extended period to recognize objects until they had done extensive coordination of their visual impressions with touch. These results have been confirmed by contemporary neuroscience, most famously by Oliver Sacks' revisiting of the whole question in "To See and Not See," a study of restored sight that exposes just how difficult it is to learn to see after an extended period of blindness. Natural vision itself is a braiding and nesting of the optical and tactile.[15]

The sensory ratio of vision as such becomes even more complicated when it enters into the region of emotion, affect, and intersubjective encounters in the visual field—the region of the "gaze" and the scopic drive. Here we learn (from Sartre, for instance) that the gaze (as the feeling of being seen) is typically activated not by the eye of the other, or by any visual object, but by the invisible space (the empty, darkened window) or even more emphatically by sound—the creaking board that startles the voyeur, the "hey you" that calls to the Althusserean subject.[16] Lacan further complicates this issue by rejecting even the Cartesian model of tactility in "The Line and the Light," and replacing it with a model of fluids and overflow, one in which pictures, for instance, are to be drunk rather than seen, painting is likened to the shedding of feathers and the smearing of shit, and the principal function of the eye is to overflow with tears, or to dry up the breasts of a nursing mother.[17] There are no purely visual media because there is no such thing as pure visual perception in the first place.

Why does all this matter? Why quibble about an expression, "visual media," that seems to pick out a general class of things in the world, however imprecisely? Isn't this like someone objecting to lumping bread, cake, and cookies under the rubric of "baked goods"? Actually, no. It's more like someone objecting to putting bread, cake, chicken, a quiche, and a cassoulet into the category of "baked goods" because they all happen to go into the oven. The problem with the term "visual media" is that it gives the illusion of picking out a class of things about as coherent as "things you can put in an oven." Writing, printing, painting, hand gestures, winks, nods, and comic strips are all "visual media," and this tells us next to nothing about them. So my proposal is to put this phrase into quotation marks for a while, to preface it by "so-called," in order to open it up to fresh investigation. And in fact that is exactly what I think the emergent field of visual culture has been all about in its best moments. Visual culture is the field of study that refuses to take vision for granted, that insists on problematizing, theorizing, critiquing, and historicizing the visual process as such. It is not merely the hitching of an unexamined concept of "the visual" onto an only slightly more reflective notion of culture—visual culture as the "spectacle" wing of cultural studies. A more important feature of visual culture has been the sense in which this topic requires an examination of resistances to purely culturalist explanations, to inquiries into the nature of visual *nature*—the sciences of optics, the intricacies of visual technology, the hardware and software of seeing.

Some time ago Tom Crow had a good laugh at the expense of visual culture by suggesting that it has the same relation to art history as popular fads such as New Age healing, "Psychic Studies," or "Mental Culture" have to philosophy.[18] This seems a bit harsh, at the same time that it rather inflates the pedigree of a relatively young discipline like art history to compare it with the ancient lineage of philosophy. But Crow's remark might have a tonic effect, if only to warn visual culture against lapsing into a faddish pseudoscience, or even worse, into a prematurely bureaucratized academic department complete with letterhead, office space, and a secretary. Fortunately, we have plenty of disciplinarians around (Mieke Bal, Nicholas Mirzoeff, and Jim Elkins come to mind) who are committed to making things difficult for us, so there is hope that we will not settle into the intellectual equivalent of astrology or alchemy.

The breakup of the concept of "visual media" is surely one way of being tougher on ourselves. And it offers a couple of positive benefits. I have already suggested that it opens the way to a more nuanced taxonomy of media based in sensory and semiotic ratios. But most fundamentally, it puts "the visual" at the center of the analytic spotlight rather than treating it as a foundational concept that can be taken for granted. Among other things it encourages us to ask why and how "the visual" became so potent as a reified concept. How did it acquire its status as the "sovereign" sense, and its equally important role as the universal scapegoat, from the "downcast eyes" that Martin Jay has traced, to Debord's "society of the spectacle," Foucauldian "scopic regimes," Virilian "surveillance," and Baudrillardian "simulacra"? Like all fetish objects, the eye and the gaze have been both over- and underestimated, idolized and demonized. Visual culture at its most promising offers a way to get beyond these "scopic wars" into a more productive critical space, one in which we would study the intricate braiding and nesting of the visual with the other senses, reopen art history to the expanded field of images and visual practices that was the prospect envisioned by Warburgean art history, and find something more interesting to do with the offending eye than plucking it out. It is because there are no visual media that we need a concept of visual culture.

Notes

1. Clement Greenberg's "Towards a Newer Laocoon," *Partisan Review* 7 (July–August 1940): 296–310, is his most sustained reflection on the desired "purification"

of the visual arts. Michael Fried's "Art and Objecthood" is the classic polemic against the mixed, hybrid character of minimalist, "literalist," and "theatrical" art practices. See *ArtForum* 5 (June 1967): 12–23.

2. *The Painted Word* (New York: Farrar, Straus, and Giroux, 1975).

3. *Life on the Mississippi*, chap. 44, "City Sights" (London: Chatto and Windus, 1887).

4. See also Jacques Derrida's *Memoirs of the Blind* (Chicago: University of Chicago Press, 1993) for a discussion of the *necessary* moment of blindness that accompanies drawing, and especially the self-portrait.

5. My own answers to these questions are outlined in *"Ut pictura theoria*: Abstract Painting and the Repression of Language," in my *Picture Theory* (Chicago: University of Chicago Press, 1994). See, more recently, Caroline Jones, *Eyesight Alone: Clement Greenberg's Modernism and the Bureaucratization of the Senses* (Chicago: University of Chicago Press, 2005).

6. Williams, *Marxism and Literature* (New York: Oxford University Press, 1977), 158–164.

7. *Understanding Media* (1964; Cambridge, Mass.: MIT Press, 1994), 354.

8. See *Understanding Media*, 42: "any extension of ourselves" is an "'autoamputation.'"

9. The Chicago School of Media Theory, a student research collective organized at the University of Chicago in the winter of 2003, is currently exploring the possibility of such a media taxonomy, a "Media HyperAtlas" that would explore the boundaries and blendings of media. For further information, see the "Projects" section on their homepage: http://www.chicagoschoolmediatheory.net/home.htm/.

10. One might want to enter a caution here, however, that from a mathematical standpoint it is the denominator (spatially "underneath") that gives the expression an identity (as a matter of "thirds," "fourths," etc.) and the numerator is merely a supernumary counting aspect of the fraction.

11. See my "Metapictures," in *Picture Theory*.

12. See my "Ekphrasis and the Other," in *Picture Theory*, ch. 5.

13. This is perhaps the central claim of Gombrich's classic, *Art and Illusion* (New York: Bollingen Foundation, 1961).

14. See David C. Lindberg, *Theories of Vision from Al-Kindi to Kepler* (Chicago: University of Chicago Press, 1976).

15. *New Yorker* (May 10, 1993), 59–73.

16. Sartre, "The Look," in *Being and Nothingness* (New York: Philosophical Library, 1956).

17. Lacan, *The Four Fundamental Concepts of Psychoanalysis*, trans. Alan Sheridan (New York: Norton, 1977).

18. *October*, no. 77 (summer 1996), 34.

Projection: Vanishing and Becoming

Sean Cubitt

In Pliny's story of the origins of painting, a maiden of Corinth, daughter to the sculptor Butades but herself nameless, is spending a last evening with her lover, who has to leave on a long sea journey. The lamplight throws a silhouette of his much-loved profile on the wall. She finds a charcoal stick among the embers of the fire and traces his outline on the wall. And this is how the world of art enters human life. As David Bachelor has argued, this classical authority for the preeminence of drawing helped establish the Western tradition of the preeminence of *disegno* over *colore*, the rational impulse of mimesis over the irrational luxury and femininity of color's rapture.[1] Interestingly enough, the Buddhist tradition offers a rather different story about the origins of art. When the Buddha was still alive and living in Bihar, a young man was sent to make his portrait, despite the fact that painting had yet to be invented:

when he arrived at the place where the Buddha was in meditation, our first artist realized he had a problem: he was so overwhelmed by his subject's enlightened glow that he could not look at him. But then the Buddha made a suggestion. "We will go down to the bank of a clear and limpid pool," he said helpfully, "And you will look at me in the reflection of the water." They found an appropriately limpid pool, and the man happily painted the reflection.[2]

The world we see is but a reflection of a reality that escapes its reflections: this Buddhist myth of origin contrasts neatly with Pliny's tale in which, as Stoichita points out in his remarkable *History of the Shadow*, the original painting

delineates not the lover but his absence.[3] I cannot help thinking here of Bazin's argument that art has always been an attempt to cheat or at least outlive death; to secure some record of presence that would fill in for the real absence of the deceased.[4] I imagine the maid of Corinth saying goodbye as if her lover will never return from the unutterable dangers and unknown reaches of ocean. Both tales, it might be argued, are about absences. The Pliny version is about line as the origin of painting in projection; the Buddhist version is about reflection and concerns the whole figure, not just its outline. The Tibetan myth of origin includes color where the Greek omits it. The Buddhist version does not distinguish line and color. Nor does it, perhaps unexpectedly, pause as Plato did before the vanishing reality of the reflection of a reflection. Pliny emphasizes light's absence, shadow; the Buddhist tale emphasizes light itself. Nonetheless, the Buddhist version and its Greek parallel share a sense that the beginning of art lies in projected light.

I like to begin lectures on the history of cinema in a darkened room with a flashlight, making hand shadows in its beam to indicate that while the moving image technologies may be the most modern of media, they are also grounded in the most ancient. How swiftly must our first ancestors have discovered, as they danced, their cast shadows in sunlight or in the firelight on the walls of their dwellings? The point is made more strongly still by the "Hands of Pechemerle" addressed by Leroi-Gourhan in his path-breaking work in structural archeology.[5] This right hand was outlined sometime in the upper Paleolithic by someone blowing clay or charcoal over a hand to leave its outline on the rock. It is hard, probably impossible to decipher what was intended by this gesture: a record of a life like Friday's footprint in the sand in *Robinson Crusoe*? A hunting signal? What is clear is the method of its making: the puffs of pigment round the hand are, I want to say, a projection of the hand, size for size, on the rock wall.

In her work in psychoanalysis, Melanie Klein proposes the mechanism of projection as a vital step in the development of the child.[6] The child, she surmises, has immensely powerful, self-destructive tendencies which, were they ever to be enacted, would destroy the infant once and for all. Projection allows the child to transfer these emotions to an other or others. We use the phrase occasionally in adult life, suggesting that a colleague is projecting his or her paranoia onto others, or imagining that his or her insecurities motivate people who are entirely self-assured. For Klein, this ability to project inner life onto external objects is a key and distinguishing element of human development, a

primary process on a par with Freud's condensation and displacement, indeed integral to the latter.

These three senses of projection establish three types of origin: one mythical, one archeological, and one psychological. As metaphor, projection has a powerful place in the ways we construct our conception of humanity, from the idea of the self and its masks that recurs throughout social and anthropological reports, to the aspirations we have to beam some word of our existence out to the furthermost reaches of the galaxy. Klein's proposal for a psychoanalysis of childhood and the hands of Pechemerle share an implicit thinking of the body as light source, a perception which provides the backdrop to the more specifically cinematic metaphor of "astral projection" associated with Madame Blavatsky's theosophy and later New Age spirituality. There is something charming, naive even, about these inferences that the human body might be in some sense made of light, a childlike and Christlike faith in the innocence and capacity for divinity of embodiment. More recent work on the concept of projection has been more resolutely critical in its production of a sense that projection is necessarily and forever an ideological action.

The critique might be taken back as far as Plato's simile of the cave in *The Republic*,[7] with its sadistic image of the prisoners restrained in their hole, their heads and necks braced so that they can only see the screen at the back of the cave. Equally constraining, equally sadistic, and older still is the second commandment of the Decalogue, which forbids in very definite terms the making of images:

Thou shalt not make unto thee any graven image, or any likeness *of any thing* that *is* in heaven above, or that *is* in the earth beneath, or that *is* in the water under the earth: Thou shalt not bow down thyself to them, nor serve them: for I the Lord thy God *am* a jealous God, visiting the iniquity of the fathers upon the children unto the third and fourth *generation* of them that hate me.

Like the Law of Moses, Plato's simile rests on the premise that the projection, which the captives see, is illusionistic. They fall for it as reality because it resembles reality. Even though they may not know reality too well, the hypothetical prisoner who makes it to the outside world can, with a little philosophical education, recognize that the shadows he thought he knew are indeed projections of an ideal world that he now can see. The moral problem for Plato is not the reflection or the projection but the illusion: that the scene

on the wall of the cave might be mistaken for reality. The simile of course is an analogue for a more contentious argument, that the phenomena we all sense are merely projections of a higher reality which exceeds them as much as our world exceeds its shadows on the wall.

The night after Maxim Gorky attended the first film screenings in Russia, he wrote:

Last night I was in the Kingdom of Shadows. If only you knew how strange it was to be there. It is a world without sound without color. Everything there—the earth, the trees, the people, the water and the air—is dipped in monotonous grey. Grey rays of the sun across the grey sky, grey eyes in grey faces and the leaves of the trees are ashen grey. It is not life but its shadow, it is not motion but its soundless specter.... Noise-lessly the ashen-grey foliage of the trees sways in the wind, and the grey silhouettes of the people, as though condemned to eternal silence and cruelly punished by being deprived of all the colors of life, glide noiselessly along the grey ground.[8]

This vision of the cinema as the realm of those who have passed over Lethe hums in harmony with Plato's account of the cave as much as it does with Virgil's and Dante's visions of the realm of the ancient dead. The realm of the dead is the realm of absence, and therefore the realm of the silent, colorless line. Gorky's land of shadows reveals the fear of death that lies behind Pliny's story of Butades' daughter making the silhouette on the wall ahead of the loss of her lover: the act of drawing as a kind of *memento mori*. The realm of shadows also equates to Plato's cave in that it is the colorless, odorless, flavorless simu-lacrum of the world stripped of what most makes it real, of sensuous materi-ality for the nineteenth-century Russian, of ideal abstraction for the ancient Greek. Likewise Gorky seems to echo the iconoclasts of the Orthodox Church who smashed every sacred picture in brutal obedience to the Second Com-mandment. Gorky's realm of shadows in this sense seems a pre-echo of Jean Baudrillard's three phases of the icon, which first "masks and denatures a pro-found reality," then reveals the awful truth that "it masks the absence of a profound reality," and finally crumbles under the discovery that "it has no re-lation to any reality whatsoever."[9] The avenue opened by anchoring our beliefs about imaging in general and projection in particular in the duty to represent cannot but lead us toward this nihilism. At such a juncture, subject disappears along with object, since they are mutually constitutive. Those damned by the God of the Old Testament for idolatry, the prisoners in Plato's cave, and the

dupes Gorky observed that night in Nizhny-Novgorod are all themselves mere specters as a result of their spectral engagement in the illusions of projection. Where projection rules, they argue, there is no self to generate a world, no world to determine a self. The final truth of the realm of shadows is that representing leads not only to the loss of object but to the loss of the self, not just the depiction of death, but depiction as death.

From the delineation of the maid of Corinth to Baudrillard's disappearance is a long but unavoidable trip. The privilege granted to line in Pliny's tale is the beginning of a task of abstraction, which is of course why the line became so central to the emergent rationalism of the Renaissance, and why it maintained that ascendancy at least into the nineteenth century, and perhaps as late as minimalism and conceptual art of the 1960s and 1970s. Form is the visual analogue of the physical sciences in that it extrapolates from the world the mathematical expressions which appear to function as its underpinnings. Beneath the world of phenomena, we believed, there lay a deeper, truer, and more real reality of physical laws expressible as formulae or as essential forms, a reality of which we mortals might only sense the projections. Everything else, but especially color and the proximal senses of touch, taste, and scent, was epiphenomenal. It was not then sight as such which was feared so much as the temptation that sight evoked, the temptation to enter into dialogue with the phenomenality, the material textures of the world.

And so it happened that the one set of theoretical accounts that have addressed the idea of projection with any degree of rigor and precision sought to understand, in its origins in perspective, the establishment of the groundwork of ideology. Building on Panofsky's 1925 essay entitled "Perspective as Symbolic Form,"[10] apparatus theory in France and later in the UK and the United States proposed that the dual vanishing points within the image and without it, at the place where the viewer stands to receive and decipher the illusion of three-dimensionality, is a machine for the production of subjection.[11] Thus roboticist and artist Simon Penny could launch his remarkable attack on virtual reality as "completion of the enlightenment project," because it employed Cartesian coordinate space to generate an immersive experience of perspective which reconfirmed the centrality of the experience of individuality, not as social construction but as metaphysical given.[12] In rigorous materialist critiques grounded on the most meticulous art-historical scholarship, the machinery of projection stood accused of being the ideological instrument of oppression regardless of what material was shown.

Artists working in projection began to unpack the machineries they worked with. Brakhage disassembled the camera, seeking a pristine vision untrammeled by habit. Structural-materialist filmmakers like Gidal and Le Grice emptied the scene of depth, refused narrative, and despised depiction. Early videomakers intervened in broadcasting to upset the transparency of the receiver. In fact it was largely video that began to remake the possibilities of moving images, around the time that Baudrillard was first influencing our understanding of televisual culture.

The first distinction came from the realization that the video monitor is a light source rather than a reflecting surface. In David Hall's *A Situation Envisaged: The Rite II (Cultural Eclipse)*, a bank of monitors is stacked facing a wall, so that only a corona of light escapes, while on the back, facing the audience, is a reconstructed vertical-scan Baird televisor image of the moon (fig. 20.1). The possibilities of broadcasting began to appear as complex and rich resources rather than an enemy predestined to destruction. For Hall, too, the sense began to emerge that when we deal with broadcast and video projection has a number of new qualities. First, the unique locus of projection is no longer the cinema, a special, quasi-social space, governed by ritual, where the crowd is addressed as individual. In domestic media, the "projector" is still central, but the screens on which it beams its images are scattered across cities and nations. And with the beginnings of satellite transmission and earth-orbit telemetry, and especially the live broadcasts of the *Apollo* mission in 1969, it slowly became apparent that human beings were not the only ones to be engaged in projecting images. As the Early Release Observations (EROS) images from the Hubble Space Telescope have made abundantly clear, the universe is just as busy projecting light (and radio and other spectra) as we are, and has been doing it for a long time. While the geometrical point-source (and its derivative, the field source investigated by Renaissance perspectivists and intrinsic to the working of cinema projectors) retained its metaphorical centrality, broadcasting gave a new sense of the radiation of light outward not to one but to a huge multitude of screens, each of them in turn a light source.

As the ill-fated Star Wars weapons program reminds us, projection is not exclusively a peaceful or a leisure activity. From Speer's searchlight architecture at the Nürnberg rallies to Reagan's elaborate satellite defense system, projection has lived out a second (dare we say "shadow") existence as a weapon. When George Pal set about realizing *The War of the Worlds*, his Martians came

Figure 20.1 David Hall, *A Situation Envisaged: The Rite II (Cultural Eclipse)*, 1988–90. By kind permission of the artist. The broadcast image reveals its function as light source, a projection of electronic light modulated from invisible radio to visible light waves. See plate 19.

equipped with one of the more impressive ray guns of the 1950s. In those early days of television, as Jeffrey Sconce's history of haunted media reminds us,[13] the technologies of broadcasting came ready to hand as metaphors for paranormal and extraterrestrial anxieties. The projector as projectile is a variant on this theme, and suggests in the oblique manner proper to popular media a deep understanding of the nature of mediation. Every missile is a missive, and every act of war and violence a clumsy, defeated, but unmistakable effort at communication, even though its message is simply "surrender or die" or even just "die."

Figure 20.2 Gina Czarnecki, *Nascent*, 2005. By kind permission of the artist. In Czarnecki's large-scale digital projection bodies project in space and time, simultaneously present and absent, deliriously beautiful and at the same time burdened with a pain they shine onto the audience.

When even popular culture is capable of clear-sighted analysis of the nature of projection, the lack of substantial contemporary concern with it seems even stranger. In the era of early broadcasting and the first inklings of what might be meant by "network media," Pal and other science fiction directors established a critical sense of projection as a deadly weapon, and made their parodies of television into "mind rays," ideological instruments of terrifying efficiency. Yet this was not the only area of popular culture where projection as ideology was and remains clearly understood, as becomes clear if we turn to the second great governing visual regime of modernity, the map. As everybody knows, a two-dimensional map has to make compromises in order to present a three-dimensional world. The familiar Mercator projection stands accused of emphasizing the northern latitudes at the expense of the equatorial; the Peters' projection pushes in the opposite direction. The upside-down map

plays on orientation (the word originally denoted East's position at the top of the map in honor of the Holy Land); the Surrealist Map of the World, in origination a parody of rationalist geography, is today legible as a forerunner of semantic mapping, where nonspatial indicators like GDP, population, and density of communication usage are depicted by geometrical expansion of boarders, while the maps generally preserve in topology the geopolitical relations between territories. Pacific-centered maps adjust for the North Atlantic bias of Mercator. The hemispheric map suggests how powerfully ideological issues can play out—since the Cold War ended, you hardly ever see hemispheric maps; and the square map emphasizes the vulnerable zones of the poles. Many, many others are possible. The necessity of projection as a translation from three to two dimensions is not entirely the same as projective egometries used in perspective, but it is a close relative in the sense that distortion is inevitable, and ideology therefore relatively visible. On the other hand, unlike images, maps are expected to be tested against the actual topography of the territory they depict. Few cartographers are naive enough to believe that the mode of projection is without impact on the meanings (and the uses and pleasures) their maps can provide. Ironically, such naivety has become an unexamined premise in the arena of video art, where you would expect it to be most tested.

The majority of video artworks presented currently in biennales and major galleries are projected foursquare onto either white walls or occasionally silvered screens. The artists involved talk of a relationship with some sort with cinema. It is a bitter shame that so few of them have come across the rich history of projection as a medium for video over the last two decades. British vanguard theater group The People's Show, in a performance at the Green Room in Manchester in 1994, projected two discrete images onto a corrugated screen. Depending on your position, you could see one, or the other, or a striped rendition of both. As part of an installation for Video Positive at the Tate Liverpool in the 1991, Elsa Stansfield and Madelon Hooykaas placed their projector a matter of centimeters from the wall, and angled obliquely to it. The image distorted anamorphically across the wall, as well as being intense and crystal clear closest to the projector and diffuse, fading to nothing, at its furthest reach. In the 1970s Chris Welsby at the London Filmmakers' Coop projected one of his films vertically onto a pool of water. A number of exterior and interior installations are using the powerful illumination of new generation data projectors to project onto scrims (Bill Viola), playing with

translucence as a performative element of projection (Char Davies).[14] I touch only the surface here: Oursler's projection's onto dummies, for example, are widely known, as are Simon Biggs' projections onto ceilings and Mona Hatoum's onto floors.

The variables here are the screen itself, its materials, shape, and reflectance; the projector, its illumination, and its position relative to the screen; the atmosphere through which the light passes (with the end of smoking in cinemas, audiences are far less fascinated by the beam of light cutting through the air, but scrims and other media can be interposed in the beam); and any intervening reflective, refractive or filtering devices placed between the projector and the surface it projects onto. And yet the practice of projection, common to photography, cinematography, video, and now the digital media arts remains unquestioned in the vast majority of cases, the banal repetition of the unexamined foursquare screen, wide open to a largely forgotten or discredited apparatus theoretical analysis, yet incapable of moving beyond the conditions which made that analysis and critique so compelling a matter of mere decades ago. My first and perhaps most important comment is that we are at the very beginning of understanding how projection might work. If, as I believe, it is a hugely significant metaphor in the ways we understand our relationships with the world and with each other, then the kinds of formal permutations signaled by artists actively engaging in projection as a malleable resource for the making of art are potentially a royal road toward making new ways of seeing. By analogy with the changing conventions of mapmaking, we have not yet made the move away from the Mercator projection. We certainly haven't made the leap toward the non-Euclidean geometries which digital animation and data projection combined make thinkable and possible as tools for remaking projection. Multiple screens are in some cases at least a basic form of interactivity, but rarely in themselves challenge the basic apportionment of presentation between projection on the one hand and the light-source monitor on the other, cinema and television, mass entertainment and domestic consumption. Hall's *Rite Envisaged II* is in this context a satire on domestic consumerism. Where is the parallel satire on mass spectacle?

Multiple screens offer another lesson, however, particularly poignant in the context of data projection and its metaphorical proximity to laser as the medium of organized light and its dependence on coherent light technologies in both DVD/CD-ROM and fiber-optic network technologies. Implicit in Hall's discovery of the network, brought to fruition in works like Eduardo Kac's *Tele-*

porting an Unknown State, a networked installation in which webcams supplied enough light to keep a plant alive in a darkened gallery in Rio de Janeiro.[15] Where Hall redirects radiated broadcast signals to make their nature as light sources apparent, but also to defeat their signal-bearing (and thence ideological) instrumentality by converting the light back into pure signal, Kac extracts from the streams of representational imagery coming from remote users only the simplest, baldest fact of illumination.

Used loosely as a synonym for "digital," the word "virtual" has a richer history which such art addresses when it makes the act of projection the central technical and metaphorical structure of the work, and especially when the projector is no longer obviously in the same room as the image. Where the term "virtual" refers to the image created at a point in an optical system where the rays of light cross over one another, the virtual image has traditionally been seen, among others by Panofsky at the fountainhead of apparatus theory, as a vanishing point. Like the absence of light that allows the illusion of movement, when the shutter falls and the "entre image" flicks through the projector under the mask of darkness,[16] the vanishing point is a constitutive absence in the technology of projection. This chimes once again with the Plinian maid of Corinth who invents art by delineating the immanent absence of her departing lover. It is as if the whole history of Western art has been an elaborate sepulcher built over the bones of the dead to keep their memories alive, and to hide the brute fact that they are no longer there. This, in effect, is the simpler truth behind Baudrillard's nihilistic vision: it is not God or the world that has vanished, but the dead who we sought so hard to replicate and so to keep alive. It is perhaps time for us to face up to our mortality. The subjection proposed by Panofskyan apparatus theory is premised on the real absence of the object represented, but also, as we saw, on the real absence of the subject which otherwise is supposed (presupposed) to be its material support in the world. The absence of the subject is as profound a consequence as the disappearance of the object in projection. Subjection, in short, is the grand illusion. There is no subject, because the subject traced in projection is already dead.

In twentieth-century philosophy, however, facing up to mortality has taken on an entirely fetishized role, most of all in the writings of Martin Heidegger, for whom the central fact of Dasein, of human being, was the being toward death. Surely, we all die, thank God. To make death the center of life is, however, something of a dialectical dead end. Instead of such "fatal theory" Hannah Arendt proposed a concept of natality—the principle that

Figure 20.3 Gina Czarnecki, *Nascent*, 2005. By kind permission of the artist. Czarnecki's title indicates the potential for projection to shift from vanishing point to the ''natality'' of becoming, from the monocular individuation of perspective to the social palimpsest of multiple layers of image and light, still fraught, still dangerous, but oriented toward a future other than death. See plate 20.

the new beginning inherent in birth can make itself felt in the world only because the newcomer possesses the capacity of beginning something anew, that is, of acting. In this sense of initiative, an element of action, and therefore of natality, is inherent in all human activities. Moreover, since action is the political activity par excellence, natality, and not mortality, may be the central category of political, as distinguished from metaphysical, thought.[17]

It is this thought, which chimes so strongly with the concept of messianic time in Benjamin,[18] that inspires the thought that in the process of projection, we might be dealing with becoming, not vanishing. Vanishing points articulate the grounds of all representation in the abstraction of form from phenomenality and thence the risk that, in the absence of the represented, which is the very condition of representation, there can only be the stitching of ideological fripperies over the brute reality of the void. Such a vanishing also governs the disappearance of subjects in the act of consumption of images, as observed by Gorky and theorized by Baudrillard.

Instead of this fatal theory, let's consider the possibility of projection as the typical manner in which all entities, human, animal, organic and inorganic, radiate their signatures across space and time. Our projection technologies then do not have to be limited to the endlessly failing argument that they give an accurate account of the world, or a more accurate one than the neighboring technology. Instead, they can participate in generating worlds, and specifically in the production of meaning as the articulation of points of becoming one with another. Remaking projection practices is going to be one of the most fascinating elements of the development of new media in the twenty-first century, if it opens itself up not to absence but to the perpetual becoming of a world which is increasingly future.

The emergence of wireless technologies over the last few years suggests a further step. We may indeed be moving toward a world of ubiquitous surveillance, in which every citizen is equipped and ready to shine a light into his neighbor's secrets. But then, privacy was only ever a privilege of the wealthy few over a brief century and a half in a remote peninsula at the Western edge of the Asiatic continent. Wireless technology seems unlikely to assimilate all our toys into a single device, but what if it could assimilate the data projector in place of its tiny screen, like the charming holographic projector in the first *Star Wars* film? What price then a world of ubiquitous communication, a

Vanishing Points

Points of Becoming

Figure 20.4 Vanishing points/points of becoming: as seen in cine projection, point a is the projector lens, point b the perspectival "vanishing point," and point c the retinal image; reconsidered as points at which the image passes through a zero point in order to become both itself and other than it was.

world whose presence to itself would not be evaporated but redoubled? A ray gun future?

Alternatively, and in parallel, Paul Sermon's *Telematic Dreaming*, which connects two beds in remote locations on which users interact with the image of another body on the remote bed, something of the sensuality of the proximal senses of which projected light is capable became intensely apparent. As well as working with the most advanced technologies of the day, Sermon's installation cannot but evoke the sense of projection that Melanie Klein explored in her theory of object relations. His projections engage both light and the psyche, the projection, however, not of rage but of sensuality, shared embodiment, and empathy, a common humanity mediated by technology but experienced as bliss. Another of Sermon's works appeared in the London Millennium

Dome, alongside Sera Furneaux's *Kissing Booth*, where users recorded kisses into a database, where they could, virtually, kiss other previous users. The presence of both in a site, which mixed art with funfair, indicates the possibilities of projection in and beyond contemporary consumerism and mass culture, as a medium of copresence rather than one of mutual absence. Kristeva posited the abject as the loathed, feared, and despised undifferentiated indifference which drives us into the cruel separation of subject from object.[19] In the series abject subject–object, there remains the dialectical possibility of a new, third term: project. Quite what this relationship might mean we cannot know: by its nature it is of the order of becoming, a future-oriented operation whose outcome depends on the mysteries of becoming at those points in projector, screen, and eye where the image passes through itself to become both other and more truly itself.

Notes

1. David Batchelor, *Chromophobia* (London: Reaktion Books, 2000).

2. Victoria Finlay, *Colour* (London: Sceptre, 2002), 228.

3. Victor I. Stoichita, *A Short History of the Shadow* (London: Reaktion Books, 1997).

4. André Bazin, 1967. "Ontology of the Photographic Image," in *What Is Cinema?*, vol. 1, trans. Hugh Gray (Berkeley: University of California Press, 1967), 9–16.

5. André Leroi-Gurhan, "The Hands of Gargas: Towards a General Study," trans. Annette Michelson, *October* (summer 1986): 18–34.

6. See for example her essay entitled "Weaning" in Melanie Klein, *Envy and Gratitude and Other Works, 1946–1963* (London: Virago, 1988), 291, and the passage from "The Origins of Transference" on pages 203–204 of *The Selected Melanie Klein*, ed. Juliet Mitchell (London: Peregrine, 1986).

7. Plato, *The Republic*, trans. H. D. P. Lee (Harmondsworth: Penguin, 1955), part 7, §7, 278–286.

8. Quoted in Jay Leyda, *Kino: A History of the Russian and Soviet Film* (London: George Allen and Unwin, 1973), 407.

9. Jean Baudrillard, *Simulacra and Simulation*, trans. Sheila Faria Glaser (Ann Arbor: University of Michigan Press, 1994), 6.

10. Erwin Panofsky, *Perspective as Symbolic Form*, trans. Christopher S. Wood (New York: Zone Books, 1991 [1924–1925]).

11. See Jean-Louis Baudry, "The Apparatus: Metapsychological Approaches to the Impression of Reality in the Cinema," trans. Jean Andrews and Bertrand Augst, *Camera Obscura* 1 (fall 1976): 104–126 (originally published as "Le Dispositif," *Communications* 23 (1975): 56–72); Jean-Louis Baudry, "Ideological Effects of the Basic Cinematographic Apparatus," trans. Alan Williams, in *Movies and Methods Volume II*, ed. Bill Nichols (Berkeley: California University Press, 1985), 531–542; Daniel Dayan, "The Tutor Code of Classical Cinema," in *Movies and Methods*, vol. 1, ed. Bill Nichols (Berkeley: University of California Press, 1976), 438–451; Stephen Heath and Theresa de Lauretis, eds., *The Cinematic Apparatus*, London: Macmillan, 1980).

12. Simon Penny, "Virtual Reality as the Completion of the Enlightenment Project," in *Culture on the Brink: Ideologies of Technology*, ed. Gretchen Bender and Timothy Druckrey (Seattle: Bay Press, 1994), 231–248.

13. Jeffrey Sconce, *Haunted Media: Electronic Presence from Telegraphy to Television* (Durham, N.C.: Duke University Press, 2000).

14. See Peter Lunenfeld, *Snap to Grid: A User's Guide to Digital Arts, Media, and Culture* (Cambridge, Mass.: MIT Press, 2000), 208, no. 2.

15. Aleksandra Kostic, "Teleporting an Unknown State On the Web," in Eduardo Kac, *Telepresence, Biotelematics, Transgenic Art* (Maribor/Sào Paolo: Kibla Gallery/Itau Cultural, 2000), 4–5.

16. The term "entre image" is Raymond Bellour's.

17. Hannah Arendt, *The Human Condition* (Chicago: University of Chicago Press, 1958).

18. Walter Benjamin, "Theses on the Philosophy of History," in *Illuminations*, ed. Hannah Arendt, trans. Harry Zohn (New York: Schocken, 1969), 253–264.

19. Julia Kristeva, *Pouvoirs de l'horreur: Essai sur l'abjection* (Paris: Seuil, 1980).

Between a Bach and a Bard Place: Productive Constraint in Early Computer Arts

Douglas Kahn

> I might also say that what is finite and numerically calculable is
> superseding the indeterminateness of ideas that cannot be sub-
> jected to measurement and delimitation; but this formulation
> runs the risk of giving an oversimplified notion of how things
> stand. In fact, the very opposite is true: every analytical process,
> every division into parts, tends to provide an image of the world
> that is ever more complicated, just as Zeno of Elea, by refusing to
> accept space as continuous, ended up by separating Achilles from
> the tortoise by an infinite number of intermediate points.
> —ITALO CALVINO, "CYBERNETICS AND GHOSTS" (1967)[1]

The widespread use of computers in all aspects of the arts has rendered the
once robust term *computer art* too broad to be useful. When people say *computer
art* today, they usually mean art made at a time when computer use was still a
novelty and limited to a relatively small number of experimenters. For many,
the term now signifies bad art, or bad art variously rationalized, that was made
with computers, an opinion they happen to share with many people at the
time it was made. For our purposes here, "early computer arts" covers the
period from mainframes in the late 1950s through minicomputers, to the first
microcomputers, what would now be called personal computers, in the mid-
1970s. There is a growing interest in this period as a means to make some
sense of the social, cultural, and technological roles computers and digital
technologies assume today. However, many accounts of the period have been

filtered through notions of the visual and graphic arts, and screen-based media arts, whereas discussions of activities at the time had the breadth that one would imagine to be signified by "the arts"—a broad range of discrete disciplines and media as well as interdisciplinary and intermedia efforts.

It may be that the evolution of the computer arts itself has been mapped onto discussions taking place today. The excited discourses from the mid-1980s for "convergence" with an accompanying telos in fantasies of virtual reality were chastened in practice by routine artistic realities of graphics, orthography, and photography on CD-ROMs and websites. Current discussions on the history of computers and the arts are tempered by a similar admixture of heady potential and visualist limitation, when a grasp of the actual breadth of the early computer arts would be much more appropriate to understanding the transdisciplinary mélange and mobility that exists among artistic practices today. The arts using computers have neither been sucked into a voracious Mammon of optical bandwidth where separate media are eliminated, nor have they gone through a band-pass filter letting through a discrete set of practices and historical notions. My goal here is to align the broad disciplinarity and interdisciplinarity of early computer arts with the true breadth of artistic practices and possibilities today. This should result in greater historical accuracy and reassurance that not all computer art was bad art. I will propose that the most interesting artistic practices during the early period, the ones that stand up to scrutiny to the present day, took place in literature and music, which are among the very practices that have been downplayed in contemporary discourses that profess the comprehensive embrace of the digital. Additionally, the reasons that early forays into literature and music were so successful can tell us about the conditions of the historical privileging of the arts, if not the nature of the digital.

Computer technology motivates the term *computer art* and demarcates the period, but what was the art and who were the artists? Discussions have included anything from innocent little ditties never meant to go past momentary edification, to crude wire-frames that would develop industrially into special effects blockbusters flowing from Hollywood or flying through with a joystick over Iraq. Most importantly, there was an overwhelming predominance of engineers compared with a smattering of professional and self-identified artists, and very few engaged in art for a sustained amount of time. There was a greater number of artists engaged in the spheres of art and technology, machine art, and cybernetics, but the digital filter on computing nar-

rowed the numbers considerably. Moreover, the limitation on what digital computers could produce textually, visually, and audiophonically meant that only certain types of artists were attracted to work with computers in the first place, since it could mean compromised standards or tangents from their main projects and aesthetics. Some engineers may have trained as artists or musicians but very few were conversant with contemporary issues and aesthetics. There was an opening up to a few more artists as minicomputers found their way into academia and other institutions and then, by the late 1970s, the diverse and diffuse social configurations that are familiar to us today began to take shape as hobbyists and technologically inclined artists took up the first microcomputers. Over the course of this period the institutional and cultural dimensions of computing changed dramatically, from the predominance of "closed world" scenarios, in Paul Edwards' term, arising from an alignment of research in science, engineering, and social science with the exigencies of military, intelligence, security, and other projects of the state, to the countercultural, new left, hobbyist and hip capitalist environs of the burgeoning of personal computing, especially in the San Francisco Bay Area.[2] Once computers were on kitchen tables instead of institutional settings, the greater likelihood there was for fully realized works to begin appearing with great frequency across a broad range of the arts and culture.[3]

There was a relatively small number of large computers with what would seem now very little power, and very few of these were ever used for artistic projects, attached as they were to primitive interface technologies, housed in institutions almost uniformly engaged in projects hostile or indifferent to the arts, staffed by very few engineers in a position to undertake artistic projects of any caliber or interested in collaborating with artists who happened to have gained access. The capabilities of the hardware and programming were limited, and the information theory poised at the gateway to computing could only deal with phenomena expressible in discrete symbolic and quantized form. The mathematics, machines, culture, institutions, and knowledge base associated with the technology were conducive to only those arts predisposed to its conditions and, as we shall see, these were minor traditions within their respective arts. Given the step-down scenario of this politically powerful apparatus of limited capability privileging minor traditions only intermittently in the most extraordinary circumstances within the closed world, it is remarkable that anything was accomplished. What was accomplished was required to be so under social constraints of access, technological constraints making

computers nonconducive to most arts, and cultural constraints imposed by the lack of interest among most communities of artists. The arts that were able to flourish had a history of working productively under constraint.

Bad Computer Art

The notoriously poor quality of computer art is compounded by the "two-cultures" divergence of the engineering from the arts at the time: while Jack Kilby was working on the first integrated circuit, Robert Rauschenberg was carefully fitting a tire around the middle of a stuffed goat. However, assessments have and must take both engineering and the arts into account. Jasia Reichardt, recounting her influential 1968 exhibition "Cybernetic Serendipity" said that the predominance of engineers engaged in computer art was a positive aspect of the computer: "whereas new media inevitably contribute to the changing forms of the arts, it is unprecedented that a new tool should bring in its wake new people to become involved in creative activity."[4] She also said that visitors to the exhibition could not tell which works were made by artists and which were made by scientists or engineers, a statement that can be read with varying degrees of generosity. More recently, Lev Manovich has stated that various digitally based

technologies themselves have become the greatest art works of today. The greatest hypertext is the Web itself, because it is more complex, unpredictable and dynamic than any novel that could have been written by a single human writer, even James Joyce.... The greatest avant-garde film is software such as *Final Cut Pro* or *After Effects*.... J. C. R. Licklider, Douglas Engelbart, Ivan Sutherland, Ted Nelson, Seymour Papert, Tim Berners-Lee, and others—are the important artists of our time, maybe the only artists who are truly important and who will be remembered from this historical period.[5]

From Reichardt's humanism to Manovich's technophilia, this class of negotiation between artists and engineers is pervasive among discussions of computers and the arts.

The poor quality usually has been assessed, at the time and retrospectively, as an evolutionary primitivism deferring tangible achievement to a later date, a teleology more accepted within engineering and technological culture than the arts, yet tolerance is difficult to maintain when it comes to what Jim Pom-

eroy called "the look of computer art ... flashy geometric logos tunneling through twirling 'wire-frames,' graphic nudes, adolescent sci-fi fantasies, and endless variations on the Mona Lisa."[6] Desires, wild ideas, anecdotal musings, literary fictions, unrealized plans, and failed attempts, anything left unburdened by technological and institutional realities could easily be more compelling than fully realized works, whereas the overall quality of the tangible record has served to scare away generations of historians of the arts.

Malcolm Le Grice in 1974 was apprehensive about the conditions for film: "One must be wary of taking the 'negative' factors of certain present limitations, like the costs of computer time, and the sensuous poverty of interface equipment, and building an aesthetic around these."[7] More recently, Johanna Drucker was candid in her assessment of how "the contents of works produced by Ken Knowlton at Bell Labs are shockingly dull images of gulls aloft or a telephone on a table or a female nude rendered in symbol set," while at the same time reasonably warning against quick dismissals—"As technological developments have stabilized, the experimental features of earlier works have become harder to appreciate for the contributions they made at the time."[8] Bell Labs engineer A. Michael Noll's Piet Mondrian imitation of the mid-1960s may have achieved results in stochastic rendering in graphics, but it did little to impress those already familiar with the actual Piet Mondrian.[9] Noll himself candidly stated, "In the early 1960s, the digital computer offered great promise as a new tool and medium for the arts. In the past ten years, however, little has actually been accomplished in computer art. I've come to the conclusion that most computer art done by engineers and scientists, my own work included, would benefit from an artist's touch."[10] Lest one think that an *artist's touch* is supplemental, Noll is explicit: "The use of computers in the arts has yet to produce anything approaching entirely new aesthetic experiences."[11]

To arbitrate these negotiations, I propose a simple criterion to determine the quality of a particular instance of computer art from this period. Computer art should be required to relate to the contemporary developmental issues and aesthetics of their respective art, in the discursive and/or practical milieu, even if this milieu must be established after the fact. This is based on an acknowledgment that both engineering and the arts have their respective standards for sophistication, performance, and accomplishment. In the restricted environment of early computing, the simple presence of the computer itself can be understood as already holding up much of the requisite standard in engineering,

as proven by how it attracted a further abundance of excellent engineers. If we correspondingly lowered engineering standards to the artistic standards of much computer art at the time, then the computer itself would disappear and be replaced by an adding machine. Artists were interlopers in this environment and, moreover, not all were conversant with contemporary developments in the arts. To assure a certain level of conversance in assessment, any computer art under consideration should not merely relate to its respective contemporary developments, it should also involve an artistic engagement arising from a consistent aesthetic or cultural project, whether expressed prior to, during, or after working with the computer.

Only because the arts and artists were interlopers in early computing does it seem that holding up artistic standards might be an unreasonable demand: it certainly limits an already sparsely populated field. Perhaps ironically, it also contradicts the impression that nothing of artistic value occurred during this period. Reichardt herself wrote that her exhibition Cybernetic Serendipity "deals with possibilities rather than achievements," and she wasn't even specifically addressing digital computer works, which were more constrained than the other types of work in the exhibition. There are, however, at least two artists included in Cybernetic Serendipity whose works could be considered achievements using my simple criterion: Alison Knowles with the textual portion of her *House of Dust*, a combinatory text of poetic architectural spaces used for elaboration into actual spaces and events, and James Tenney with his compositions realized at Bell Labs, indicated in his account of his residency, "Computer Music Experiences, 1961–64" excerpted in the Cybernetic Serendipity catalog.

Reichardt's inclusive survey allows such comparisons, whereas, despite the interconnected nature of practical activities, recent studies of computer art and media arts have restricted notions of the arts that often exclude literature and music. Knowles' and Tenney's engagements are emblematic of the conduciveness of computers at the time to literature and music, specifically, the predispositions of the minor traditions of formalist and experimental literature and electronic music.[12] These traditions were capable of being born from the hip into the hip and did not require subjection to representations of primitivist or evolutionary deferral, with the obverse being that their present-day exclusion signals the privileging of a technological teleology. Productions within these traditions could be generated, manipulated, and presented in the realm of constraint attending early computers, programming, and interface technologies.

Their elements could be expressed in discrete forms—the letters and language of poetry, notational values and then sound synthesis in music—and in this way were amenable to the information theory positioned at the doorstep to computation. These sympathetic constraints could attract formidable artists with the promise that their efforts could result in fully realized works. Thus, during the early period of computer arts, the constraints of computation, programming, and institutional access were caught nicely between a Bach and a Bard place where so much could occur.

Constrained Literature: Perec and Knowles

Literature was the first art favored in computation, if only because Claude Shannon used the assembly of letters into language to demonstrate information theory. He did not use a computer, but he did use a random technique that could have easily belonged to experimental poetics in the 1950s and '60s:

one opens a book at random and selects a letter at random on the page. This letter is recorded. The book is then opened to another page and one reads until this letter is encountered. The succeeding letter is then recorded. Turning to another page this second letter is searched for and the succeeding letter recorded, etc.[13]

Shannon's literary connection was further elaborated in a 1949 article in *Astounding Science Fiction* (the same year Shannon's famous essay was published) written by Bell Labs engineer and Shannon colleague, John R. Pierce, under the pseudonym J. J. Coupling, and again in his book *An Introduction to Information Theory: Symbols, Signals, and Noise* (1961), where he affectionately interprets the results of Shannon's approximation rules on how letters might form words: "To me, *deamy* has a pleasant sound; I would take 'it's a deamy idea' in a complimentary sense. On the other hand, I'd hate to be denounced as *ilonasive*. I would not like to be called *grocid*; perhaps it reminds me of gross, groceries, and gravid. *Pondenome*, whatever it may be, is at least dignified."[14] He goes on to find a message for writers in one of Shannon's word order approximations:

The head and in frontal attack on an English writer that the character of this point is therefore another method for the letters that the time who ever told the problem for an unexpected.[15]

He says amusingly, "I find this disquieting. I feel that the English writer is in mortal danger, yet I cannot come to his aid because the latter part of the message is garbled."[16] Writing in 1961, the specter of writers in mortal danger melded with popular fantasies of every human role being replaced by computers, automation, and robot brains. As a writer himself, Pierce could relax because he knew the limitations of information theory and, being familiar with modernist literature and music, he knew it had a productive failure mode. He admitted that he was driven by "a sort of minimum philosophy of art" and asked that however he used it not be blamed on information theory. It was minimum because it said "nothing about the talent or genius which alone can make art worthwhile."[17]

During the 1960s a number of writers escaped mortal danger and brought their talents to computers. Among them was Georges Perec, one of France's most interesting authors during the second half of the century, and a member of OuLiPo (*Ouvroir de literature potentielle*), a small group of writers and mathematicians that included such famed individuals as Italo Calvino, Harry Mathews, and Raymond Queneau. OuLiPo busied itself with imposing *constraints* on literature and performing marvelously within them, which predisposed them to algorithmic devices and computation. In 1968, Perec created *L'art et la manière d'aborder son chef de service pour lui demander une augmentation* ("Ways and Means of Approaching Your Head of Department to Request an Increment [pay raise]"), a work that played on the correspondence between rationalistic processes involved in computing and the tedious, Kafkaesque rat-maze rationality of modern bureaucracies, a correspondence supported by the fact that computers were being increasingly installed at the heart of such bureaucracies. Indeed, *L'augmentation* could have been retribution as much as literature since Perec himself nearly lost his job for refusing to retrain on a computer. Based on a commission from the Humanities Computing Centre of the CNRS (*Centre National de la Recherche Scientifique*) "to explore the literary potential of an algorithm ... an ordered sequence of instructions written in a programming language for input into a computer, usually laid out in a flow chart. . . . The plot itself is a pun, since the French word for a pay rise or increment (*augmentation*) also signifies 'incrementation,' the procedure used by a computer to mark its path around an algorithm."[18] From entering management offices, to waiting expectantly with interior monologues, taking stock of the signaling environment, buttering-up small talk of great significance,

reverting to Plan B after failure at minor obstacle, diversion by unexpected bout of measles, waiting until later, waiting until much later, etc., and after final refusal waiting six months whether there is hope or not, then recycling through a completely different set of possibilities before refusal and another six-month wait. In the end, labors pass through the system but no pay raise, plenty of incrementations but no incrementation, only a serpentine rationality biting its own tail. Thus, the Perec's *L'augmentation* algorithm circles back onto the capabilities of the computer to produce technical plenitude as it locks into social cycles of impoverishment, and unwittingly acts as a bilingual cautionary to Douglas Engelbart's *augmentation*.

Computer literature extended long-standing traditions of formal literatures, word and language games, rhetorical displays and experimental poetics and, in turn, we can find a common ancestry for computers and these literatures in Gottfried Wilhelm Leibniz's *De arte combinatoria* (*On the Art of Combination*) from 1666, with the simple fecundity of the "protean verses" it described of common interest to both rhetoricians and mathematicians. The relevance of this tradition to the constrained and potential literatures of OuLiPo has already been noted by commentators both in and outside OuLiPo,[19] with perhaps the best-known OuLiPo work, *Cent mille milliards de poèmes* (1961) (*One Hundred Million Million Poems*) by Raymond Queneau, deriving metaphysically from the plenitude of the writing machine imagined by Athanasius Kircher in his *Ars Magna* (1669) that produces a number of texts—

so immense that one could fill the entire world with books in which these propositions [enumerating the attributes of God] would be written; and if the entire Ocean, even all the liquid portion of the universe were changed into ink, it would run out before one reached the end of these books to be written, even if all men devoted millions of years to writing them, from the creation of the world to its end.[20]

Combinatorial techniques have long existed in musical culture. For those students lacking invention, Francesco Galeazzi in his *Elementi teorico-pratici de musica* (1791–96) demonstrated how easily a great number of choices could be generated. As Leonard Ratner describes, "if the eight notes of the octave are combined with values of minims and crotchets one can obtain 20,922,789,880,000 different melodies, and by adding quavers to the permutations the enormous sum of 620,448,401,733,239,439,360,000 melodies is

available."[21] Early descriptions of information theory and computation similarly overflowed with extravagant amounts, accompanied by the redundant means to tame wild proliferation.

Predictably, OuLiPo was attracted to musical machinations.[22] There was no direct musical connection for Alison Knowles in her creation of *House of Dust* (1968), only a contextual one stemming from her involvement in Fluxus and an oblique one through her friendship with the composer James Tenney. Knowles and Tenney knew each other from the Manhattan arts scene during a time when it was still relatively small. Knowles was one of the central members of Fluxus before it was Fluxus, from its nominal launch in Wiesbaden, and has had a long and productive career to the present day. Fluxus was the most musical of the avant-gardes up to that time and, with much experimental music, was heavily influenced by the ideas, works, and person of John Cage. Tenney was not only influenced by Cage; from the mid-1960s he began to compose Fluxus-influenced pieces, including *Swell Piece, for Alison Knowles* (1967). Based on the skills he had garnered during his composer residency at Bell Labs from 1961 to 1964, Tenney offered a workshop in Fortran to friends in New York, including Philip Corner, Dick Higgins, Jackson MacLow, Max Neuhaus, Nam June Paik, Steve Reich and Knowles. With assistance from Tenney, Knowles generated a combinatorial text destined in part for the book *Fantastic Architecture*, edited by Wolf Vostell and Dick Higgins. The computer text excerpted in the book began:

```
A HOUSE OF PAPER
     AMONG HIGH MOUNTAINS
          USING NATURAL LIGHT
               INHABITED BY FISHERMEN AND FAMILIES
A HOUSE OF LEAVES
     BY A RIVER
          USING CANDLES
               INHABITED BY PEOPLE SPEAKING MANY LANGUAGES
               WEARING
               LITTLE OR NO CLOTHING
A HOUSE OF WOOD
     BY AN ABANDONED LAKE
          USING CANDLES
               INHABITED BY PEOPLE FROM MANY WALKS OF LIFE
```

```
A HOUSE OF DISCARDED CLOTHING
      AMONG HIGH MOUNTAINS
            USING NATURAL LIGHT
                  INHABITED BY LITTLE BOYS
A HOUSE OF DUST
      IN A PLACE WITH BOTH HEAVY RAIN AND BRIGHT SUN
            USING ALL AVAILABLE LIGHTING
                  INHABITED BY FRIENDS[23]
```

The computer generated reams of additional poetic architecture, sites, and social situations. To the extent that it is combinatorial, the computer merely expedited a literary technique. Where the text differs from similar texts is that it also served as a set of instructions, which Knowles used to build structures and conduct actions. In this way, it was part of the event score tradition associated with Fluxus, where short texts act as instructions open to interpretation and methods of realization, even if they were improbable, impossible, or purely conceptual. The descriptive computer-generated stanzas of *House of Dust* were, in Knowles' realizations, the germs for intermedia expression moving provocatively among art, architecture, poetry, performance, and everyday life.

The further Knowles' descriptions jumped off the page and entered into the field of intermedia mobility the more technological valorization of computation fell into the background as a service rendered. In this regard, it resembles present-day practice where computation and the digital are simply working components in a larger artistic, social, and technological scheme, working perhaps in an ingenious but not front-and-center manner. In contrast, Perec's *L'augmentation* places the computer symbolically and in a more focused manner in a tradition of literary parody and narrative. The computer becomes an operating system that operates in a system of bureaucratic capitalism, complicit in managerial containment of individuals working in the algorithms of day-to-day life. It has not entered directly into such containment, as the fears and realities of automation specified at the time, but instead aligns itself more ominously in an epochal *coup* of rationality imposing itself. Unlike the evident service role it plays in *House of Dust*, it lurks under the surface of the text, intact but not immediately obvious. Perec acknowledges its hidden role in social power, whereas Knowles shows how it might be overpowered. For our purposes here, both are clearly achievements rather than possibilities, in

Reichardt's terms, and were not meant as drafts for a deferred artistic or technological fruition.

Un/Constrained Music: Tenney at Bell Labs

Although both literature and music were capable of fully realized works during the early period of computer art, there is a case for music to be acknowledged as the first digital art. The simplicity of conventional music notation, of Western art music's native code, the discrete character of its symbolic elements, its absence of semantic content, its long tenure with mathematics—all rendered it conducive to quantizing, to information theory and computation.

It was the same rationality that attracted early forays of information theory into discussions of music composition and analysis in the 1950s by the likes of Leonard Meyer, Richard Pinkerton, Werner Meyer-Eppler, Abraham Moles, and Lejaren Hiller. In this way, musical investigations (analysis and composition) based on notation were not too different from literary and linguistic investigations. In most respects, as long as it remained discrete and outside the flow of time, notation resembled the textual basis of the letters and words of literature. However, where early computer music differs fundamentally from literature is that it also used computers for realization, not merely expedition, manifesting itself in time as densely controlled, synthesized sound. When the computer was used to generate notation to be played by conventional musical instruments, it operated on the same coarse level of a letter, but sound synthesis dipped down to the voltages coursing through the code of the computer.

Notes were the same native code capable of relating musical intervals to the putative proportions of the universe which could then underscore the cosmic conceit parlayed in Western art music discourse. That began to be challenged with the separation of acoustics from music in the late eighteenth century, which later would inform the twentieth-century avant-garde mission of superseding the limitations of musical notation with the plenitude of acoustical phenomena. The musical avant-garde from the first half of the twentieth century was concerned with the incorporation of hitherto nonmusical sounds into music, including dissonance, percussion, expanded timbre, nonorchestral instruments, noise, electronic and environmental sounds. This was part of a larger artistic trend beginning in the late nineteenth century toward an incor-

poration of *all sounds* that had found its clearest expression outside the arts in ideas surrounding the phonograph (and earlier with the phonautograph). As the twentieth century proceeded, part of the new regime of all sound was trafficked in electronic music. Not only did electronic music provide the aesthetic whereby the fruits of digitally synthesized computer music could be entertained in the first place, its voltages harbored the signal that would in turn be used to supersede acoustics by promising the controlled creation of any and all sound, including those unavailable among existing phenomena. Historically, therefore, acoustics superseded notes and the signal superseded acoustics to establish the infinitesimal constitution of *all sound*.

However, a proliferation of new, complex sounds seemed at odds with the reductions and quantifications of information theory and computation, but the signal promised just that, at least in theory. "All sounds," wrote Bell Labs engineer Max Mathews, "have a pressure function and any sound can be produced by generating its pressure function, it will be capable of producing any sound, including speech, music, and noise."[24] But to do so meant effectively working at a minute level requiring huge numbers to produce short sounds, with the computer expediting a process that would otherwise be measured in lifetimes. For instance, to specify "the sound of Beethoven's Fifth Symphony we would have to specify 30,000 numbers for each second of music and the entire piece would require as many numbers as could be written on all the pages of the whole Encyclopaedia Britannica. No human being could possibly write all the samples in any but the shortest sound."[25] John Pierce wrote that "30,000 three-digit decimal numbers a second," would allow any number of "twenty-minute compositions which can be written as 1 followed by 108 million 0's."[26] This is not an infinite number, but it would still put a composer in mortal danger, because this is a number only Rotman's Ghost could contemplate.[27] These factors haunted early sound synthesis more prosaically in the meticulous, incredibly tedious and time-consuming process of programming. Huge stacks of punch-cards, along with difficult problems in acoustics and psychoacoustics, reasserted practical constraints on any promise of plenitude.

The first composer to work for any length of time with digitally synthesized sound at Bell Labs was James Tenney. He is part of the tradition of "American rogue" composers—including Charles Ives, Carl Ruggles, Edgar Varèse, Conlon Nancarrow, Harry Partch, and John Cage—a tradition he helped champion, and was friends with many of them. He was married to

the artist Carolee Schneeman and participated in many of her performances and films, and was close friends since high school with the filmmaker Stan Brakhage, providing sound and making appearances in some of his films. At the time of his residence at Bell Labs he was living in New York and was centrally involved in the arts scene.

Immediately prior to coming to Bell Labs, Tenney studied with Lejaren Hiller in the Electronic Music Lab at University of Illinois, who also introduced him to Shannon's information theory. His master's thesis, *Meta/Hodos*, an original theory of twentieth-century music composition, became an important text for younger composers and helped establish Tenney's reputation as a composer's composer. In it he theorized, among other things, that the trajectory distinguishing twentieth-century Western art music as a whole could be understood as a product of a deeper reign of speech, as opposed to traditional musical form. This might very well have provided a sense of historical sanction as he took up residence at Bell Labs.

It is not insignificant that the whole institutional drive for computer sound generation derived from efforts to synthesize speech. That was the original impulse to develop the program at Bell Labs. No one said, "Oh, let's make music." Instead, there just happened to be a guy who was involved in the speech synthesis project who was an amateur musician, and he said, "Hey, I can make music with this too."

The amateur musician that Tenney mentions was Max Mathews, who was primarily responsible for developing synthesis and music software. Tenney felt that Mathews, along with John Pierce, Joan Miller, and others were, as engineers, "The best. But musically, I'm afraid, just engineers."[28] To their credit, it was their musical interests that moved them into the development of this significant music technology in the first place, and their self-awareness of the extent of their musical knowledge that moved them to engage composers at the lab. They were not interested in composers entranced in the nonscientific mathematics of the implied esoteric tunings and geometries of what Pierce called a numerological approach;[29] Tenney was required to meet them on their ground of engineering to move the project forward.

Tenney saw the computer as a means to further the emancipatory modernist project of *all sound*, following the likes of Varèse and Cage who had already

done much of the work. He felt strongly that the "distinction between so-called musical sounds and unmusical sounds was useless," and to privilege the former was to negate much of the great music of the twentieth century. "How can you listen to Webern's Opus 6 without realizing how integral tone and noise have to be considered to be in order to even describe such a piece?"[30] The notion that all sounds could be synthesized proved more difficult in practice. There was a common complaint that Mathew's early programs produced uninteresting hornpipe sounds or, as the first composer-in-residence at Bell Labs (1961) David Lewin said, "bad-Hammond-organ sounds."[31] From the start of his residency at Bell Labs, Tenney was concerned with changing this situation. He had a long-standing interest in complex sounds and sound events that he theorized as the *clang* in *Meta/Hodos*, and he had been particularly disappointed with the simplicity of the sounds in "purely synthetic electronic music . . . particularly with respect to *timbre*."[32]

Historically, timbre was inscribed at the inception of avant-garde manifestations of *all sound* within music. Luigi Russolo's *art of noises* from 1913, for example, proposed an artistic incorporation of hitherto nonmusical sounds in the tradition of Western art music but was in practice a more limited program for extending the scope of timbre. Tenney likewise concentrated on timbre, but brought a much more scientific approach to bear which included substantive readings and research into acoustics (including generation of the exceedingly complex acoustics of bells) and psychoacoustics. Whereas other researchers would normally start from the simple and move to the complex, Tenney reversed this approach. "From the very beginning of my work at Bell, I said I want to start with the whole world of sound, so what kind of programming structure would I have to design here that would have all the variables needed to get that noise that I just heard down the street? I would walk around New York City listening to sounds and ask myself, how would I generate that?"[33] *Noise Study* (1961), his first composition during the residency, was inspired by his daily trip through the Holland Tunnel en route from Soho to Bell Labs at Murray Hill, New Jersey. Such pursuits were in no way contradictory to the larger needs of the project at Bell Labs. The modernist impulse for generating *all sound* overlapped nicely with the need for accurate synthesis of conventional musical instruments, and for lending greater understanding to the acoustical and psychoacoustical properties needed more generally in telephony and other telecommunications research.

Equipped with the computer, Tenney felt that he could pick up where Varèse, Cage, and others had left off, extending further into realms of sound and moving through sound in unprecedented ways.

The computer could move across a continuum, demonstrate a continuous character by creating a sound that goes from one category to another with no break. What were once two different categories would become just two ends of the same sound. I don't know but I may have been the first person to do this. Certainly the computer made it possible, but it also required somebody who wanted to do it.[34]

The categories he mentions included amplitude, frequency, harmonic spectrum, noise, or any number of other parameters, moving continuously through respective differences among each one as well as from one category to another. Simple demonstration can be found in Tenney's sound for George Brecht's *Entrance and Exit Music* (1964), consisting of a six-minute, quarter-track audiotape of a smooth transition from white noise to sine wave tone for the entrance, which is then reversed for the exit.[35] "The continuum from a sine wave to more complex wave forms is easy enough; you just gradually begin to modify the wave shape and you start introducing harmonics. So you're altering a spectrum, you're enriching the spectrum."[36] This continuity itself was mobile, moving through different gestalts, from the minute constituent events of short sounds, to larger events within a work, to an even larger event of the work itself. For Tenney, all were objects of perception and products of the signal. "What the computer did with the program was to make available, for the first time in history, the possibility of moving continuously throughout the total field of sound because it was dealing with the signal itself."[37]

Tenney's emphasis on continuity was part of a legacy in modernist music from at least the time of Busoni.[38] Only because time could be controlled at the level of the signal could it negate the privileging of the discrete in information theory and early computation and manifest itself so explicitly in continuity. For computer literature to do the same would have required that it enter into the arena of time in the form of the sounds of speech. Tenney's compositions at Bell Labs are clearly achievements in themselves as well as a consistent body of work, but they also signaled a possibility based on the promise of digital sound synthesis for the production of all sound. For the continuous movement Tenney sought among the reduced code of electronic sounds could

theoretically be extended to all the parameters of all sound, including those of speech and environmental sounds.

Social Parameters of Constraint

During the postwar period in the United States, technologically working from the infinitesimal signal to the infinitude of artistic possibility was both rhetorically and practically in the shadow of "the greatest scientific gamble in history ... the greatest achievement of organized science in history," as Harry Truman said in his speech sixteen hours after the United States bombed the civilian population of Hiroshima. Rhetorically, according to Truman, in raiding the inner sanctum of the infinitesimal atom the United States had control over the forces of the entire universe. They were able bring the reality of the of sun down upon the earth and set it against the false, symbolic rising sun of Japan, although they still needed sanctioning by God. Practically, the successful engagement of science and engineering in the war effort continued to flourish in what C. Wright Millsand and Seymour Melman termed the *permanent war economy* during the second half of the century. Computer music at Bell Labs promised to unleash a different plenitude at the same time that military and intelligence projects flourished in other corners of the institution, especially the Whippany Laboratory: radar, satellite communications, guidance, navigation, cryptography, encryption, and so on.

The robot brains of war continue to this day apace, of course, but over the course of three decades after the war, the once unified, militarist closed-world environs of computers would be transformed at a historically rapid pace to the individual and collectivist uses brought on by the advent of microcomputing in the latter half of the 1970s. Correspondingly, the artistic activity and collaboration of mainframes mapped onto closed-world scientific models and habitats would pass culturally and politically through the antimilitarist, antibureaucratic, democratizing and radicalizing effects of the civil rights movement, antiwar movement, new left, counterculture, and feminism, on its way to various forms of institutionalization, hip capitalism, to new complicit and countering forces.

Tenney and the artistic community to which he belonged were artistically, culturally, and politically radical. A few years after his residency at Bell Labs, Tenney had an experience which itself embodies the growing tensions manifesting themselves in the 1960s. He was asked to present a talk on computer

music at the Polytechnic Institute of Brooklyn, but he was told that there would be in attendance representatives of the Department of Defense or corporations under defense contracts. After initially refusing to talk to them, he was persuaded to do so.

So finally, I said okay. I had just finished a piece called *Fabric for Ché* (1967), which said something about my disgust about the war in Vietnam. I talked about the process, which is all very interesting, then I announced it and turned it on. These guys began to squirm. Rudy [Rudolf Drenick, Head of the Department of Electrical Engineering] squirmed. He had been very friendly to me before that point.... It all blew over after a while. I was defended by some very high powered people at the Institute.[39]

Just as Tenney had internalized engineering skills during his tenure at Bell Labs which he then shared with a wider community of artists in his programming workshop, so too had the skills of throngs of engineers become embodied in the technological development leading to the microcomputer kits and consumer models of the 1970s. With those kits in hand, the single individual of Tenney-the-composer, accorded privileged access to scarce computing resources, was likewise distributed historically into the composer-performer collectives in the 1970s and '80s. And just as music had been the first digital art among mainframes, the same was true for microcomputers. Instead of going to work at Bell Labs, a new generation of musicians and artists met outside laboratory walls in dispersed social formations in the San Francisco Bay Area, including the mid-Peninsula locales that would develop into Silicon Valley.

The Bay Area has historically been better at generating cultural movements than producing art stars and markets. The collectivist nature of the area, especially in the 1960s and '70s, was conducive to the development of the free speech movement, counterculture, personal computing, hacker culture, and early art using personal computers.[40] This collectivism, in itself part of and designed into the fabric of personal computing, along with the access that came with a dramatic lowering of costs, was responsible for a removal of the social constraints that had saddled the computers arts.

In 1975 Steve Dompier, a Berkeley building contractor, began making music quite by accident on the first widely available microcomputer, the Altair 8800 (named after a planet on *Star Trek*), when the electromagnetic field of the computer interfered with a nearby radio. He developed a simple

program to set off different pitches and then applied the program to the first sheet music he could find—the Beatles' "Fool on the Hill"—for presentation at the legendary Homebrew Computer Club.[41] However, the first serious piece of music utilizing the Altair, and likely the first made on a personal computer, was *Seastones*, composed by Ned Lagin the same year. Lagin had broad scientific, technological, philosophical, and artistic interests and was, for a short period, involved closely with the Grateful Dead. He was studying to be a biologist and astronaut at MIT, while also studying jazz and composition, when he helped organize a Grateful Dead concert in May 1970. As their escort in Cambridge, he played them one of his compositions, for eight channels on four tape recorders, at the MIT Chapel. They were impressed and he was soon brought into their ranks, collaborating with the band for the next five years. *Seastones* was begun in 1970 and later performed at Dead concerts and elsewhere until it was released on LP in 1975, the same year Lagin separated from the band.[42] With the participation of Phil Lesh, Jerry Garcia, and David Crosby, the countercultural and Bay Area connections are explicit. *Seastones* has received little attention, perhaps because it falls between the cracks of experimental works by pop figures (Lou Reed's *Metal Machine Music*, John Lennon's work with Yoko Ono) and the conventionally described ranks of experimental and electronic music.

The earliest concentration of artistic innovation carried out on microcomputers in the United State took place on the KIM-1 among a group of artists and musicians in and around the Center for Contemporary Music (CCM) at Mills College in Oakland in the latter half of the 1970s. The electronic and experimental music concentration at CCM was manifest in the use of tape recorders, synthesizers, and the modular black-box, DIY circuit design and live-electronic approaches inspired by David Tudor, Gordon Mumma, David Behrman, and Pauline Oliveros, among others. These technological concerns layered on top of traditions of musical scores and performance practices proved to be rich ground for the adoption of, in Paul DeMarinis' words, "a primitive, slow, memory-limited, bandwidth-limited computer" that was the KIM-1.[43] DeMarinis observed that the feeling in the Bay was that music technology was ten years ahead of time-based technology for the visual arts, and no doubt further ahead for its live performance capabilities. Pinning the reason on bandwidth alone was, he felt, too heavy-handed. "There were other factors. The differentiation of control level and synthesis level in music had already been very well established. There was a level of knobs, control voltages, variations,

a level of performance, a level of oscillators, all that had been very well established for how you make something for people who were doing what could be agreed upon as *music*."[44] All these factors had been internalized in the culture and pedagogy at Mills.

The social conditions at Mills were crucial. There was on openness, not uncommon for the time, that had been instituted at Mills when the community-oriented San Francisco Tape Music Center moved to Mills, and was codified under the anti-authoritarian authority of the composer Bob Ashley when he became director. A hallmark of these conditions was an open-campus model that welcomed people with no official capacity as students, faculty, or staff. Their license was granted if they contributed to the milieu. One such person was Jim Horton, a monastic individual who would have undoubtedly qualified as one of those "numerologists" that irritated John Pierce. Interested in arcane tuning systems, although not for their esoteric content, Horton followed the development of kit computer and chip technology closely and persuaded his peers to begin using the KIM-1. Paul DeMarinis, John Bischoff, Rich Gold, Tim Perkis, David Behrman, George Lewis, Chris Brown, and others followed Horton's lead. In my discussions with them, several of these individuals contrasted the open-campus approach at Mills to the laboratory setting across the Bay at Stanford's Center for Computer Research in Music and Acoustics (CCRMA, pronounced *karma*). All respected the work done by John Chowning and others, but still felt that it was a different universe, one that would not have been conducive to the developments that took place at Mills. CCRMA was operating on a vertical model of scientific research not unlike Bell Labs, whereas Mills operated on a horizontal model that opened up to the creativity of a more diverse set of individuals and networks.

The KIM-1 was a portable device for extending the Mills milieu further still. Synthesizers were still too expensive for personal ownership and there was a queue waiting to use them at the CCM. The KIM-1's affordability meant that an electronic instrument could be taken home for full-time use; its size meant it could be toted around for use in performance, and its programmability meant a greater flexibility in performance. John Bischoff, David Behrman, and George Lewis have all stated that one of their main interests was how the KIM-1 could be used in a live-electronic framework for performance, rather than conventional computer music composition at the time which would be presented after the fact on audiotape played through speakers. Behrman and Lewis were also expert at incorporating the KIM-1 interactively

with improvising musicians in such works as *On the Other Ocean* (1977) and *The KIM and I* (1979), respectively. For the League of Automatic Music Composers (Horton, Gold, Bischoff, Behrman, among other groupings) this meant a new form of networked music that, along with The Hub later on, was an important precursor to distributed production and performance on the Internet.

Mills was open to the influences of people like Horton, and the microcomputer's conduciveness to music was in part responsible for its location among the ranks of the CCM. However, the social and technological diffusion of the Mills milieu into the arts and culture of personal computing can be attributed to the fact that Mills was not merely open to musicians and the signal was not merely open to music. Electronic music overlapped with experimentalism among all the arts, all the new forms of performance, installation, sculpture, conceptual and media arts and design that were occurring in the arts communities of the Bay Area. The KIM-1 itself came equipped with user groups with a myriad of amateur and professional interests, resembling and in fact drawing directly from the community of amateur radio operators.[45] Paul DeMarinis and Rich Gold, in particular, moved the KIM-1 into a broader range of purposes.

DeMarinis' first use was a simple one: his contribution to the performance/installation of David Tudor's *Rainforest* (January 1977) at the Center for Musical Experiment (University of California at San Diego) in which he sent a square-wave through "a big disc of stainless steel with a transducer on it." The same month he collaborated with Jim Pomeroy in *A Byte at the Opera*, "a cantata for computer and creeper."[46] DeMarinis performed live sound on the KIM-1 while suspended on a platform five feet above a small elevated stage covered with powder. Pomeroy, in the crawl space below the stage, was responsible for small objects moving mysteriously through the powder, and for puncturing and drilling through the stage floor, while DeMarinis used the KIM-1 to trigger small explosions in the powder, finally emerging to rescue the musician from his perch. (See fig. 21.1.) DeMarinis also used the KIM-1 in the sound installation *Sounds and the Shadows of Sounds* (1978), which used a pitch follower and white noise generated from a Radio Shack police-band radio. He used the former to "search for pitched sounds in the environment and listen for awhile and play back this kind of spectral shadow of the sounds. So the sounds might have been very pitched but they were played back through a filter as these shadows of white noise."[47] DeMarinis subsequently

January 22, 1977

Figure 21.1 Paul DeMarinis and Jim Pomeroy performing *A Byte at the Opera*. By kind permission of Paul DeMarinis.

developed into and continues to be perhaps the most substantial artist ever to have used sound in his work and is one of the main artistic practitioners of what has come to be known as media archaeology.

Rich Gold performed on his KIM-1 with the League of Automatic Music Composers and also produced art installations and performances, including an MFA exhibition at Mills with little paintings on the backs of playing cards. For a piece of musical theater called *Fictional Travels in a Mythical Land* performed at CCM (December 1977) Gold used the KIM-1 ("program in the 1K

of memory ... with nothing more than a digital to analog converter between the computer and amplifier")[48] for a program called "A Terrain Reader," in effect, a topographical sonification device that could be used to generate sound from movement across virtual, mythical, and real landscapes. Gold formulated his approach from three related ideas in modernist and avant-garde music: how twelve-tone and serial music led to computer music in terms of numeric parameters; "concept music," or how numerical processes and other ideas could be used to generate music where the concept was just as important as the sound; and how John Cage's random and indeterminate processes and concepts were then applicable to a "liberation of sound ... that *any* sound could be used in a piece of music."[49]

The important part of this approach was that it contained its own seeds of abstraction and extension which could in turn be generalized to numerical-computational processes (parameters) of concepts belonging to larger domains and dimensions of life beyond sound and music. In one instance from 1978, the trajectories and travels in a mythical land calculated the offsetting relationships that would lead to "Happiness of the Suburbs," or unhappiness, among a set of characters who were narcissistic, agoraphobic; rich, self-confident; smart, structuralistic; attendant, appreciative; and so on.[50] Beginning in 1980, Gold produced his remarkable "Goldographs," on ongoing set of self-published projects, each one a "sophistry from a semi-fictional world." The first Goldographs were based on the early cellular automata of John H. Conway's "Game of Life"—itself based on John von Neumann's hypothetical machine that could build copies of itself—and Gold's own invention of "algorithmic symbolism." They were intensely conceptual, poetic, and funny exercises, some of them manifesting Duchamp-like technosexual allegories into the digital age.[51] The breadth and ingenuity of the Goldographs, Gold's subsequent activities until his untimely death in 2003, and his ideas about game and interface design, and social interaction in general can perhaps best be described as an extension of conceptual design to *metadiscursive design*, a field and approach which will no doubt be elaborated and indebted to Gold for years to come.

The interactive and improvisational modes of David Behrman and George Lewis, the networking of the League of Automatic Music Composers, and the extension to new fields of activity in the work of Paul DeMarinis and Rich Gold were facilitated by access, mobility, and a horizontal model of integration that came when personal computing met the interdisciplinary and

intermedia experimental arts and counterculture among the collectivist formations of the San Francisco Bay Area during the 1970s. That this moment in microcomputing was located at Mills was due to the conduciveness of early computing to music, whether the early mainframe typified by Tenney's residence at Bell Labs, or the early hobby kits and consumer model microcomputers. The vertical integration of scientific research models for social and discursive organization at Bell Labs or later at CCRMA, with their prowess in technological development, and their institutional, technological, and artistic constraints, opened up to radical undiscipline and interdiscipline, flourishing toward the artistic and cultural breadth and mobility more typical of today.

Notes

1. Italo Calvino, "Cybernetics and Ghosts," in *The Uses of Literature: Essays* (New York: Harcourt, Brace, Jovanovich, 1982), 3–27 (9).

2. Paul Edwards, *The Closed World: Computers and the Politics of Discourse in Cold War America* (Cambridge, Mass.: MIT Press, 1997); Steven Levy, *Hackers: Heroes of the Computer Revolution* (New York: Penguin Books, 1984); John Markoff, *What the Dormouse Said: How the 60s Counterculture Shaped the Personal Computer* (New York: Viking Press, 2005); Special section "Personal Computers," *CoEvolution Quarterly* (summer 1975), 136–151; Andrew Ross, "Hacking Away at the Counterculture," *Strange Weather: Culture, Science, and Technology in the Age of Limits* (London: Verso, 1991), 75–100.

3. Artists and engineers were not mutually exclusive. At first, engineers were awkward artists, and artists engaged with computers were too few in number to have significant impact. By the late 1970s, as a melding of roles became more common, there was better chance of finding technologically sophisticated artists and artistically sophisticated engineers (although even today to find both in the same individual is rare). Later, these roles would be elaborated through the corporate wisdom of distributed communities. The internalization of social roles mimicked the progressive capital intensivity of the technology itself, where the pervasive presence of the dead labor of thousands of engineers locked into every nook and cranny of the hardware and software explained their absence from the earlier, fleshier forms of collaborations with artists.

4. Jasia Reichardt, "Cybernetics, Art, and Ideas," in *Cybernetics, Art, and Ideas*, ed. Jasia Reichardt (London: Studio Vista, 1971), 11.

5. Lev Manovich, "New Media from Borges to HTML," in *The New Media Reader*, ed. Noah Wardrip-Fruin and Nick Montfort (Cambridge, Mass.: MIT Press, 2003), 13–25 (15). He also states that writings by "Licklider, Sutherland, Nelson, and Engelbart from the 1960s . . . are the essential documents of our time; one day the historians of culture will rate them on the same scale of importance as texts by Marx, Freud, and Saussure" (24).

6. Jim Pomeroy, "Capture Images/Volatile Memory/New Montage," in *For a Burning World Is Come to Dance Inane: Essays by and about Jim Pomeroy*, ed. Timothy Druckrey and Nadine Lemmon (Brooklyn: Critical Press, 1993), 61.

7. Malcolm Le Grice, "Computer Film as Film Art," in *Computer Animation*, ed. John Halas (London: Focal Press, 1974), 161.

8. Johanna Drucker, "Interactive, Algorithmic, Networked: Aesthetics of New Media Art," in *At a Distance: Precursors to Art and Activism on the Internet*, ed. Annmarie Chandler and Norie Neumark (Cambridge, Mass.: MIT Press, 2005), 55, 36.

9. In music of the late 1950s, an early warning against such derivation could be found in the book *Experimental Music* by Lejaren Hiller (who had migrated from science to music) and Leonard Isaacson. After establishing the conventional divide between Western art music and commercialism where the use of computers would bring about the "efficient production of banal commercial music," which would be "nonartistic and fall outside the area of problems of aesthetic interest," they stated that simulating Beethoven, Bartók, and Bach or any other composer was likewise "not a particularly stimulating artistic mission." Lejaren A. Hiller and Leonard M. Isaacson, *Experimental Music: Composition with an Electronic Computer* (New York: McGraw-Hill, 1959), 176.

10. A. Michael Noll, "Art ex Machina," *IEEE Student Journal* 8, no. 4 (September 1970): 10.

11. Ibid., 11. He goes on to say that "it is virtually impossible to describe what these entirely new aesthetic experiences might be like," and tries to support his claim that "The computer has only been used to copy aesthetic effects easily obtained with the use of conventional media" by referring to music. "Computers have done little more than copy effects that can be obtained through the use of a few audio oscillators, noise generators, and tape recorders" (11). The world awaits a "Charles Ives of the future" lurking around some corporate or university computer lab (14). As I show in my discussion below of the composer James Tenney, Noll is correct in superficially claiming a continuity between electronic and computer music, but betrays the very type of

engineer's insensitivity he warns against by failing to recognize what was actually being accomplished.

12. Another example of an early achievement reliant on computing based on a minor tradition is Joseph Weizenbaum's *Eliza*, which was based on the limited discursiveness of Rogerian analysis, the psychological method developed by Carl Rogers.

13. Claude E. Shannon, "The Mathematical Theory of Communication," in Claude E. Shannon and Warren Weaver, *The Mathematical Theory of Communication* (Urbana: The University of Illinois Press, 1949), 14–15. He showed his familiar with contemporary literature through citing James Joyce's *Finnegans Wake* as an example of an extreme lack of redundancy in communications, and thus a good piece of compression software. "Two extremes of redundancy in English prose are represented by Basic English and by James Joyce's book *Finnegans Wake*. The Basic English vocabulary is limited to 850 words and the redundancy is very high.... Joyce on the other hand enlarges the vocabulary and is alleged to achieve a compression of semantic content" (26).

14. Reprinted in John R. Pierce, "A Chance for Art," in *Cybernetics, Art, and Ideas*, ed. Jasia Reichardt (London: Studio Vista, 1971), 46–56. John R. Pierce, *An Introduction to Information Theory: Symbols, Signals, and Noise* (1961), 261. He also mentions Gertrude Stein's writing in the framework of redundancy and information in English grammar (109).

15. Pierce, *An Introduction to Information Theory*, 262.

16. Ibid.

17. Ibid., 266.

18. David Bellos, *Georges Perec: A Life in Words* (Boston: David R. Godine, 1993), 409–411.

19. Fernand Hallyn, "'A Light-Weight Artifice': Experimental Poetry in the 17th Century," *SubStance* 71/72, vol. 22, nos. 1/2 (1993): 289–305.

20. Cited in Hallyn, "'A Light-Weight Artifice,'" 303.

21. Leonard G. Ratner, "*Ars Combinatoria*: Chance and Choice in Eighteenth-Century Music," in *Studies in Eighteenth-Century Music: A Tribute to Karl Geiringer on His Seventi-*

eth Birthday, ed. H. C. Robbins Landon (New York: Oxford University Press, 1970), 343–363 (350).

22. Susanne Winter, "A propos de l'Oulipo et de quelques constraints musico-textuelles," *OULIPO–POETIQUES*, ed. Peter Kuon (Tübingen: Gunter Narr Verlag, 1999), 173–192.

23. *Fantastic Architecture*, ed. Wolf Vostell and Dick Higgins (New York: Something Else Press, 1971 [circa 1969]), n.p.

24. Max Mathews, *The Technology of Computer Music* (Cambridge, Mass.: MIT Press, 1969), 3–4. He jokingly mused that this could have been done with the earlier voltage-control machine, the phonograph: "if one had a minute chisel, grooves for new sounds could be cut by hand. However, the computer can accomplish an equivalent result by a much easier process."

25. M. V. Mathews, J. R. Pierce, and N. Guttman, "Musical Sounds from Digital Computers," *Gravesaner Blätter*, vol. 6 (1962), reprinted in *The Historical CD of Digital Sound Synthesis, Computer Music Currents* 13, Wergo 2033-2, 282 033-2, 36–37.

26. Pierce, *An Introduction to Information Theory*, 250.

27. Brian Rotman, "The Technology of Mathematical Persuasion," in *Inscribing Science: Scientific Texts and the Materiality of Communication*, ed. Timothy Lenoir (Stanford: Stanford University Press, 1998), 55–69.

28. "James Tenney, Interviewed by Douglas Kahn, Toronto, February 1999," in *Leonardo Electronic Almanac*: http://mitpress2.mit.edu/e-journals/LEA/ARTICLES/TENNEY/kahn.html/.

29. John R. Pierce, interviewed by Harriett Lyle, oral history, California Institute of Technology Archives: "The musicians of this century . . . seem to be afraid of science. They love mathematics, in the sense of numerology, but the actual physics of sound production and why it is that things sound different is foreign to their thinking" (38). See http://resolver.caltech.edu/CaltechOH:OH_Pierce_J/.

30. Tenney interview, n.p.

31. Email correspondence with the author (October 8, 1999).

32. James Tenney, "Computer Music Experiences, 1961–1964," reprinted in *Leonardo Electronic Almanac* (*LEA*): http://mitpress2.mit.edu/e-journals/LEA/ARTICLES/TENNEY/cme.html/.

33. Tenney interview, n.p.

34. Ibid.

35. Jon Hendricks, *Fluxus Codex* (New York: Harry N. Abrams, 1988), 192. Tenney remembers the piece being used as the opening and closing of Nam June Paik and Charlotte Moorman's European tour performances (*LEA* interview).

36. Tenney interview, n.p.

37. Ibid.

38. On Busoni's *infinite gradation* and modernist glissandi, see the subsection "The Gloss of the Gliss," in Douglas Kahn, *Noise, Water, Meat: A History of Sound in the Arts* (Cambridge, Mass.: MIT Press, 1999), 83–91.

39. Tenney interview, n.p.

40. The discussion in this section is based on interviews and email correspondence with John Bischoff (April 2003), George Lewis (March–April 2005), Maggi Payne (April 2005), Paul DeMarinis (April 2005), Marina LaPalma (April 2005), Ned Lagin (July 2005), and David Behrman (July 2005).

41. Levy, *Hackers*, 204–206.

42. See interview in David Gans, *Conversations with the Dead* (Cambridge, Mass.: Da Capo Press, 2002), 343–389.

43. Paul DeMarinis, interview with the author (21 April 2005).

44. Ibid.

45. See the introductory remarks in *Kim-1/6502 User Notes*, vol. 1, issue 1 (September 1976): 1. "Several Amateur radio operators have suggested starting a Kim Users Net to meet on the ham bands. This is an excellent idea—as there are quite a few Hams in the group (myself included). Would anyone like to coordinate activities in this area?"

46. Paul DeMarinis and Jim Pomeroy, program notes for *A Byte at the Opera*, 80 Langton Street, San Francisco, 1977 January 22.

47. Paul DeMarinis, interview with the author (21 April 2005).

48. Richard Gold, "A Terrain Reader," in *The Byte Book of Computer Music*," ed. Christopher P. Morgan (Peterborough, N.H., 1979), 129–141 (131).

49. Ibid., 129.

50. Rich Gold, "Notes on the Happiness of the Suburbs. Weeks 51–55" (1978), in *Break Glass in Case of Fire: The Anthology from the Center for Contemporary Music* (Oakland: The Center for Contemporary Music, 1978), n.p.

51. The most readily available example is described in A. K. Dewdney, "Computer Recreations: Diverse Personalities Search for Social Equilibrium at a Computer Party," *Scientific American* 257, no. 3 (September 1987): 112–115.

Picturing Uncertainty: From Representation to Mental Representation

Barbara Maria Stafford

Galen Strawson has recently argued that it is a great fallacy of our age to suppose that human beings typically experience their lives as a sustained narrative. That is, he challenges the unitary assumption that when I am apprehending myself as an inner mental presence, this self-consciousness must necessarily carry with it the "feeling or belief that what is remembered happened to me, to that which I now apprehend myself to be when apprehending myself specifically as a self."[1] While the cultural norm seems to favor the supposition of long-term self-continuity—a diachronic view stretching back to Plato and forward to Graham Greene—history offers plenty of evidence for nonpathological "episodic" individuals who do not habitually gather their lives into a coherent story (Michel de Montaigne, the third Earl of Shaftesbury, Samuel Taylor Coleridge, Ford Madox Ford).

What is at stake—and what current scientific experiments are addressing only piecemeal[2]—is that most enigmatic aspect of the feeling human mind: the qualitative experiencing of our sense of self. "Episodic" authors and "patchy" artists, I want to suggest, provide insight into the uncertainty and instability of self-consciousness. Precisely because they favor joining improvisation and flashes of spontaneity—inlaying irregular and antithetical elements rather than blending them—the resulting works of the imagination open a window onto the ragged and reciprocal emergence of the self from tangles of neurons. These assemblagists-in-the-flesh are interested in the conversational or extemporaneous ways that performance—as opposed to narrative—responds to the granularity of contigent stimuli and the particularity of

Figure 22.1 Carlo Ponti (attributed), Naples, *View from the Vomero*, 1880–1889. Mega-lethoscope view, albumen photograph. By kind permission of The J. Paul Getty Museum.

changing circumstances. Rephrasing Santiago Ramon y Cajal's findings that memories involve strengthened neural connections, performance would seem to aid long-term potentiation—one of the most widely studied forms of neuronal plasticity occurring both in excitatory and inhibitory interneurons.[3] It is a type of synaptic enhancement that goes on when new tasks are replayed while we are awake and even when we are asleep.[4]

Certainly, keeping track of the shifting behavior of others in real time is an ancient survival strategy. Evolutionary biologists have shown that both humans and animals form social groups in which cooperation and reciprocity prevail—at least among many species—and this entails carefully watching and remembering the faces and actions of others.[5] A more nuanced history of the origins of ethology is also now emerging, investigating the phenomenon

Figure 22.2 Anonymous, stereograph representing dominoes, late nineteenth century. Colored lithograph. By kind permission of The J. Paul Getty Museum.

of "imprinting" first studied by Konrad Lorenz in the 1930s to help explain the mechanisms that trigger instinctive responses in different species.[6] Without falling into biological determinism, it is interesting to consider the bidirectional operations of imitation/attachment in performative media. Consider Byron's vagabond *Don Juan*: one of the best-known literary cases of the risk-taking poet-hero, able to adapt immediately to the most alien and challenging events.[7] Or think of the creative give-and-take demanded by Goya's famous print series. By creating bistable percepts—that is, blotchy shapes that look like one thing to the beholder one moment and quite another when one either turns the shadowy aquatint or rotates oneself—Goya's *Los Caprichos*, for example, similarly externalizes the broken search for meaning in a protean world—tailoring this insight to every individual viewer.[8]

In fitful self-performance, identity becomes an impromptu matter of physically and mentally playing oneself out or composing oneself in public, with other participants present, rather than the solitary Wordsworthian confluencing of scenes—edited and recollected from prior serial witnessing. But it also highlights the difficulties of standing alone, the cost of romantic independence, or going against the cohesiveness of the group whose positive or negative reactions one is perceiving and registering in brain regions associated with emotional salience (in the right amygdala and right caudate nucleus).[9]

Strawson might well have cited the virtual remix as the premiere contemporary example of the persistent obsession with narrative. If one accepts continuity as a central feature, then the remix embodies the extreming of narrative to infinity. I mean the fantasized, digitized, resequenced blur that exists only to be remixed. The near-ubiquitous practice of grabbing iconography from everywhere and, hence, nowhere—old-master paintings, photography, anime, movies, television, rock videos, hip hop, fashion (the stunning success of Prada's retro refashionings)—and extending it indefinitely now engulfs us. As artist Warren Neidich states, we have entered the era of "visual and cognitive ergonomics" where "objects, their relations, and the spaces they occupy, affect changes in the brain."[10] Jamie Hewlett of Gorillaz, "the world's greatest live, pre-recorded, re-mixed, animated pop band," unintentionally highlights the narrative implications of this audiovisual sampling and filtering that interfaces with our deepest physiology and innermost being. He points to more and more cultural groups that are "cross-pollinating,"[11] thereby auto-organizing themselves into a vast conceptual network.

Unlike twentieth-century cut-and-paste collage techniques—juxtaposing recognizable snippets of the world—or earlier divisionist intarsia from mosaics to caricature, for that matter, the new electronic recombinant media are seamless and endless.[12] Such aggressive repurposings are not about creating physical and spatial adjacency among incongruent bits. Rather, their intent is to procure morphed synchronization across complex multidimensional data. While knockoff sampling appears to be dealing in deconstructed pieces, the remix, in William Gibson's words, actually "*generates* [my emphasis] countless hours of creative product. . . ."[13]

We are thus living in paradoxical times when the remote or original unit of reference is being continuously melded into an equivocal, bootlegged or "mashed-up," hybrid. The romantic *improvissatore's* spectacular reinventions, on the other hand, gave the audience the aesthetic and ethical opportunity to see a singular poetic mind at work.[14] Given the hypermediation and anonymous communality of the remix, uncertainty rules. Can we know whose mind-at-work we are actually witnessing? Has the paradigm of the computational remix, in fact, subtly warped our view of the self as being no different from the customized bit whose meaning derives from the automated link-up? Conversely, is self-awareness as well as a keen sense of the present just a momentary rupture in the ongoing processing between the frontal regions and the posterior perceptual brain, between the front of the brain and the parietal

lobe, between the face-recognizing system and the amygdala and the hypothalamus, areas associated with the emotions?

Revisiting Strawson's terminology, are we right in supposing that the "episodic" self must somehow be resistant to the binding drive that connects the topographically distributed sensorial packets in our cognitive field into linked associations? Further, what does such selectionism tell us about the patterned ways in which the brain integrates different types of information? Significantly, PET imaging and fMRI experiments have demonstrated that connectivity problems—a lack of correlation between visual areas in the back of the brain and the inferior central cortex governing action planning and other coordinated activity—are central to autism. Characteristic of this disorder is the easy memorization of discrete facts but difficulty in collecting these particulars into a coherent concept. In short, this want of cross-cortical cooperation looks a lot like an *extreme* form of nonnarrative experience.

Many autistic abnormalities, it is currently believed, can be explained by a person focusing on details and not being able to integrate the clear-cut elements—whether facts, words, visual stills—into broader patterns of reasoning.[15] It is as if one sees the world pixelated or "parceled," owing to the genetically determined operations of what Gerald Edelman calls the "primary repertoire."[16] This microbiological architecture of the brain relates to different functional capabilities (color, form, motion detection), each of which responds to a partial aspect of an object. These dispersed partial features only become selected and bound together into a whole during "reentry."[17] But understanding binding remains a "problem" because of the absence of an explanation of the ordered integration of many and varied sensory elements into a subjective experience.[18] During this temporal process, neural mappings mysteriously become communicating components in a large network of synchronized electrical signals. The *story* of the self somehow emerges from this widely distributed *pattern* of signals. And it is from the resulting functionally coherent assemblies that the illusion of unfurling reality derives.

I want to mobilize Strawson's insight that there are two, contrasting sorts of from-the-inside experience for a very different purpose. The distinction between recounting oneself as a developmental continuum and figuring oneself as an irreducible formal fact without apparent causal connections with what went before or what comes after the present moment characterizes two major types of artistic representation. Broadly speaking, what might be termed the

"illusionistic" strategy exhibits the tendency to find or create—whether consciously or unconsciously—patterns in an otherwise unconnected manifold.

This smoothing of the disjunctive aspects of sensory experience—magically gathering them into a seamless sequence—is one of the major reasons that the visual arts have long been accused of being merely clever "systems of imposture."[19] But there is another venerable representational strategy that is not flowingly mimetic. Consider the venerable tradition of the lapidary symbol and the triune emblem.[20] Mosaic-like or crystalline, these compressed forms deal in intractable bits and pieces. Such sensory intarsias are simultaneously resistant both to the euphonious harmonizing that comes with decaying into ruin and the dexterous blending that revises the sketch into a "finished" work. Further, such attention-holding inlays are the reverse of the hyperexpansive Burkean Sublime where the overstretched mind—as Donald Davie said of the forceful Dr. Johnson—comes to know "the power of its own potentially disruptive propensities."

The Sublime's upward-driving, transcendent dimensionality—never content to focus on the present or attend to the moment—is particularly evident in the Kantian and post-Kantian formulations of *das Erhabene*. Containing echoes of *Erhebung* and *Erbauung*, the German term doubly connotes being swiftly elevated above the common ground and being morally raised to the heights, that is, edified.[21] By its insistent verticality and ecstatic elision of antipodal realms, this phantasmatic style of synthesis comprises a telling contrast to Ezra Pound's correlational marquetry. The imagist poet constructed the world as well as the work of art as fretwork, as autonomous checkered thing "thrown free of its creator."[22] Not unlike geometric hallucinations—those striking visual experiences grouped into four form constants (lattices, gratings; cobwebs; tunnels, cones; spirals) interconnecting the retina and the striate cortex (V1),[23] Pound's lapidary formal symmetries, as well as Goya's honeycomb pattern of alternating glare and gloom, are dependent upon a horizontal connectivity. Further, as recent research by Jack Cowan et al. suggests, the cortical mechanisms by which geometric hallucinations are generated are closely related to the circuits *normally* involved in the detection of oriented edges and contours.[24] Visual imagery is thus the result of a constant competition between visionary (remembered) afterimages and attentive focus.

In a performative, presence-based aesthetic—unlike either a mimetic or a sublime aesthetic—independent self and free-standing environment appear to coalesce like lipids forming cell membranes, cells organizing to produce

tissues, and tissues combining to create organisms. Instead of cofiguration emerging from encompassing description or rhapsodic extension, complex structure arises through self-assembly by means of associative jumps and synchronized recurrences. This correlating—as opposed to illusionizing—approach adumbrates the resurgence of interest in neural networks in the late 1980s and the development of genetic algorithms during the 1990s, founded, significantly, on the belief that simple systems can learn and adapt just by interacting with their surroundings as two coupled, but distinct, entities. Leave the right components alone and they will organize themselves into ordered structures from the ground up.[25] From the barest juxtapositions, then, often spring wholly unpredictable conclusions which, after the initial shock, appear as natural and stable as what passed before.

Throughout the twentieth century, many artists commented on the autonomy of the artworks they made. "Machine art," the long shadow cast by Russian Constructivism, the process aspects of conceptualism, the field or ambient concerns of minimalism, as well as systems and procedural art: all set in relief not only the activity of autopoietic self-generation but the fact of emergence and transformation brought about through unconstrained, even random, combinatorics. Take Dan Flavin's discovery of the dark corner, rarely used by other artists before him.[26] By dint of pressing a single eight-foot fixture into that cavernous angle, or leaning fluorescent light into the triangular penumbra, or lacing it with a chromatic grid, he reveals the inaccessible depths of the background while flooding the foreground to expose its unsuspected tunnel of color.

Flavin's performative bars of discrete light, however, have tended to be overwritten by flowing, cinematic models. Andreas Kratky's *Software Cinema Project* is consistent with the remixing software age of DJ Spooky. These multiframe narratives demonstrate how cinema, human subjectivity, and the variable choices made by custom software combine to create films that run infinitely without ever exactly repeating the same image sequence, screen layouts, and stories.[27] Visuals, sounds, and even the identities of characters are auto-assembled from multiple databases allowing myriad media to "bleed through" real and onscreen spaces.

Hiraki Sawa's lyrical video, *Dwelling* (2002), is a riveting—if more traditional—montage of still shots of different areas of his London apartment. These vacated spaces become mysteriously enlivened by fleets of toy planes that silently and continuously take off from a kitchen table or shorn rug, cruise

through an airy hallway, land on a rumpled bed, in a glazed bathtub, or upside down on a ceiling—propelled by some invisible force.

One airplane on the floor inexplicably nudges into motion, gathers speed, lifts its nose, takes off while casting a convincing shadow, and angles through the air. You rationally know that this is all artifice, but you still perceive it as astonishing, indeed with a childlike sense of wonder and delight. . . .[28]

Hiraki Sawa's work is enthralling precisely because it appears self-generative; it is mysteriously performative like some amazing eighteenth-century automaton. Instead of airplanes eerily disappearing through cracks in doorways or crisscrossing in the "sky" of the living room, weird miracles are everywhere in evidence today. The techniques of a-life (realized through evolutionary and adaptive computing) have opened new vistas where ambiguity and autonomy reign. Computational entities are being trained to find solutions to problems that even the programmer may not know how to solve.[29] Or, thanks to nanotechnology, astrobiology, and microbiology, consider how we have been made alert to the carbon self as merely one among many objects in a shared world composed of everything from cellular microprocessors to bizarre two-meter tube worms, eyeless crabs, and green sulfur bacterial extemeophiles thriving around caustic deep-sea hydrothermal vents.[30]

Given this confounding state-of-things, it is not accidental that defining the nature of mental representation looms as a central issue for cognitive scientists, neurobiologists, and philosophers of mind. The conundrum of relating what we see—variable surfaces directly visible to us together with their outline, orientation, color, texture, movement—which become collected into a sketchy representation that is additionally processed by the brain into a three-dimensional representation of which we are probably not visually aware—is intimately tied to what Francis Crick and Christof Koch call "the overwhelming question in neurobiology today." Finding the neural correlates of consciousness (NCC) involves "trying to put neuronal events into correspondence with mental events."[31]

The two experimentalists go on to say that most neuroscientists—harking back to William James—think that *all* aspects of the mind, including awareness, are the result of material processes.[32] Central to Crick's and Koch's theory of mind (as well as to V. S. Ramachandran's and Semir Zeki's) is the

conviction that the way reality looks to us depends on its encoding of discrete aspects of the world. In a sort of neural Platonism, what we see is determined by the prior nature of our *internal* mental representations such that physical stimuli act mechanically on sensory neurons. From a fleeting perception of transient objects and events in the environment, the brain—relying on personal and ancestral past experience—goes on to construct a viewer-centered representation. What we see vividly and clearly is made into something we pay cognitive attention to. A major question arising from this correspondence theory is just how does any sustained or broader structure emerge from one hundred billion neurons? As Jean-Pierre Changeux reminds us, each of these cells has on average about ten thousand discontinuous contacts. And the resulting "forest of synapses" yields as many possible combinations as the number of positively charged particles in the universe.[33]

Distributed cognition, on the contrary, does not explain mental representation as an automatic matching of lines, edges, and contrast to the neurons sensitive to these primitives. But it, too, manages to kill the "first-person perspective" on experience, that is, the illusion that we witness it or see the world directly.[34] The optic nerve was once thought of as a simple vehicle carrying raw sensory data to the brain. Now we know it shapes its information in transit. The brain, in fact, leaps out into the world through its light receptors and actively seizes photonic data.[35] Consequently, mental objects (the sense that we have a representation of the world inside our skull) results from the simultaneous analysis of signals coming from the physical and the social environment as well as their internal organization into hierarchical levels of integration.

A locationally "wide computationalism" thus maintains that some of the systems that drive cognition, in fact, lie beyond the organismic boundary. They are situated in nature and outside of the head.[36] Antonio Damasio and Thomas Metzinger offer two interesting attempts to reconcile these contrasting internalist–externalist perspectives by exteriorizing the self-model, or, conversely, virtualizing the world. For the pantheistic Damasio, the feeling of a coherent self is built from the autonomous, global representations of inner homeostatic functions. While unconsciously maintaining our sense of bodily integrity, the homeostatic system intimately registers our emotional reactions to external events.

Metzinger, on the other hand, belongs to the *"mens-*class of Idealism,"[37] along with Berkeley and Leibniz, since he argues that material bodies do not

exist as extramental realities but only as phenomena within the mind. He thinks of consciousness as the epiphenomenal by-product of an illusionizing projection: no one is on center stage in his theater of the mind. Not unlike the latest views on schizophrenia[38]—where normal perception, dream imagery, and hallucinations are mainly manifestations of the same internal creative process (located in the thalamocortical circuits), differing only with respect to the degree by which they are constrained by sensory input—Metzinger claims we constantly hallucinate the world. But these autonomously generated visions flowing outward must, at some point, collide with the sensory influx streaming inward.

Dissatisfaction with the strict encoding or merely symbol-processing view of mental representation has also led cognitive psychologists such as Merlin Donald to argue that there is a "mind beyond itself." According to this view, a performative memory system incorporates aspects of the environment. Our epistemological apparatus is enactive since awareness comes about in the very activity of representation. Because individuals must *perform* the extraction and deployment of information, representing oneself as a subject involves an agent "enmeshed" in the world, someone with world-involving capabilities.[39]

Bearing in mind that brain scientists are far from unified in their view of neural operations, I nonetheless want to try and pin down a definition of the elusive concept of "mental representation," utilizing the aesthetic perspective I have been developing throughout. I will argue that, like the narrative–nonnarrative dialectic, it addresses two fundamental functions of our visual system. To find a target object in the Berkeleyesque prismatic blur of any moving scene, a salient face in the vagueness of the crowd, the visual system, it appears, turns the neural representation of each distinctive object on and off in serial fashion, testing each representation against a stored template. But it also seems that it processes all the streaming objects in parallel.[40] The visual system, confusingly, is biased in favor of those neurons that represent critical features of the target, until the target emerges from its camouflage in the background—as the dark recesses of the white-cube gallery emerge when Flavin's radiant light destroys the receding darkness, eroding the architectural frame to expose real space.

If we keep Strawson's narrative–nonnarrative division in mind, as well as my distinction between sustained illusion and rupturing autonomy in visual art, we are really talking about object recognition mechanisms in the temporal cortex. In a crowded visual scene, we typically focus our attention serially on

stimuli that are relevant to our behavior. The outcome of our directed eye movements is to enhance the attentional responses of visual cortex neurons to the discrete object in question and ignore surrounding distracting features. But this eventual, post-hunting, focus on the chunklike singularity presupposes that a person knows in advance the location of the relevant object surfacing from the swirling flux. Most of our waking lives, in contrast, are spent not in instant or smooth identification but in struggling visual search.

Parallel processing gets at those attentional mechanisms sensitive to emotion-laden features, such as color and shape, that represent the target features—mosaic-like—in neurons distributed throughout the visual field. While neurons synchronize their activity in both focused and free-gaze activities, correlation and coherence of stimuli into a single mental representation is especially complex in the latter. Think of it. The features of the searched—for target are scattered throughout a visual field filled with distractions and prolonged through the time of the search. In both cases, spatial attention enhances synchrony. But, as art movements from mannerism to romanticism have shown, visual search tasks in which the object is complexly defined by the conjunction of different features are particularly difficult for the viewer. The motile "binding" involved in tying together conflicting stimuli does not flow easily. Not effortless but effortful, it draws attention to itself, flaunts the perceptual and cognitive labor required to combine parallel and quite distinctive components into a conjuncted array.

Significantly, the notion of binding as the kinetic *performance* of bundling stimuli as well as the spatial activity of self-collection is reminiscent of J. J. Gibson's theory of affordances. His revolutionary ecological approach to a theory of visual perception considered "viewing" to be different from straightforward visual perceiving. Pertinent for our consideration of mental representation is Gibson's claim that viewing is involved in the visual control of locomotion, in seeing the world in perspective. That is, one's entire physical and mental behavior is based on "what one sees now from here."[41] Gibson is not a behaviorist. He argues for a simultaneous awareness of the environment and the self, but not an awareness of what is transpiring in the experiential stream itself. We can never pick up all the available information that is out there.

But unlike everyone else considered so far, Gibson believed that there is a *direct* perceiving of the affordances. His sophisticated realism thus gets rid of both the mind–matter distinction as well as the representation–object

distinction. Vivid visual awareness of an ambient object and of our own self-awareness is neither just Koch's and Crick's modular representation of an object distributed over many neurons nor Metzinger's dreaming at the world. It is what comes next: the psychosomatic performance of coalition by the living observer. As I have suggested this takes two artistic-stylistic forms: a coherencing, narrative "filling in" or ignoring of the blind spots in the eye and the visual field, and the competing focus on the hard edges and contours of an object that command foveal attention.

I hope I have made clear how the search for a more general theory of consciousness has inflected the concept of mental objects and mental representation. For the neurophysiological question of cognitive coherence—how does our brain, for every object of perception, bind a large set of features to yield neural synchrony—is also the question of representational coherence. If aesthetic representation since Aristotle has been principally about defining ways to unify the manifold into a coherent image, then mental representation has become a more complex, elusive, *nonmimetic* act of construction in the hands of contemporary brain scientists. It operates in the no-man's land where our ability to sweep together self-awareness with the stony otherness of the world breaks down.

I want to conclude by raising another problem. Finding ways to visualize blur, vagueness, ambiguity, equivocality, and uncertainty in all areas of scientific and cultural production are, I believe, among the central issues of our time. Quantum mechanics, born at the close of the nineteenth century, has made us familiar if not exactly comfortable with the bizarre and counterintuitive actions of the tiny denizens of the submicroscopic realm. Not only does quantum theory undermine solid objects by supposing them to be waves, it injects uncertainty into their positions and movements, so that as we gain knowledge about one property, we lose it about another.[42]

The quantum model has also ambiguated that staple of our age: information. Whether we think of it as stored in images, books, on silicon, in quantum "qubits" inscribed on a cluster of atoms[43]—and processed at length or in a blink—these multiple platforms have only made us more intensely aware of data's limits, instability, error-proneness, and, most tellingly, equivocality. Recall that the unifying *narrative* of uncertainty allows quantum objects, paradoxically, to have two mutually exclusive (and untestable) behaviors at the same time. This blurring elision has found its way up to the macrolevel.

In the information technology era of simulation, morphing, cloning, and remixing—where it is difficult to separate the synthetic from the empirical, the degrees of the artificial from the untinkered substrate—it is not surprising that narrative as an artificially unified account of singular actions and events has become the master *topos* in everything from art history to anthropology to law to literary studies.[44] But this process of compacting the heterogeneous and the anomalous into the coherent corresponds only to one part of the complex functions that make up human cognition. Understanding the webwork of interrelations shaping mental representation, then, is essential for dealing intelligently with the discretely autonomous as well as the coalescent aspects of our polymodal information age.

Notes

1. Galen Strawson, "A Fallacy of Our Age," *Times Literary Supplement*, 15 October 2004, 12.

2. Greg Miller, "What Is the Biological Basis of Consciousness?," *Science* 309 (1 July 2005), 79.

3. "Preserving Memories," *Science* (Editor's Choice) 309 (15 July 2005), 361.

4. Greg Miller, "How Are Memories Stored and Retrieved?," *Science* 309 (1 July 2005), 92.

5. Elizabeth Pennisi, "How Did Cooperative Behavior Evolve?," *Science* 309 (1 July 2005), 93.

6. Richard W. Burkhardt, Jr., *Patterns of Behavior: Konrad Lorenz, Niko Tinbergen, and the Founding of Ethology* (Chicago and London: University of Chicago Press, 2005).

7. See the excellent article on the importance of improvisation in contrast to inspiration among the Romantics by Angela Esterhammer, "The Cosmopolitan Improvisatore: Spontaneity and Performance in Romantic Poetics," *European Romantic Review* 16 (April 2005), 161.

8. See my "From 'Brilliant Ideas' to 'Fitful Thoughts': Conjecturing the Unseen in Late Eighteenth-Century Art," *Zeitschrift fur Kunstgeschichte*, Sonderdruck 48 (no. 1, 1985), 329–363.

9. See the fascinating research on social conformity which, I believe, helps us understand the emotional difficulties of the "Romantic" antigroup stance: Sandra Blakeslee, "What Other People Say May Change What You See," *New York Times*, 28 June 2005, D3.

10. Warren Neidich, *Blow-Up: Photography, Cinema, and the Brain* (New York: Distributed Art Publishers, 2005), 21.

11. Neil Gaiman, "Remix Planet," *Wired* (July 2005), 116.

12. See my essay "To Collage or E-Collage?," *Harvard Design Magazine*, special issue: Representations/Misrepresentations (fall 1998), 34–36.

13. William Gibson, "God's Little Toys. Confessions of a Cut & Paste Artist," *Wired* (July 2005), 118.

14. Esterhammer, "The Cosmopolitan Improvisatore," 158.

15. Ingrid Wickelgren, "Autistic Brains Out of Synch?," *Science* (24 June 2005), 1856.

16. Gerald Edelman, *Neural Darwinism* (New York: Basic Books, 1987), 106.

17. Gerald Edelman, *Remembered Present* (New York: Basic Books, 1994).

18. Jonathan C. W. Edwards, "Is Consciousness Only a Property of Individual Cells?," *Journal of Consciousness Studies* 12 (nos. 4–5, 2005), 60.

19. See my *Artful Science: Enlightenment Entertainment and the Eclipse of Visual Education* (Cambridge, Mass.: MIT Press, 1994; 1996), 73ff. For the role of optical technologies in this rhetoric of deception, see my "Revealing Technologies/Magical Domains," in Barbara Maria Stafford and Frances Terpak, *Devices of Wonder: From the World in a Box to Images on a Screen*, exh. cat. (Los Angeles: Getty Research Center, 2001), esp. 47–78.

20. See my essay, "Compressed Forms: The Symbolic Compound as Emblem of Neural Correlation," in *Proceedings of the International Congress on Emblems* (forthcoming).

21. Iain Boyd White, "The Expressionist Sublime," in *Expressionist Utopias: Paradise, Metropolis, Architectural Fantasy*, exh. cat., ed. Timothy O. Benson (Los Angeles: Los Angeles County Museum of Art, 2005), 123.

22. Clive Wilmer, "Song and Stone: Donald Davie Reappraised," *Times Literary Supplement*, 6 May 2005, 12.

23. Paul C. Bressloff, Jack D. Cowan, Martin Golubitsky, Peter J. Thomas, and Matthew C. Wiener, "Geometric Visual Hallucinations, Euclidean Symmetry and the Functional Architecture of the Striate Cortex," *Philosophical Transactions of the Royal Society of London* 356 (2000), 299–330. I am grateful to Jack Cowan for this reference.

24. Ibid., 324.

25. Robert F. Service, "How Far Can We Push Chemical Self-Assembly?," *Science* 309 (1 July 2005), 95.

26. Tiffany Bell, "Fluorescent Light as Art," in *Dan Flavin: The Complete Lights 1961–1996*, exh. cat., ed. Michael Govan and Tiffany Bell (New Haven and London: Yale University Press, 2005), 77.

27. Andreas Kratky, *Soft Cinema: Navigating the Database*, DVD (Cambridge, Mass.: MIT Press, 2005). On the cinematic language of new media, see Lev Manovich, *The Language of New Media* (Cambridge, Mass.: MIT Press, 2001).

28. Gregory Volk, *Hiraki Sawa: Hammer Projects* (Los Angeles: Hammer Museum, 2005), brochure.

29. See the research project, "Computational Intelligence, Creativity, and Cognition: A Multidisciplinary Investigation," headed by Margaret Boden (Sussex, UK), commencing May 2005 and running for three years. For further information contact paul@paul-brown.com.

30. John Bohannon, "Microbe May Push Photosynthesis into Deep Water," *Science* 308 (24 June 2005), 1855.

31. Jean-Pierre Changeux and Paul Ricoeur, *What Makes Us Think?* (Princeton: Princeton University Press, 2000), 44.

32. Francis Crick and Christof Koch, "The Problem of Consciousness," *Scientific American* 10 (2002), 11.

33. Changeux, *What Makes Us Think?*, 78.

34. Thomas W. Clark, "Killing the Observer," *Journal of Consciousness Studies* 12 (nos. 4–5, 2005), 45.

35. William Illsey Atkinson, *Nanocosm: Nanotechnology and the Big Changes Coming from the Inconceivably Small* (New York: AMACOM, 2003), 143.

36. Robert A. Wilson, *Boundaries of the Mind: The Individual in the Fragile Sciences* (Cambridge: Cambridge University Press, 2004), 165.

37. Darren H. Hibbs, "Who's an Idealist?," *Review of Metaphysics* 58 (March 2005), 567.

38. Ralf Peter Behrendt and Claire Young, "Hallucinations in Schizophrenia, Sensory Impairment, and Brain Disease: A Unifying Model," *Behavioral and Brain Sciences* 27 (December 2004), 771–772.

39. Wilson, *Boundaries of the Mind*, 184–188.

40. Narcisse P. Bichot, Andrew F. Rossi, and Robert Desimone, "Parallel and Serial Neural Mechanisms for Visual Search in Macaque Area V4," *Science* 308 (22 April 2005), 529–534.

41. See the excellent analysis of Gibson's complex theory by Thomas Natsoulas, "'To See Things Is to Perceive What They Afford': James J. Gibson's Concept of Affordance," *Journal of Mind and Behavior* 25 (fall 2004), 323–348.

42. Charles Seife, "Do Deeper Principles Underlie Quantum Uncertainty and Non-locality?," *Science* 309 (1 July 2005), 98.

43. Charles Seife, "Teaching Qubits New Tricks," *Science* 309 (8 July 2005), 238.

44. The implicit stranglehold of a unified modernist architectural narrative has been critiqued in the excellent article by Sarah Williams Goldhagen, "Something to Talk About: Modernism, Discourse, Style," *Journal of the Society of Architectural Historians* 64 (June 2005), esp. 150–151.

Contributors

Rudolf Arnheim is Professor Emeritus of the Psychology of Art at Harvard University. His books include *Film als Kunst* (1932), *Art and Visual Perception: A Psychology of the Creative Eye* (1974), *The Dynamics of Architectural Form* (1977), and *The Split and the Structure: Twenty-Eight Essays* (1996).

Andreas Broeckmann (b. 1964) lives and works in Berlin. Since the autumn of 2000 he has been the Artistic Director of transmediale—festival for art and digital culture berlin. With its 35,000 visitors, transmediale is one of the major venues for the presentation and discussion of media art in Europe. The festival has paid particular attention to recent debates about the understanding of media art and its latest developments, including electronic music, software art, and locative media. Broeckmann studied art history, sociology, and media studies in Germany and Britain. He worked as a project manager at V2_Organisation Rotterdam, Institute for the Unstable Media, from 1995–2000. He co-maintains the Spectre mailing list and is a member of the Berlin-based media association mikro, and of the European Cultural Backbone, a network of media centers. In university courses, curatorial projects, and lectures he deals with media art, digital culture and an aesthetics of the machinic. See http://www.transmediale.de/, http://www.v2.nl/abroeck/.

Ron Burnett, President, Emily Carr Institute of Art and Design and author of *How Images Think* (2004, 2005), is the former Director of the Graduate Program in Communications at McGill University, recipient of the Queen's Jubilee Medal for service to Canada and Canadians, Educator of the Year in Canada in 2005, member Royal Canadian Academy of Art, Adjunct Professor in the Graduate Film and Video Department at York University, Burda Scholar at Ben Gurion University, and William Evans Fellow at the University of

Otago. Burnett is also the author of *Cultures of Vision: Images, Media and the Imaginary* (1995) and the editor of *Explorations in Film Theory* (1991). Burnett is on the Board of Governors of BCNet and was one of the founders of the New Media Innovation Centre in Vancouver.

Edmond Couchot is a doctor of aesthetics and visual arts. From 1982 to 2000 he was the head of the Department of Arts and Technologies of Image at the University Paris 8 and continues to participate in theoretical and practical research in the Digital Images and Virtual Reality Center of this university. As a theoretician, he is interested in the relationship between art and technology, in particular between visual arts and data-processing techniques. He has published about a hundred articles on this subject and three books: *Image. De l'optique au numérique* (1988); *La technologie dans l'art. De la photographie à la réalité virtuelle* (1998, translated in Portuguese); and *L'art numérique* (2003–2005), in collaboration with Norbert Hillaire.

As a visual artist, Edmond Couchot created in the mid-1960s cybernetic devices requiring the participation of the spectator. He later extended his research with digital interactive works and was involved in about twenty international exhibitions.

Sean Cubitt is Professor of Screen and Media Studies at the University of Waikato, New Zealand. Previously Professor of Media Arts at Liverpool John Moores University, he is the author of *Timeshift: On Video Culture* (1991), *Videography: Video Media as Art and Culture* (1993), *Digital Aesthetics* (1998), *Simulation and Social Theory* (2001), *The Cinema Effect* (2004), and *EcoMedia* (2005); and coeditor of *Aliens R Us: Postcolonial Science Fiction with Ziauddin Sardar* (2002) and *The Third Text Reader* with Rasheed Araeen and Ziauddin Sardar (2002). He is the author of over 300 articles, chapters, papers, and catalog essays on contemporary arts, culture, and media. A member of the editorial boards of *Screen; Third Text; International Journal of Cultural Studies; Futures, Time, and Society; Journal of Visual Communication; Leonardo Digital Reviews; Iowa Web Review; Cultural Politics; fibreculture journal; International Journal of Media and Cultural Politics; Public;* and *Vectors*, he has lectured and taught on four continents, and his work has been published in Hebrew, Arabic, Korean, and Japanese as well as several European languages in publications from Latin and North America, Europe, Asia, and Oceania. He has also curated video and new media exhibitions and authored videos, courseware, and Web poetry. He is currently working on a book on techniques of light of MIT Press.

Dieter Daniels initiated 1984 the Videonnale Bonn. He was director of the ZKM Video Library from 1992 to 1994, and since 1993 he is Professor of Art History and Media Theory at the Leipzig Academy of Visual Design. As well as authoring and editing numerous publications (including *Duchamp und die anderen. Der Modellfall einer künstlerischen Wir-*

kungsgeschichte in der Moderne, 1992; *Media Art Interaction. The 1980s and '90s in Germany*, 2000; *Kunst als Sendung. Von der Telegrafie zum Internet*, 2003; *Vom Readymade zum Cyberspace. Kunst/Medien Interferenzen*, 2003), and curating many exhibitions (e.g., 1994 Minima Media, MedienBiennale Leipzig) he is coeditor of the Internet project mediaartnet.org. Since 2006 he is Director of the Ludwig Boltzmann Institute Media.Art.Research., in Linz, Austria.

Science photographer **Felice Frankel** is a Senior Research Fellow at Harvard, as part of the new Initiative in Innovative Computing (IIC), while maintaining a part-time office at MIT's Center for Materials Science and Engineering as a research scientist. Her latest book *Envisioning Science: The Design and Craft of the Science Image* is now out in paperback. She is coauthor with Harvard chemist George M. Whitesides of *On the Surface of Things: Images of the Extraordinary in Science*. She is a Fellow of the American Association for the Advancement of Science.

Working in collaboration with scientists and engineers, Frankel creates images for journal submissions, presentations, and publications for general audiences. Her column, "Sightings," in *American Scientist Magazine*, addresses the importance of visual thinking in science and engineering.

She was awarded a Guggenheim Fellowship, and has received grants from the National Science Foundation, the National Endowment for the Arts, the Alfred P. Sloan Foundation, the Graham Foundation for the Advanced Studies in the Fine Arts, and the Camille and Henry Dreyfus Foundation. She was a Loeb Fellow at Harvard University's Graduate School of Design for her previous work photographing the built landscape and architecture.

Frankel's work has been profiled in the *New York Times, LIFE Magazine*, the *Boston Globe*, the *Washington Post*, the *Chronicle of Higher Education*, National Public Radio's *All Things Considered, Science Friday*, and the *Christian Science Monitor*, among others. Her images and graphical representations have appeared on the covers and inside pages of *Nature, Science, Angewandte Chemie, Advanced Materials, Materials Today, PNAS, Wired, Newsweek, Scientific American, Discover Magazine, New Scientist*, and others. See web.mit.edu/felicef/.

Oliver Grau is Professor for Bildwissenschaft and Dean of the Department for Cultural Studies at the Danube University Krems. He is also head of the German Science Foundation project Immersive Art, whose team since 2000 developed the first international Database of Virtual Art. He lectures in numerous parts of the world, has received various awards, and is widely published. Recent works include *Virtual Art: From Illusion to Immersion* (2003) and *Art and Emotions* (2005). His research focuses on the history of media art, the history of immersion and emotions; and the history, idea, and culture of telepresence, genetic art, and artificial intelligence. Grau is an elected member of the Young Academy of

the Berlin–Brandenburg Academy of Sciences. He is chair of Refresh! First International Conference on the Histories of Media Art, Science, and Technology, Banff 2005. See http://www.mediaarthistory.org/ and http://www.virtualart.at/.

Erkki Huhtamo (born Helsinki, Finland, in 1958) is a media archaeologist, educator, writer, and exhibition curator. He is Professor of Media History and Theory at the University of California Los Angeles, Department of Design | Media Arts. He has published extensively on media archaeology and the media arts, lectured worldwide, curated media art exhibitions, and created television programs on media culture. His recent work has dealt with topics such as peep media, the history of the screen, and the archaeology of mobile media. He is currently working on two books, one on the history of the moving panorama, and the other on the archaeology of interactivity.

Douglas Kahn is founding Director of Technocultural Studies at University of California at Davis. He writes on the history and theory of sound in the arts, experimental music, auditory culture, and the arts and technology, and coedited *Wireless Imagination: Sound, Radio, and the Avant-Garde* (1992) and wrote *Noise, Water, Meat: A History of Sound in the Arts* (1999). He is an editor of *Senses and Society* (Berg) and *Leonardo Music Journal* (MIT), and is currently researching early computing and the arts and the cultural incursion of electromagnetism from the nineteenth century to the present.

Ryszard W. Kluszczynski, Ph.D., is a professor of cultural and media studies at Lodz University, where he is Head of the Electronic Media Department. He is also a professor at the Academy of Fine Arts in Lodz (theory of art, media art) and Academy of Fine Arts in Poznan (media art). He writes about the problematics of information society, theory of media and communication, cyberculture, and multimedia arts. He also critically investigates the issues of contemporary art theory and alternative art (avant-garde). In the years 1990–2001 Kluszczynski was a chief curator of film, video, and multimedia arts at the Centre for Contemporary Art in Warsaw. He curated numerous international art exhibitions. Some of his publications include: *Information Society. Cyberculture. Multimedia Arts*, 2001 (second edition, 2002); *Film–Video–Multimedia: Art of the Moving Picture in the Era of Electronics*, 1999 (second edition, 2002); *Images at Large: Study on the History of Media Art in Poland*, 1998; *Avant-Garde: Theoretical Study*, 1997; *Film—Art of the Great Avant-Garde*, 1990. See http://kulturoznawstwo.uni.lodz.pl/.

Machiko Kusahara is a media art curator and a scholar in the field of media studies. Her recent research is on the correlation between digital media and traditional culture. Drawing on the fields of science, technology, and art history, Kusahara analyzes the impact of digital technologies and their background from a cultural point of view. Her recent

publications include analyses of Japanese mobile phone culture, game culture, and visual media. She has published internationally in the fields of art, technology, culture, and history, including sixteen laserdiscs on computer graphics, and coauthored books including *Art@Science* and *The Robot in the Garden*, among many others. Projects on which she collaborated with others in the fields of net art and virtual reality were shown at SIGGRAPH. She has curated digital art internationally since 1985, and was involved in founding the Tokyo Metropolitan Museum of Photography and ICC. Kusahara has also served as a jury member for international exhibitions including SIGGRAPH, Ars Electronica, LIFE, and the Japan Media Arts Festival. Since 2004 she has been involved in the Device Art Project with colleague artists and researchers, which won a five-year grant from the Japan Science and Technology Agency. Kusahara holds a Ph.D. in engineering from University of Tokyo. She is currently a professor at Waseda University and a visiting professor at UCLA.

Timothy Lenoir is the Kimberly Jenkins Chair for New Technologies and Society at Duke University. He has published several books and articles on the history of biomedical science from the nineteenth century to the present, and is currently engaged in an investigation of the introduction of computers into biomedical research from the early 1960s to the present, particularly the development of computer graphics, medical visualization technology, the development of virtual reality and its applications in surgery and other fields. Lenoir has also been engaged in constructing online digital libraries for a number of projects, including an archive on the history of Silicon Valley. Two recent projects include a Web documentary project to document the history of bioinformatics, and *How They Got Game*, a history of interactive simulation and videogames. In support of these projects, Lenoir has developed software tools for interactive Web-based collaboration.

Lev Manovich (www.manovich.net) is Professor at the Visual Arts Department, University of California, San Diego, where he teaches new media art, theory, and criticism. His publications include *DVD Soft Cinema: Navigating the Database* and the book *The Language of New Media* in addition to over eighty articles on new media aesthetics, theory, and history.

W. J. T. Mitchell is Professor of English and Art History at the University of Chicago, and editor of *Critical Inquiry*. His publications include "Iconology" (1986), "Picture Theory" (1994), and *The Last Dinosaur Book* (1998). His latest book is *What Do Pictures Want?* See

http://humanities.uchicago.edu/faculty/mitchell/home.htm/
http://www.chicagoschoolmediatheory.net/home.htm/
http://www.uchicago.edu/research/jnl-crit-inq/main.html/

Gunalan Nadarajan, currently Associate Dean for Research and Graduate Studies in the College of Arts and Architecture at Penn State University, is an art theorist and curator. His publications include a book, *Ambulations* (2000), and several academic articles and catalog essays on contemporary art, philosophy, new media arts, and architecture. He has curated several exhibitions internationally including *180kg* (Jogjakarta, 2002) and *Negotiating Spaces* (Auckland, 2004) and was contributing curator for *Documenta XI* (Kassel), and *Mediacity 2002* (Seoul). Gunalan, who is on the Board of Directors of the *Inter Society for the Electronic Arts*, was recently elected as a Fellow of the *Royal Society of the Arts* (UK).

Christiane Paul is Adjunct Curator of New Media Arts at the Whitney Museum of American Art and Director of Intelligent Agent, a service organization dedicated to digital art. She has written extensively on new media arts and her book *Digital Art* was published in July 2003. She teaches in the MFA Computer Arts Department at the School of Visual Arts in New York, the Digital Media Department of the Rhode Island. School of Design and has lectured internationally on art and technology. At the Whitney Museum, she curated the show "Data Dynamics" (2001), the net art selection for the 2002 Whitney Biennial, as well as the online exhibition "CODeDOC" (2002) for artport, the Whitney Museum's online portal to Internet art for which she is responsible. Other curatorial work includes "The Passage of Mirage" (Chelsea Art Museum, 2004); "Evident Traces" (Ciberarts Festival Bilbao, 2004); and "eVolution—the art of living systems" (Art Interactive, Boston, 2004).

Louise Poissant (Ph.D., philosophy) is Dean of the Faculty of Arts at Université du Québec à Montreal where she directs the Groupe de recherche en arts médiatiques since 1989 and the Centre interuniversitaire en arts médiatiques since 2001. She is the author of numerous works and articles in the field of new media art that have been published in various magazines across Canada, France, and the United States. Among her accomplishments, she supervised the writing and translation of a new media art dictionary published by the Presses de l'Université du Québec (PUQ) in French, and sections in the *Leonardo Journal* published by the MIT Press in English. An online version is available at http://www.dictionnaireGram.org/. She cowrote a television series on new media art in collaboration with TV Ontario and TÉLUQ, and she collaborated on a series of video portraits with the Montreal Museum of Contemporary Art (MACM). Her current research is on art and biotechnologies, and on the new technologies used in performing arts.

Edward A. Shanken is Professor of Art History and Media Theory at the Savannah College of Art & Design. He edited a collection of essays by Roy Ascott, entitled *Telematic Embrace: Visionary Theories of Art, Technology, and Consciousness* (2003). His essay, "Art in the Information Age: Technology and Conceptual Art" received honorable mention in the

Leonardo Award for Excellence in 2004. He recently edited a special series for *Leonardo* on the topic "Artists in Industry and the Academy: Interdisciplinary Research Collaborations." Dr. Shanken earned his Ph.D. in art history from Duke (2001) and his M.B.A. from Yale (1990). He has been awarded fellowships from the National Endowment for the Arts and the American Council of Learned Societies. He serves as an advisor to the REFRESH conference, the journal *Technoetic Arts*, and the Leonardo Pioneers and Pathbreakers project, and is Vice Chair of the Leonardo Education Forum.

Barbara Maria Stafford does research at the intersection of the visual arts and sciences from the early modern to the contemporary era—with a specific focus on visualization strategies and optical technologies. She is completing a book dealing with visuality and the cognitive turn.

Peter Weibel in 1984 was appointed Professor for Visual Media Art at the Hochschule für Angewandte Kunst in Vienna, and from 1984 to 1989 was Associate Professor for Video and Digital Arts, Center for Media Study at the State University at Buffalo, New York. In 1989 he founded the Institute of New Media at the Städelschule in Frankfurt on the Main. Between 1986 and 1995 he was in charge of the Ars Electronica in Linz as artistic consultant and later artistic director. From 1993 to 1998 he was curator at the Neue Galerie Graz. Since 1999 he has been Chairman and CEO of the ZKM/Center for Art and Media in Karlsruhe.